2004

GIFT

from

CHRIS ZITKO

LEONARDO DA VINCI

LEONARDO DA VINCI

D.M. Field

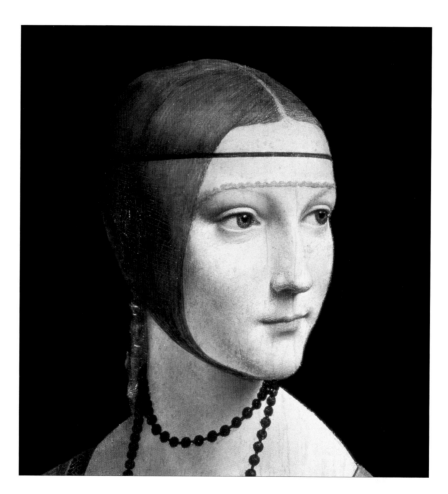

THE WELLFLEET PRESS
WELLFLEET

Published in 2003 by
Wellfleet Press
A division of Book Sales, Inc.
Raritan Center
114 Northfield Avenue
Edison. NJ 08837 USA

ISBN 0-7858-1462-0

Printed in China by Sino Publishing House Limited

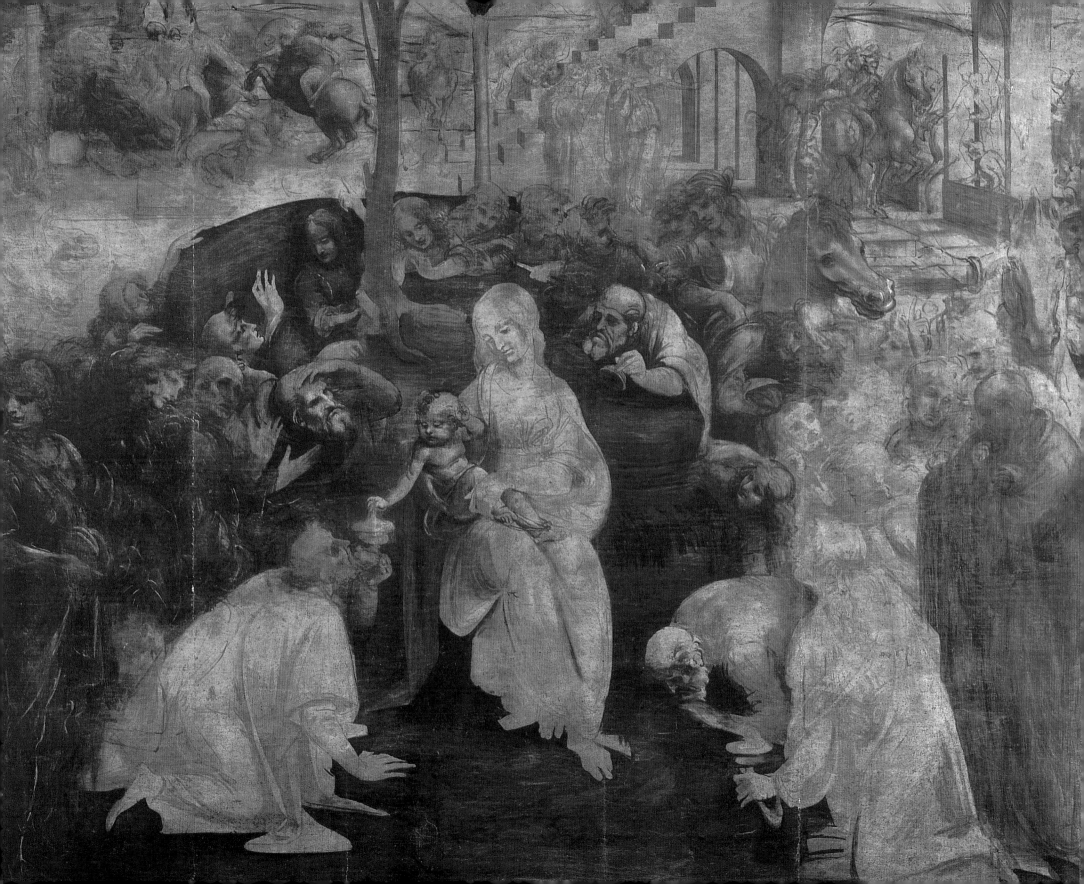

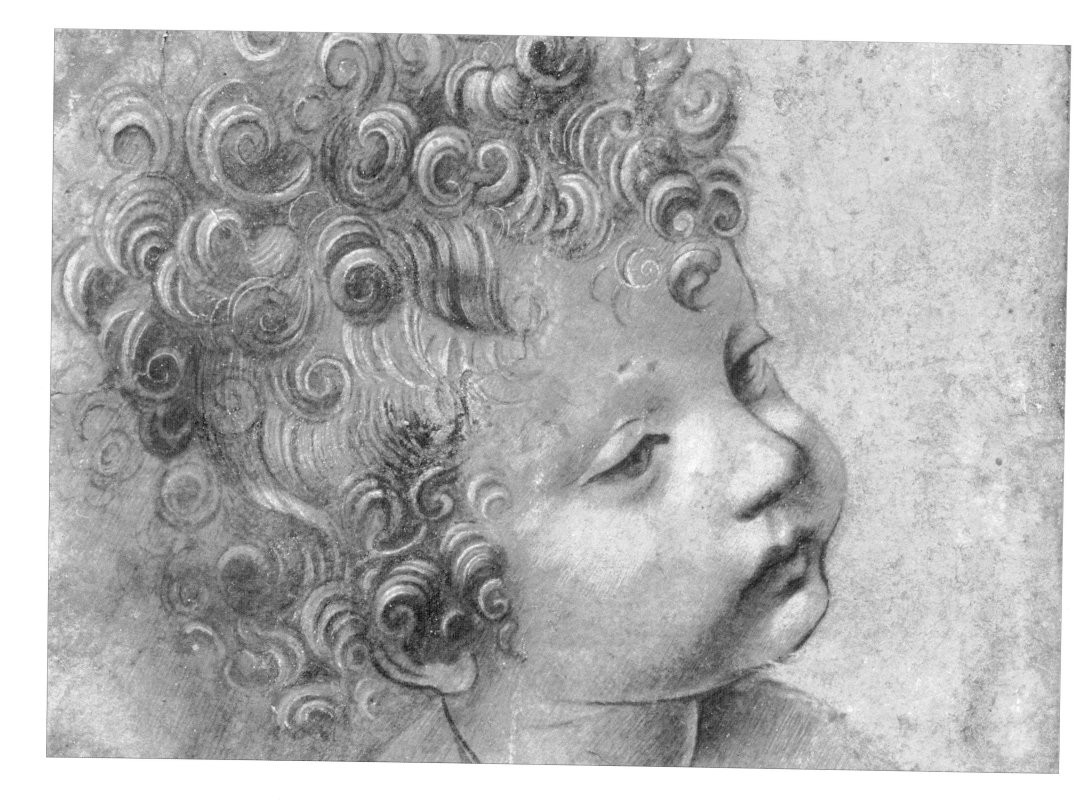

Contents

Introduction

The heavens often rain down the richest gifts on human beings, naturally, but sometimes with lavish abundance bestow upon a single individual beauty, grace and ability, so that, whatever he does, every action is so divine that he distances all other men, and clearly displays how his genius is the gift of God and not an acquirement of human art. Men saw this in Leonardo da Vinci ...

Vasari, ***Lives of the Painters...***, 1550

Introduction

Leonardo was famous in his own lifetime and has remained famous ever since. Until quite recently, however, his celebrity rested almost exclusively on his reputation. Few of his pictures were known, even fewer were available for inspection, and he was believed to be the artist of a variety of often nondescript pictures by imitators and others that were nothing to do with him at all. The notebooks and manuscripts that contained his extensive scientific thought and theories, his extraordinary technological inventions, and his perceptive observations on nearly every subject under the sun, had never been reproduced or printed, and except for an adulterated version of his *Treatise on Painting*, his writings were also unknown to all but a handful from his own time until the late 19th century.

That was the situation until about 1800, when the Napoleonic upheaval in Europe stirred up some interest, in particular as a result of the French carting off to Paris the extensive Leonardo manuscripts hitherto held in Milan (some were never returned). Two or three books were written on Leonardo then, but there was no further significant advance until the last quarter of the 19th century. In 1860 Jacob Burckhardt in his classic work *The Civilization of the Renaissance in Italy*, pointed out that the most authoritative work on Leonardo was still the short biography written by a near contemporary, Giorgio Vasari, which was first published in 1550.

From the 1880s, the rediscovery of Leonardo's works began, a work of immense labour in view of the vast extent of the material and the difficulties associated with it, the absence of any guide to its contents, and not least the effort of reading Leonardo's neat but tiny mirror-writing (from right to left). The first instalment of the enormous *Codex Atlanticus* began in 1894, and Leonardo, hitherto known almost exclusively as a painter, began to be seen as a figure of massive and intimidating intellectual power. Publication of his studies on anatomy around 1900 led some to see him as the founder of the modern science of anatomy, and as the teacher of Vesalius. He appeared as the ultimate Renaissance genius, capable of anything, who had apparently envisioned or invented every device and anticipated every discovery of the ensuing centuries.

The human inclination to myth-making explains

RIGHT
A working model of a weaver's loom in the museum at Vinci, based on a drawing by Leonardo. Some of the many models on view in the museum testify to the ingenuity of the model-maker no less than to the designer.

OPPOSITE
The drawing on which this chain-driven, wooden bicycle was based turned up in the recently rediscovered Codex Madrid. *Although its presence there is a mystery, it is in a child-like hand, is probably not more than about 100 years old, and has nothing to do with Leonardo, bar wishful thinking.*

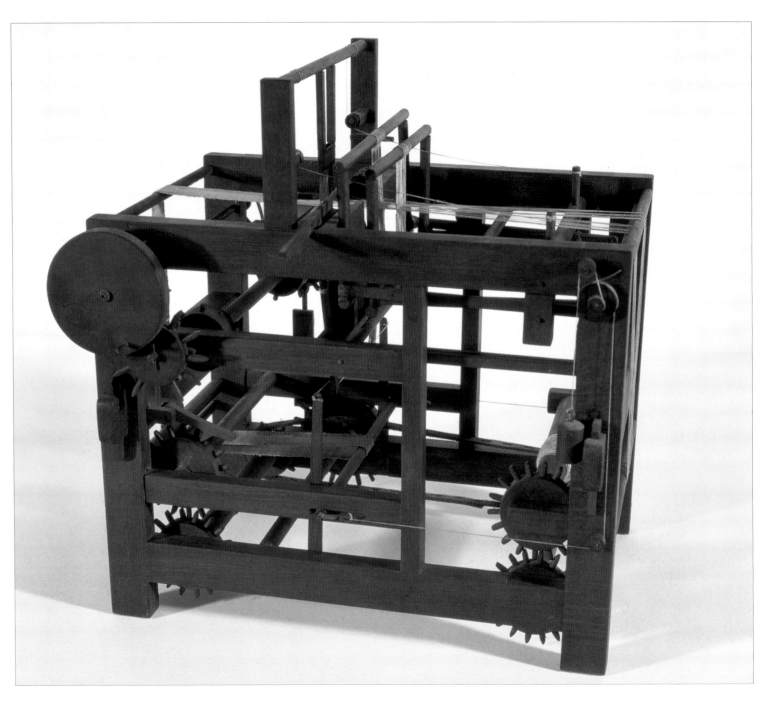

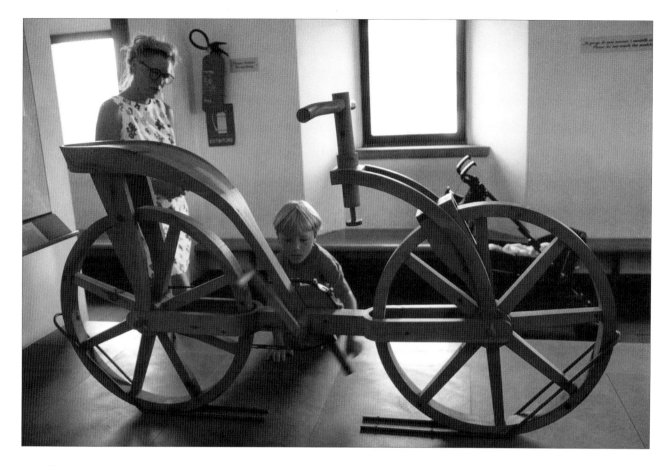

the common tendency to ascribe exaggerated abilities to any great figure, and more recently the overall picture of Leonardo's scientific and technological accomplishments has been slightly modified, the wilder claims denied, while at the same time, through the work of several generations of devoted, sometimes combative art historians, we have acquired much better knowledge of Leonardo's painting. The many inferior works that were once attributed to him have been dismissed from the canon, and several genuine works have been rediscovered and reassessed (not one of Leonardo's early works, from his first period in Florence, was known before the 19th century).

Yet the paradox of Leonardo remains. Compared with other giants like Michelangelo, Raphael or Titian, his legacy is small. The number of his surviving paintings (all of them today in public collections, as are almost all his drawings) that are complete and in reasonable condition is tiny, and apart from the rather unsatisfactory *Treatise on Painting*, none more than Leonardo himself has managed to create a coherent work on any subject from the immense mass of his notes and drawings.

There is a story, stemming from Vasari, that at the end of his life Leonardo lamented his many unfinished artworks and uncompleted books. While it would be absurd to suggest he left so many paintings incomplete on purpose (circumstances were sometimes against him), and while he certainly intended to organize – one day – his diffuse studies on several subjects in an orderly form, regret was not a characteristic emotion with him, and we may suspect that Vasari's report reflects not what he said

Model of a clock

Based on a drawing by Leonardo da Vinci, the model sits on display at the museum in Vinci.

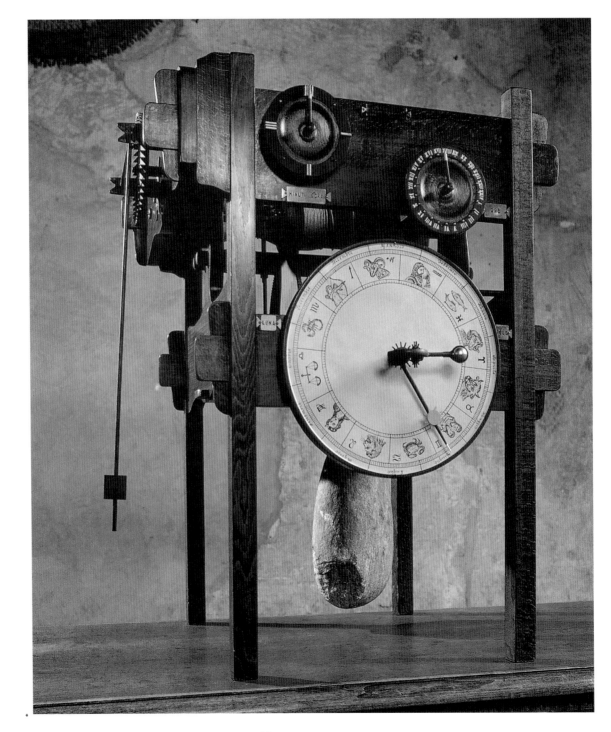

Leonardo da Vinci

Model of a digging machine

Based on a Leonardo da Vinci design, the model is in the National Museum of Science and Technology in Milan.

Introduction

Leonardo da Vinci

but what his contemporaries thought he should have felt. Until near the end of his life, Leonardo remained a fervent seeker after knowledge. He was more interested in finding out than in communicating his findings. To some extent this explains not only the disorderly state of his literary legacy but also the notoriously high proportion of works he left unfinished or, as a result of his creative/destructive impulse to experiment, ruined. The most interesting, most challenging part of doing a painting was in the design and preparation, whereas the final application of colours was largely foreordained; many artists left it partly to assistants. Leonardo also found it difficult to reach a conclusion, to put down his brush and say 'That's it. Perfect!'

In spite of all this, enough of Leonardo's art survives to support Vasari's view of him as a founder of modern painting, and his notebooks present ample justification for the belief almost universally held by his contemporaries that Leonardo was a prodigious genius, 'possessed of a divine and marvellous intellect'.

A wooden bicycle designed by Leonardo

Leonardo da Vinci Museum, Vinci

Fascinated by the power of the elements, Leonardo exercised his ingenuity in devising ways of exploiting the energy available from wind, water and muscle. Without knowing it, he yearned for some new source of power and would have been delighted by the technology of the Industrial Revolution.

OVERLEAF
A view of Florence with the Palazzo Vecchio on the right.

Chapter One
The Early Years
1452–69

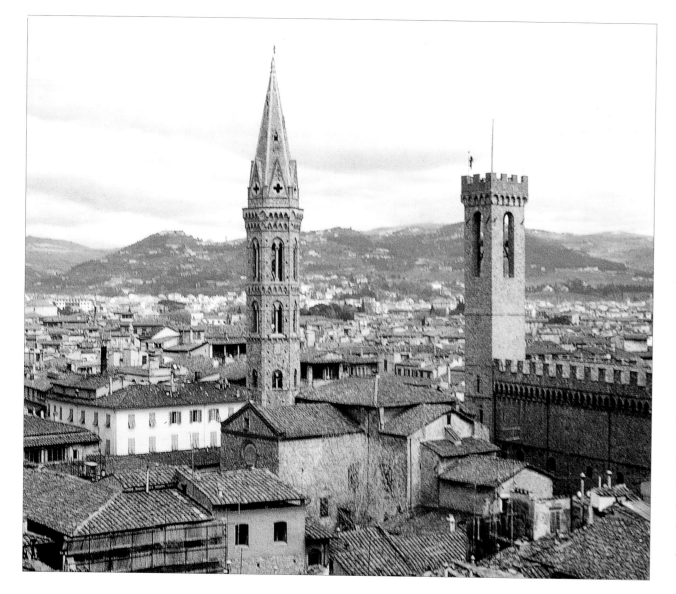

The background, ancestry and childhood of any person of unusual talents, let alone a genius like Leonardo, must be of interest, although it does not necessarily provide any explanation of where those gifts came from. Of Leonardo's inheritance and early years we know comparatively little, yet, given the circumstances, more than might be expected, and since Leonardo is himself almost a figure of myth, the many legends that have accrued to his memory should not be dismissed out of hand.

His father, Ser Piero da Vinci was, or became, a notary, or lawyer (the title 'Ser' denoted his status), a hereditary profession in which he followed a long family tradition. He did well, eventually marrying a daughter of the state chancellor and being appointed notary to the city of Florence. He may have been able, on occasion, to deploy his influence to advance his son's early career. He lived to the age of 78, and had four wives altogether who provided him with about 15 children, the last of them born when he was in his late 60s. But when Leonardo was born, he was a still a young man and as yet unmarried. Although he married his first wife in the same year,

VINCI

Vinci is a small, attractive, Tuscan hill town about 28 miles (45km) north-west of Florence, surrounded by vineyards and olive groves. The house where Leonardo was allegedly born (below) is a humble single-storey dwelling of mellow stone and red tiles, with only three rooms. It stands on its own and, even today, the place is quite remote and peaceful.

The Museo Leonardiano at Vinci, housed in the Guidi castle, was extended in the 1980s to provide exhibition space for models, mainly in wood, of many mechanical devices based on Leonardo's drawings and descriptions, copies of which are shown adjacent to the models. Besides complex gearing systems, winches, cranes, etc., there are machines designed for the cloth and building industries and a number of war machines, including such well-known examples as his circular battle tank, capable of moving in any direction, and a multi-barrelled gun like a rocket launcher. On the upper floor are full-scale models of machines and devices deriving from Leonardo's designs for movement through the air, on the ground, or under water. A figure wearing a 'parachute' is suspended over the courtyard. Some of the models incorporate assumptions necessarily made by their makers, and the model of a bicycle is based on a famous, recent discovery in the long-lost *Codex Madrid* of a pedal bicycle, which is in a hand that is not Leonardo's (it is probably a child's), and is possibly a quite recent addition.

RIGHT
Model of a swing bridge, after Leonardo
Leonardo da Vinci Museum, Vinci

OPPOSITE
Two Horsemen
Drawing, metal point

Several witnesses testify to Leonardo's love of horses which, in one way or another, figured in a remarkably large proportion of his total oeuvre.

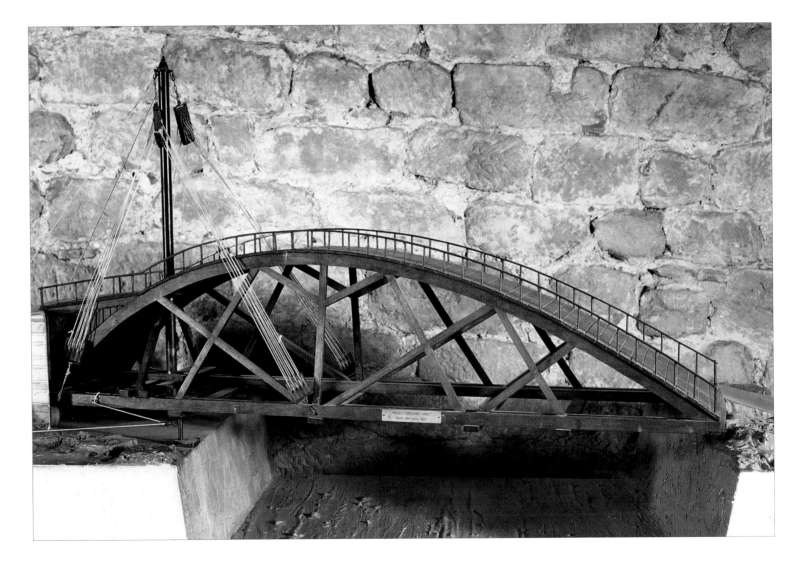

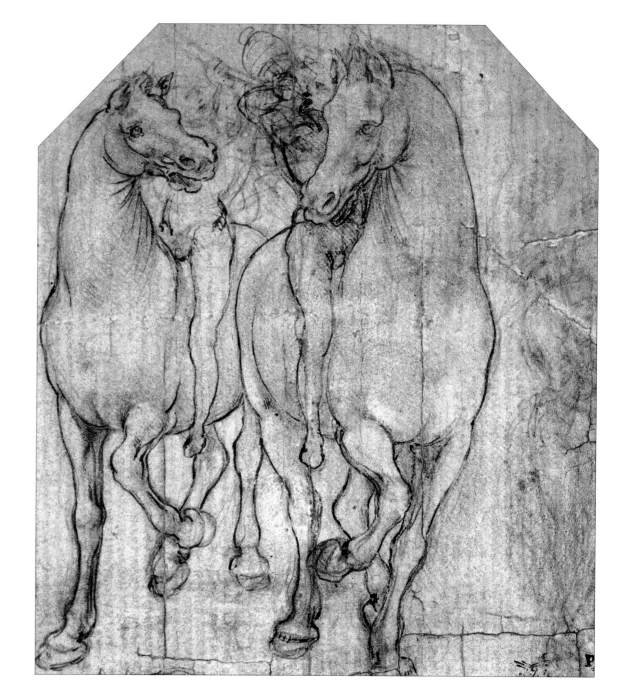

his first legitimate child was not born until many years later.

Leonardo's mother, Caterina, who was of a lower social class than her lover, lived in Vinci, where Ser Piero's family owned some land (she was possibly a tenant). Illegitimacy did not create the difficulties with stepmothers and legitimate siblings that might otherwise have complicated Leonardo's childhood because he was nearly grown up when the first of his legitimate half-brothers was born. Although his mother also married and had children, from the time of her marriage Leonardo probably lived with his grandparents in Vinci and, later, in Florence with his father. He was in effect an only child.

The artist's birth in 1452 was recorded in a diary by his paternal grandfather, Antonio, who, unlike his forefathers, was not a notary, preferring the quiet life of a country gentleman. He noted that his grandson was born on 15 April, a Saturday, between two and three hours after midnight. The mother's name was not registered, because the birth was illegitimate, but the name of the officiating priest and the ten witnesses at Leonardo's baptism are on record.

For his first five years, Leonardo grew up in the care of his mother or his paternal grandparents. It is impossible to be precise, but it seems certain that he was nursed by his mother but that, by the time he was about five, she married and moved out of the Vinci house into something even smaller a couple of miles away, where she soon started a family. Apart from occasional visits to or from his father, Leonardo was then presumably reared by his very elderly grandparents, until he eventually moved into his father's comfortable household in the city.

The date of this move is doubtful. Tax records of 1469 place him as a dependent of his grandmother (Antonio having died earlier), whereas returns for the following year have him living in Florence with his father. However, the former document refers to family members, not necessarily resident, and Leonardo was almost certainly already in Florence before 1469, probably at least three years earlier.

After moving into his father's apartments in a building (soon to be demolished for the Palazzo Gondi that still stands on the site) on the Via della Prestanza, overlooking the Palazzo della Signoria (Palazzo Vecchio), Leonardo probably saw his mother only seldom. In later life he seems to have borne a grudge against her, and always referred to her as 'la Caterina', never as his mother, but from a note of 1493 it appears that she may then have been living in his house in Milan. He does not seem to have been close to his father either, and as a young boy he was perhaps closest to his uncle Francesco, his father's younger brother, who also lived in the family farmhouse. Francesco, only 16 when Leonardo was born, was a countryman like his father, content to manage the family estate and unambitious for worldly success. When he died in 1506 he made Leonardo his sole heir, despite the existence of other, legitimate nephews who would normally have inherited (and indeed apparently expected to do so in this case, as they sued). It may have been Francesco, on their rambles through the countryside, who first inspired Leonardo's intense interest in nature. The boy's love of animals was reflected in tales of how he would buy wild birds in the market merely to set them free, and his affinity with horses – something he shared with Lorenzo

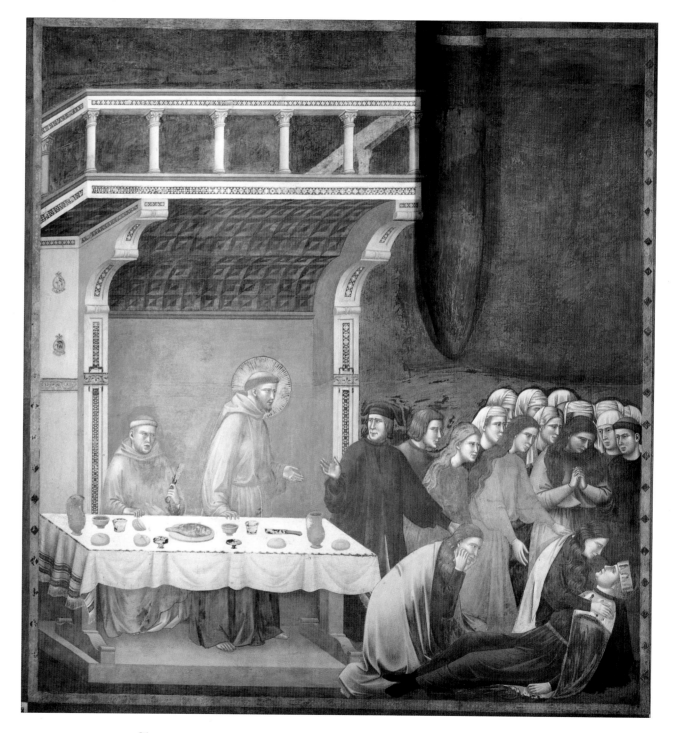

de' Medici – is confirmed by his numerous drawings of them.

Many of his biographers have traced the roots of Leonardo's alleged misanthropy, misogyny, and his questionable view of human beings in general (his fascination with grotesques for example), to his childhood. Certainly, the experience of relative loneliness, the loss of his mother when he was at the most vulnerable age, and the facts of his birth that divided him from his – much younger – half-siblings may help to explain his unusual degree of independence of other human beings, his tendency to pursue lines of inquiry that engaged him personally to sometimes excessive lengths, and his notorious failure to complete so much of what he started.

The move to his father's house represented a sharp upward step in social status. Leonardo may be assumed to have been more interested in the contents of his own head than the comforts of his body, but numerous witnesses testify to his liking for luxury. An internationally famous artist, courted by princes and prelates eager to own a sample of his

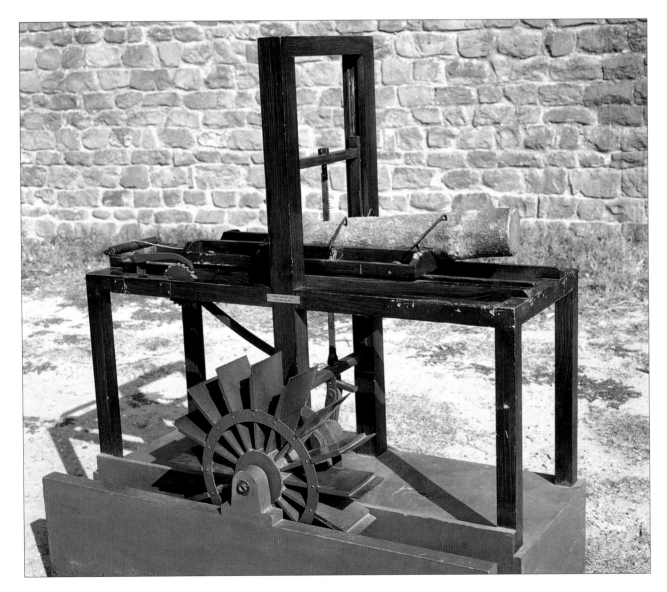

work, may be expected to enjoy the material fruits of his achievements and to live in a certain style. For a young artist in Florence whom few people had even heard of to maintain a similar style – with his own servants and horses – is more surprising. Presumably his father, who was very comfortably off but not rich on a Medician scale, was more indulgent than might be expected from what otherwise appears to have been, perhaps simply because we do not know enough about it, a rather remote relationship.

Illegitimacy may not have damaged Leonardo as a small child, but it was a severe drawback as he grew older. It was probably the reason for his lack of education and would also have prevented him following the family profession, although whether that was much of a handicap is open to question. It is hard to imagine Leonardo becoming a lawyer, but other professions, such as physician, might have appealed to him. He could not go to university either and was largely self-educated, painfully teaching himself the Latin so essential to his studies when over 40 years old.

Leonardo da Vinci

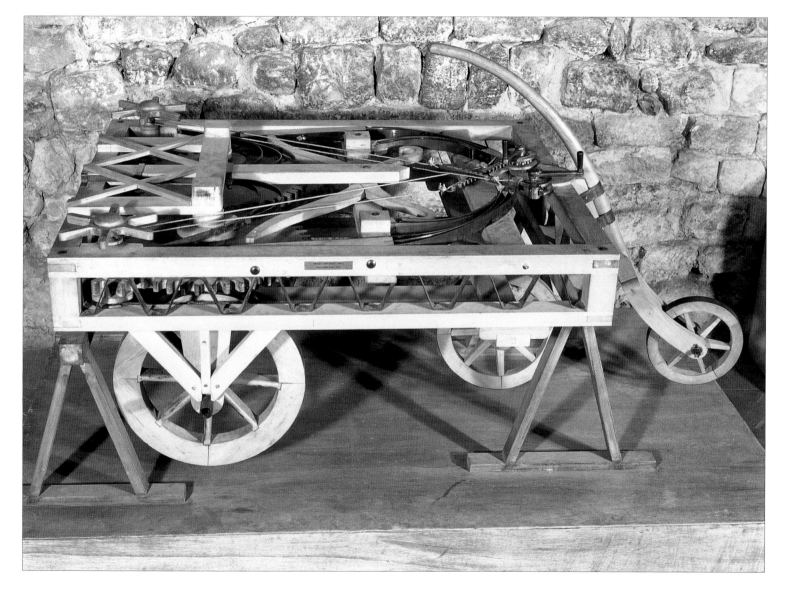

RIGHT

The Tribute Money, by Tommaso Masaccio *(c.1427)*

Fresco

Brancacci Chapel, Santa Maria del Carmine, Florence

Masaccio owed little to the charming, graceful work of his contemporaries, but his ability to convey meaning through gesture and expression may be traced to Giotto and in turn influenced Leonardo.

Exactly how much formal education he did have is a matter of dispute. He may have attended a primitive village school in Vinci, and some say that he later attended the same school in Florence as his legitimate half-brothers, though there seems to be no firm evidence. The workshop of Verrocchio inculcated much useful knowledge, not all of it exclusively practical, and that was probably the best schooling Leonardo ever had. His lack of formal education no doubt largely explains his lack of sympathy with the cultured Neo-Platonists of the Medici court, though Leonardo was by temperament more easily aligned with the broad tradition of Aristotle than the narrower idealism of the Platonists. Certainly, even in his own day, he was widely hailed as a great 'philosopher' – then a term with a much broader meaning than today.

The absence of officious teachers also had compensations, one being that no effort was made to 'correct' the boy's left-handedness. Like some other naturally left-handed people he was to a degree ambidextrous, and taught himself to draw or paint with either hand.

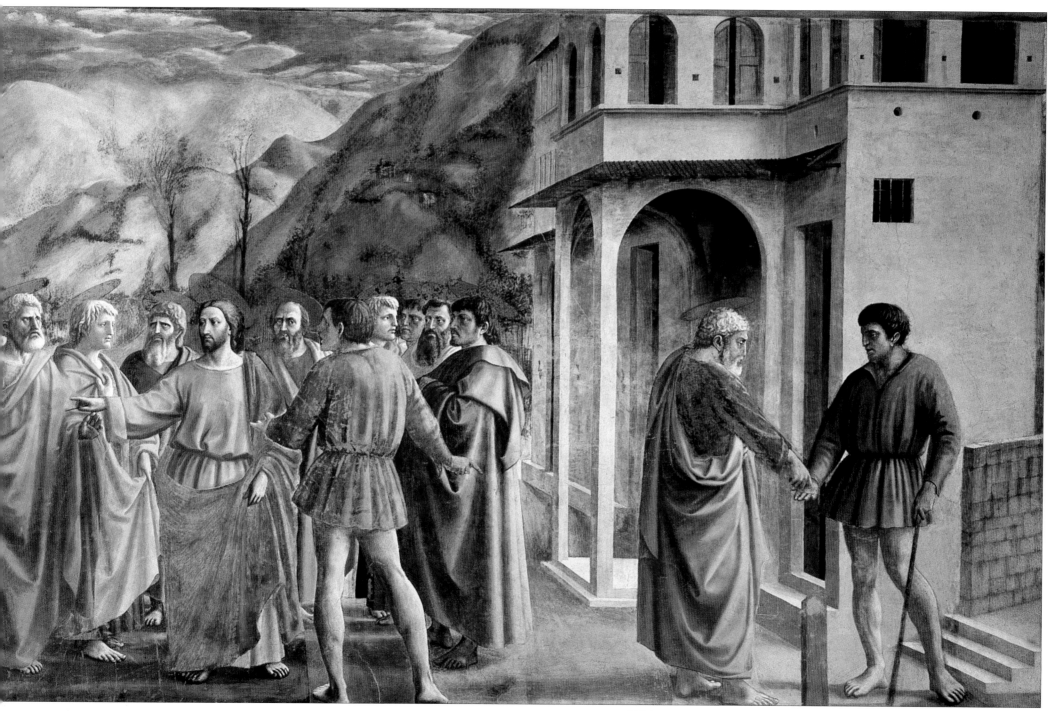

OPPOSITE
Tuscan scenery: Badia Passagnano in Chianti. Leonardo was (like Masaccio) a country boy. He spent most of his life in cities but seems to have drawn refreshment and strength from visits to the countryside.

Leonardo himself sometimes professed to scorn mere book learning.

'*As I am not a man of letters,*' runs a passage in his notebooks, '*I realize that some presumptuous people will feel justified in condemning me on the grounds that I am ignorant of writing. Idiots!... They will say that I cannot properly deal with the subjects on which I wish to write because I have no literary training. They do not realize that what I have to say is to be expressed not on the basis of the writings of others but on experience, the mistress of all good writers.*'

Greatness attracts legend, and many stories are told of Leonardo that belong to mythology rather than history, although they may well enshrine a poetic truth. Other stories are told by contemporaries or near-contemporaries such as Giorgio Vasari, his first biographer, that are credible but unprovable. As might be expected, they include some extraordinary feats accomplished as a mere child that foretold his future achievements, such as his confusing a teacher of mathematics with problems of his own devising.

One famous story of early childhood comes from an impeccable source, Leonardo himself. It was, he says, one of his earliest memories. 'When I was in my cradle a kite flew down and opened my mouth with its tail and struck me many times with the tail on the inside of my lips.' Sigmund Freud, not unpredictably, thought the tail feathers of the bird (which, owing to a mistranslation in the German version, Freud thought was a vulture, leading him into irrelevant speculations related to Egyptian mythology) actually represented the mother's breast. Leonardo interpreted his dream more literally, taking it to mean that he was destined to explain the workings of nature to the world. That, he added, 'seems to be my vocation.'

Chapter Two
Florence
1469–82

Though the domains of Florence hardly extended as far as the borders of Tuscany, and the city itself had only about 150,000 inhabitants, it was one of Europe's liveliest and most prosperous cities which, since the time of Dante and Giotto, had enjoyed its image as a kind of cultural totem, the pinnacle of civilization, something like Paris in the 19th century or New York in the 20th. Vast family fortunes were built on the wool industry and banking; the Florentine bankers did business all over Europe and included kings among their clients. The Florentine republic was, it seemed, firmly established, the gold florin was the most reliable currency in Europe, the Tuscan dialect was on its way to becoming the language of all Italy, the *duomo* (cathedral), topped by Brunelleschi's great dome which rivalled the Pantheon of ancient Rome, was the most magnificent of modern buildings. New palazzi, grand though severe and classically symmetrical, were being built at an average rate of nearly two per year, while most of the fortified towers that had served as battle headquarters for the city's hostile clans in the Middle Ages had been partly or wholly demolished. (Feuds, however, were not entirely a thing of the past, as the Pazzi conspiracy of 1478 would bloodily demonstrate.)

The city was changing fast. Municipal ordinances enforced sensible town planning. Old slums were being cleared away, streets widened, new bridges planned across the Arno (there were four already). Environmental improvement had been going on since Dante's time. The poet himself was a member of a commission of the communal government charged with widening the cramped and festering medieval streets in 1299. Such programmes, though often of limited achievement, were an indication of the pride that the citizens took in their city. 'Those who are charged with the government of the city should pay particular attention to its beautification', according to a Sienese proclamation. The building of the cathedral, culminating in Brunelleschi's engineering miracle of the dome, was always a communal enterprise, reflecting the determination of the citizens to build 'the most beautiful church in Tuscany'.

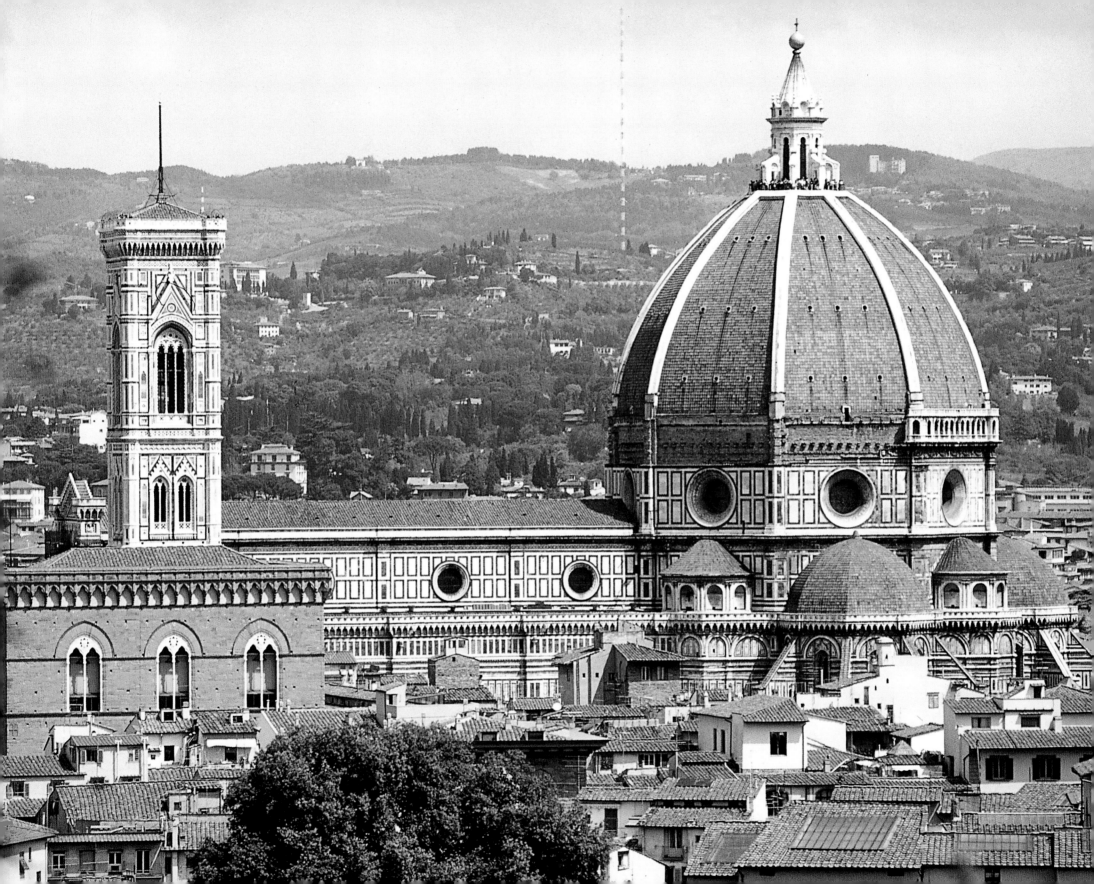

**The Duomo, Florence
(Santa Maria del Fiore)**

*The east end of the duomo, below
Brunelleschi's great dome, the most
remarkable structure of its time.*

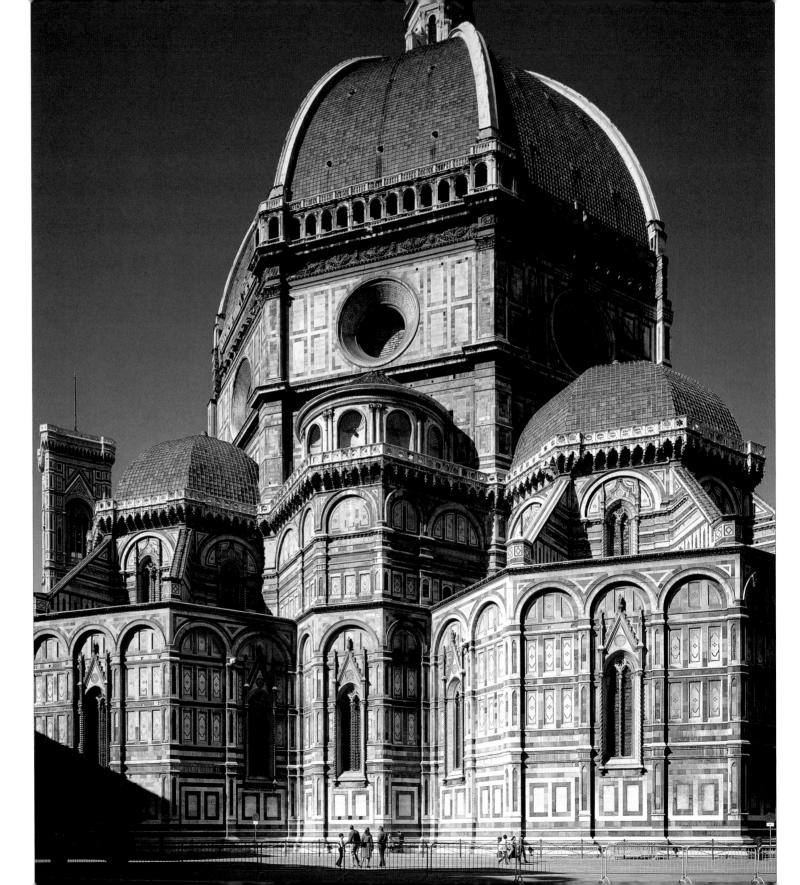

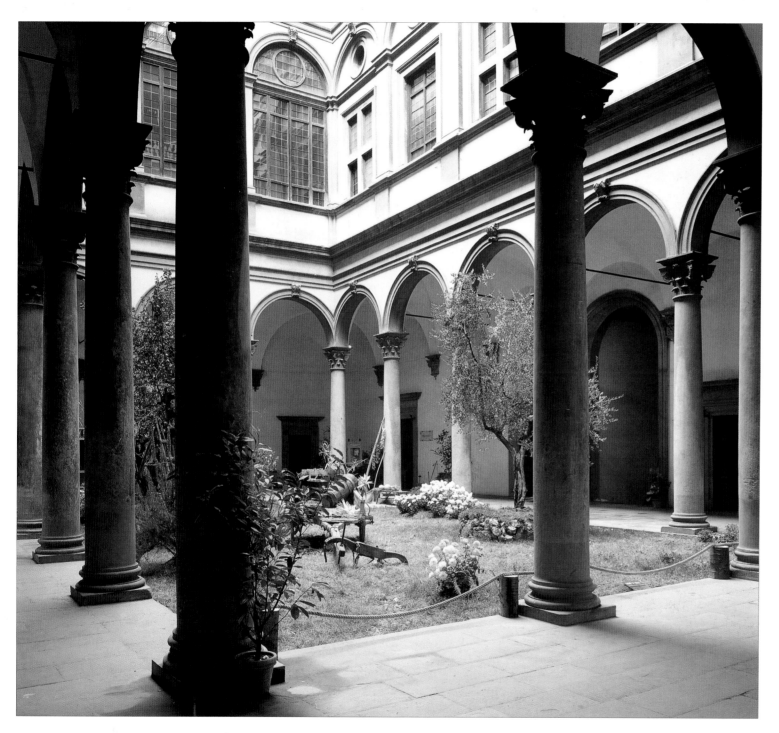

Palazzo Strozzi, Florence
(1489–)

Inner courtyard of the Palazzo Strozzi. The inward-looking plan of the palazzi of the rich suggests a social trend towards aristocratic elitism in Renaissance Florence.

Palazzo Vecchio, Florence
(1298–1314)

The great 308-ft (94-m) tall bell tower of the Palazzo Vecchio in the Piazza della Signoria. Though a civic building rather than a fortress, it was equipped to withstand a certain amount of violence.

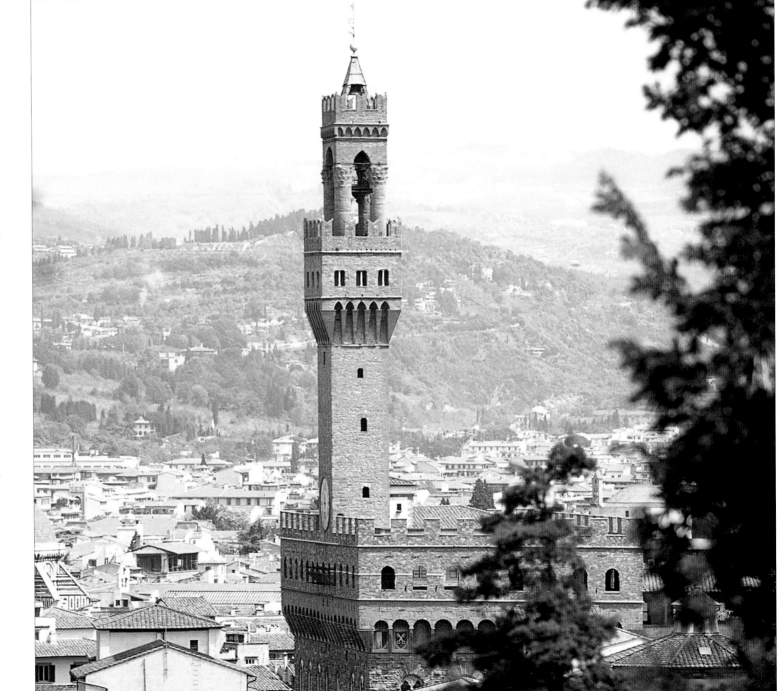

Leonardo da Vinci

In Leonardo's time, Florence was still a republic although, as in other medieval communes, political power had passed to a small group of wealthy patrician families. The fortunes of rival families changed, but in 1434, when Cosimo de' Medici staged his comeback after a period in exile, the Medici and their close allies became the effective rulers of Florence. They remained in power for 60 years, a period that, coincidentally or not, witnessed an unparalleled blossoming of cultural wealth.

Vastly rich and therefore powerful, Cosimo and his successors, his son Piero (1464–69) and grandson Lorenzo (1469–92), occupied an anomalous position in the state, since they held no great office and claimed no grand title, but exercised their control through influence and patronage, ensuring that the chief offices of state, though elective, were always held by their adherents. Economically, the Medici bank was in decline by Lorenzo's time, but in spite of occasional rumbles of discontent, the patrician class by and large accepted Medici rule because it

ensured peace and stability, the conditions required for increasing their fortunes and building their palazzi, the tangible signs of their wealth and status – and their rising aristocratic pretensions. Medici patronage, most famously, extended also to the arts and Humanist scholarship.

The most obvious weakness of Florence, as of other, smaller city-states, was military. The strains of war were one of the causes for the decline of the medieval communes. By the 14th century the civic militias were insufficient and states were forced to hire mercenary armies. The drawbacks of mercenaries were obvious: their unreliability, their need to live off the land, and the danger of their becoming involved in politics; but, above all, they were very expensive. Debts piled up, and they were often not paid off by the time new resources were required for another war. Florence in the early 15th century was the only substantial republic (besides Venice) still functioning in a country increasingly dominated by despots. That added an ideological element to the usual economic and strategic causes of war, and resulted in Florence

having to defend its liberties against great odds. It was perhaps fear as much as avarice that drove Florence's territorial expansion in Tuscany in the late 14th–early 15th centuries.

The foreign policy of the Medici has generally been praised by historians as it largely succeeded in its aims of preserving peace and the balance of power in Italy. It was based chiefly on personal links and their own international prestige, which in Lorenzo's case especially was immense. The crucial alliance was with the Sforza dukes of Milan. This policy, which was established by Cosimo and continued by his successors, reversed an old tradition of hostility between Florence and the Lombard state. Of course, personal reputation and skilful diplomacy by itself was not enough. A coincidence of interests was also necessary, and in that respect Florence and Milan fitted rather well. Briefly, Milan needed money and Florence needed soldiers. Thus, in return for Medici loans, Sforza troops were sent to Florence in 1458 and again in 1466 to crush incipient rebellion. It worked well enough, although a state that needs to call in foreign troops to keep its own citizens in order is not in a healthy condition for the longer term.

Some historians believe that the Florence of Lorenzo the Magnificent was already in decline. This is hard to judge since, as always, while some family fortunes were shrinking, others were being made, and in spectacular fashion. Certainly, few contemporaries would have been aware of gathering shadows, rather the opposite. Florence sparkled in the bright, spring-like colours of a *quattrocento* fresco. When the young Leonardo – he was three years younger than Lorenzo de' Medici – arrived in Florence in the late 1460s (assuming he had not been living there earlier as some believe), he entered a rich and famous city, capital of a substantial state which, through its arts and scholarship, was the cynosure of all Europe. Though the actual distance was only about 28 miles (45km), it was a world away from sleepy little Vinci. What impression it made on him we can only guess, perhaps nothing very startling as it seems certain that he had visited it before to stay with his father and may have been living there as early as 1460.

THE CULTURAL SCENE

The reputation of Florence in the 14th century was outstanding in almost every cultural field, most obviously perhaps in the visual arts: in painting, sculpture and architecture, but also in what we should call the decorative arts, such as ceramics and metalwork, and many of Leonardo's inventions were the culmination of decades of technical innovations (and often less original than was once thought). Florence also led all others in the study of the classics and the subjects associated with them, such as history and poetry. In medicine, law and even theology, Florence was at the front. Educated Florentines, a high proportion of the population, were seemingly interested in every variety of literature, from learned treatise to bawdy story.

It is simple to explain the roots of the Renaissance in terms of the two cultural traditions of antiquity and Christianity, but these were common to all Italy (and to most of Europe). They do not explain the pre-eminence of Florence. What, therefore, was the magic ingredient in the Tuscan air that accounted for the universally acknowledged superiority of its leading city?

The answer must lie in a third ingredient, the native or vernacular tradition, rooted in the commercial community and the numerous other cultures that contributed to the social mix. This was less structured, less formal than the classical/Christian traditions, largely oral and visual, and expressed in a language itself not yet fully defined. It was also more interactive, less distinctly separated from the classics and Christianity, and communication between them was more free, thanks to the comparative lack of social barriers in Florence and the high degree of social tolerance. A crucial figure was Dante, who represented the classical and Christian traditions but wrote in the vernacular – the Tuscan dialect. In painting, a comparable figure was Giotto, whose figures were both grandly monumental and realistically human.

The cliché of 'the Renaissance man', gifted in many different spheres, originated in Florence, where merchants, scholars, lawyers, clergy, and artists mingled freely. The library of a 14th-century notary contained not only law books but also

religious works and classical literature. Rich bankers and poor workmen sat as equals in the Signoria, and people of all sorts might be encountered in the various informal assemblies or discussion groups (*convegni*) associated with particular individuals, or in places like the more fashionable artists' workshops. The aristocratic class were not merely patrons of art and learning, they took an active part in cultural life. Cosimo de' Medici, besides being banker, politician and patron, was also the friend of leading Humanists and artists, and his grandson, Lorenzo the Magnificent, was an able statesman and gifted poet, besides encouraging writers and artists. He took the 15-year-old Michelangelo into his household after spotting his talent in a marble faun's head in the garden of San Marco, Florence.

Florence was not dominated by any particular social group or institution. The hegemony of the Church, with its monopoly of education, which had seriously inhibited free intellectual debate during the Middle Ages was, perhaps surprisingly, less strong in Italy than elsewhere, and from the 13th century was virtually non-existent. It was not that the Church and clergy were not respected, only that they were not held to be the sole arbiters of knowledge. The case of a man condemned for witchcraft by the Inquisition in 1383 roused a storm of opposition, not least from the bishop and his clergy. Indeed, we hear little of the activities of the Inquisition in Florence. When a Franciscan preacher called upon the city to expel the Jews in 1493, he, not the Jews, was thrown out.

Similarly, the intellectual domination of a particular profession deriving from the university, such as law in Bologna or medicine and natural history in Padua, was absent from Florence, where the university's standing was less high. Its governors lamented in 1430 that 'this glorious republic … should be surpassed in this one respect by some of our neighbouring cities, which in every other way are inferior to us'. It might be said that the idea of Florence as a community largely driven by a commitment to intellectual concerns is undermined by the relative feebleness of the university, but that was balanced, to some extent, by the humanist, Platonic Academy of Marsilio Ficino, a kind of

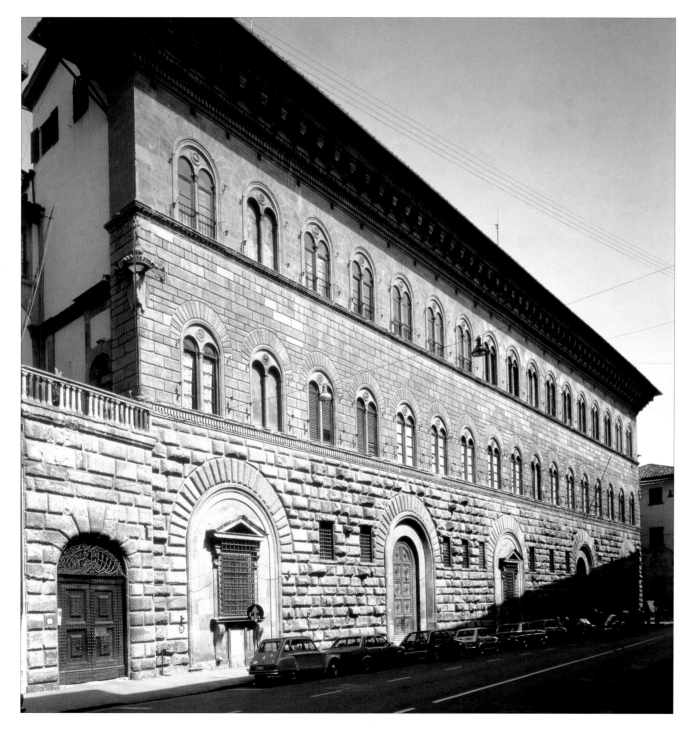

The Palazzo Medici-Riccardi, Florence (1444–)

Originally designed by Michelozzo, the palazzo was later extended by the Riccardi family in 1680.

**St. Francis of Assisi Preaching
to the Birds, by Giotto**

The Louvre, Paris

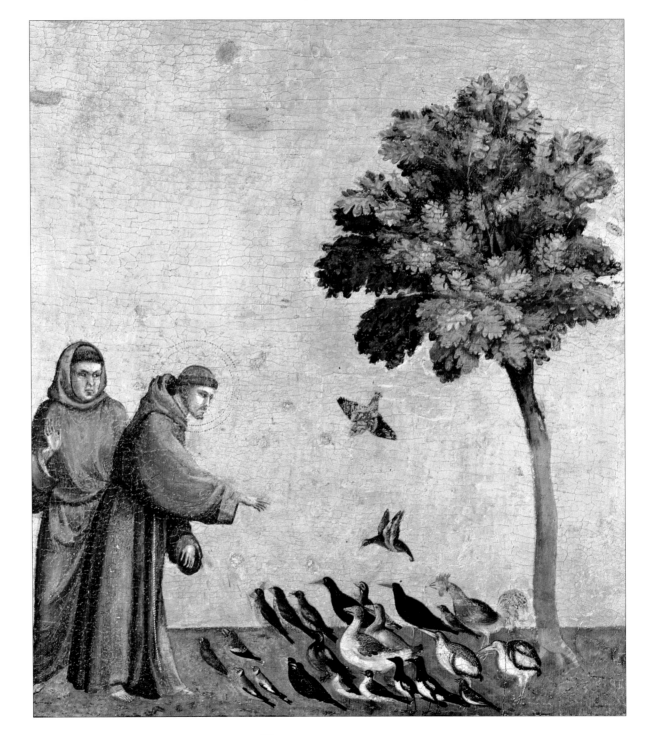

Leonardo da Vinci

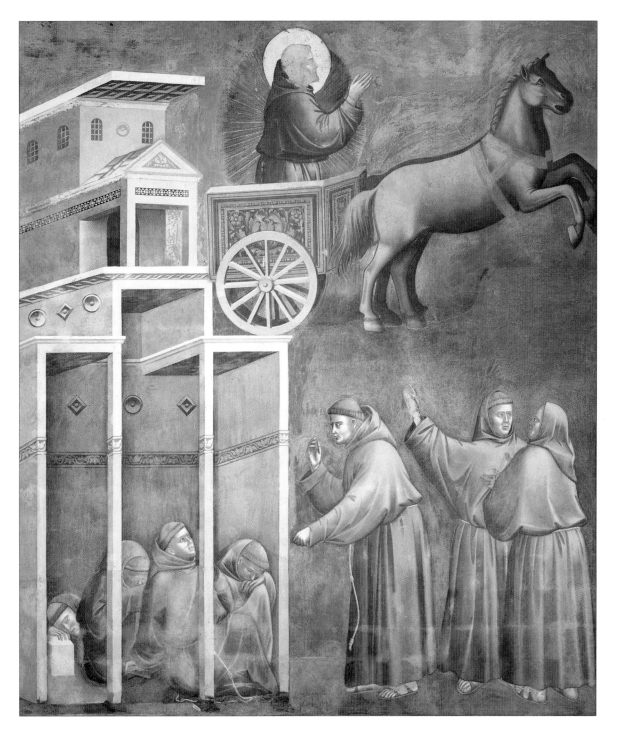

The Vision of the Chariot of Fire, by Giotto

Church of San Francesco, Assisi

Another example from the famous fresco cycle on the life of St. Francis at Assisi, usually attributed to the school of Giotto, since some experts dispute his authorship.

informal university, with neither campus nor courses, which provided unorganized classes and social events and attracted famous scholars from far and wide. But in spite of the great influence of Humanism, even the Humanists did not dominate.

Historians have also argued that the precarious existence of the Florentine republic, riskily involved in business ventures in so many regions and resented by other Tuscan towns that it sought to control, fostered quick thinking, intelligence and a commitment to high standards, exemplified by the craft guilds. That in turn encouraged the Florentine admiration for aesthetic quality, whether in artifacts or in nature. A banker of the Pazzi family remarked on his love for coins that were well designed, not the first criterion of today's financiers, and when a religious house proposed to cut down a long-established grove of trees, it received a letter from the Signoria deploring such vandalism.

In general, learning in Florence was essentially practical. Boys were educated for a specific career, whether in school, university, or in a craftsman's workshop, and literacy was extremely high. Talent was rewarded, sometimes by high office, sometimes

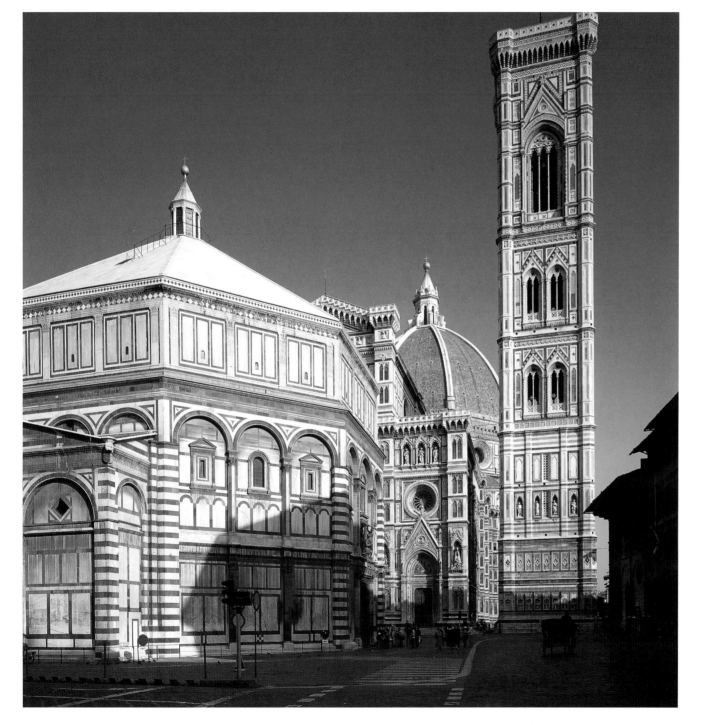

OPPOSITE

The Church of Santa Croce, Florence

The chief church of the Franciscans in Florence was originally designed by Arnolfo di Cambio round about the end of the 13th century, and is famous for its Giotto frescoes.

LEFT

Florence Cathedral

The Baptistery of the cathedral, perhaps the oldest building in Florence, and the bell tower begun by Giotto in the 1330s.

The Holy Trinity with the Virgin and St. John, by Tommaso Masaccio *(1425–28)*

Santa Maria Novella, Florence

A seminal work of the Florentine Renaissance.

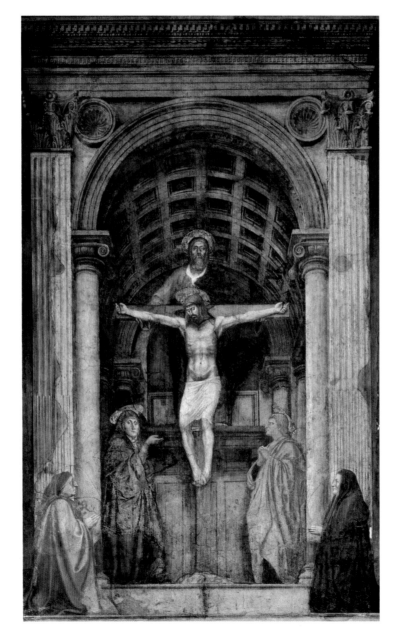

in the form of tax concessions, and eminent citizens were honoured even after death. The city was keen to recover the bodies of famous Florentines, reclaiming Michelangelo who died in Rome (though not Leonardo, who died too far away in France) for honourable burial in the great basilica of Santa Croce, where their graves may still be seen. Although many of the most talented individuals, including both Michelangelo and Leonardo among artists, left their native city, its reputation attracted many men of talent from outside its walls, from Siena, Pisa and more distant places, even from beyond the Alps.

THE ARTS

The dramatic changes in the art of the early Renaissance in Florence were closely linked to the growth of Humanism and similarly derived their main stimulus from the revival of classical antiquity. Artists believed they had rediscovered the principles of classical art and architecture, examples of which could still be seen in Italy, most notably in Rome. Painting was rather different because virtually no classical paintings existed (and the few that did, for

instance under the ash in Pompeii, were unknown). Painters strove for a realistic image of the world, which they believed they achieved primarily through perspective and the laws of proportion. But the developments in art that occurred, with remarkable rapidity, around 1420 cannot be traced through documents, of which few exist, only through the works themselves. For many years this period has been intensely studied by art historians although, naturally, total agreement on what was happening has not been reached.

Some of the reasons why the sensational developments in art should have occurred in Florence rather than somewhere else have already been mentioned. However, the emergence of such luminaries as Brunelleschi (1377–46), Donatello (1386–1466) and Masaccio (c. 1401–28) at about the same time must be to some extent fortuitous. They were men of powerful personality, high intelligence and vigorous self-confidence, who were largely self-taught, profoundly curious and willing to experiment – all qualities, incidentally, that marked out a later artist, Leonardo. They rejected the decorative, formal style of late Gothic and looked back further, to Giotto, a century before them, and to antiquity, where they found confirmation of their fundamental desire to portray the human figure and the physical universe with the utmost realism.

When Brunelleschi and Donatello visited Rome to study classical remains, they went not as antiquarians, nor to seek models that would appeal to cultured patrons. They were craftsmen, educated in a trade, not in the classics. Brunelleschi, with his tape, measured ancient Roman buildings to discover mathematical ratios. But eventually, through their practical research into formulas and principles, they came to understand the spirit as well as the craft of the ancients, a sympathy first convincingly demonstrated in 1419, the year of Brunelleschi's orphanage, the Ospedale degli Innocenti, and of Donatello's standing statue of *St. George*. Equally revolutionary was the painter Masaccio, in spite of his death at only 28. His fresco of the *Trinity* (opposite) is an intensely realistic and dramatic crucifixion scene in a classical Roman setting. The sense of depth is conveyed by brilliant perspective

RIGHT

The Loggia of the Ospedale degli Innocenti (Foundling Hospital) of Brunelleschi *(1419)*

This is a near contemporary of the cathedral dome but in a different spirit, reflecting the breath of pure classicism. Luca della Robbia supplied the glazed ceramic plaques of swaddled babies between the arches.

OPPOSITE

The Coronation of the Virgin, by Fra Filippo Lippi *(1441–47)*

Tempera on panel
Uffizi, Florence

Lippi (1406–69) was a pupil, or at least a disciple of Masaccio, but eventually evolved a quite different style. His later works are lyrical and deeply religious (though he was a highly reluctant monk).

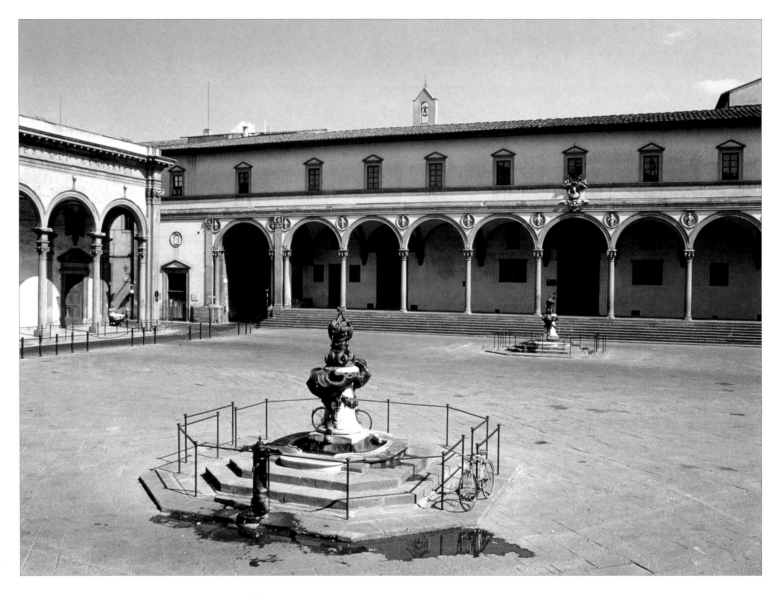

RIGHT

The Barbadori Altarpiece:
Virgin and Child Surrounded by
Angels with St. Frediano and St.
Augustine, by Fra Filippo Lippi
(1437)
Tempera on panel
Uffizi, Florence

Fra Filippo's escapade with a nun
(whom he later married) resulted
in the birth, in about 1457, of
Filippino Lippi, whose career
frequently intersected with
Leonardo's.

OPPOSITE

The Ognissanti Madonna
(Madonna in Glory with Saints
and Angels), by Giotto *detail*
(c.1310–15)
Uffizi, Florence

and Masaccio's unique understanding of the crucial importance of space.

These pioneers helped to break the old tradition of the artist as a craftsman working within a fixed social structure. Significantly, many of them showed little interest in material concerns or the conventions of contemporary society. They preferred to work independently, and wanted a high degree of control over their work – to make their own choices, not to be tied down by a patron's brief. They expected to be paid, not just for labour and materials, but for quality. The idea that art could improve, make progress, was itself a new one, possibly originating with the sculptor Lorenzo Ghiberti (1378–1445). He was another of the great pioneers, best known for the bronze doors of the Baptistery (1401), who, more than the others, had close contacts with the humanists. The new status of artists led Leon Battista Alberti (1404–72) to suggest in 1435 that painting, sculpture and architecture ought to be classified among the liberal arts, along with poetry and rhetoric.

What starts as a breakthrough by a few individuals becomes, within a generation or so, a

general trend. All the same, we should be wary of supposing that all art in 15th-century Florence conformed to the ideals of the early Renaissance. For example, Gothic made a comeback as International Gothic, essentially a courtly style, colourful and charming (and related to the fashion for medieval 'romance'), but lacking both the emotional impact and intellectual stimulation of the Renaissance style. At the same time, second-rate artists provided scenes from classical mythology for domestic purposes. The leaders of the new generation of painters that appeared about 1440 included artists like Fra Angelico and Fra Filippo Lippi, whose 'sweet', exquisite frescoes strike markedly different notes from those sounded by Masaccio. Sculpture was in temporary decline, awaiting Michelangelo (or at least Verrocchio), but some of Donatello's late works must have startled progressive Florentine connoisseurs. All these – and many more – influences had their varying effects on the next generation.

VERROCCHIO'S STUDIO

Superficially, the young Leonardo's prospects were not very promising. Excluded from the professions

and probably not very well educated, he was already, in the late 1460s, somewhat past the age when most boys began apprenticeships. Of course, as time would reveal, he had phenomenal natural gifts, and to those attributes still hidden within could be added the immediately obvious ones of an attractive personality and startlingly good looks. His 'personal beauty', wrote Vasari, 'could not be exaggerated'.

Vasari was only eight years old when Leonardo died and so never knew him, but his description need not be interpreted as that of a biographer besotted with his subject because every other witness agrees with him, and every contemporary account of Leonardo alludes to his strikingly handsome appearance. He was also charming and courteous, yet slightly mysterious, and could be very persuasive. His eloquence was to remain with him throughout his life. Vasari reported how, years later, Leonardo demonstrated to a rapt audience how he proposed to shore up the sagging church of San Giovanni, and it was only much later, when the powerful influence of his personality had been removed by his departure from the city, that people

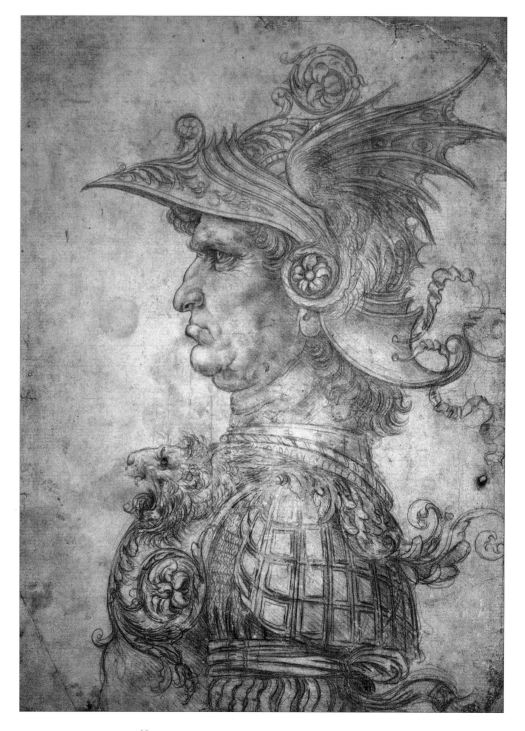

realized his plan could not have possibly worked.

Many historians believe that we see the young Leonardo when we look at the bronze *David* of Andrea del Verrocchio (1435–88), his teacher. As Leonardo was living in Verrocchio's house at the time, he may well have been called upon to model for the statue (today in the Bargello). The faintly detached half-smile and the dynamic twist of the body are certainly very Leonardo-like.

A famous story related by Vasari bears witness to Leonardo's precocious gifts, as well as to his lifelong engagement with the world of nature. A peasant at Vinci, no doubt a tenant on the family estate, gave Ser Piero a round, flat piece of wood cut from a fig tree and asked him to take it to Florence and get it painted with some device. Instead he gave it to Leonardo who, after careful preparation, worked on it in a private room with the aid of a smelly collection of lizards, newts, maggots, snakes, butterflies, locusts, bats and other animals of the kind, from which he composed a 'horrible and terrible monster'. He took so long over it (as he frequently would later on more important commissions) that both Ser Piero and the peasant

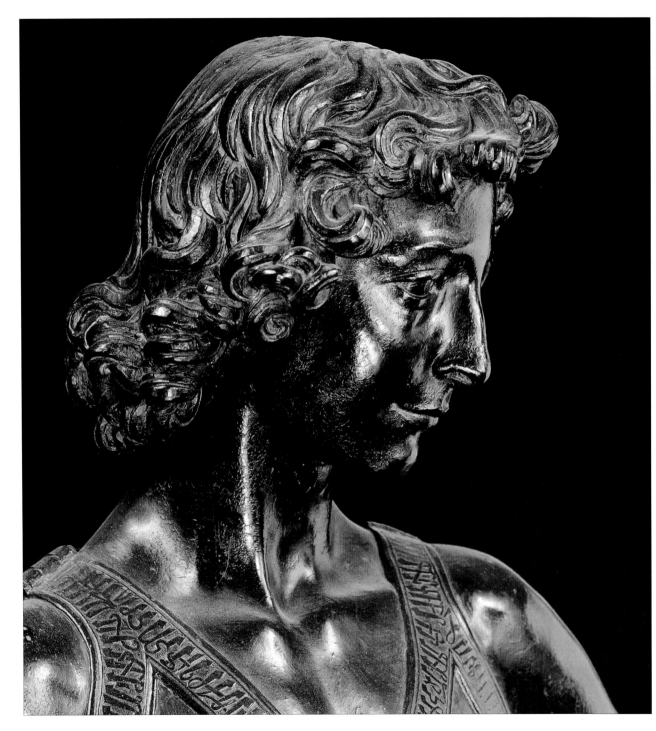

forgot about it, until Leonardo asked his father to come and collect it. He dimmed the light and arranged the painting so that his father, on entering and catching sight of it, reeled back with shock, not realizing the monster was painted.

Later, Ser Piero purchased another wooden plaque painted with some tawdry heart-and-arrow device to give the peasant who, apparently unaware that it was not from his fig tree, was very pleased with it. Ser Piero then took his son's work to Florence, where he sold it for 100 ducats. The buyer was equally pleased, because he later sold it on to the Duke of Milan for three times as much.

Ser Piero was probably acquainted with Verrocchio (Vasari says he was a 'close friend'), whose studio/workshop (*bottega*) was the most famous in Florence, rivalled only by that of Antonio Pollaiuolo. He showed the famous artist some of his son's drawings, and Verrocchio, who was then aged about 32, was so impressed that he agreed immediately to take the lad into his household.

Leonardo would remain with Verrocchio for the best part of a decade. Although he was acting independently by about 1478 he probably retained

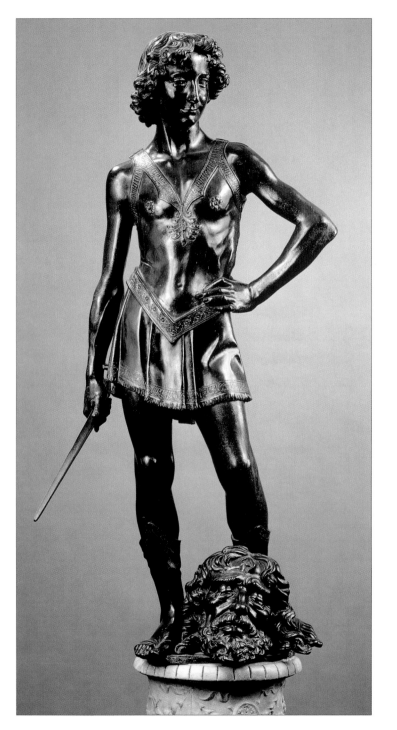

his connection with the workshop until he left for Milan in about 1482. He was admitted as a painter to the guild of San Luca (St. Luke) in 1472, but remained as Verrocchio's assistant for at least four years after that.

Verrocchio's studio was his university. The interests of such establishments were not exclusively confined to painting or even to the fine arts in general. Like so many Renaissance artists, Verrocchio was a trained goldsmith, who was also a sculptor and painter, admired for his mastery of perspective, a capable musician and a man of ideas – mainly practical ones although he clearly understood the principles of his art. He was not like that artist who was said to have declared that he 'does not want so much science …, practice is enough for him to draw the things in nature'.

Besides paintings, sculpture, jewellery and other goldsmith's work, Verrocchio's workshop undertook other projects requiring different skills. During the early 1470s a great deal of the Verrocchio workshop output was decorative schemes and devices for the Medici. (A rare survival is a design for a tournament banner, now in the Uffizi, by Verrocchio, which was

LEFT and OPPOSITE (detail)
David, by Andrea del Verrocchio
(c. 1470)
Bronze
Museo Nazionale del Bargello, Florence

A seductive legend claims that Leonardo was the model. The craggy old man (page 49) and the beautiful, wavy-haired youth form two opposed types in both Verrocchio and his pupil. The mysterious half-smile associated with Leonardo is also evident in this bronze and in other works by Verrocchio.

The Uffizi, Florence

The Uffizi is today an art gallery, but was commissioned as a civic building by the Grand Duke Cosimo and built in the 1560s to a design by Vasari. In the background is the Palazzo Vecchio.

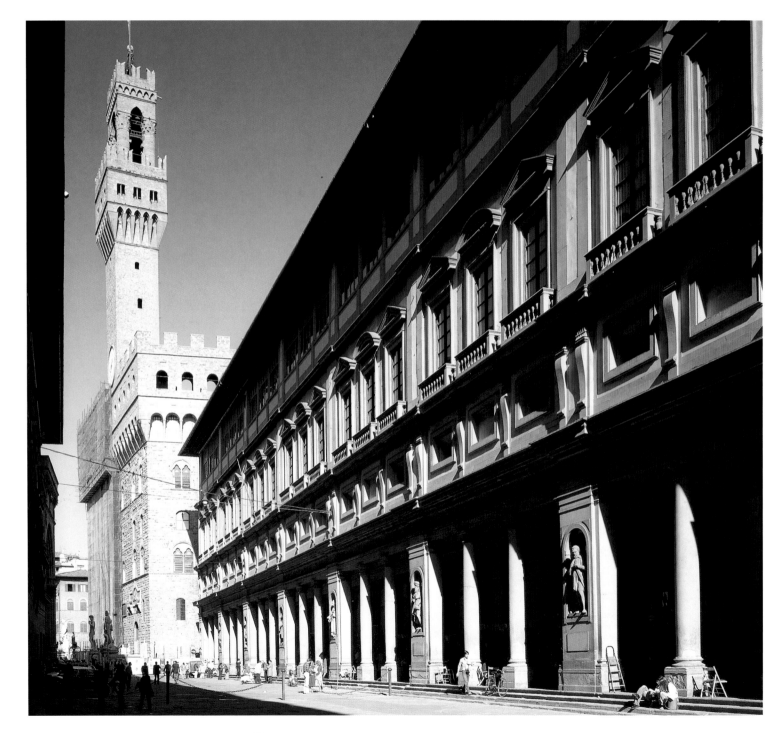

Leonardo da Vinci

partly drawn by Leonardo.) There were occasionally other more challenging projects, notably the great gilded copper ball, set on a disc and surmounted by a cross, for the lantern of the *duomo*. Leonardo referred back to the solder used in welding the ball together when confronted with a similar structural problem in Rome half a century later.

Technical knowledge was also imparted, informally at least, by people like Paolo Toscanelli (1397–1482), an eminent physician and scientist whose ideas were partly responsible for triggering Columbus's voyage of discovery. Though elderly, Toscanelli, whose lectures Leonardo probably attended, may have also had some one-to-one contact with him, and he seems to have been an early source for Leonardo's understanding of mechanics. Numerous other gifted people dropped in, keen to take part in discussions on art and other subjects, and to learn about new techniques, among them the comparatively new Flemish method of mixing the ground pigments with oil, rather than water and egg yolk (tempera), which, due presumably to the great Florentine tradition of fresco painting, painters in Florence were slow to adopt.

Leonardo, the pupil, preferred oils; Verrocchio, the master, apparently remained loyal to tempera.

It was customary for established artists to take on apprentices and assistants in varying numbers according to their own reputation and personality and the work on which they were engaged. The amiable Raphael (1483–1520) had a great many, but no painter could undertake a major fresco cycle without assistants. Apprentices often began about the age of 12, when they would perform simple tasks such as preparing pigments or polishing carvings, and rose in time to be capable assistants who in some cases did the lion's share of their master's painting. Eventually they became fully qualified artists in their own right, taking on individual commissions but remaining attached to their old master's studio for the sake of convenience. It was often equally convenient for both.

In Leonardo's case we may well suppose that Verrocchio hung on to him for as long as he could, because Leonardo was soon recognized as a superior painter and, in his later years, Verrocchio did little or no painting himself. At the same time, it

Florence 1469–82

was convenient for Leonardo, not only because it provided him with facilities and a kind of second home, but also because he was not well equipped by temperament to deal with what, in Florence particularly, was a fairly hard-nosed business, dependent on dates and contracts. Leonardo, notoriously unbusinesslike, could hardly have coped on his own.

While it was not unusual in any craft for a man to remain in his master's studio long after becoming an established member of the guild, others might work there temporarily, perhaps on some job requiring specialists. Not all Verrocchio's assistants were his former pupils, and the whole set-up seems to have been quite fluid. While that may seem attractive in our over-regimented society, the informality of arrangments has disadvantages for historians, in that we have little idea of exactly how work in Verrocchio's studio was undertaken or apportioned.

In fact, there is no indisputable proof that Leonardo was Verrocchio's pupil at all. Vasari, though he had access to contemporaries of Leonardo, was writing the best part of a century

after Leonardo joined Verrocchio's workshop and in any case was not the most reliable of writers: he was inclined to jump to conclusions on slight evidence, and he could never resist a good story. Among reasons for doubting his account of Leonardo and Verrocchio is the fact that, throughout his voluminous notebooks, Leonardo never mentions his former master by name.

There could, however, be other reasons for that. Leonardo, who once said that any artist who did not excel his master was second-rate, did not like to think he was beholden to any man. Such an opinion could be more easily justified in his case than almost any other, but he was not so besotted by his own worth that he failed to admire certain predecessors, or indeed some contemporaries. No more than any other artist (or any other person in any profession) could he shrug off his antecedents. His early work shows the strong influence of Verrocchio, and some aspects of it surfaced many years later. While there is no hard proof that for nearly a decade Leonardo worked in Verrocchio's studio, there is plenty of circumstantial evidence that he did and not a shred of evidence to explain

where otherwise he might have been during that long period in Florence. Today, few historians seriously doubt the traditional view.

Verrocchio was no doubt lucky in his pupil, but so was Leonardo in his master. The difference in age was not enormous and although we know nothing certain about their relationship we can hardly doubt that they got on well, and as Verrocchio also never married they may have shared the same sexual orientation. Barring occasional irascibility and the odd feud, Leonardo got on well with practically everybody, but he and Verrocchio had many interests in common, while Verrocchio's mark on Leonardo's early work is there to see.

Both men based their work on current geometric principles (which Verrocchio had studied) and shared predilections for twisting forms (Leonardo was still drawing ladies' complicated hairstyles much in Verrocchio's manner 30 years later) and what is called *contrapposto*, in which the body is represented on contrary axes – the torso twisted one way, the legs the other (a feature that, thanks chiefly to Michelangelo's influence, was later a marked characteristic of Mannerism). Both men were hard

workers. As a painter, Verrocchio was highly competent and workmanlike, and (like his most famous pupil) not afraid of innovation and experiment. He was a much better painter than Vasari suggests, but he had, for instance, little of Leonardo's later command of *chiaroscuro* (the balance of light and dark). Vasari, determined to play down his quality as an artist, says that he acquired his skill by study, not natural facility.

Contemporaries, and still more markedly posterity, regarded Verrocchio most highly as a sculptor, and as Kenneth Clark remarked, it is in certain of his sculptures that we sense something of the mysterious force of Leonardo. He was seen, and saw himself, as the successor to Donatello, who was actually still working though half a century older. Donatello, probably the single most influential artist of the Florentine *quattrocento*, may conceivably have been his teacher at some point. Being sandwiched between the two greatest sculptors of the Renaissance has perhaps not helped Verrocchio's reputation. If the Davids of Donatello, Verrocchio and Michelangelo were placed together, Verrocchio's would win no prize for passion or heroic grandeur,

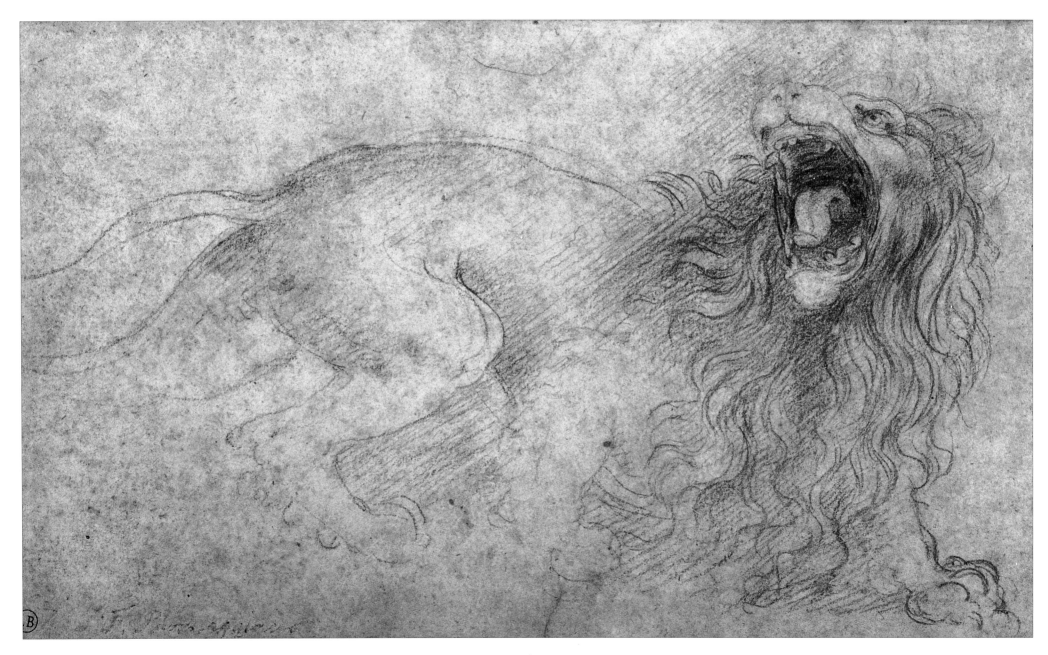

Leonardo da Vinci

but it might be judged the most graceful.

Some scholars have found evidence of Leonardo in the sculptures of Verrocchio during the years when Leonardo was still an apprentice. It is tempting to see the younger artist at work in particularly successful representations of nature, especially (as in *Tobias and the Angel*, discussed in the next chapter) of animals. The highly realistic lion's head on the carved stone washbasin (*lavabo*) just off the sanctuary in San Lorenzo is one example. Another is the equally convincing bronze tortoises that support Verrocchio's rich and magnificent tomb of Piero de' Medici in the same church, and possibly some of the adorning bronze foliage.

Verrocchio had a higher reputation as a painter than Vasari and others gave him credit for, and one report on Florentine artists of about 1490 noted, with some exaggeration no doubt, that 'Verrocchio had as disciples almost all those whose names now fly about the cities of Italy'. Among Leonardo's contemporaries, some would soon be famous, some already were. Of these the best-known was Sandro Botticelli (1440–1510), 12 years older than Leonardo and never Verrocchio's pupil. In those days he was a merry fellow, fond of creative practical jokes. Leonardo, also fond of tricks and riddles, speaks of him affectionately but is critical of his art, accusing him, not unfairly, of carelessness in calculating perspective and of treating landscape in too summary a manner.

Botticelli was the favourite painter and a close friend of Lorenzo de' Medici, whose Humanist and literary interests (he wrote a commentary on Dante) echoed his. In painting Lorenzo also leaned towards the tradition of elegant line and exquisite fancy to which Botticelli, like his master Fra Filippo Lippi, belonged (for example, the *Primavera*, the *Birth of Venus*), being less sympathetic to the more 'modern' scientific naturalism represented by Verrocchio and shared, at least by intellectual inclination and training, by Leonardo, although in temperament, as shown particularly in his drawings, Leonardo bridged the two traditions.

Another of Verrocchio's artists was Pietro Perugino, about six years older than Leonardo. As

OPPOSITE
Sketch of roaring lion
Red chalk on paper
Musée Bonnant, Bayonne, France

**Madonna and Child with a
Pomegranate (Dreyfus
Madonna)** *c.1470*
*Oil and tempera on wood, $6^1/_2$ x
$5^1/_4$in (16.5 x 13.4cm)
National Gallery of Art,
Washington, D.C. (Samuel H. Kress
collection)*

*From the workshop of Verrocchio,
possibly by Leonardo.*

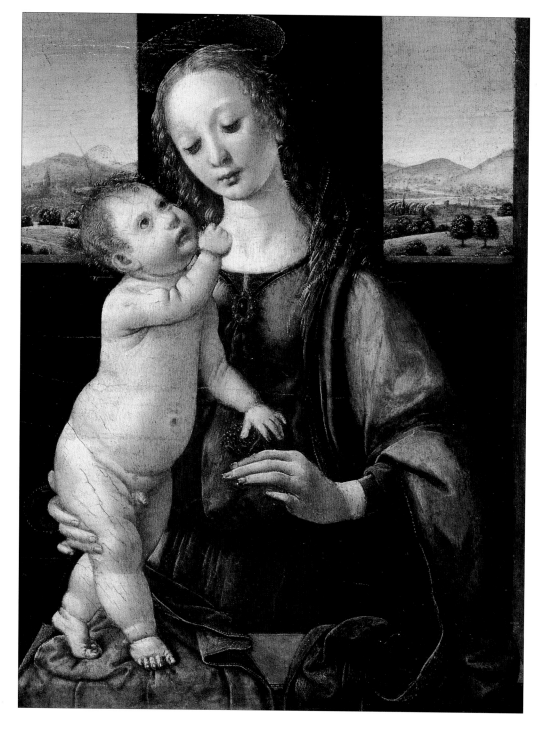

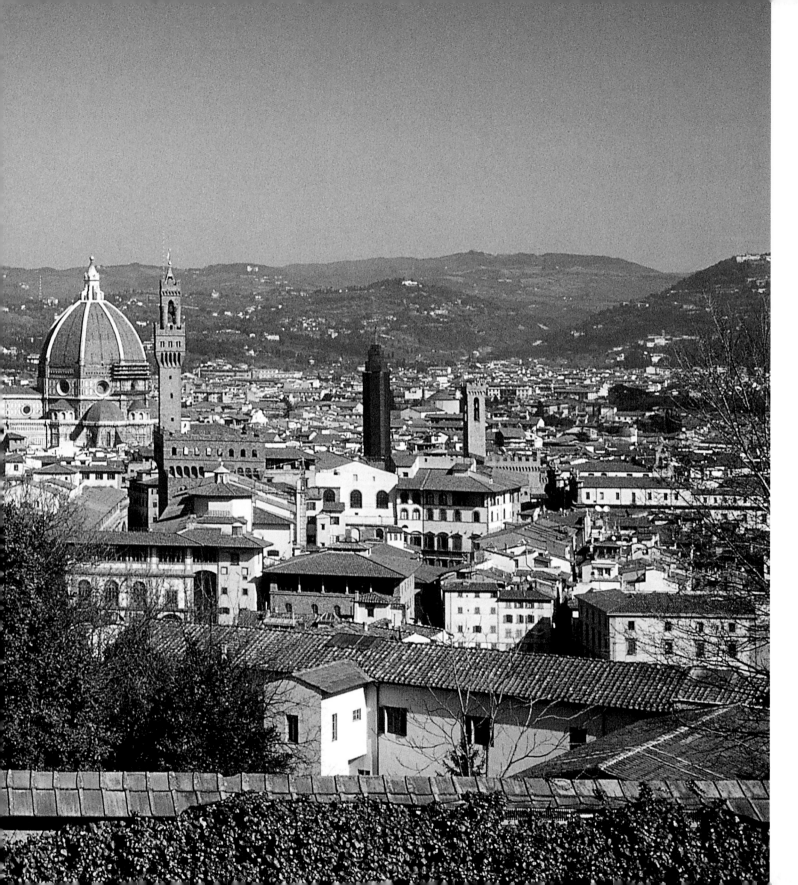

View of Florence

Young Woman with a Bunch of Flowers (or 'Flora', thought to be Lucrezia Donati), by Andrea del Verrocchio

Museo Nazionale del Bargello, Florence.

Leonardo da Vinci

his name suggests, he came from Perugia where, earlier, he may have been a pupil of Piero della Francesca. Later, among his own students was Raphael (1483–1520), some of whose frescoes in the Vatican he finished after Raphael's early death. Perugino's was a gentler, sweeter art than Leonardo's, and was regarded by some as equal or superior, but in spite of his gifts, and his intense desire for success, he eventually fell somewhat out of fashion in *quattrocento* Florence. Leonardo does not speak of him, though his criticism of artists who paint figures that all belong to the same type could have applied to him. Perugino eventually retired to his native Umbria.

Lorenzo di Credi (c.1458–1537) must have entered the Verrocchio workshop later, as he was at least six years younger than Leonardo. The first evidence of his presence is in late 1480, and by that time Leonardo was independent, though still keeping up his connection with Verrocchio's workshop. He was a modest and amenable youth who eventually became the workshop's chief painter. He was still working there when Verrocchio died in Venice in 1488. Vasari says he was

Verrocchio's favourite pupil, and he became his master's chief heir and executor. He was the only member of the workshop who appreciated Leonardo, though he did not understand him, and his style resembles that of the early Leonardo closely enough to have been the cause of some arguments over attribution. Lorenzo's work is technically of a high class, but he did not have Leonardo's sense of colour values nor his imaginative sensitivity. His surviving paintings are mainly of religious subjects (he is said to have destroyed some of his paintings, presumably of 'pagan' subjects, during Savonarola's 'bonfire of the vanities' in 1497), but they also included a portrait of his master, Verrocchio (now in the Uffizi).

Chapter Three
The Early Works
1473–82

The earliest dated work by Leonardo is an ink drawing of a landscape, one of the earliest in European art (now in the Uffizi), dated 5 August 1473, when he was 21. It is unusual for such a work to be dated, but perhaps his note is meant to emphasize that this is how things were on that particular day, though some have suggested that it is connected with some event of special significance, at least to the artist (and possibly occurring earlier than the actual drawing). If so, we have no inkling what that might have been. The drawing suggests something approaching a revolution in the approach to landscape. It is full of movement – of light, foliage, water – and has little in common with the predominant style of the time, certainly not with Verrocchio. The subject has not been firmly identified, but the suggestion that it was imaginary seems unlikely; more probably it was a scene near Vinci in the Arno valley. It features a castle, which could be the Castello di Poppiano, north of Vinci, though there are other candidates. It is an appropriate work for a man who was 'driven by an ardent desire … to view the abundance of varied and strange forms created by nature the artificer…', and whose governing principle was fidelity to nature and its workings (and, though not here, especially its violent workings – floods, storms, tidal waves, volcanoes – nature's demons).

The drawing also suggests that Leonardo, by then a qualified artist, was not entirely consumed by the fashionable life of Florence, with its festivals, ceremonies, parades, carnivals and parties – the social round that kept Verrocchio's studio busy (one would guess that Verrocchio never turned down any commission) and encouraged artists to compete with each other in exotic trivia, almost like modern interior designers. As Martin Kemp remarks, 'the drawing reads like a visual sigh of relief on escaping from the Florentine cauldron in August.' Leonardo's love of nature was inborn: he was a countryman who, throughout his life, showed a desire to get away now and then from cities and people (of whom, *en masse*, he had a low opinion), to find some kind of spiritual replenishment in the countryside.

Not that Leonardo was exclusively devoted to

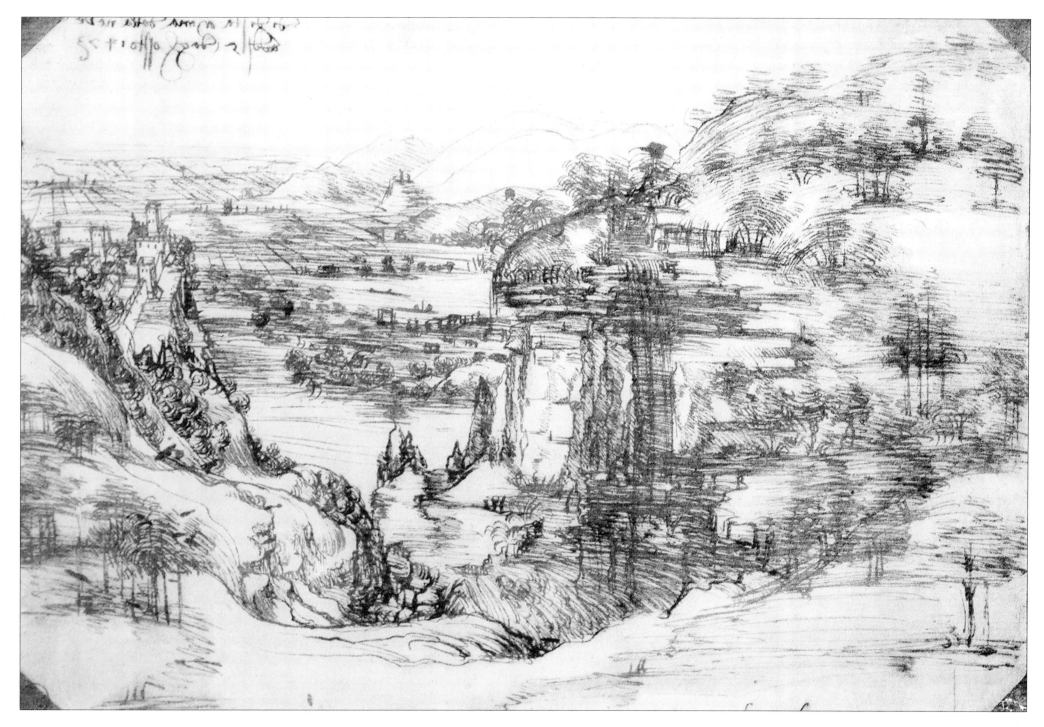

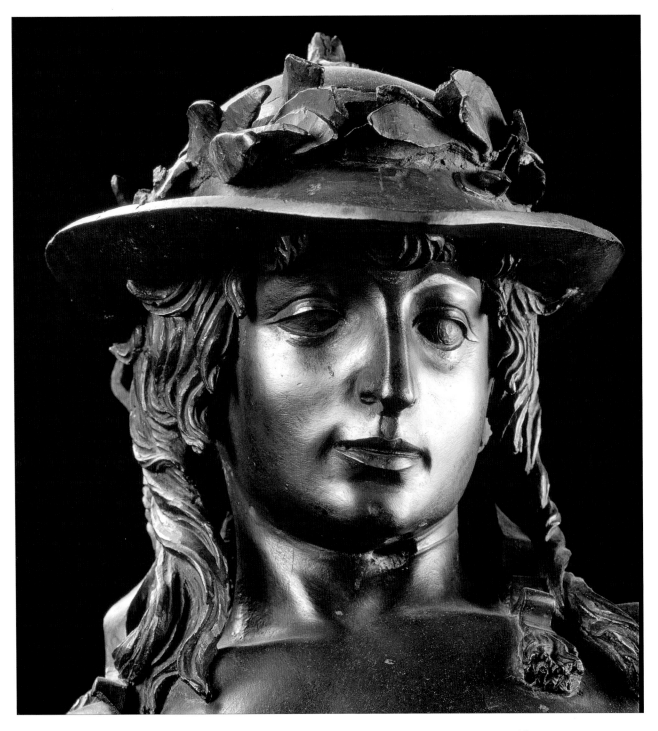

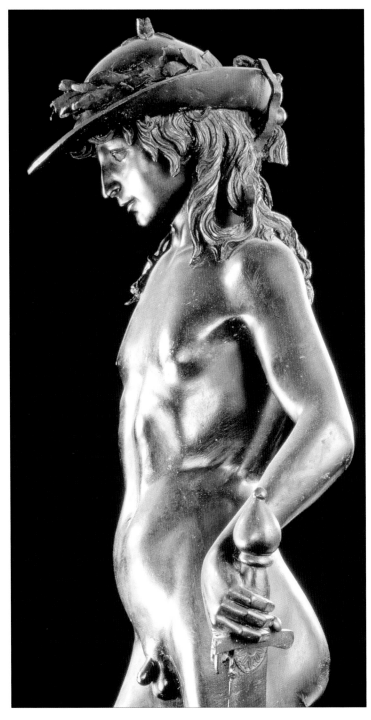

Leonardo da Vinci

serious work while living in Florence. The scarcity of his known work in this period might itself suggest that, like most young men, he was also intent on sowing a few wild oats, or having a good time. No doubt that included sexual activities.

A great volume of words has been expended on discussions of Leonardo's sexuality, many of them pointless, far-fetched, or indeed boring. In fact, there is little to say, not only because, as with most individuals, we do not know what happened in private moments, but also because Leonardo's sex life was probably not particularly exciting. No reasonable person can doubt that he was mainly attracted to beautiful young men, and it seems likely that he never made love to a woman. He was revolted by the idea of copulation and considered that sensuality was inimical both to love and to creativity. With rather less confidence, we may conclude that he was not particularly active sexually, perhaps because his sex drive was diverted into other, more creative channels, and although he probably (though not certainly – impotence has been suggested by some) did have

sexually active partners, he was not promiscuous.

At the age of 24, Leonardo and two other young men were accused of committing sodomy with the 17-year-old Jacopo Saltarelli, a goldsmith's apprentice who had a reputation as a male prostitute. It was possible in Florence for accusations of criminality to be made anonymously, by placing a paper in a box specially for that purpose, which resulted in an official inquiry. This is certainly a very unattractive method of policing, but in fact the body that investigated cases of alleged vice seems to have proceeded in a responsible, judicious manner. In theory, sodomy was punishable by death though in reality such a sentence was never carried out. Homosexuality was in fact widespread, or at least it was believed to be so. In Germany, 'Florenzer' was a slang word for homosexual. For a man of high social status, homosexuality was hardly a serious disadvantage, and the artistic community was no doubt more liberal in these matters than the citizenry at large. It is unlikely that Leonardo's associates were shocked. Verrocchio himself has also been suspected of

being homosexual, and it would therefore not be surprising if the affinity between him and his beautiful young pupil had a sexual element.

An inquiry into the anonymous accusation against Leonardo was duly held, but as no witnesses could be procured it was adjourned for two months. The second inquiry, finding that the evidence for the prosecution was nil, dismissed the charges against all three. It is tempting to speculate what lay behind this affair, which would have undoubtedly been painful to Leonardo, but never was speculation more idle. Since Leonardo was cleared, the matter was over. Some may say that it had the effect of making him rather more cautious in future.

Much of Leonardo's earliest work in Verrocchio's studio is lost. Vasari mentions, for instance, a cartoon for a tapestry which he praises in extravagant terms for its depiction of nature. As an apprentice, Leonardo would have begun by preparing pigments and brushes, and later graduated to making a contribution to workshop paintings that would be ascribed to Verrocchio. Art

historians have spent many enjoyable hours, indeed careers, seeking these traces.

In the National Gallery in London is a painting, *Tobias and the Angel*, ascribed to the workshop of Verrocchio with the cautious note that some parts may be the work of Leonardo. If so, this would probably be the earliest surviving example. The subject of a young man guided on a journey by the Archangel Raphael, from a story in the *Apocrypha*, was a popular one at the time, supposedly because it was often commissioned by merchants sending their young sons off on foreign business trips.

This is a small, superficially rather ordinary panel, which a curator of the National Gallery in Washington nevertheless considers 'one of the most fascinating pictures of the entire Quattrocento' (David A. Brown, *Leonardo da Vinci: Origins of a Genius*, 1998), largely because of the light it throws on the rivalry between the studios of Verrocchio and Antonio Pollaiuolo, whose version of the subject (now in Turin) is the earlier. Verrocchio's is notable for its psychological content, an aspect of Leonardo's art that he inherited from Verrocchio but

Leonardo da Vinci

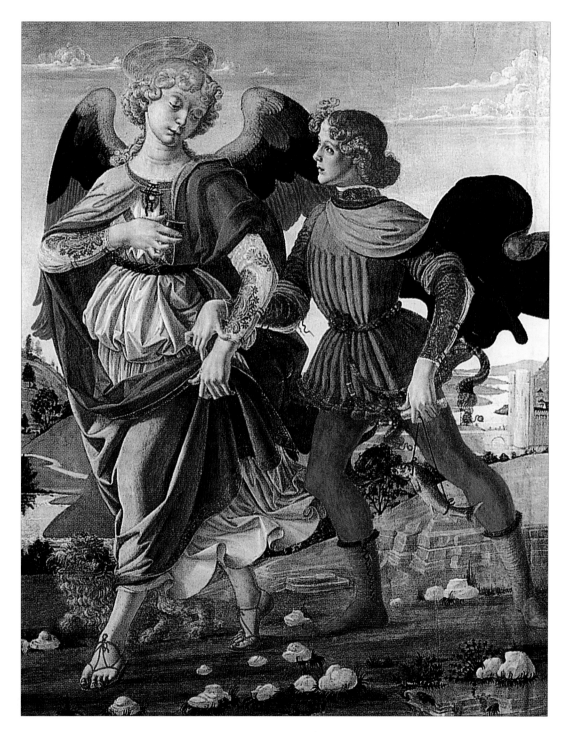

Tobias and the Angel
School of Verrocchio
Tempera on wood, 33 x 26in
(83.6 x 66cm)
National Gallery, London

The painting that may well include
the earliest surviving work of
Leonardo. It is pleasant to think of
the jolly little dog in this role.

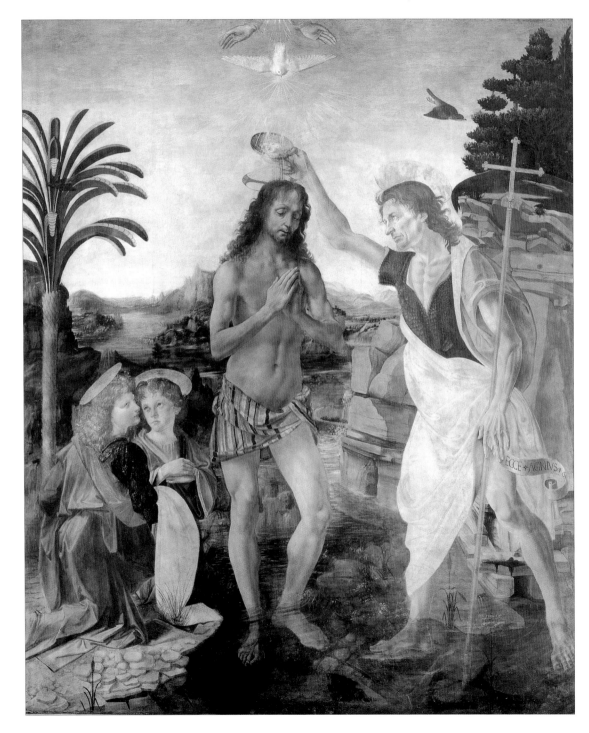

one foreign to Pollaiuolo. In modern eyes especially, this lifts Verrocchio's version on to an altogether higher plane. Leonardo's gift for depicting nature, however, owed nothing to Verrocchio, and that has led modern authorities to assign the jolly if – owing to the age-induced transparency of the paint – slightly spectral little dog that trots at the Angel's heels, and the utterly convincing fish carried by Tobias, to Leonardo. Both creatures appear in the same form in Pollaiuolo's painting, but as very inferior specimens. Some authorities believe that Leonardo had a hand in the figure of Tobias also.

THE BAPTISM OF CHRIST AND THE ANNUNCIATION

Further evidence of the new approach to nature and to landscape that we have noted in reference to Leonardo's drawing of 1473 appears in Verrocchio's *Baptism of Christ*, painted for the monastery of San Salvi outside Florence, some years after the *Tobias*. It has been suggested that Leonardo was largely

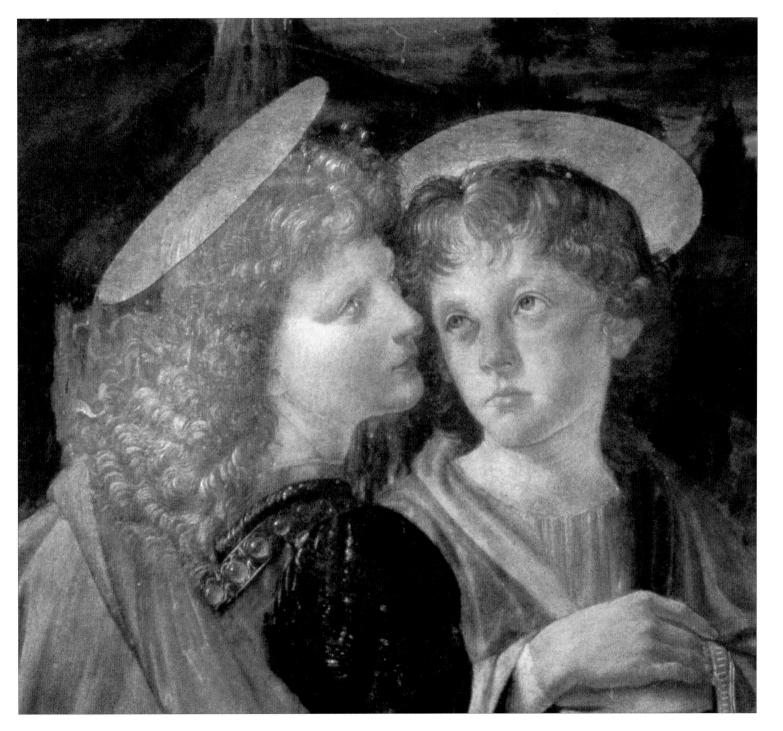

The Baptism of Christ by John the Baptist, by Verrocchio
(c.1480)
Tempera and oil on panel,
69²⁄₃ x 59¹⁄₂in (177 x 151cm)
Uffizi, Florence

Virtually all authorities agree that
the left-hand angel (see detail),
which is in oil rather than tempera,
is the work of the apprentice
Leonardo. Recent expert opinion
holds that the painting is later than
previously assumed, and in
particular later than Leonardo's
Annunciation *(page 74 et seq.).*

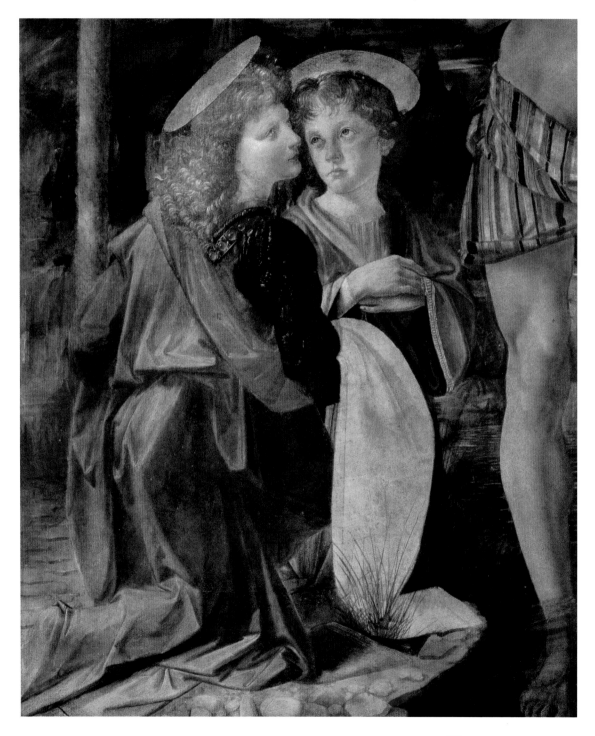

responsible for the landscape background in this picture, which was probably a workshop production. It is certainly unlike other landscapes by Verrocchio, who followed the customary Florentine convention of a static, orderly, almost symbolic countryside, with rounded hills and trees dotted about on the plain before them. Leonardo's landscapes belong almost to another world. They are full of movement: foliage flutters in the wind, sunlight and shadow chase each other over the hills, mists rise above gleaming pools, streams cascade over the rocks. Leonardo's landscapes are not merely decoration, they are part of the emotional tone of the picture. Simultaneously, they bear witness to his love of nature and determination to depict it realistically through form, modelling, light and shade – not merely by line.

However, Leonardo's most famous contribution to this painting is not the background but the kneeling angel on the left. This attribution was recorded by Vasari, but the painting was lost a few years after he wrote and not rediscovered until the early 19th century. Initially doubted, Leonardo's input is now almost universally accepted on the basis of stylistic

Leonardo da Vinci

analysis, and it is supported by the fact that it is in oil paint (Leonardo's preferred medium), often applied with the fingers, while most of the picture is tempera. (However, modern methods of research increasingly suggest that the divisions between various media were less sharp than we have hitherto supposed.)

Arguing again on stylistic grounds, most scholars now hold that the famous Leonardo angel is of later date than the early 1470s – later, at any rate, than the less sophisticated angel in his *Annunciation*, later also than his portrait of Ginevra de' Benci (which advances it by more than a decade), largely because it provides evidence of Leonardo's further progression from the linear depiction of form in favour of suggesting form by effects of light. Certainly no one would deny that his angel is the finest feature of the picture ('a space of light in the cold, laboured painting' said Walter Pater, who however, like Vasari, was far too severe on Verrocchio). The second angel, gazing at his ethereal companion in some astonishment, is probably Verrocchio's, and a more prosaic creature. Recent

scientific examination of this picture, while adding some complications, has not changed the basic situation – that Leonardo painted, or repainted, most of the background and the left-hand angel, whereas the rest of the painting was Verrocchio's work. It confirms that work on the painting went on over a long period, and that it belongs to a relatively late stage of Leonardo's presence in Verrocchio's workshop.

Vasari says that when Verrocchio saw his former pupil's work, he was so disconcerted by its superiority to his own that he swore to give up painting entirely. Anecdotes of that kind were meat and drink to Vasari; nevertheless, this may not be entirely fictional, as Verrocchio did eventually, and at about this very time, give up painting altogether. David A. Brown suggests that whereas, at the time of the *Tobias and the Angel*, Leonardo and his master could work comfortably in harness, by the time of the *Baptism* the pupil's style had diverged so far from the master's that a close partnership was no longer possible. Verrocchio was perhaps acknowledging that fact. The younger Lorenzo di

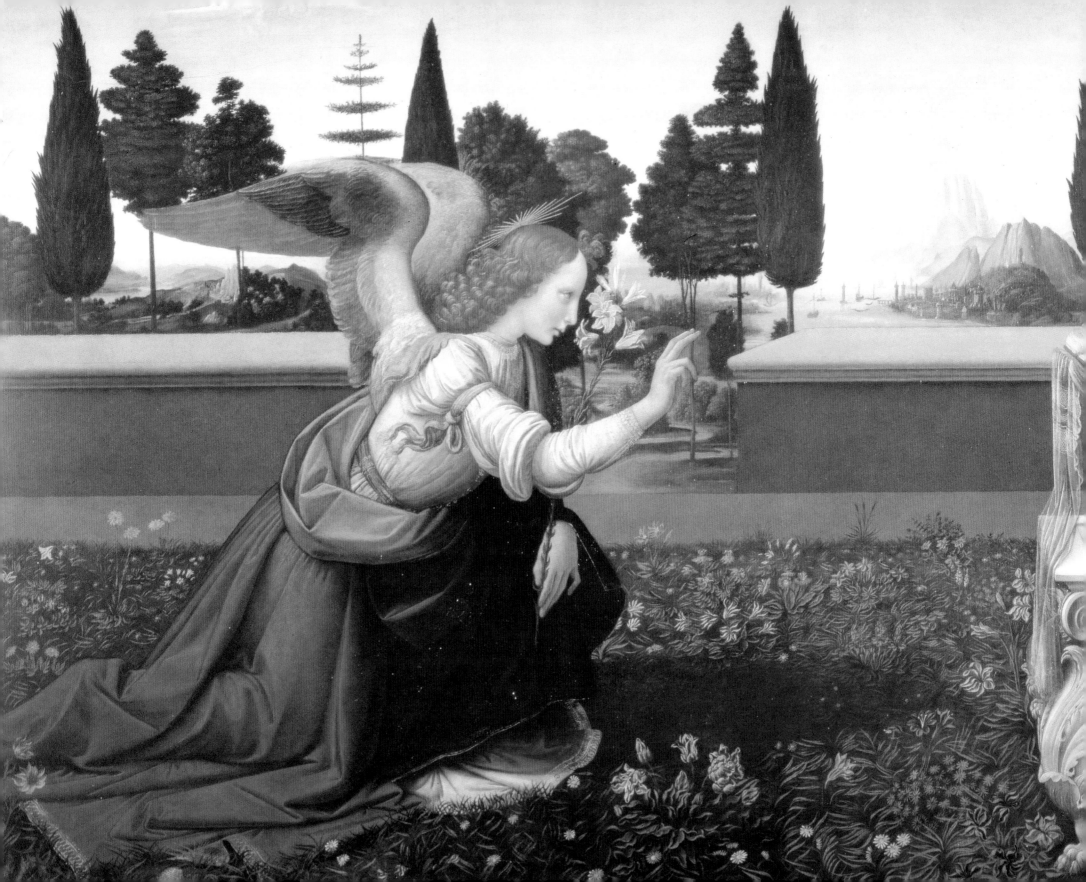

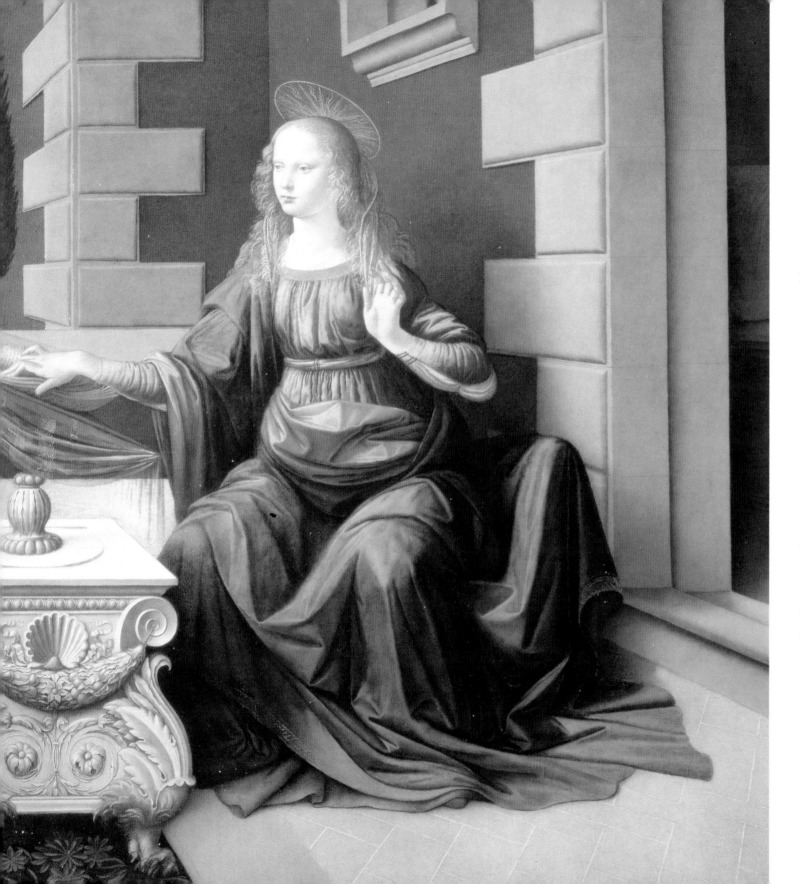

LEFT and OVERLEAF details
The Annunciation (c.1472–5)
Oil on panel, 38½ x 85⅜in
(98 x 217cm)
Uffizi, Florence

This is Leonardo's first complete
surviving painting, restored and,
indeed, in some degree altered at
various times. Some clumsy features
of the composition reveal the artist's
inexperience (though parts, such as
the angel's wings, are due to later
alteration). But other features,
according to Kenneth Clark,
notably the treatment of nature,
are characteristically effective
and in general the shortcomings of
composition are outweighed by
beauties of detail and mood.

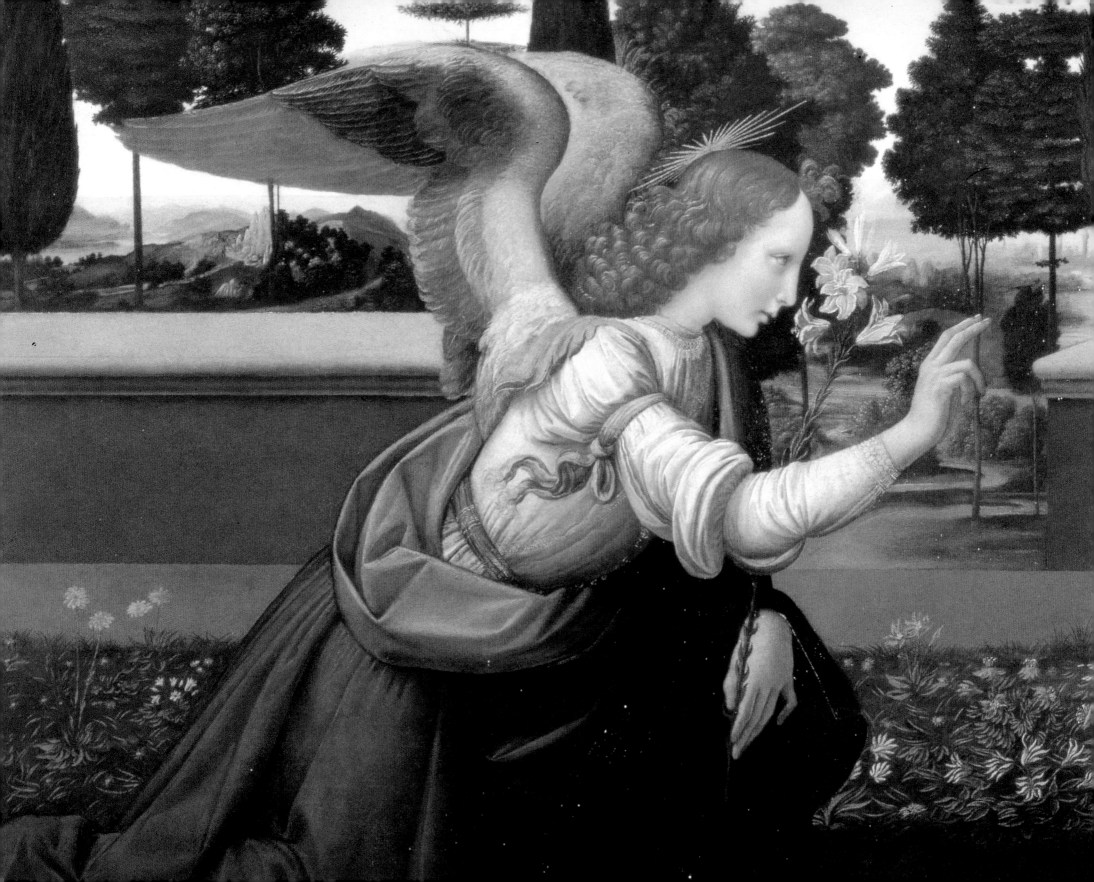

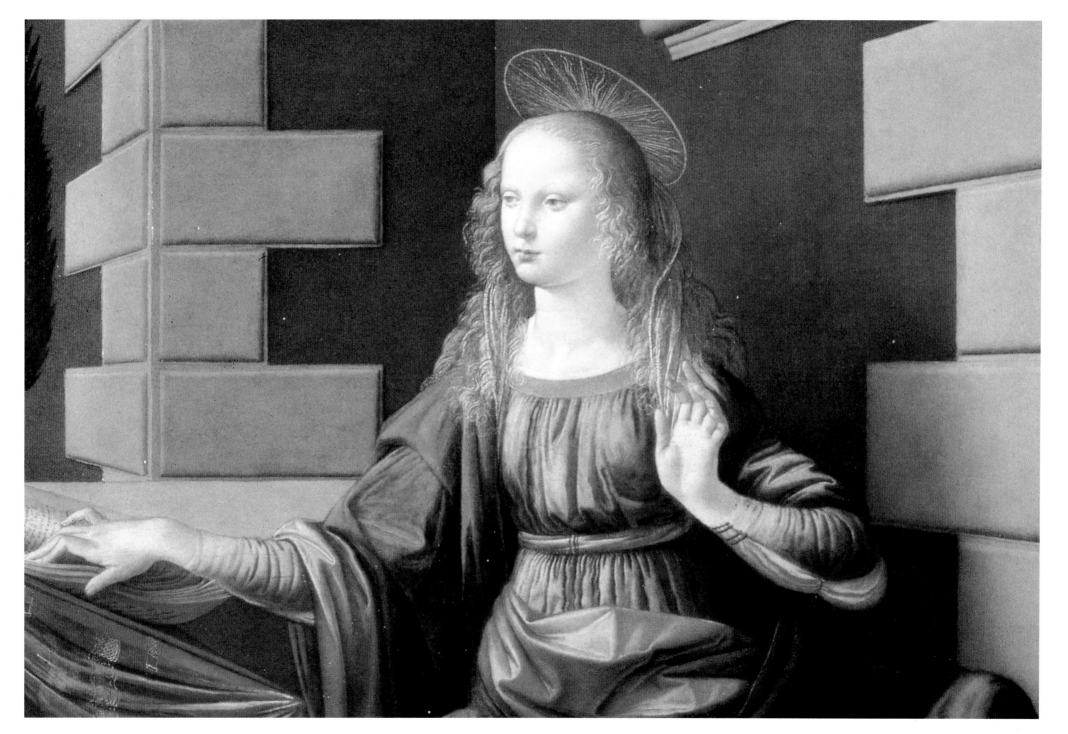

The Annunciation (c.1472–75)
Oil on panel (post-restoration)
Uffizi, Florence

Detail of the writing desk from
Leonardo's Annunciation. This
rather intrusive article of furniture
was possibly copied from a model
in Verrocchio's studio. It draws
attention to a tyro's error in spatial
relationships.

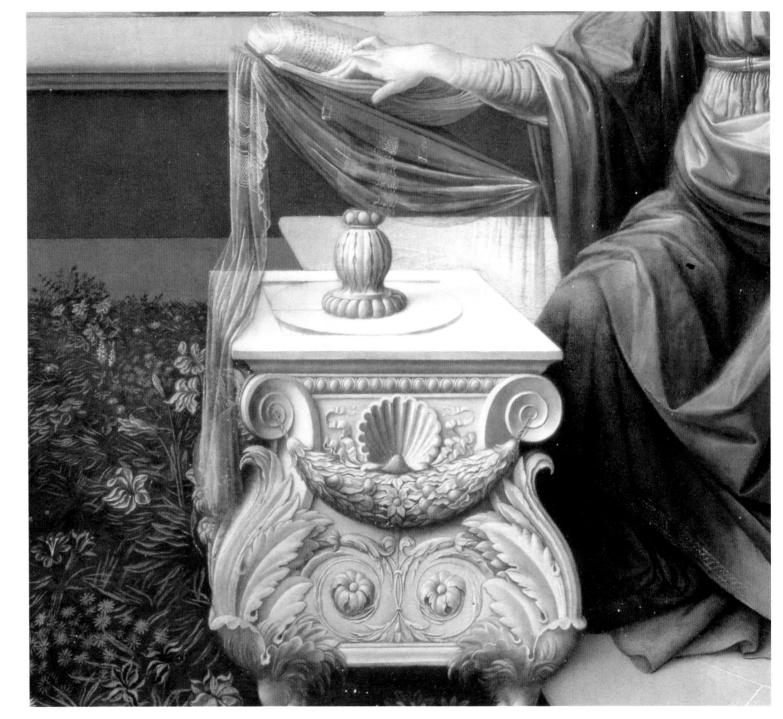

Leonardo da Vinci

Draped figure

Pencil on paper
Uffizi, Florence

Credi eventually succeeded Leonardo as the leading painter of the studio.

The rather stiff and severe folds of Leonardo's angel's drapery in the *Baptism* offer confirmation of Vasari's interesting account of how Leonardo practised this technique. 'He would make clay models of figures, draping them with soft rags dipped in plaster, and would then draw them patiently on thin sheets of cambric or linen … with the point of the brush.'

Similar treatment of drapery appears in Leonardo's *Annunciation* (now in the Uffizi), which was probably begun much earlier than the *Baptism* and worked on over a longish period. This was in origin probably a studio picture, commissioned by the convent of San Bartolommeo di Monte Oliveto. It was once attributed to the fresco painter Domenico Ghirlandaio (1449–94), who may have worked in Verrocchio's studio for a short time, while others suggested, rather more probably, that Verrocchio had a hand in it. In the 19th century John Ruskin firmly declared it to be a Leonardo, and his opinion gained added authority in 1907 when Leonardo's pen and ink sketch for the angel's sleeve turned up in the

RIGHT

Drawing of the Virgin and Child with St. John

Musée Bonnat, Bayonne

OPPOSITE

Study of hands

Silverpoint with white highlights on paper
The Royal Collection, Windsor Castle

A possible preparatory study for the Mona Lisa.

library of Christ Church, Oxford. In the Royal Collection at Windsor, moreover, there is a beautiful drawing of what is surely a study for the lily held by the angel, although it takes a slightly different form in the finished picture. Unfortunately, the painting was apparently altered somewhat at a later date with deleterious effect and it is in poor condition. Together with the incongruous lectern or writing table (page 78), which looks more like an academic exercise by a pupil of Verrocchio than part of the picture, and the rather unsatisfactory composition, which is partly but not entirely the result of the alterations, this makes its effect overall, as the first complete surviving work of one of the world's greatest painters, a little disappointing.

The angel, whose pose is familiar from the typical *quattrocento* treatment of the subject (such as Fra Filippo Lippi's in the Barberini, Rome, for example) is, in spite of the more conventional pose, almost as fine as the wingless angel in the *Baptism*, and the wings, modelled on those of a bird, are unusually convincing: this angel, we may think, has a better chance of achieving flight than most, and reminds us

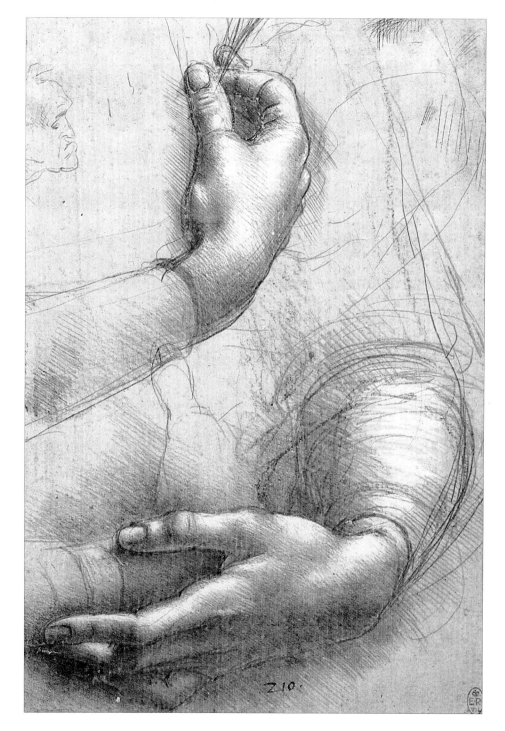

of Leonardo's lifelong desire to fly. In fact, the angel appears to have just landed, causing the plants in front of him to flutter in a sudden breeze and startling the Virgin. Part of the background, with the black silhouettes of trees set against the sky at dusk, evokes the way in which our emotions are mysteriously touched by effects of nature, and equally characteristic of Leonardo are the flowers in the foreground, which are not set out in the conventional way, as in an orderly garden or spread over the ground like a floral quilt, but are wild and full of life. The outdoor setting for this scene is also unusual.

The head of the Virgin is less successful. It makes a poor comparison with Leonardo's later female portraits and some critics have doubted that it is his work at all. It bears a quite close resemblance to a very fine drawing of a female head by Verrocchio. A technical fault in composition has the Virgin's hand resting on the rather too prominent lectern, the location of which, as we can see from its base, is nearer to us than she is, making such a gesture impossible. The artist's command of perspective has

The Annunciation, by Fra Filippo Lippi (c.1450)
Tempera on panel
National Gallery, London

This was a common subject and suited to a particular space in an altarpiece. It is an example from the honeyed period of the Florentine Renaissance represented by artists such as Fra Filippo Lippi and Fra Angelico.

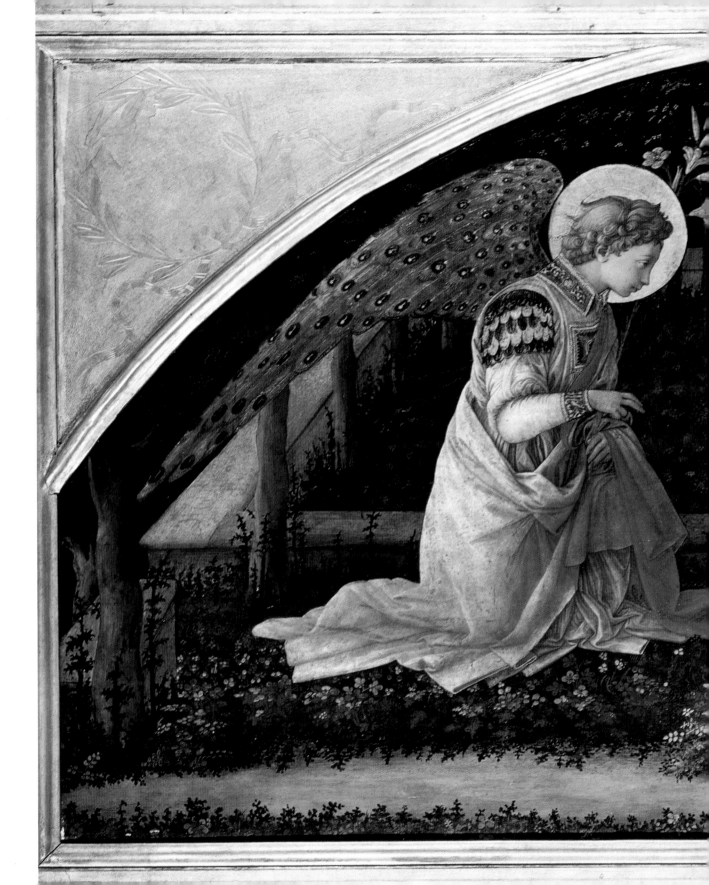

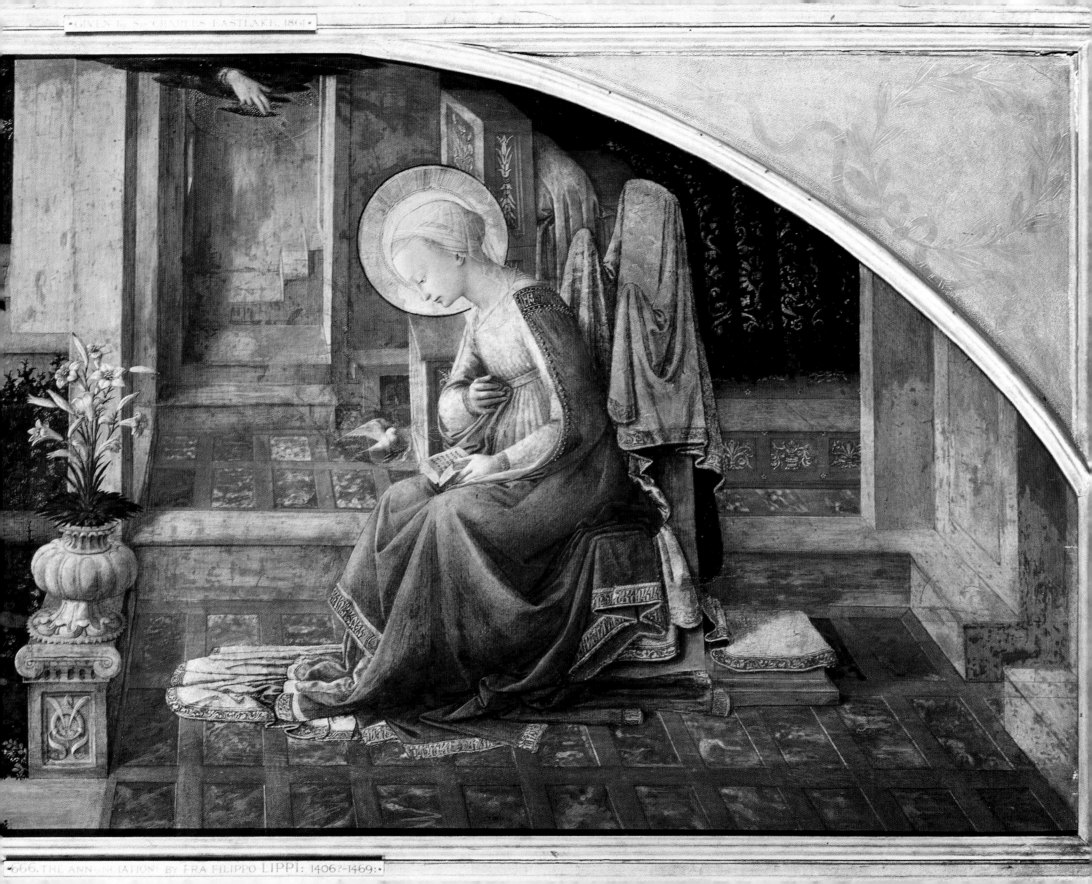

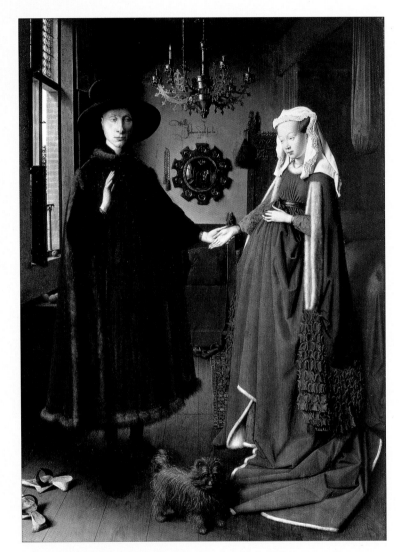

The Arnolfini Wedding, by Jan van Eyck (1434)

The Flemish master's command of perspective is demonstrated.

PERSPECTIVE

Perspective is the illusionist technique of representing three-dimensional objects on a two-dimensional surface. Renaissance artists believed that art is governed by mathematical rules, and the discovery, or rediscovery, of perspective by Giotto and others in the 14th century, taken further by Leon Baptista Alberti and others in the 15th century, was the most important. Perspective takes several forms, but the basic assumption is that although parallel lines never really meet, they appear to do so. This conjunction occurs at what is called the vanishing point. Thus, if you have a straight road leading from your viewpoint to the far distance, the sides steadily converge until, at some point on the horizon, they come together. If the road is lined with identical houses, all other parallel lines going in the same direction, as might be formed by their roofs, windows, etc., also meet at that point.

Perspective applied to a single object is called foreshortening, as in the arm of a figure pointing towards the spectator.

This system, while artistically satisfying, cannot in fact convey an exact representation of reality, and it was refined by introducing two or even more vanishing points on the horizon: Piero della Francesca's famous *Flagellation of Christ* (right) in Urbino, has two vanishing points, and an early example of the highly sophisticated use of the technique may be seen in Jan van Eyck's *Arnolfini Wedding* of 1434 (National Gallery, London), in which a convex mirror reflects the room back to the viewer.

No very advanced knowledge of mathematics is necessary to work out the system, though some artists, Albrecht Dürer for one, had special instruments for calculating perspective. It was a source of great delight to many *quattrocento* painters, some of whom seem to have chosen subjects specially to show off their command of perspective. Of course, it was normally worked out in advance, as can be seen in Leonardo's study for the *Adoration of the Magi* in the Uffizi (page 110–111). Anyone who has tried to draw even a simple scene will recognize the necessity for that.

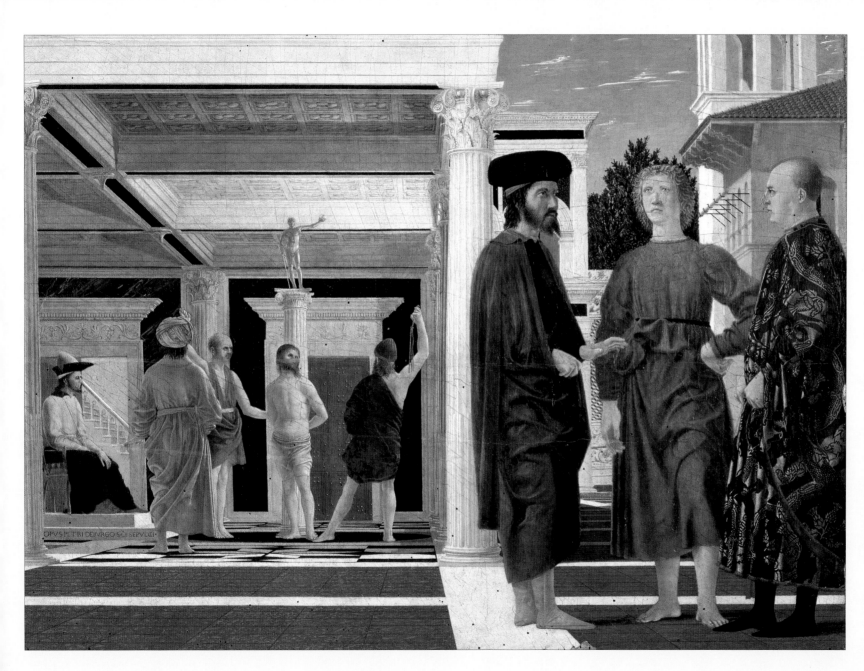

The Flagellation of Christ, by Piero della Francesca (c.1463–64)
Tempera on panel
Galleria Nazionale delle
Marche, Urbino

A famous and mysterious painting, the significance of the three figures at right being unclear. The careful architectural setting may have been influenced by Alberti, a friend of the artist.

Study of a Madonna and Child

Pen and ink on paper

Uffizi, Florence

Many of Leonardo's studies for Madonnas exist of which some cannot be directly related to a surviving painting.

also been questioned, though the trouble appears to be not that the perspective is mathematically inaccurate but that the precise rules have been followed without regard for their actual purpose, to achieve a harmonious composition, the fault of a relative tyro.

Recent examination of this painting has shown that the artist occasionally used his fingers to manipulate the slow-drying oil paint, rather than a brush, perhaps the earliest example of this technique.

TWO MADONNAS

Leonardo seems to have done comparatively little in the 1470s, though it is unlikely that this was due to idleness or irresponsibility, despite his presumed extracurricular activities. We do know of some work that has not survived, but much of what we do have is controversial. From Leonardo himself we know that in December 1478, 'I have begun the two Virgin Marys'.

The previous year he and several others had accompanied Verrocchio to Pistoia, a town he may

have known, since his father had once worked there. The commission was for a marble statue of a prominent ecclesiastic but, while there, Verrocchio was persuaded to provide also a *Virgin and Child with the Saints* as an altarpiece. Leonardo may have contributed to this, though it would seem that his position as Verrocchio's chief painter was soon to be taken over by Lorenzo di Credi, who completed the altarpiece, in effect almost repainted it, in 1485, long after Leonardo left Florence. Careers were less formally organized in the 15th century, and by this time Leonardo had a sufficient reputation to act as an independent artist. Besides the portrait of Ginevra de' Benci (pages 94 and 95), he had already accepted a commission for the chapel of the Signoria, which he never fulfilled (it passed to Ghirlandaio, and then to Filippino Lippi, who finally completed it). That he should undertake work on his own account did not preclude him working also for Verrocchio, who was about to embark on his last and perhaps finest project (and homage to his master, Donatello), the unfinished equestrian statue of the deceased *condottiere*, Colleoni, in Venice.

Leonardo da Vinci

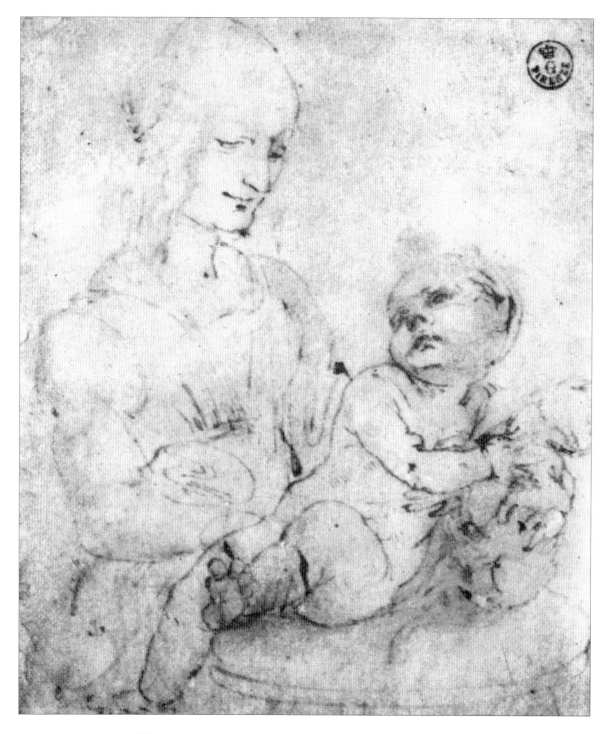

'The two Virgin Marys present some problems. One is simply Leonardo's statement that he started a certain painting and by no means implies that he ever finished it. Another is that his drawings and studies of this period indicate up to half a dozen different Madonnas! The consensus is that the two he most likely referred to are the *Benois Madonna* (page 88) now in the Hermitage, St. Petersburg, and either the so-called *Madonna of the Cat* (pages 246–247), for which only studies exist, or the *Madonna of the Carnation* (the *Munich Madonna*, page 90) in the Alte Pinakothek, Munich. Another possibility is the *Madonna Litta* (page 130 et seq.).

The *Benois Madonna*, so called after a previous owner, is the least problematic, at least in the sense that nearly everyone agrees that it is a genuine Leonardo and not a co-operative workshop product. Judging by style, it is also the latest (barring the *Madonna Litta*), and may have been painted as late as 1481. A small picture, it was unknown until it turned up in the early 19th century in, rather surprisingly, Astrakhan, where it was bought by a Russian. His descendant, who was

The Benois Madonna

Hermitage, St. Petersburg

An early work, though the exact date is disputed. In spite of its chequered provenance and poor condition, it is generally accepted as predominantly, if not entirely, the work of Leonardo himself, though some crude overpainting renders surfaces, notably of the skin, most unLeonardo-like, and its importance now is historical rather than artistic.

This laughing Virgin carries much further a trend towards a more human figure, notable a generation earlier in Filippo Lippi, and the Child's intent expression testifies to Leonardo's keen powers of observation.

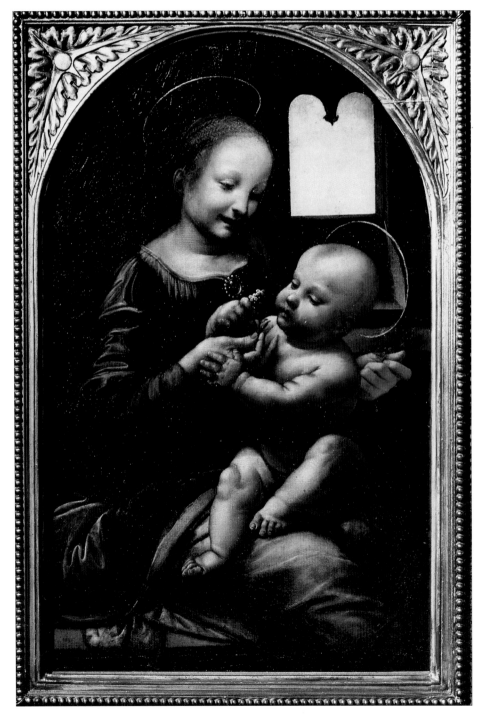

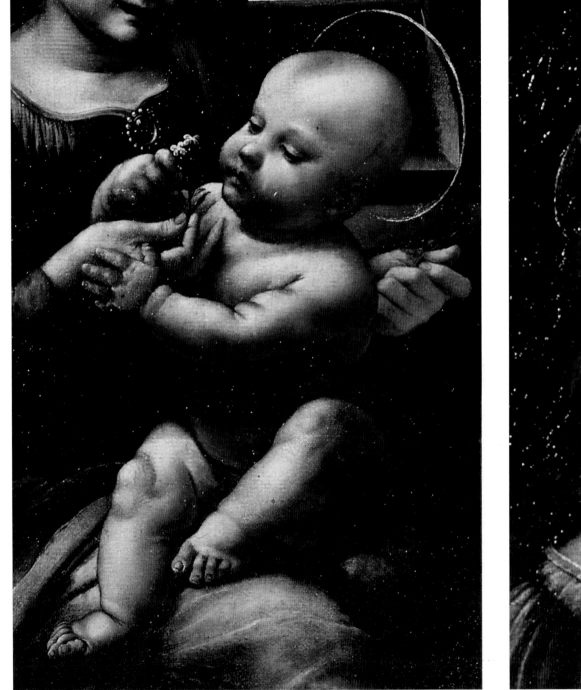
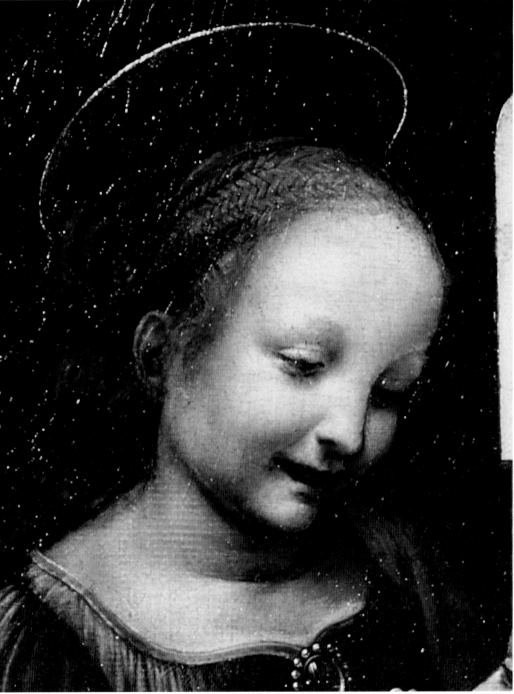

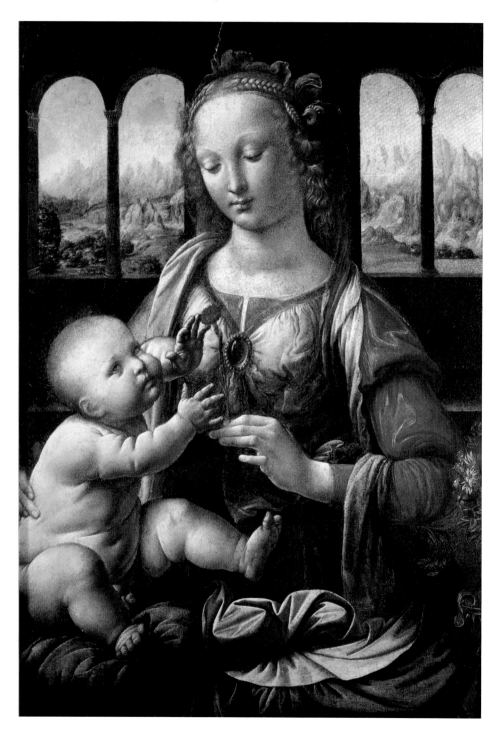

Madonna of the Carnation (The Munich Madonna)

Alte Pinakothek, Munich

This work has been attributed at different times to a variety of artists, including Leonardo, and there are obvious signs of his style, for instance in the landscape; but the general consensus is that it belongs to the school of Verrocchio, with Lorenzo di Credi probably having had a hand in the painting.

OPPOSITE RIGHT

Study for The Madonna of the Cat

Pen and ink on paper
Musée Bonnat, Bayonne

Possibly a study for a painting that was never realized.

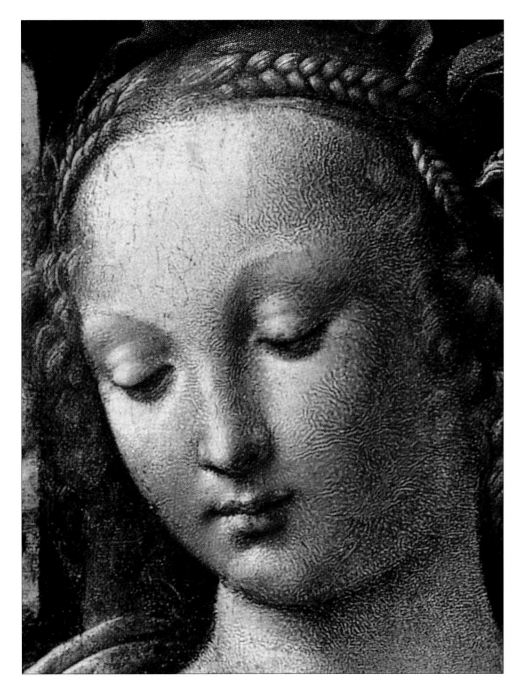

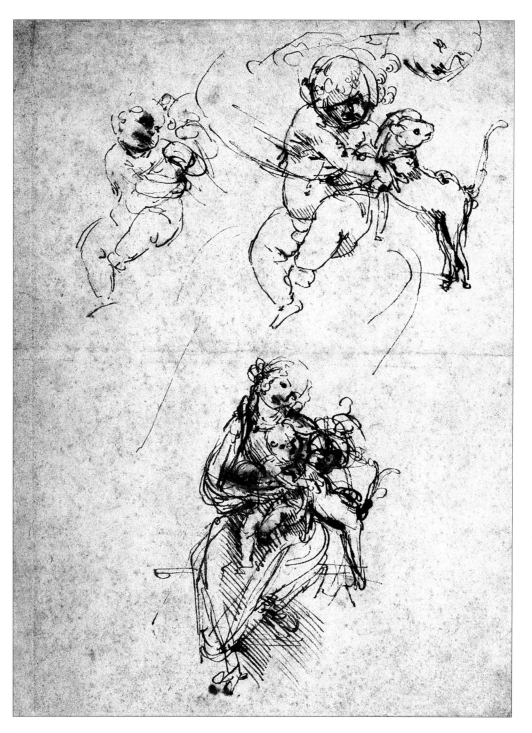

the wife of the painter Léon Benois, bequeathed it to the Hermitage in 1914, and only then was it identified as a Leonardo. That seems to be confirmed by the survival of Leonardo's studies, although studies known to be by Leonardo do not confirm his authorship of a surviving painting of the subject beyond question, as he had many copyists; the *Madonna Litta* is a case in point.

But further evidence of Leonardo's authorship, if needed, can be found in the striking similarities in pose and drapery between this painting and the Paris version of *The Virgin of the Rocks*, painted about 30 years later. It represents a new trend, one not originated by Leonardo but carried much further in this picture, portraying the Virgin Mary not as the saintly, iconic figure of long tradition, invariably presented frontally, but as a mother, laughing and playing with her baby and seated at an angle to the picture plane. A study for the painting in the Louvre has the Child feeding his mother with some titbit, perhaps a cherry, from a plate she is holding, and some lively, carefree drawings, rather different in mood from the final painting, in the British Museum, have her feeding

the Child. Some of these feature a cat rather than a plate of goodies, and are therefore associated with the putative *Madonna of the Cat*, known through studies only, which is either lost or, equally likely, was never painted, the cat being abandoned in favour of, first, the plate and, finally, the flowering sprig she holds now. (The same floral motif appears in the *Munich Madonna* and indeed figures holding flowers are common in Leonardo, so that the name *Madonna with a Flower* can cause confusion.)

Incidentally, the remarkable, dynamic drawings for the *Madonna of the Cat*, reworked many times until the alternative lines become so confused that the artist was forced to start again by pressing hard on the last version so that it came through on the other side, then continued from there, is a sign of a new approach to the making of preparatory sketches. This appears to have been an innovation by Leonardo, but it was followed almost universally by later artists so that it now seems instinctive.

The Child in the *Benois Madonna*, like most Renaissance babies, is not particularly attractive to our eyes, being bald and overweight, though certainly less gross (and much more convincing)

Leonardo da Vinci

than the Child in the *Munich Madonna*. The damaged and dirty condition of the painting, which once led the great Bernhard Berenson to assume – from a photograph – that the laughing Virgin had no teeth, does not help matters. The colours generally are dark but harmonious, and the composition highly original if not perfectly conceived. The number of copies by other painters testifies to its contemporary popularity. One sorry lapse is the window at top right, which is unexpectedly and startlingly blank – nothing appears beyond but a colourless sky. It throws the whole picture out of focus, and we can hardly doubt that it once framed a landscape, or at least was intended to do so.

There is no such lapse in the *Munich Madonna*, which is undoubtedly earlier. The paint has gone wrinkly, a sign of inexperience with oils, and the same fault affects both the *Annunciation* and *Ginevra de' Benci*. Here spiky, Leonardoesque mountains appear beyond the windows that span the width of the panel. That was a typically Flemish device, and Gothic influence has also been suggested to explain the remarkably contorted

drapery; in fact this painting was at one time attributed to Dürer. It was first assigned to Leonardo in about 1890, but most modern historians have regarded it as a workshop production. Significantly, Lorenzo di Credi used the same model and clothing in a similar picture. If it is Leonardo, it is Leonardo at his most Verrocchioesque. No studies exist, except for a questionable head, and the head of the Virgin seems more likely to be by Verrocchio than Leonardo. Other details, notably the landscape but also the flowers in the vase and some of the drapery, suggest Leonardo's hand. It is hard for any admirer of Leonardo to suppose that he was responsible for the baby, whose unattractive appearance cannot be blamed entirely on the wrinkling paint. On the other hand, it has been pointed out that this baby is anatomically faultless and, being hairless, is more like a real baby than those of Leonardo's contemporaries, including Verrocchio. The *chiaroscuro*, for instance in the Child's body, also suggests Leonardo and his insistence that forms should be defined by light and shade.

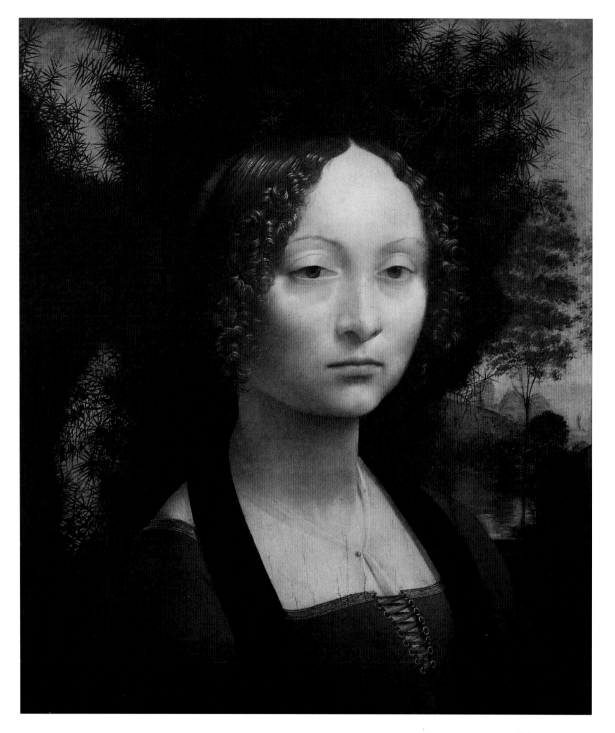

A link has been suggested between the 'two Virgin Marys', and the two altarpieces, the Pistoia altar completed by Credi and that in the Palazzo Vecchio completed by Filippino Lippi. Both are said to bear traces of Leonardo's design, and many features are common to both. The hypothesis is that these two, not the *Benois Madonna* nor the *Munich Madonna*, are the subjects Leonardo referred to in his note of 1478. But all this remains tenuous speculation.

GINEVRA DE' BENCI

Another Leonardo portrait of a young woman, Ginevra de' Benci, dates from about this period, though most modern judgements put it earlier than the Madonnas discussed above. Although the sitter was only tentatively identified in 1905, we know from contemporaries that Leonardo did paint a lady of this family, and the presence of the large juniper (Italian *ginepro*) bush, is evidently a pun on her name. Recent examination with an infra-red camera of the heraldic device on the reverse of the panel have confirmed the sitter's identity beyond all

Leonardo da Vinci

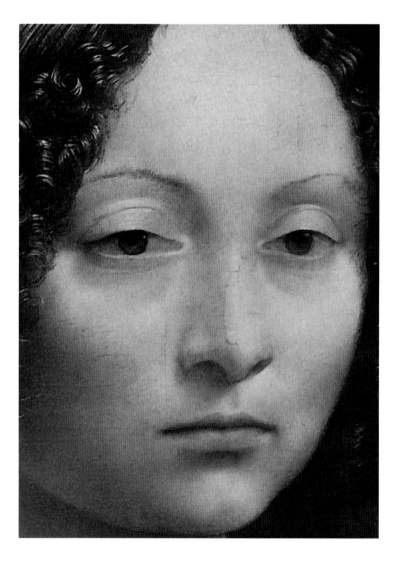

doubt. She was the daughter of a rich banker, whose house still stands in what is now called the via de' Benci, and was celebrated for her beauty by poets, Lorenzo the Magnificent among them, being famous for her chivalric and chaste romance with the Venetian ambassador. She also wrote poetry herself.

Ginevra de' Benci was married in 1474, when she was 16 (her husband was twice her age, though her Venetian 'lover' was even older), and as it was customary to mark those ceremonies with a portrait, it seems a likely deduction that the painting is probably of that year too. Formerly in the Liechtenstein Collection in Vienna, it was sold to the National Gallery, Washington, in 1967 for what was then a record sum for a painting, and it remains the only Leonardo in the USA.

The painting was much admired by contemporaries: the so-called Anonymous Florentine, or Anonimo Gaddiano, perhaps the most reliable witness to Leonardo's early years in Florence, declared that it had 'such finish that it appeared not to be a portrait but Ginevra in

***Ginevra de' Benci** (c.1480)*
15¹⁄₈ x 14¹⁄₂in (38.4 x 36.8cm)
National Gallery of Washington, D.C.

This is an astonishing painting from a young artist. No less an authority than Kenneth Clark concluded that in certain effects Leonardo never surpassed it, and we can easily sympathize with the contemporary opinion that it looked more like the beautiful Ginevra in the flesh than in paint (for Renaissance connoisseurs no praise was higher than that).

OPPOSITE

Head of a woman

Metal point heightened with gouache

Musée Bonnat, Bayonne

person'. More recently Kenneth Clark considered that 'there are passages, such as the modelling of the eyelids, which Leonardo never surpassed in delicacy', and David A. Brown, who has possibly spent more hours studying the painting than anyone, calls it 'not only a portrait but a picture of nature, in which the artist saw the sitter in the light of his own preoccupations: her pale luminous skin and golden hair combine with the juniper leaves and the distant scene to form a sequence of tonal and textural effects that is unprecedented in Florentine art.'

The panel is quite badly damaged, insofar as there are up to 4in (10cm) missing at the bottom that almost certainly included the hands – a study of hands at Windsor may relate to this painting – but it is in better condition than the Madonnas discussed above and is possibly the only painting of this period that is without a shred of doubt entirely Leonardo's work. It struck the late Cecil Gould as representing, 'in a sense the epitome of Leonardo's earliest period as a painter, combining as it does, affinities with Flemish modes, and with Verrocchio

and contemporary Florentine sculpture.'

The sitter is posed, again outdoors, in a level landscape with trees and water, rather in the Flemish manner. It is possible that Leonardo had seen this effect in Flemish portraits, and some have pointed specifically to Petrus Christus, the leading successor of Jan van Eyck. He may have visited Italy some time before his death in about 1472, and the Medici owned one of his paintings – possibly the near-frontal _Portrait of a Lady_ now in the Gemäldegalerie, Berlin, which, though set indoors, has obvious similarities with _Ginevra_. The three-quarter figure, which marks the end of the _quattrocento_ tradition of painting female portraits in profile (and showing head and shoulders only, never including the hands), may derive from Verrocchio's sculpture, in particular his _Flora_ (or _Young Woman with a Bunch of Flowers_, page 62) in the Bargello in Florence, which in hairstyle, facial features, dress, and even in the (assumed) arrangement of the hands, is a similar figure. The painting embodies all kinds of skilful technical devices, especially in the handling of light, in the

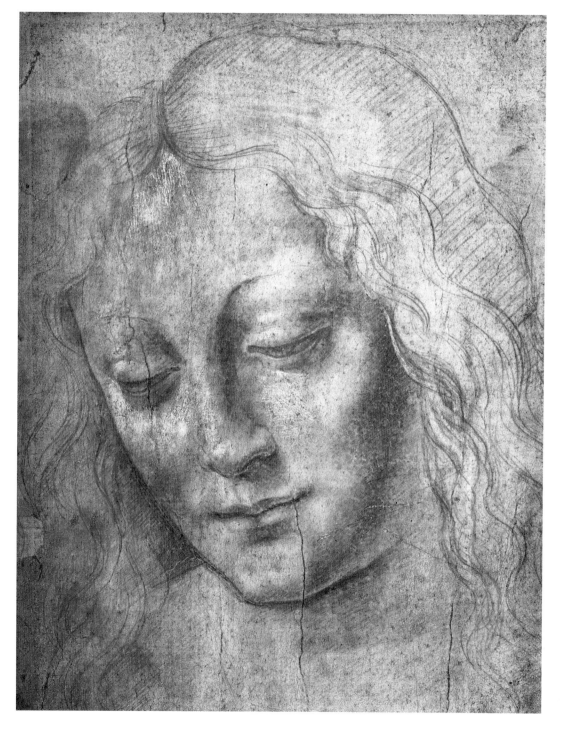

contrast of light, direct and reflected, and shade, and the broken or spiky forms that accentuate the smooth, pale face. But above all Leonardo has painted a person, a character, someone whom, over 500 years later and with practically no other evidence than this portrait, we feel we almost know.

Whether we would wish to know her is another matter. Some have remarked that her expression is downright disagreeable, and Ginevra does not appear very enthusiastic at the prospect of married life. She lacks the contentment of another bride, the subject, nearly 30 years later, of Leonardo's most famous portrait, the *Mona Lisa* (La Gioconda).

ST. JEROME

In the wake of the Pazzi plot, a painting was commissioned of the execution of the traitors for the wall of the Bargello (then a prison). Perhaps Leonardo was in the running for this commission, but it went instead, not unexpectedly, to Lorenzo's friend Botticelli, who had recently completed a happier painting, his allegorical fantasy of Spring,

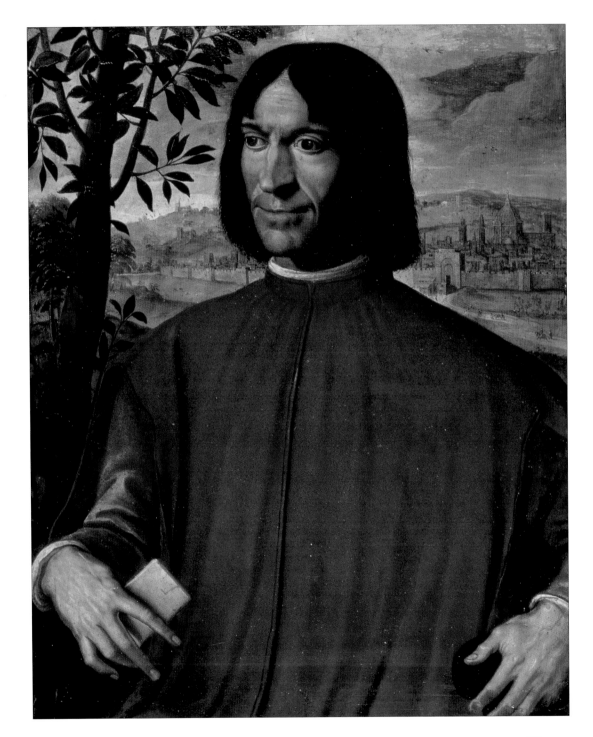

THE PAZZI PLOT

In the popular image of Florence, the chief preoccupations among the elite are seen as art and conspiracy. The image goes back to contemporary times when, for instance, the political realism of Machiavelli was seen abroad, especially in a Protestant country like England, as little short of satanism. In fact, poisonings and stabbings were less frequent than others liked to suppose, but violence was not uncommon and the republic, in its last years, was more fragile than it seemed. Even while the Medici were popular, and the Medici controlled the Signoria, political opposition at a lower level was not uncommon and the city councils frequently displayed a surprising degree of independence. Among the ruling elite themselves, inevitably some nursed an ambition to replace the Medici, ambitions that were encouraged by their lack of official status as rulers.

The most dangerous crisis faced by Lorenzo de' Medici, and the episode chiefly responsible for the idea that Italian conspiracies were uniquely violent and scandalous, was the Pazzi plot. It would not have surprised those foreign Protestants to learn that the pope was behind it.

The Pazzi were an old Florentine family, much older than the Medici and resentful of their exclusion from power, who had suffered something of an eclipse in the 15th century until their fortunes revived after they founded a bank in Rome. The pope, Sixtus IV, who possessed most of the vices associated with the phrase

'Renaissance pope' in large measure, was a bitter enemy of the Medici since Lorenzo had scotched his plans to extend the papal empire in central Italy.

The head of the Pazzi family, Jacopo, was personally on good terms with the Medici, though he resented a recent change in the laws that was engineered by Lorenzo with the deliberate intent of depriving the Pazzi of an inheritance. At first he considered that a coup was doomed to failure, but he was eventually won over by the promise of military backing from various *condottieri* and the encouragement of the pope, who insisted, however, that 'there be no killing'. The Pazzi considered that it would be vital to kill Lorenzo and his lively, popular, younger brother, Giuliano. (It may well have been Giuliano, rather than Lorenzo, who was the Medici who most appreciated Leonardo's talent.) After the event, the conspirators reckoned that the pope would not be much troubled. Lorenzo having declined an invitation to Rome, they decided that the best moment to strike would be at Mass in Florence Cathedral on Easter Sunday, 1478.

The signal would be the ringing of the bell at the Elevation of the Host. Two malignant priests were assigned to despatch Lorenzo after the soldier who had agreed to do it withdrew, protesting that he was prepared to commit murder but not sacrilege. The substitute assassins were an unwise choice. Though the priests' daggers wounded him in the neck, Lorenzo drew his sword and drove them back, vaulted the altar rail, and raced for safety in the sanctuary. Meanwhile, Francesco de' Pazzi and Bernardo Baroncelli, a dissolute adventurer in debt to the Pazzi, disposed of Giuliano, stabbing and slashing in such a frenzy of blood lust that Francesco inadvertently stabbed himself in the leg. But Lorenzo and his supporters gained the sanctuary and managed to close the heavy bronze doors before the assassins reached them.

The coup was a failure. When Jacopo de' Pazzi rode through the streets shouting 'Liberty and the People!' he encountered jeers and Medici war cries. The mercenaries, led by an archbishop, to take over the Palazzo della Signoria, were admitted, then found themselves locked in. They were later slaughtered by Lorenzo's guardsmen. Many conspirators were killed in the fighting. Some, including Francesco and the archbishop, were lynched, others, including Jacopo, were later caught and killed in horrifying ways. Over 100 were condemned to death. Among the few who escaped was Bernardo Baroncelli. But only temporarily. The tentacles of Medici vengeance sought him out and located him far away in Constantinople. Florence had substantial commercial dealings with the Ottomans, who had captured the ancient Byzantine capital a year after Leonardo's birth, and Baroncelli was extradited and hanged outside the Palazzo Vecchio in December 1479.

OPPOSITE
Portrait of Lorenzo de' Medici, 'The Magnificent'
(Italian School)
Oil on panel
Palazzo Medici-Riccardi, Florence

RIGHT

Study of a hanged man

Pen and ink

Musée Bonnat, Bayonne

Leonardo's drawing of the executed conspirator, Bernardo Baroncelli, the assassin of Giuliano de' Medici in 1479. The accompanying notes suggest both that Leonardo was present at the execution and that this ink drawing was in preparation for a painting.

OPPOSITE

St. Jerome (c.1480)

Vatican, Rome

It is fortunate that Leonardo took such care with the underpainting, since in this and other cases it is virtually all we have. The pose of the self-tortured saint is a tour de force, and so is the thoroughly naturalistic lion.

Primavera (the Bargello fresco was destroyed when Savonarola's puritanical republic was established in 1494). Whether Botticelli or Leonardo had witnessed the gruesome event, we do not know, but it is certain that Leonardo was present at the execution of Baroncelli, for there is a drawing by him of the hanging body, together with notes on what he was wearing, including the colours of his garments. That seems to be as far as the (presumably) projected painting went, and in fact the drawing is not a success. Leonardo has got the angle of the head wrong, and he was clearly aware of it himself because in the corner he has made another sketch of the angled head.

It was a subject miles removed from Madonnas and young society girls, and so was the unfinished painting of *St. Jerome* (now in the Vatican), which was probably done a year or two before Leonardo's departure from Florence, which might explain why it was unfinished. This monochrome painting of the hermit-saint in the desert is something new, particularly in the forceful figure of St. Jerome himself in a state of extreme distress, which

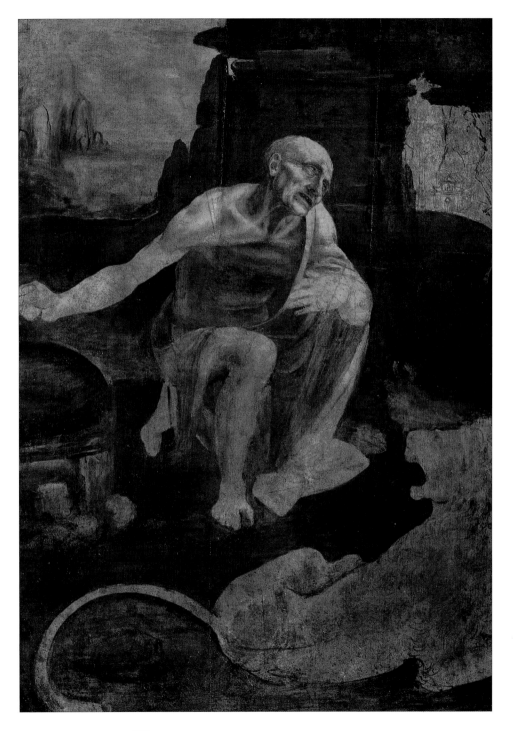

Kenneth Clark described as 'a great invention'. It is nearer in spirit to the High Renaissance than the *quattrocento* and influenced Raphael and Titian among the many later artists who essayed this subject. It has been suggested that it echoes the emotional state of the artist, and there is some slight evidence that Leonardo was going through a period of disillusionment at this time; on the other hand the figure of the saint is, among other things, an example of an artist demonstrating his virtuosity with a certain confidence.

The rocks behind suggest the later *Virgin of the Rocks* (page 148 et seq.), and the growling lion in the foreground is a 'real' lion, perhaps drawn from life, not the heraldic beast seen in virtually all painting hitherto (St. Jerome was associated with the popular legend of the saint who earns a lion's gratitude by removing a thorn from its foot).

The work has been obscured by overpainting and revarnishing and is altogether in poor condition. This is hardly surprising if the story of how it came to light is true. In the early 19th century Cardinal Fesch, an uncle of the Emperor

RIGHT and OPPOSITE details
St. Jerome *(c.1480)*

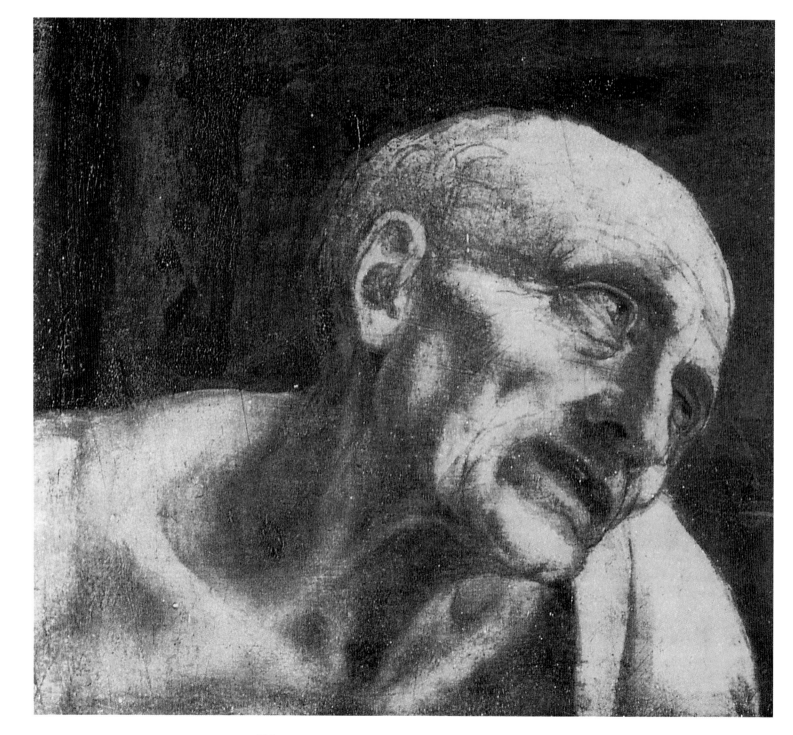

Leonardo da Vinci

Napoleon, was browsing in a shop in Rome when he noticed a striking panel in the door of a cupboard. He recognized the head as a work of the Renaissance and, having bought it, realized that he had only half the picture. He set out to find the rest, and after weeks of searching the many small shops in the area he eventually did find it, attached to a shoemaker's bench. Reassembled, the picture passed into the Vatican collection after the cardinal's death. Although we know nothing more about it, and it is not mentioned specifically in any contemporary document, it has since been universally recognized as the work of Leonardo.

ADORATION OF THE MAGI

By far the most important work of Leonardo's early years is the *Adoration of the Magi* (in the Uffizi), which was, probably, commissioned by the monastery of San Donato at Scopeto as an altarpiece in March 1481. Very likely Leonardo's father, who looked after the monastery's affairs, had some influence in gaining him the commission.

Since Leonardo had already acquired a

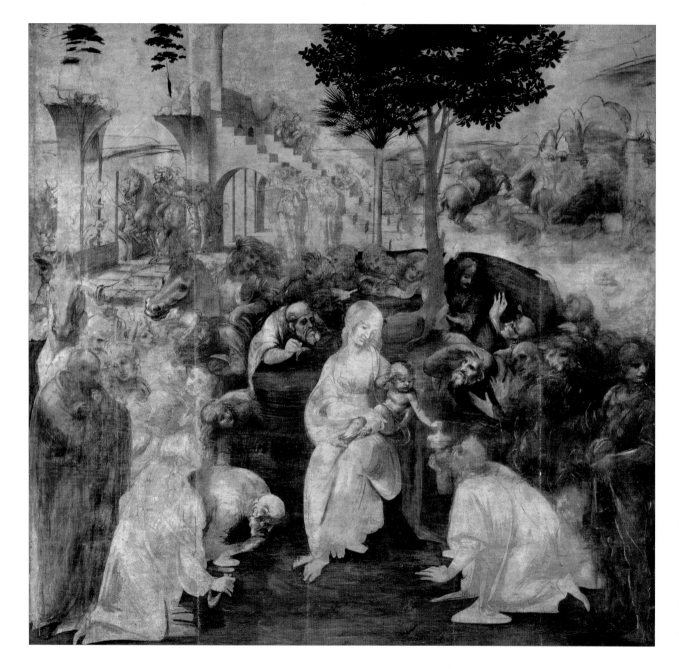

reputation for slow delivery, the monks imposed a time limit, and the contract was an odd one in other ways. Instead of being paid cash, Leonardo was granted a one-third share in an estate left recently to the monastery, out of which he had to provide a dowry for the deceased benefactor's daughter. In fact, both Leonardo and the monks seem to have been short of cash, since Leonardo was constrained to repaint the monastic clock, for which he received merely a couple of loads of firewood. The monks did manage a small advance to buy pigments, and at different times a bushel of wheat and a barrel of wine. Whether the fatherless bride ever received her dowry must be doubtful. All this was rather unpromising and – ominous sign of the future – the painting was never finished. Fifteen years later a picture of the same subject, the same size and shape, was delivered to San Donato by Filippo Lippi. The monks had presumably long given up all hope that Leonardo would ever finish his painting. What survives is basically the underpainting, in tones of 'earth-green' and brown, and even that is incomplete.

Leonardo da Vinci

When Vasari saw it many years later, it was in the house of Amerigo Benci. According to the contract, it was the property of the monastery whatever its state, so Benci must presumably have thought it worth buying although unfinished, though it raises the possibility, no doubt a remote one, that the monks, not Leonardo, reneged on the contract and Leonardo sold the painting. Perhaps the monks did not like the drawing (Leonardo was easily discouraged – or disgusted – by even a hint of disappointment). Alternatively, the reason why Leonardo stopped work on the *Adoration* may have been simply the upheaval caused by his move to Milan. A more likely reason was that, having solved the problems and done the most difficult part, he lost interest in achieving the finished painting. Or perhaps, in spite of his pursuit of 'scientific' realism, he considered that a carefully finished painting in the Florentine manner would ruin the effects he had achieved. Although Vasari himself once remarked (in his account of Luca della Robbia) that 'rapid sketches in the first flush of inspiration' may be preferable to 'excessive labour and too great

The Adoration of the Magi (1481–82)
*Underpainting on panel,
97 x 96in (246 x 243cm)
Uffizi, Florence*

The masterpiece of Leonardo's early Florentine period, this was the first of comparatively few attempts at a picture on a truly grand scale, full of figures and incident. As usual, he spared no effort in preparing the picture and to judge by the number that have survived, he must have made literally hundreds of studies. The work is full of strikingly creative, novel ideas, superbly worked out, and it is tempting to wonder if he failed to complete the painting because, having solved all the problems that most deeply engaged him, he simply ran out of steam.

The Adoration of the Magi

Details of the Virgin and Child and (opposite) the turbulent, fearful, anarchic crowd that surges around the calm and peaceful centre.

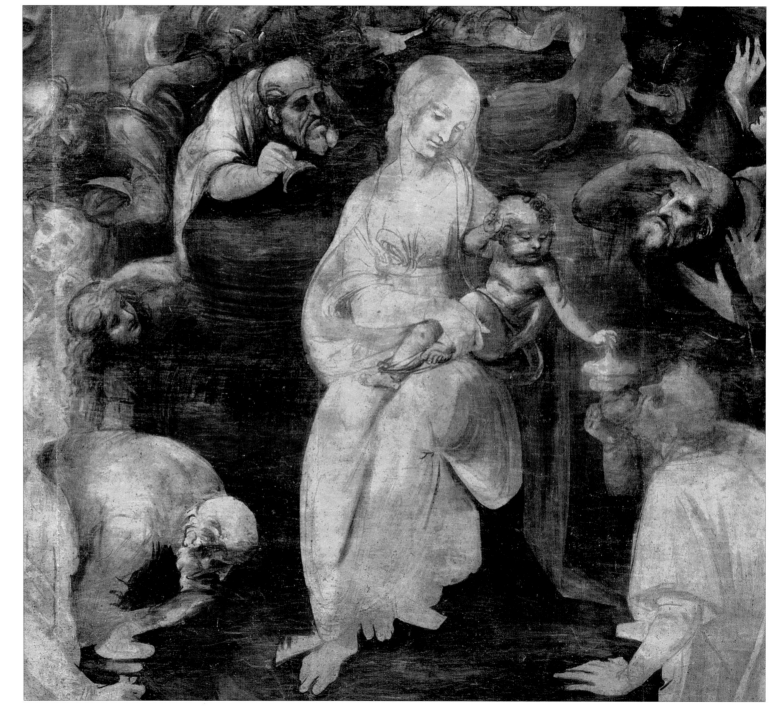

meticulousness', this is a view that encounters more sympathy today than it did among Leonardo's classicizing contemporaries. They would have found the picture too dark and too restless, and Leonardo's disorderly crowd ran right against classical principles. Leonardo would have replied to such criticism that he followed life, not the classics.

In the Church calendar the Adoration of the Kings took place on 6 January, an important date for Florence as it was also the date of the Baptism of Christ by St. John the Baptist, the patron saint of the city. By tradition, great processions were organized on that day by a religious guild, the Compagnia de' Magi. These processions (which have no biblical authority) are reflected in the customary treatment of the subject by painters, in which a stream of rich and colourfully dressed persons passes across the surface parallel to the picture plane. It therefore required a rectangular, 'landscape' shape, and those dimensions meant that it usually appeared in some such room as a refectory. A famous example was Benozzo Gozzoli's gorgeous fresco in the Palazzo Medici-Riccardi (page 203), with the Medici family

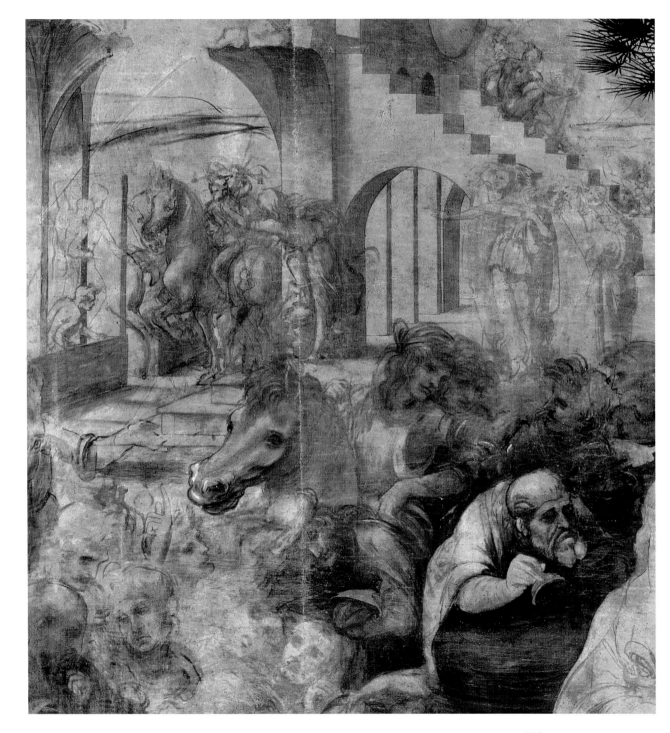

portrayed as the Magi (this was afterwards associated with an actual event – the arrival in Florence, seeking help against the Turks, of the Byzantine emperor, John VIII Palaeologus, in 1439).

When a squarer format was introduced for this subject, it presented new possibilities. They were exploited by Botticelli, who placed the Virgin and Child in the centre of the picture instead of at the side (he too included portraits of members of the Medici as Magi). Leonardo, among others, followed this example, and heightened the effect by bringing the Virgin and Child farther forward.

Besides a large number of studies of details, individual figures, and other elements, two sketches of the whole composition, probably two out of a great many, survive. One, in the Louvre, has the ruined architectural complex (signifying the decay of the old, pagan order at the coming of Christianity) on the right of the picture. The other, in the Uffizi, is later and includes a camel that is absent in the final version, and the Egyptian (rather than Roman) tower. The Uffizi sketch is basically a working out of perspective, with the receding lines drawn in. The masterly assembly of ruined arcades,

Leonardo da Vinci

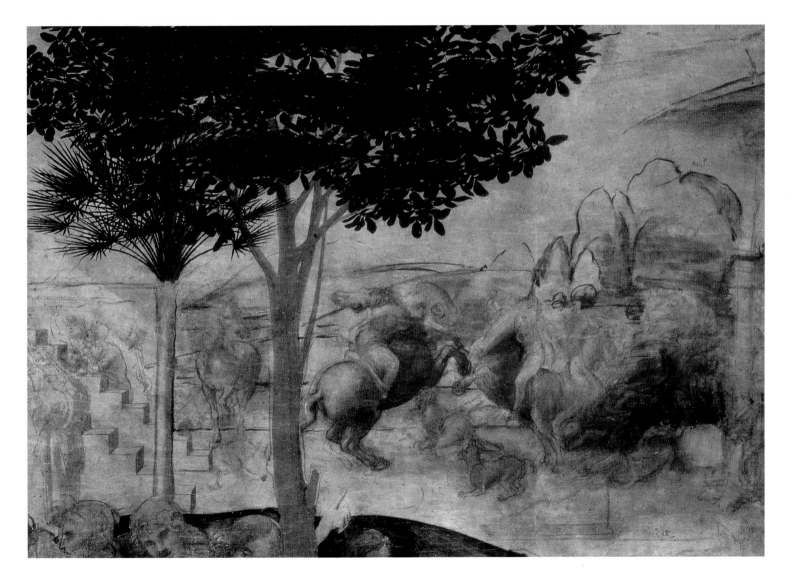

The Adoration of the Magi

Details of the background representing the violence and chaos of the dying world of paganism.

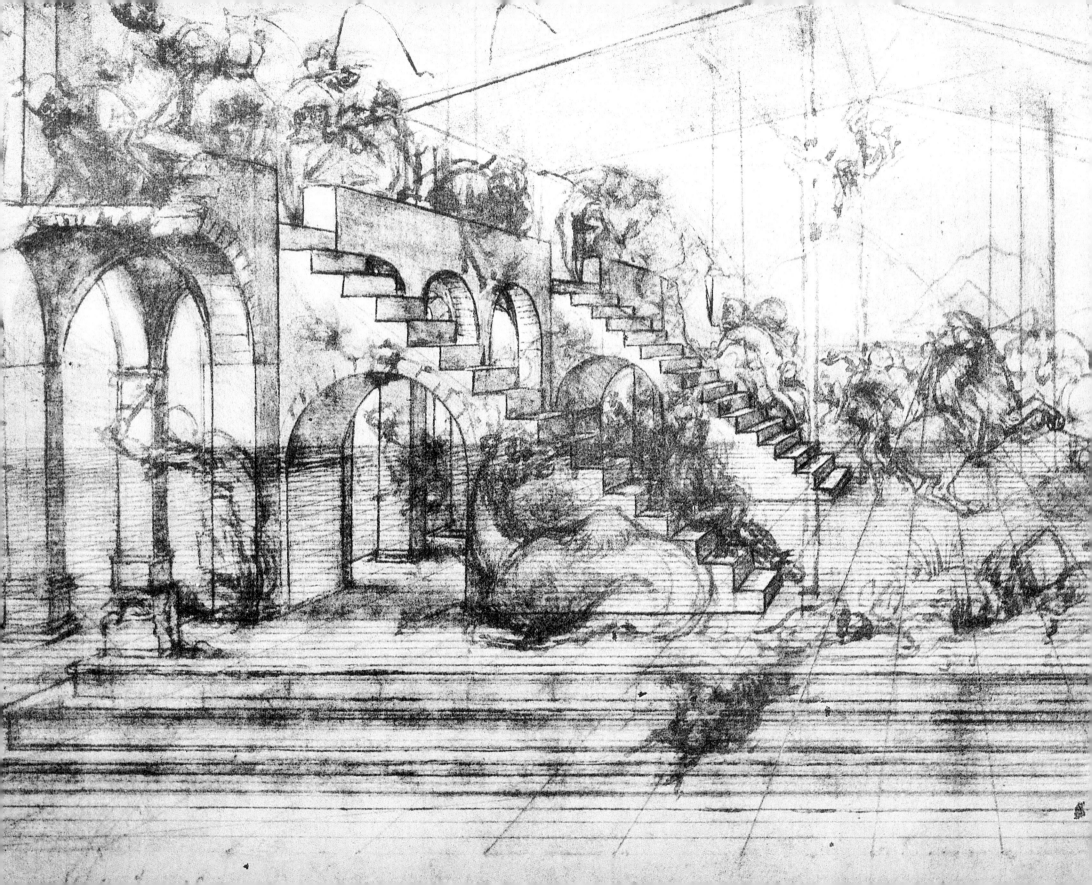

Leonardo da Vinci

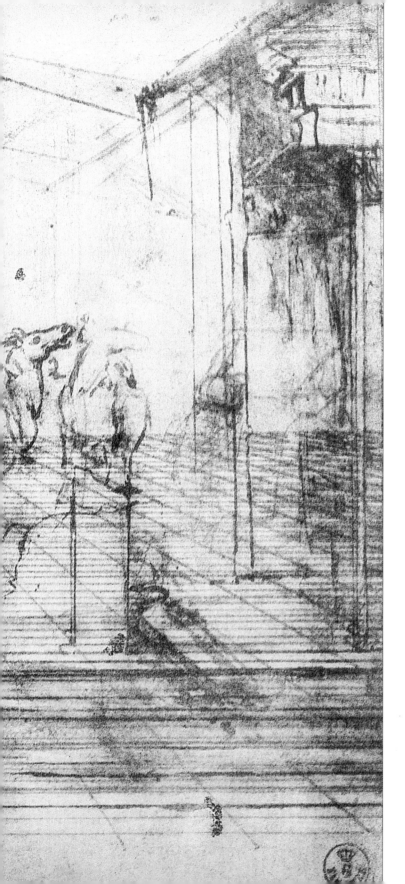

walls and exterior steps moves to the left, where it remained in the final version. But this orderly geometric exercise has been invaded by strange, ghostly figures, dissected by the lines of perspective, which race about in exaltation or excitement while horses rear and toss their heads. It is a dynamic yet dreamlike scene in which even the supine camel seems startled. Many of these figures reappear in the final version. Some may be angels or shepherds (Leonardo had made some studies for an *Adoration of the Shepherds* in 1478 for the altar in the Palazzo Vecchio), although in general they seem to have no specific relevance to the subject except as representing a primitive, pre-Christian society.

The composition of the *Adoration of the Magi*, which is almost a square format, is based on a triangle formed by the Virgin and the kneeling kings and is anchored by verticals – the two trees near the centre and the two standing figures at bottom left and bottom right. This is a typically strong structure, but around the ordered central group the animated, pagan mob and excited horses surge darkly in a disturbing, almost threatening

The Adoration of the Magi
Uffizi, Florence

Perspective study for the Adoration of the Magi. *In preparation, the work probably went through more changes than any other in Leonardo's career.*

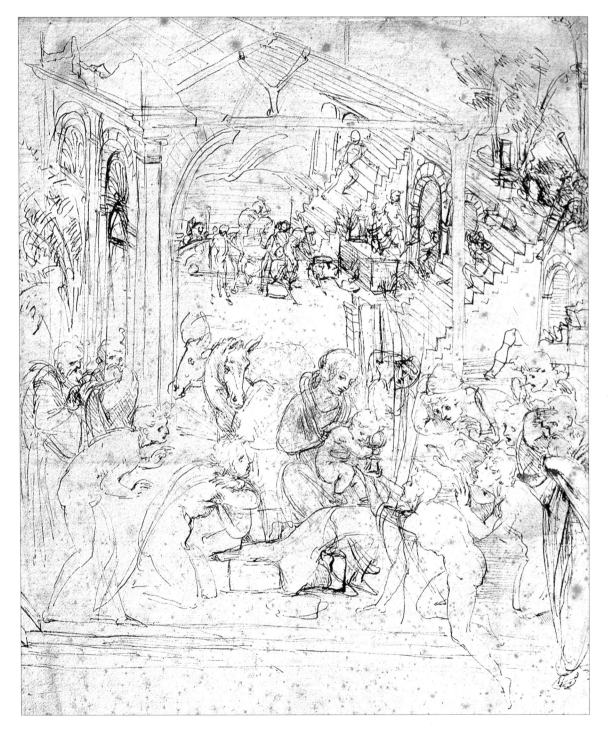

manner, while in the background, some sort of fight is going on. All this signifies the disorder and violence of the pagan world, in contrast with the central incident in which the Child, acknowledging the gift of one of the Magi, conveys a sense of calm, pious devotion.

Bernhard Berenson thought 'perhaps the quattrocento produced nothing greater' than Leonardo's *Adoration*. Kenneth Clark described it, over 60 years ago, as 'the most revolutionary and anti-classical picture of the 15th century' and an 'overture' to all Leonardo's oeuvre. He listed numerous expressions and gestures that can be related to works done 20 or 30 years later, and some more immediately familiar, such as the face of an old man who strongly resembles the Vatican's *St. Jerome*. One of the horses looks very like the horse in the statue of Colleoni on which Verrocchio was working at the time (page 117). We also find here, immediately to the right of the first tree, an early appearance of an uplifted, pointing finger, a gesture of which Leonardo was inordinately fond (and his imitators no less so).

The figure of the handsome young man at

bottom right, who turns away to look over his shoulder at something outside the picture, is of particular interest, as it is frequently described as a self-portrait. He belongs to the recognizable Leonardo type of the fair young man, and his position in the picture, plus his evident lack of interest in the subject, is in line with the contemporary convention of Renaissance artists who often included themselves in a crowd; but there is no other evidence that this is a deliberate likeness. The youth is balanced by the detached, philosophic figure (transmogrified from the now-banished figure of Joseph in the Louvre drawing) in the opposite corner, presenting a series of contrasts – youth and age, physical beauty and moral stature, action (the youth is in armour) and thought.

Time has made some of the dark parts of the *Adoration* difficult to 'read' (and notoriously difficult to photograph). News that the Uffizi planned to restore it recently caused an outcry from organizations such as Art Watch, which threatened legal action to prevent it being done without extensive consultation first and won support from many international scholars, including the late Sir Ernst Gombrich. After various scientific tests were carried out, the Uffizi announced early in 2002, to widespread relief, that the planned restoration had been abandoned. Restoration is always a controversial subject, and the conservation of Leonardo's paintings, few in number, many unfortunately in poor condition, and several damaged by insensitive earlier restoration, has provoked ferocious rows before. This will not be the last.

LEONARDO AND LORENZO

Among many obscure jottings in Leonardo's notebooks is one that reads, 'The Medici made me and the Medici destroyed me.' What this means is anybody's guess. It could be a quotation or an epigram, not referring to himself at all. The name 'Medici', which according to Leonardo's usual custom is not capitalized, may refer to 'doctors', the meaning of the word in Italian. Certainly he knew the Medici, although, as mentioned above, the evidence points to Giuliano rather than Lorenzo as the man most likely to have noticed his gifts, and Giuliano's death in the Pazzi plot removed a kindly

OPPOSITE
The Adoration of the Magi
*Compositional sketch, pen and ink
on paper
Uffizi, Florence*

To begin with Leonardo customarily drew human figures nude so that he could get the anatomy right beneath the clothes.

Study for *The Adoration of the Shepherds*

Pen and ink and metal point on paper
Musée Bonnat, Bayonne

This study was for an uncompleted painting commissioned for a chapel in the Palazzo Vecchio in 1478, a conventional composition that was probably Leonardo's starting point for the Adoration of the Magi.

influence. Florence was not a large city by modern standards (about 150,000 people), and the cultural-artistic circle was far smaller. Although, unlike Michelangelo, Leonardo was never, so far as we know, invited to live in the household of Il Magnifico, according to the Anonimo the young Leonardo was 'admitted to the company of Il Magnifico, who paid him an allowance and had him work in the garden in the Piazza San Marco' – this was the so-called 'sculpture garden' where classical sculptures were restored and young sculptors like Michelangelo trained.

Leonardo and Lorenzo, of similar age, had some things in common. Both were good musicians and good horsemen, both were lovers of beauty, both liked riddles, but in other respects they were unlike and, as we have seen, Leonardo was not fundamentally in sympathy with the courtly culture of Medici Florence.

But Leonardo was generally recognized as not only a charming and gallant, if faintly mysterious fellow, but also a young man of great gifts and, although it is true that Lorenzo never commissioned a painting from him, when did Lorenzo

Leonardo da Vinci

commission a significant painting from anyone else? He was no great admirer of painting and, unlike Leonardo, he certainly did not regard it as the highest of the arts. Possibly he was not an admirer of Leonardo's painting, as it developed, since he preferred the linear style, mythological subject matter and scholarly, humanist sympathies of a Botticelli or a Pollaiuolo.

Yet he valued artists, not only for their gifts but also, and perhaps not least, because they represented a valuable diplomatic asset. As everyone knew, great artists (in the broadest sense of the word) came from Florence, and therefore any ruler requiring the best decorators for his palace applied to Lorenzo, who was generous in lending them to courts from which he might expect benefits in return. Moreover, Florentine artists seem to have been more than ready to go, exchanging the tough, stimulating, intellectual edge of social and professional intercourse in the bottegas of Florence, where fellow artists did not mince words in discussing their work, for a more comfortable place where they would enjoy greater respect and reverence. Whether the move was always good for

Study of figures for The Adoration of the Magi
Pen and ink on paper
Louvre, Paris

The Castello Sforzesco, Milan

This grandiose structure, one of the most extraordinary monuments of the Renaissance, was started in the 14th century by Galeazzo II Visconti. In 1450 the condottiere *Francesco Sforza, after the fall of the Republic, took possession of the stronghold.*

their art is less certain, and many later returned, at least for a time, perhaps missing the stimulation.

In 1481 Verrocchio was in Venice working on the Colleoni statue. In Rome, Pope Sixtus IV, now reconciled with Lorenzo, sought Florentine artists to decorate the chapel in the Vatican that is now named after him. The papacy was the most lavish patron and at the same time Rome was full of reminders of the great civilizations that the Renaissance so much admired. Hence its attraction. Leonardo was less enthralled than some by classical remains, though he was not indifferent to them, indeed he studied them and admired them for their realism, and he may well have hoped for an invitation to the Eternal City. Botticelli went, so did Perugino, Ghirlandaio, Pollaiuolo and several others, but Leonardo's name was not among those recommended to adorn the Vatican.

Did Il Magnifico think the 'unlettered' Leonardo would not do him credit? Did he dislike him, or just forget about him? Or did he already have other plans for him? And did he consider that his greatest talent lay elsewhere than in painting.

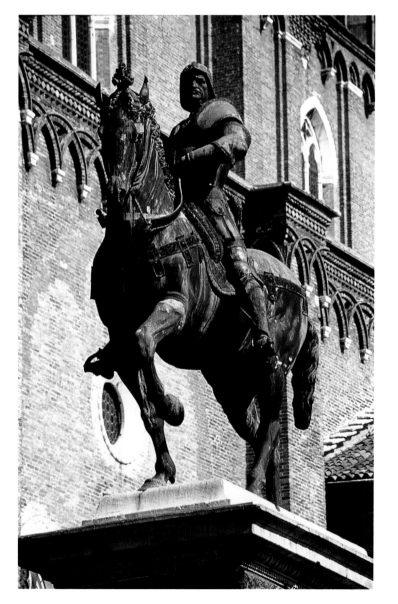

Equestrian monument of Bartolommeo Colleoni, by Andrea del Verrocchio *(1481)*
Campo di SS. Giovanni e Paolo, Venice

It is said that when Renaissance artists debated the relative merits of painting and sculpture, the Colleoni statue was cited as an example of sculpture's superiority as an art form.

Chapter Four
Milan
1482–99

Milan, capital of Lombardy, whose plains had attracted many invaders over the centuries, was the most substantial state in northern Italy and the city itself was one of the largest in Europe, exceeded only by London and Paris. Its wealth depended on trade (though the duchy had no port it had access to Genoa), more particularly on the taxes on trade that filled the government's coffers. At one time it looked as if Milan, under the Visconti, might come to control the whole peninsula, being challenged only by Florence. In the early 15th century, circumstances were less favourable, due to the hostility of Venice, but Milan was still a formidable military and economic power.

Its main weakness was that it could not be called a 'national' state; no European country could truly be described as a 'nation' in the 15th century, but the lesser towns and cities of the duchy had nothing in common with the city of Milan except that they happened to be ruled by the same lord. If the Visconti duke's grip on Milan weakened, the lesser towns would follow their own path, often

under the leadership of one of the duke's generals, and the fact that they were invariably sharply divided in themselves introduced further complications. One of these periods of strife occurred between the death of the last Visconti duke and the establishment of the rule of Francesco Sforza.

THE SFORZA DUKEDOM

The Sforza were an old family of warlords who held lands in the Romagna and the kingdom of Naples in the early 15th century. Alessandro Sforza became ruler of Pesaro in the Papal States, while his brother, Francesco Sforza (1401–66), moved north and entered the service of the last of the Visconti dukes of Milan. Although, in the course of two decades, he was against him almost as often as he was for him (at one time he was imprisoned for treason), he married the duke's illegitimate daughter and only child (she was aged eight at the time), and clearly had hopes, if not promises, of inheriting the duchy. When the duke died, he proved not to have named Sforza as his heir, but Francesco, who

by this time controlled considerable lands himself, eventually gained Milan anyway (1450), albeit more by force of arms than by right of inheritance.

Sforza rule may have been tyrannical but it was not unpopular:

'Never was the triumph of genius and individual power more brilliantly displayed than in [Francesco Sforza]; and those who would not recognize his merit had at least to honour him as Fortune's favourite. The Milanese avowed it an honour to be governed by so distinguished a master; when he entered the city the thronging populace bore him on horseback into the cathedral...' (Burckhardt, The Civilization of the Renaissance in Italy*)*.

Francesco's court was rich and cultured, open to the new Humanist education. His successor, Galeazzo Maria, was an equally cultured man, a patron of arts and literature, who encouraged rice-growing, mining and the silk industry. But he was also capricious, given to fits of extreme cruelty, and altogether lacked his father's popular appeal. He was assassinated in 1476. His heir, Gian Galeazzo (1469–94) was only seven years old and, as he

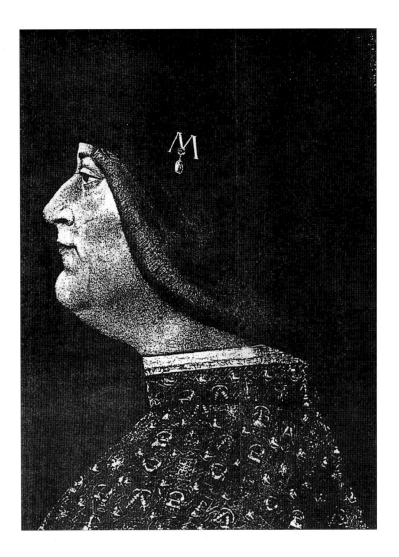

Lodovico Sforza, Duke of Milan, by Boltraffio
Trivulzio Collection, Milan

Lodovico was also known as 'Il Moro' for his dark Moorish features.

Galeazzo Maria Sforza,
Duke of Milan,
by Antonio del Pollaiuolo
Uffizi, Florence

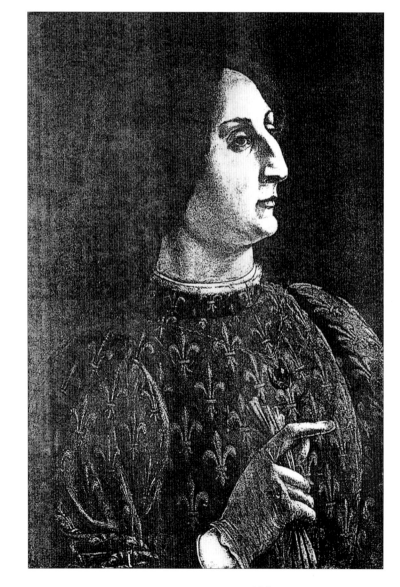

grew older, proved frail in both body and spirit. After a regency dogged by conspiracy and conflict, which permanently weakened ducal authority, by 1480 power had effectively passed to the boy's uncle (a younger son of Francesco), Lodovico Sforza (1451–1508), known as 'Il Moro' because of his dark, 'Moorish' complexion.

Il Moro, one of the most famous of the Renaissance princes, was determined to establish his own line as dukes of Milan. He finally achieved that when, on Gian Galeazzo's death in 1494, he was invested with the title by the Holy Roman Emperor, Maximilian I, and was popularly elected soon afterwards as their duke by the people of Milan, even though he had been de facto ruler since 1481. His triumph would not last long, and his downfall (1499) was partly the result of his own efforts to preserve his power in Milan. His diplomatic stratagems, designed to strengthen his control of Milan, encouraged the fateful invasion of Italy by Charles VIII of France in 1494, the beginning of the long series of wars in which the Italian states, Milan especially, became

the prey of the great powers beyond the Alps.

The court of Lodovico Sforza, said to have been the most brilliant since the demise of medieval Burgundy, was greatly enhanced by the addition of many distinguished people from elsewhere, though few of them are now well-known names. Two were of particular interest. One of these was Beatrice d'Este, a vivacious young woman of formidable capacity and keen ambition, equally ready to take a leading part in a pageant or a stag hunt. Lodovico married her in 1491, when she was 16. The other was Leonardo da Vinci, who arrived at the Sforza court probably at some time in 1482. The presence of each represented the remarkable frequency with which the Italian states exchanged both brides and artists.

Why did Leonardo decide to leave Florence for Milan? There are good reasons for thinking that by 1481 he was deeply dissatisfied with his life in Florence, and was undergoing some kind of personal crisis. Though his gifts were admired, he had also suffered criticism, which he never took kindly, and he may have resented not being among

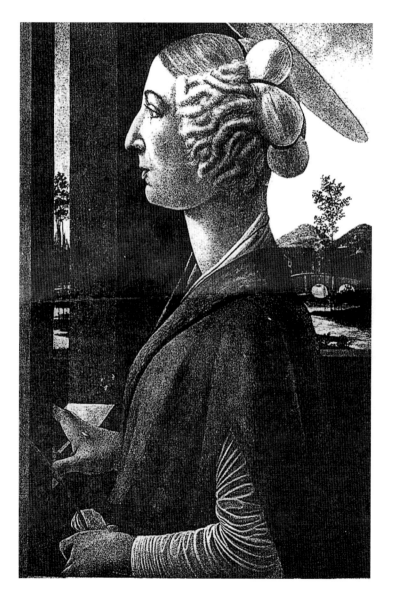

Caterina Sforza, by Botticelli (or Piero di Cosimo)
Altenburg Museum

Daughter of Galeazzo Maria Sforza and wife of Girolamo Riario.

Head of a woman with tousled hair

Gouache on wood
Galleria Nazionale, Parma

It has been suggested that this work is a study for Leonardo's Leda, *though this is not certain.*

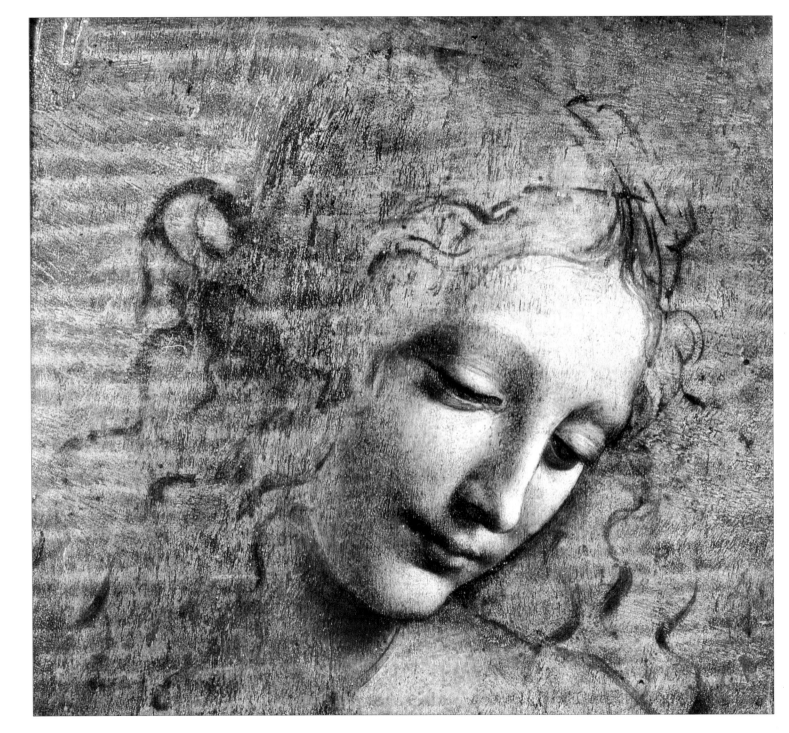

Leonardo da Vinci

the Florentine painters chosen for the Sistine Chapel. He was out of sympathy with the Neo-Platonist culture of Medici Florence, frustrated and irritated when any contribution he might make to an intellectual discussion would be devalued to his hearers as that of a man deplorably ignorant of 'letters'. It was only after he had settled in Milan that he taught himself Latin and thus opened his powerful intellect to a wealth of learning that was not at that time available in another language. It is often assumed that he was underestimated by the literary Lorenzo de' Medici, whose view of the visual arts seems to have placed sculpture as superior to painting – the reverse of Leonardo's opinion.

There may have been other reasons. Of course, Leonardo may have had some personal reason to make a break of which we know nothing, but we do know that, in the autumn of 1481 the monks of San Donato ceased to make the regular payments for work on the *Adoration of the Magi* and we can be reasonably sure that the reason was that Leonardo had stopped working on it. There were

also other projects with which he may have wished to sever his connection. It is possible, for example, that he reached a similar impasse with the *St. Jerome* about this time, and then there was his commission from the Signoria for an altarpiece in a chapel of the Palazzo Vecchio, signed in January 1478, which seems to have got nowhere. Like the Scopeto altarpiece, it was eventually completed by Filippino Lippi although, since several other painters after Leonardo had failed to deliver, the contract may have been an unsatisfactory one.

If asked, Leonardo would probably have gone to Rome to work for Sixtus IV. That he chose to go to Milan was no doubt because he needed to leave Florence and Milan offered an attractive, though perhaps unexpected, alternative. It turned out to be a good move, for he would stay there for nearly two decades, and then leave only because of the pressure of public events. Moreover, those two decades were to be among the most productive periods of his life.

Leonardo was not by nature attuned to the businesslike way in which art was commissioned,

Study of a child's head

Red chalk heightened with white on paper

Musée des Beaux-Arts, Caen

One can imagine how Leonardo rejoiced in that luxuriant head of hair.

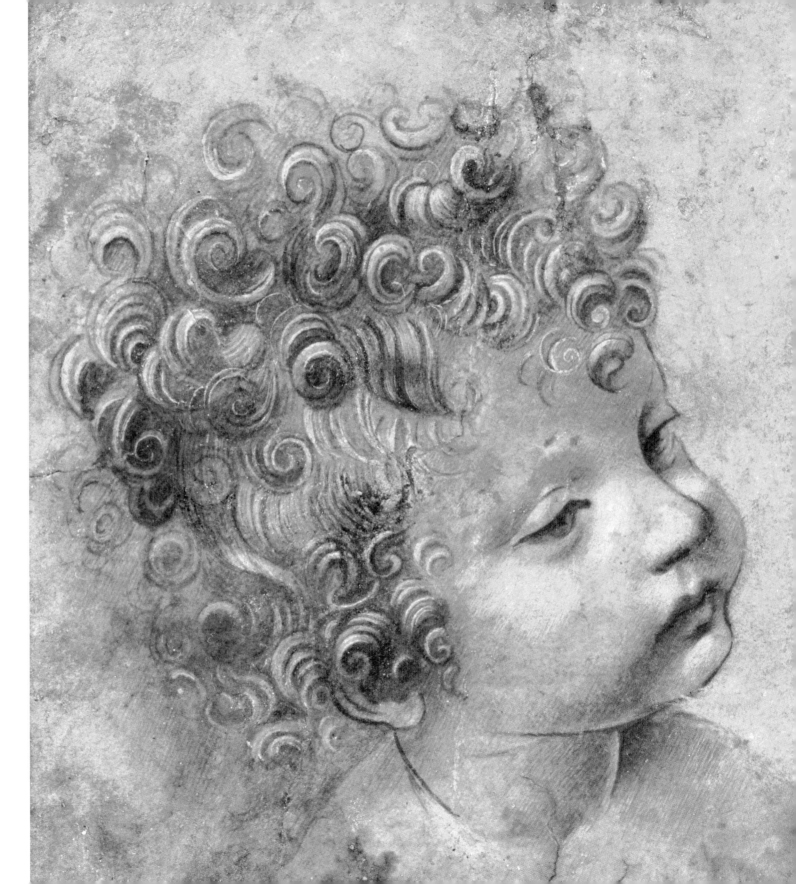

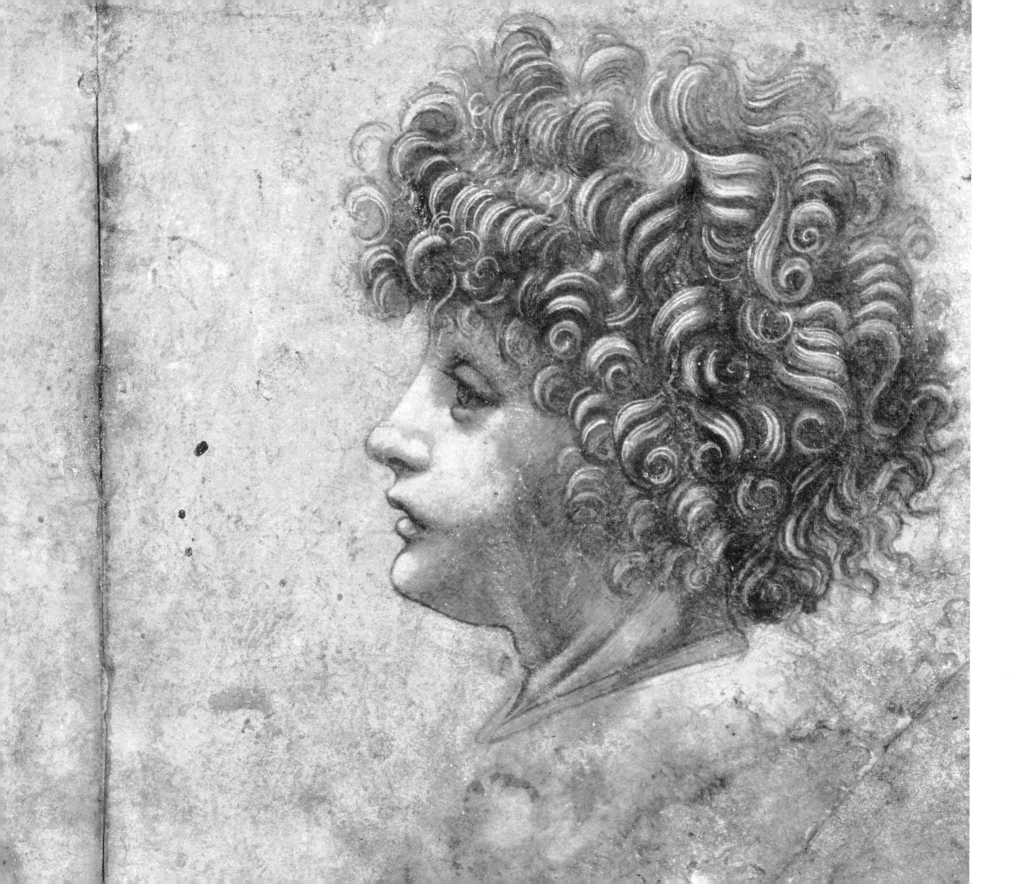

produced (on time!) and paid for (less promptly sometimes) in Florence. He required a reliable and generous patron who allowed him time and opportunity for his many interests and enterprises. Lodovico Sforza probably came as near to that ideal as anyone could reasonably expect, paying him a salary as a court employee but allowing him to take up private commissions. Though it is unlikely to have had any influence on his decision to move, the cultural atmosphere in Milan was perhaps more sympathetic to Leonardo's eclectic temperament and encyclopedic interests, being broader, more Aristotelian in the medieval tradition, than the devoted Platonism of Renaissance Florence.

Lodovico's efforts to turn Milan into a 'new Athens' resulted in Leonardo meeting many gifted people there – architects, engineers, mathematicians, physicians – but, significantly, few painters of the highest rank. He had left a city in which brilliantly talented artists, many with reputations on a level with or above his own, probably formed a larger proportion than in any other place at any other time. He had come to a city, larger, equally ambitious and no less rich, that had plenty of artists but none of

much importance, except Bramante. As a painter, Leonardo would have no peer and, although he cared remarkably little for fame and even less for money, this was a situation that anyone would have relished. Moreover, the variety of work available to him in other fields in Milan would be much greater.

The Anonymous Florentine and Giorgio Vasari give similar accounts of how Leonardo happened to go to Milan, at the invitation of Lodovico Sforza. 'Leonardo was invited to Milan with great ceremony by the duke to play the lyre, in which that prince greatly delighted. Leonardo took his own instrument, made by himself in silver, and shaped like a horse's head, a curious and novel idea to render the harmonies more loud and sonorous…'. (So says Vasari who, however, gives a date for Leonardo's arrival that is several years out.)

Leonardo was apparently accompanied by another musician, a young (16 years old) man called Atalante Migliorotti. It is also said that Lorenzo de' Medici originally recommended him to his ally, who had passed on a request for a musician. Leonardo could hardly have gone against Lorenzo's wishes. But the suggestion, advanced by some writers, that

Leonardo da Vinci

Lorenzo's willingness to let him go is evidence of his failure to appreciate Leonardo's talents is unjustifiable: as we have seen, it was Lorenzo's policy to employ his large stock of outstanding artists for diplomatic advantage, and the frequency with which Florentine artists ever since Giotto had left their native city for work elsewhere is striking. Recommending Leonardo to his fellow ruler did not betray his willingness to get rid of him, it was more likely a testament to his genuine regard for Leonardo's abilities.

It is a surprise to find Leonardo apparently valued above all else as a musician, but, historically, music is an art that tends to get short shrift by comparison with the visual arts, for the obvious reason that we cannot hear it. But of course Leonardo had other gifts to offer, and there is a letter surviving (perhaps never delivered), addressed to the illustrious Sforza ruler (not yet officially duke), which suggests a different version of events leading to his employment in Milan. The letter, which is written in another hand but is generally accepted as genuine, amounts to something like a job application, and lists the applicant's assets.

'Most Illustrious Lord' (always difficult to know how to address a ruling despot), the letter begins, 'having studied the work of [the] masters and makers of instruments of war … I submit to your Lordship my secret inventions…'. Leonardo apparently sees his ability as a military engineer (evident in drawings of weapons dating from before his departure from Florence), though as yet untested, as likely to prove of greatest use in a warlike state such as Milan, and he goes on to list numerous offensive and defensive devices that he is willing and able to construct. Nearly all of them appear in later drawings. He continues with what he might do 'in time of peace', which includes designing buildings, conduits and bridges. Coming at last to the visual arts, 'I can make sculpture in marble, bronze or terracotta…'. According to the Anonimo, Lorenzo de' Medici employed Leonardo as a sculptor, and although nothing by his hand has survived we have seen possible evidence of his work in San Lorenzo, and we can be sure that he was responsible for other such work in Verrocchio's workshop and later. Regardless of the low opinion of sculpture that he was more than

once to express, two of his greatest projects, though unrealized, were for bronze statues.

Tacked on to his qualifications as sculptor, almost as an afterthought, is the phrase, 'and in painting I can do as well as anyone'.

Finally he says, 'I can undertake to work on the bronze horse, … a monument … to the honour of the Prince your father.' He refers to an equestrian statue of Francesco Sforza that Lodovico wanted, a project that, as we shall see, would occupy much of his time, though not, in the end, very profitably.

The letter is 34 lines in length, of which just six mention Leonardo's capacity as an artist – a proportion that posterity would find startling. No doubt Leonardo was tailoring his talents to what he believed to be Lodovico's particular concerns. But to some extent, surely, he was presenting his own view of his capacities, and our surprise is the result of our conception of the overwhelming significance of art in Renaissance Italy, by comparison with which the incessant wars of the Italian states seem, to us, rather mundane. To contemporaries, things looked different.

AT THE SFORZA COURT

We do not know exactly when Leonardo arrived at the Sforza court. The first documentary evidence of his presence there is not until April 1483 (the date of the contract with the Confraternity of the Immaculate Conception, discussed below), but the likelihood is that he left Florence some time after September 1481 and was probably in Milan about a year earlier than the date of the contract. (Although Lodovico was interested in this newly founded religious order, it is intrinsically unlikely that Leonardo's first job in Milan would be for a private contract.)

Whenever he arrived, we can be sure that he was warmly welcomed. Barely 30 years old and still handsome, his natural courtesy and charm, enhanced by his slightly mysterious reserve, made him an asset even to the splendid court of Milan, grander, even, than that of the Medici, quite apart from the manifold gifts he had listed. 'The court,' wrote Cecilia Ady in her account of Milan under the Sforza, 'hung upon his fables and satires; his epigrams were on every one's lips.' We are told also that he 'joined in the conferences upon philosophy

and literature conducted by Il Moro and other kindred spirits of the Court', though this can hardly apply to his early years in the city.

He made many friends. Among them – though he did not arrive in Milan until some years later – was the mathematician Luca Pacioli, who sparked his consuming interest in mathematical problems. Fra Luca, a Franciscan, was author of a book on mathematics that is said to contain the first printed description of double-entry bookkeeping (although the practice was certainly at least 100 years old), and Leonardo worked with him on his *De Divine Proportione*, designing the plates and earning a fulsome tribute from his friend in the preface, though there is no justice in the accusation of Vasari, who believed Leonardo was cleverer than anyone, that Pacioli stole his ideas from Leonardo. Like any Renaissance artist, Leonardo had a reasonable grasp of geometry, but the importance he placed on 'mathematics' ('Let no one read me who is not a mathematician') should be interpreted in a more general sense, meaning logic, discipline, the scientific approach. Nevertheless, a year or two after Pacioli's arrival in Milan, mathematical problems

begin to figure prominently in Leonardo's notebooks, and he was playing with geometrical puzzles at the very end of his life.

Galeazzo Sanseverino, the highly regarded and personable Milanese military commander (and Lodovico's son-in law), consulted him on military matters and employed him on designing the costumes for a tournament (won, to no one's surprise, by Sanseverino himself). Pageants and other entertainments were a major feature of court life in the Renaissance, and probably took up a great deal of Leonardo's time. Since by their nature such events are ephemeral, we know little about them, but there is every reason to suppose that Leonardo enjoyed this side of his duties, which gave full rein to his imaginative ingenuity and love of play.

Isabella of Aragon arrived in Milan early in 1489 to wed Lodovico's nephew, Gian Galeazzo, then about 20 years old and officially duke of Milan, though a feeble figure (he was apparently unable to consummate the marriage – the bride's father accordingly withheld her dowry). The extensive festivities were largely overseen by Leonardo. They

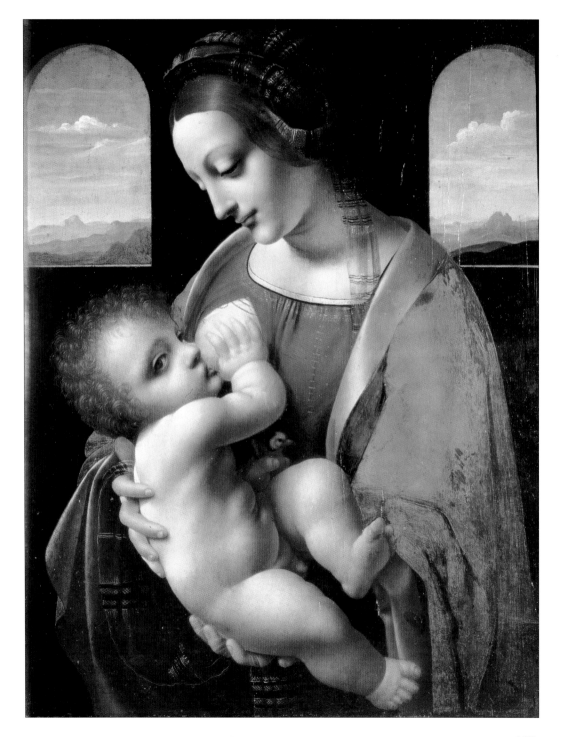

included a banquet at which the food was presented by servants and courtiers dressed as characters from classical mythology. The fish was served by naiads (water nymphs), roast birds were dished up by Orpheus. A masque was specially written for the occasion by the court poet, Bernardo Bellincione, and 'produced' by Leonardo.

Two years later, more festivities, including Sanseverino's tournament and an even more elaborate masque employing illusionistic effects (Leonardo had recently embarked on his work on optics), were required for an even bigger marriage, of Lodovico himself to Beatrice d'Este. There is little sign of such activities in Leonardo's notebooks, and no doubt his plans were submitted in draft to the craftsmen charged with putting them into effect and as a result disappeared. We hear occasionally of his ingenious toys, like the mechanical lion (symbol of Florence) made to welcome the King of France many years later, which advanced a few paces, then stopped, whereupon a panel opened in its chest to reveal lilies (fleur-de-lys, badge of the French monarchy). He is said to have made many such clockwork animals.

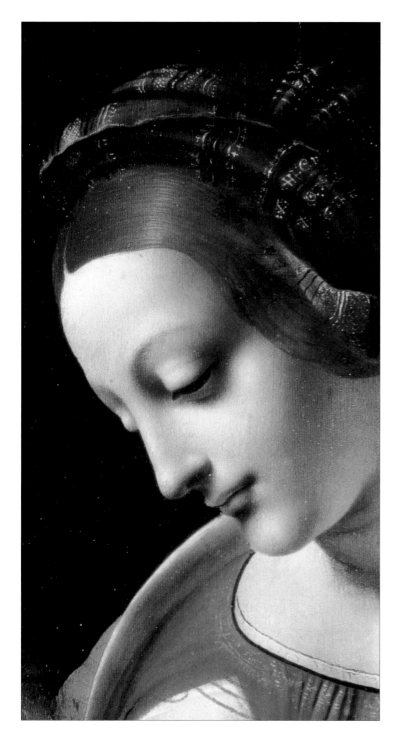

The Madonna Litta (c.1482)
Hermitage, St. Petersburg

The Madonna Litta probably dates from soon after Leonardo's arrival in Milan, but his actual input is a matter for argument. Basically, the painting is more Florentine than Milanese, but much of the actual painting seems to be in another hand than Leonardo's, probably that of Ambrogio da Predis, and it was perhaps repainted when it was transferred to canvas in the 19th century. The question who did exactly what is more important to us than it was to contemporaries.

SALAI

In 1490 Leonardo made a note: 'Giacomo came to live with me on the feast of St. Mary Magdalene [22 July] of the year 1490, being ten years old.' The boy, called Salai (apparently a nickname meaning, roughly, 'little rogue'), was described by contemporaries as his servant – quite legitimate at ten years old – or pupil, and he appears to have been something of both. Vasari also tells us that the boy, presumably a poor Milanese, was very beautiful, with the mass of curly blond hair that Leonardo admired, and, if the boy is the subject, as seems likely, certain sketches by Leonardo bear out this description: they are in fact reminiscent of supposed drawings of himself as a youth. No doubt Leonardo's attraction to him was predominantly sexual.

If, indeed, he had been merely a servant, his employment would have soon terminated. For he was an inveterate thief and liar, who caused his master no end of trouble. On his second day in the house, Leonardo ordered him some clothes, but Giacomo stole the money he put away to pay for them, then denied doing so. A day or two later, when Leonardo was dining with a friend, Giacomo reduced the occasion to anarchy by misbehaving, breaking three vessels, spilling the wine, and finally being banished to finish his meal elsewhere. Another of Leonardo's pupils lost a valuable silverpoint pencil (the 'lead' being made of silver wire – this was an instrument capable of beautiful effects, as Leonardo demonstrated). It was eventually found in Giacomo's possession. 'Thief, liar, pig-headed glutton!' Leonardo raged to his notebook.

A surely unsatisfactory servant, he was not much better as a pupil. In spite of Leonardo's efforts, he never manifested any talent for art, and the few drawings said to have been by him strike most who have seen them as owing more to his master's hand than his own.

Presumably, Salai's behaviour improved as he grew older, though he was still difficult. Without much evidence one way or the other, it would be unjust to dismiss him as a worthless oaf. He would not be worth mentioning but for one remarkable fact. From the feast of St. Mary Magdalene in the year 1490, until not long before Leonardo's death nearly 30 years later, the two were seldom separated.

Leonardo da Vinci

THE MADONNA LITTA

Leonardo was certainly the greatest artist in Milan, but he was not the only one. He had several colleagues as well as pupils, and sometimes co-operated with them. Ambrogio Preda, or da Predis, was one of the first, if not the most brilliant. Since he was about the same age as Leonardo, he was a mature artist, but he was nonetheless influenced by the Florentine master and his name is remembered largely for his association with Leonardo. He has been mentioned as a possible co-worker in several paintings or the actual author of several works sometimes attributed to Leonardo.

The former include the *Madonna Litta*, named after earlier owners, a Milanese family, which is now in the Hermitage (there are other, inferior versions elsewhere). Possibly dating from about 1482, this is a picture that has troubled the scholars. The near-profile pose of the Virgin is Florentine, not Milanese, and this may be the painting referred to in a letter from Gian Galeazzo Sforza to the King of Hungary in April 1485, promising to send the King a Madonna by a 'wonderful' painter (not mentioned by name)

who was currently in Milan. It also sounds like the description of a painting seen by a member of the distinguished family of the Contarini in Venice nearly 60 years later. Its high colours and oily-smooth handling have led some to deny outright that it is a Leonardo, though there is a beautiful, silverpoint study of what seems to be the head of the *Madonna Litta*, dating from about 1480, in the Louvre. In the painting though, another hand, or hands, seem to have been at work.

The most convincing hypothesis, though not universally accepted, was put forward by Kenneth Clark, who claimed the picture, probably left unfinished by Leonardo, was finished by a Milanese artist a dozen years later (others have suggested this was Ambrogio da Predis) and again repainted in the 19th century when it was transferred from the original wood panel to canvas. Leonardo himself referred to a 'partly finished' Madonna in profile, which must be this one, and Clark suggests that the Virgin's head and perhaps part of the Child's body were finished by Leonardo while the Child's ginger-mopped head, which is certainly Milanese, and the

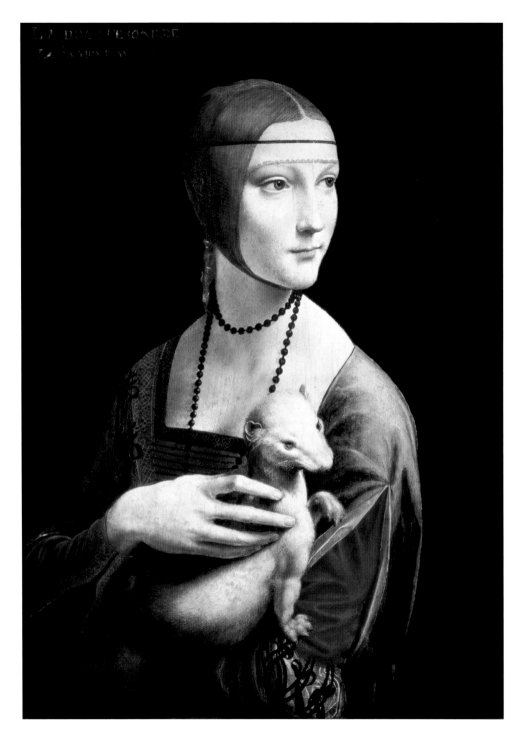

costume and background details were left by Leonardo at a preliminary stage.

THE LADY WITH AN ERMINE

The trouble with a despot is not just that he is above the law but that, whatever he says, he really believes that legality and morality are codes to govern the behaviour of others, not him. Thus even the most benign of dictators at some time proves capable of terrible deeds, especially when dealing with challenges to his power. As Machiavelli would have pointed out, it is often necessary for a ruler to be ruthless, and it is not surprising that Il Moro was suspected of causing the death of his nephew Gian Galeazzo, which allowed him to become duke. On that charge, if not others, he was probably innocent, or at least not directly guilty: he certainly encouraged Gian Galeazzo's dissipated life style, which no doubt contributed to his death at 25. It is ironic that Gian Galeazzo seems to have been devoted to his vastly more formidable, usurping uncle.

Regardless of the Church's teaching, Lodovico did not consider himself confined to one woman – he was hardly unique in that – and although genuinely

Leonardo da Vinci

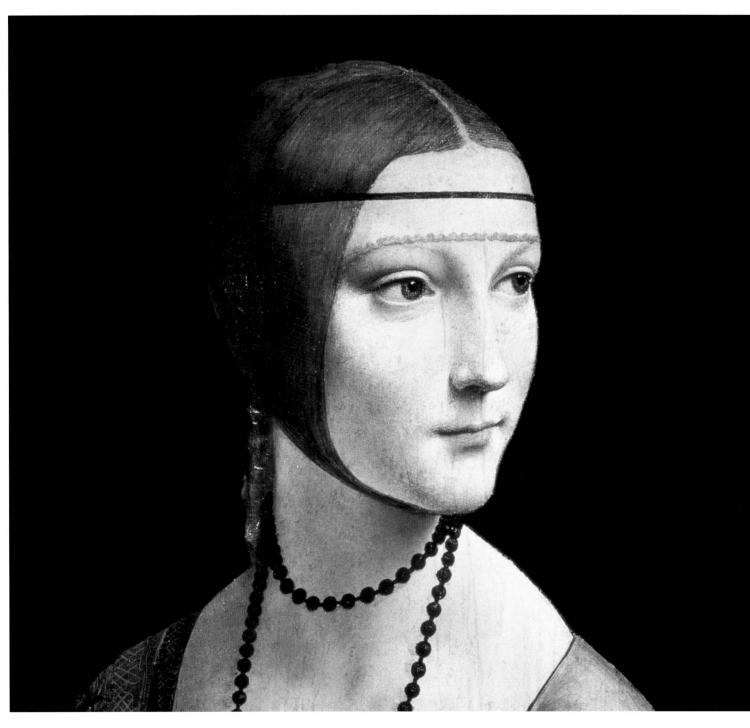

The Lady with an Ermine
1483–90
Oil on wood, 21 x 15¹/₂
(53.3 x 39.4)
Czartoryski Museum, Cracow

Another of Leonardo's wonderful portraits of women. She is generally identified with Cecilia Gallerani, mistress of Lodovico Sforza, and known to have sat for a portrait by Leonardo. Like most of Leonardo's paintings, it has suffered considerable damage and parts seem to have been repainted, creating oddities like the hair that appears to be somehow fixed under the chin; but there is quite enough to prove that this half-length portrait is his, notably in the ermine itself – an example of Leonardo's profound sympathy for animals.

LEFT
Detail of the head. The slightly disconcerting second band across the forehead relates to what was originally a veil, clumsily retouched.

delighted with his teenage wife, he saw no reason to abandon his mistress. In fact, this association caused the d'Este wedding to be delayed several months, but the contest between wife and mistress ended, as it was bound to, with the victory of the wife. Three months after the wedding, Beatrice's rival, provided with a husband, not to mention a son by Lodovico, left the court. (In due course Lodovico took another mistress.)

The name of the mistress whom Beatrice ousted was Cecilia Gallerani. She was in place by the end of 1481, before Leonardo arrived in Milan and long before Beatrice appeared on the scene. Cecilia, who was as accomplished as she was beautiful, enjoyed an exalted position at court. Poets praised her, and Leonardo was asked to paint her portrait.

The picture, sometimes called *Lady with an Ermine*, and now in Cracow, is perhaps Leonardo's finest female portrait, with the obvious exception of the *Mona Lisa*, and further evidence of his affinity for female subjects. He clearly liked this girl, as he liked La Gioconda (both of them rather more, we may guess, than he liked that tough cookie, Ginevra de' Benci). Identification of the sitter is confirmed by the ermine, a creature whose name in Greek is a near-pun on Gallerani and was also associated heraldically with Lodovico Sforza. Bellincioni, who died in 1492, refers to the picture in a poem, and it is mentioned again in a letter of 1498 from Isabella d'Este (sister of Beatrice and wife of the Gonzaga duke of Mantua), who asked to borrow it in order to compare it with works of Giovanni Bellini. Cecilia was reluctant to send it, though she apparently complied, explaining that she no longer looked like that. Indeed, the picture may have been about 13 years old at that date, although many scholars put it somewhat later.

Naturally, the painting is not in mint condition, though better than many, and some parts appear to have been repainted. Kenneth Clark considered that the ermine and the sitter's face and hands are self-evidently Leonardo, and especially the ermine: 'The modelling of its head is a miracle; we can feel the structure of the skull, the quality of skin, the lie of the fur. No one but Leonardo could have conveyed its stoatish character, sleek, predatory, alert, yet with a kind of heraldic dignity.' There is a touch of genius also in the pose – half-length, informal – which is

Leonardo da Vinci

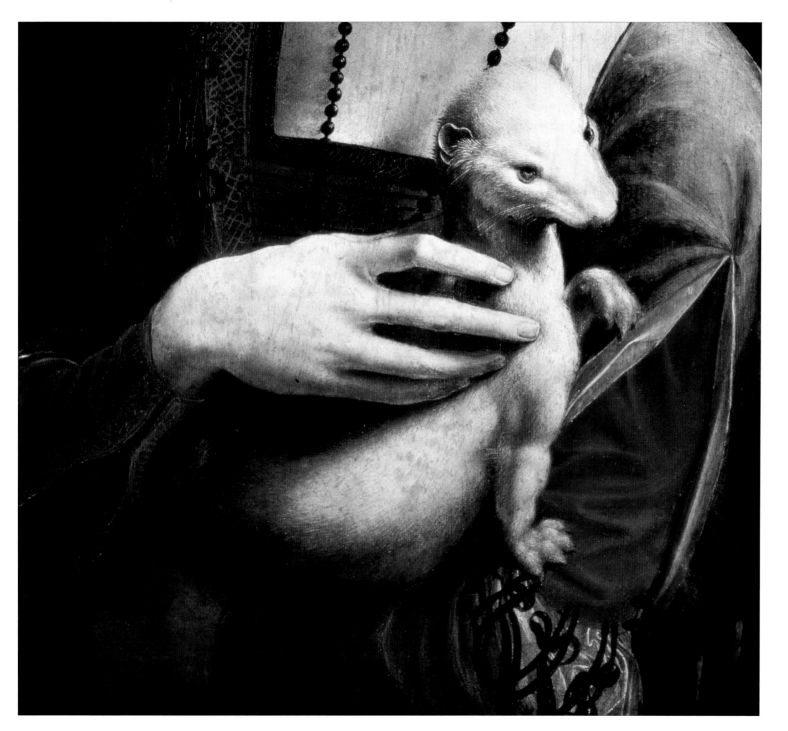

The Lady with an Ermine
(detail)

The subject's left hand has apparently been painted out.

La Belle Ferronnière (c.1490)

Oil on wood panel, 24¾ x 17¾in

(63 x 45cm)

Louvre, Paris

This owes its name to mistaken identity, and although the subject is not the French royal mistress who bore that appellation, but undoubtedly a lady of the Milanese court, no one is sure who she is. Most modern scholars agree that the painting is probably by Giovanni Antonio Boltraffio, far the most talented of Leonardo's Milanese pupils, no doubt with touches by the master and probably to his design. Incidentally, if the sitter is, as sometimes suggested, Lucrezia Crivelli, mistress of Lodovico from about 1495, that would tend to identify Leonardo as the painter, for we know for certain that he did paint that lady.

quite new, and led Cecil Gould to suggest that this picture 'might claim to be the first modern portrait'.

LA BELLE FERRONNIÈRE

Other portraits of the 1480s contain no hints like the ermine or the juniper bush, and their subjects are as uncertain as the identity of the artist. The portrait in the Louvre generally called *La Belle Ferronnière*, nickname of a French king's mistress, derives its name from some ancient clerical error. She is clearly a young lady of the Milanese court, but who? Many names have been suggested, including Lucrezia Crivelli, who became Lodovico's mistress in 1495. Leonardo is known to have painted Lucrezia's portrait, but it seems unlikely that this is it. The candidate most widely favoured is Lodovico's wife, Beatrice d'Este, although it does not look especially like another, certain portrait of her in Milan and the pent-up expression does not agree with what we can gather, through written evidence, of Beatrice's frolicsome personality. Nor is she dressed like a Renaissance princess.

More important is the question whether

Leonardo painted it. Most modern scholars whose eyes can penetrate the dark obscuring varnish would agree that, as a whole, the painting is not up to his standard, although he may have contributed, for instance to the face, which examined in enlarged photographs shows some of the fine modelling and delicate touches of the *Mona Lisa*. Otherwise, the most likely attribution is to Giovanni Antonio Boltraffio (1467–1516). Boltraffio, who came from a good family, was the most gifted of Leonardo's pupils in Milan, the only one to establish a lasting reputation as a mature artist. He seems to have spent all his working life in Milan, but today there are examples of his works, chiefly portraits and religious subjects, in many international galleries, often showing, in a downbeat way, the influence of his Florentine master.

One reason for our relative ignorance of the Milanese school in general is that so many pictures were unsigned. Thus, another portrait attributed to Leonardo has also been associated with Boltraffio, or alternatively with Ambrogio da Predis. This is the

charming portrait of a young woman in profile, now in the Pinacoteca Ambrosiana, Milan. Gould suggested that the subject is the same as the *Lady with an Ermine*, that is, Cecilia Gallerani, and she has also been identified with Bianca Maria Sforza, Lodovico's niece, but the most common assumption is that this is Beatrice d'Este, probably at about the time of her marriage to Lodovico Sforza. At one time the picture was apparently framed together with Leonardo's painting, *A Musician*, which was at the time alleged to be a portrait of Lodovico.

The profile portrait was de rigeur for women in Florence in the 15th century and there are plenty of such portraits among Leonardo's drawings, though not paintings. Nevertheless, Clark, declaring that this painting 'is certainly not by Leonardo', ascribed it to Ambrogio da Predis on the evidence of the 'old-fashioned' pose, which is adopted in other portraits linked to him. One objection is that the painting is of higher quality than other known works of his, and the force of this is not entirely negated by the supposition that Predis painted it under the close supervision of Leonardo, who

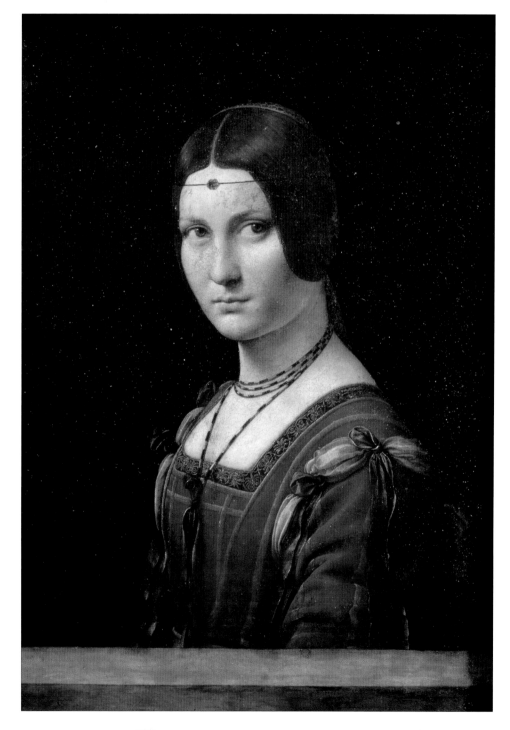

Portrait of a Lady, by Giovanni Antonio Boltraffio
Private Collection

This potrait by a follower of Leonardo in Milan closely follows the style of his master and is reminiscent of La Belle Ferronière *in its treatment.*

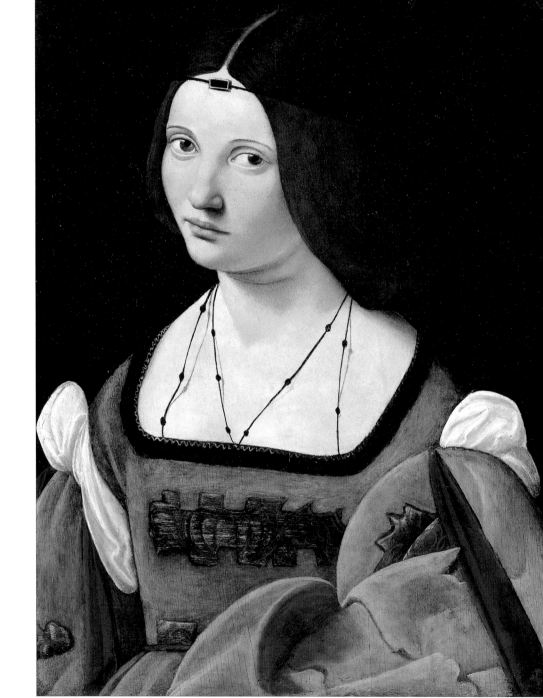

Leonardo da Vinci

might therefore have contributed some of the fine touches, such as the way the lights are caught in the pearls of her necklace. This implies an unlikely relationship between the two men since, as we have seen, Predis was too old and too well-established in Milan to have been Leonardo's pupil. Although neither the colouring nor the rather flat light suggest Leonardo, on balance it seems most likely that it is largely, though not entirely, his work. The later testimony of a witness that Leonardo's pupils in Milan would paint a portrait which, 'from time to time he works on himself', suggests that the other hand in this case was most likely that of Boltraffio.

The other portrait in the Pinacoteca Ambrosiana is less confusing. Dating from the mid 1480s, it is, like the portrait with which it was once twinned, in generally good condition, although the lower part is unfinished (and was once painted over, presumably to suggest that the painting was finished). It offers evidence of the subtleties of Leonardo's technique, and particularly of his colouring, that in other paintings have been more thoroughly obscured by

the effects of time. It is therefore rather surprising that of all Leonardo's works, with one or two exceptions such as *St. John*, it has aroused the least enthusiasm among Leonardo aficionados. The subject is undeniably a musician, since he is holding a sheet of music, and he is probably Franchino Gaffurio, or Gafori, a well-known figure at the Sforza court and the outstanding writer on musical theory of his generation: his *Practica musicae* was published in Milan in 1496. He was about the same age as Leonardo, and they may well have been friends, although there are no strong signs in the portrait of the personal warmth that one sees, or senses, in the female portraits. Though undocumented, this painting, at one time attributed to Ambrogio da Predis, is generally accepted as Leonardo's on the grounds of quality. The dramatic handling of light and dark, the extreme subtlety of the face, and the way the light plays on the man's abundant curly hair (always an attractive feature to Leonardo) could hardly be the work of any other painter. Incidentally, it is Leonardo's only undisputed surviving portrait in oils of a man.

La Belle Ferronnière (*details*)
Louvre, Paris

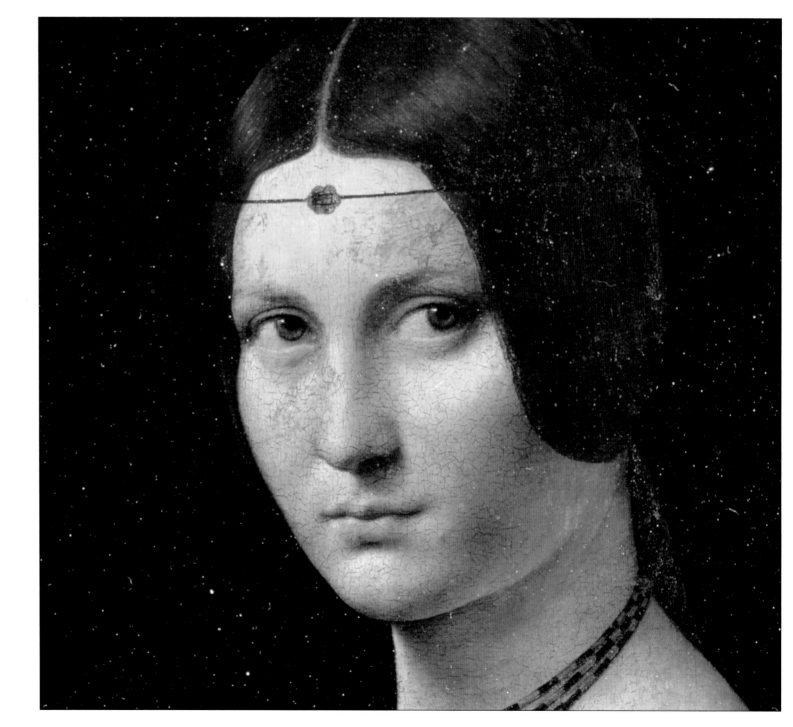

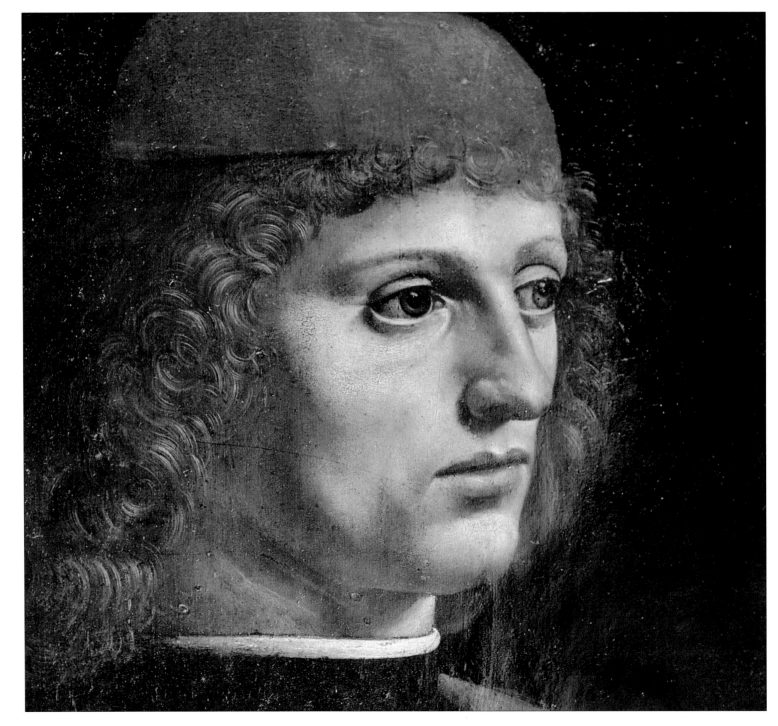

Portrait of a Musician

17 x 12¼in (43 x 31cm)

Pinoteca Ambrosiana, Milan

The solitary male among Leonardo's portraits in oils, this painting, although unfinished, is also in a better state than most, but in spite of its quality it has never acquired quite the status in popular esteem of most of his other paintings. Leonardo was (of course) interested in music, which he could read and write, and memorably described it as his 'representation of invisible things'.

Leonardo da Vinci

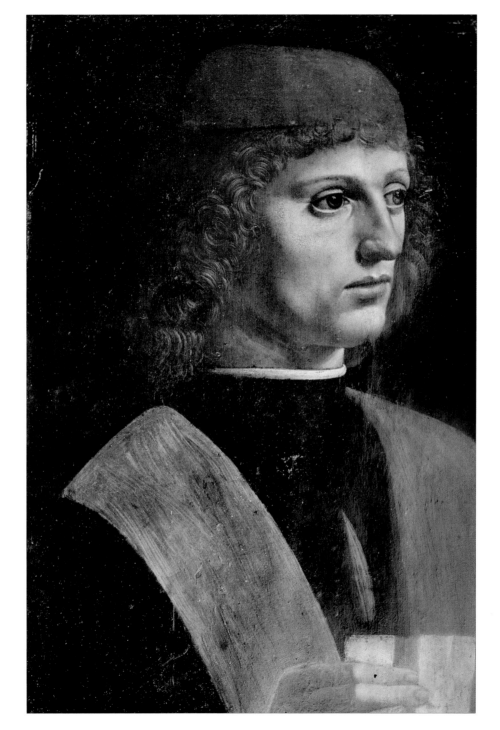

OPPOSITE

The Annunciation

(see page 74 et seq.).

Leonardo's earliest work shows his early command of sfumato, *as in this landscape, with pale mountains receding into misty distance beyond the line of almost black trees.*

SFUMATO

The Italian word *sfumato* describes the effect of steam rising or mist dispersing in the air, and in art describes the change of tone, from light to dark, and to an extent of colour also, which is so gradual that the eye cannot detect any boundaries. It is an illusionist technique associated with Leonardo above all others. He used it with great skill to convey the contours of an object, an impression of three dimensions, which he regarded as vital. In his notes on painting he said that light and shade should always merge 'without lines or borders, in the manner of smoke'.

Of course, most artists are concerned with depicting relief, but for Leonardo, 'relief is the summit and the soul of painting'. The Florentines of the *quattrocento* achieved it mainly by skilful drawing and modelling. Leonardo went further to achieve it by employing light and shade (*chiaroscuro*) in a manner based on scientific principles. His diagrammatic drawings of the effect of rays of light falling in different ways on different surfaces and in varying combinations are extremely complex, perhaps excessively so for the practical needs of a painter. Elsewhere in his *Treatise on Painting*, Leonardo advises the student to be wary of sunlight that casts dark shadows. If painting outdoors, he should introduce a slight haze between the object and the sun.

Unfortunately, the softness of contours in Leonardo's paintings, when combined with the darkening of the shadows through the effects of age, sometimes contributes to the dimming of the original effect.

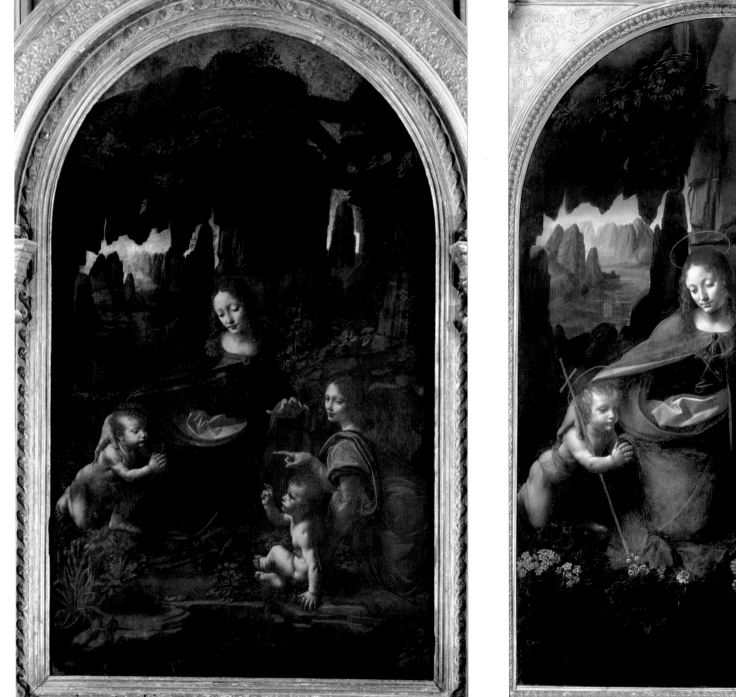

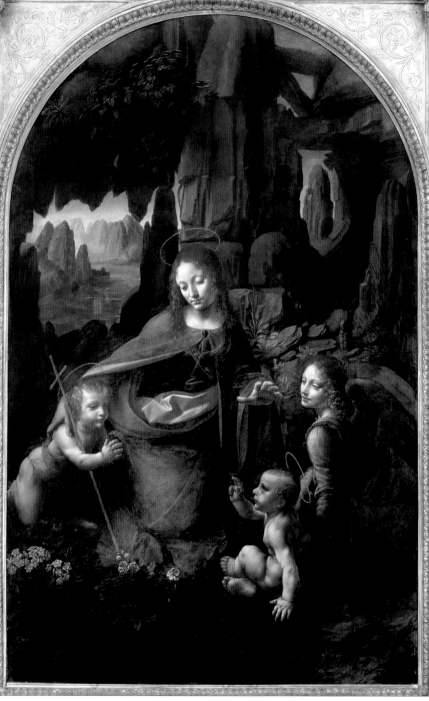

Leonardo da Vinci

THE VIRGIN OF THE ROCKS

In the long, sad story of paintings lost, unfinished or ruined, Leonardo's first great surviving masterpiece comes as a generous blessing, since it exists in two versions! One is in the Louvre, Paris, the other in the National Gallery, London. It is generally agreed that the Paris version is the finer, that it is completely finished and is exclusively by Leonardo. The London version is unfinished – though in one, comparatively small area only – and it is probably in part the work of, presumably, Ambrogio da Predis, striving hard to measure up (the exquisite head of the Angel is indisputably Leonardo). The relationship between the two versions has been the subject of more discussion and argument than almost any comparable problem in the history of Western art, and the improbability of final conclusions ever being reached, barring the discovery of more evidence, is indicated by the frequency with which even the greatest scholars have changed their minds about the presumed facts of the matter.

The original contract for the painting still exists, a long legal document dated 25 April 1483. In it a religious order in Milan called the Confraternity of the Immaculate Conception contracted for three paintings to fit an existing frame for an altarpiece for its chapel in the church (since demolished) of San Francesco Grande. Leonardo was to paint the main, central panel; Ambrogio da Predis and his brother Evangelista were to prepare and gild the wooden frame and paint the side panels, which would have included sculptural elements. The work was to be completed by the end of the year.

The contract goes into some detail on the subject of the picture, which was to consist of a Virgin and Angels, with God the Father overhead, flanked by two Prophets in the side panels. What the brothers eventually got was rather different: the figures in the side panels were angels, not prophets, and the central image contained no flock of angels nor God the Father but included two infants, the Child Jesus and John the Baptist. It was quite common for Renaissance artists to interpret commissions freely, but the Confraternity was keen to uphold the popular new doctrine of the

The Virgin of the Rocks

RIGHT
Detail of the angel from the Louvre painting. The pointing finger and the sideways glance are clearly sending us a message, although it is not entirely obvious what the message is. The gesture is absent from the later, London version, no doubt Leonardo's decision (since he was surely directly responsible for the angel's head).

OPPOSITE
Detail of the infant St. John in the Louvre version. The most obvious difference between the two is that in the later, London version, a cross has been added, possibly for iconographic reasons.

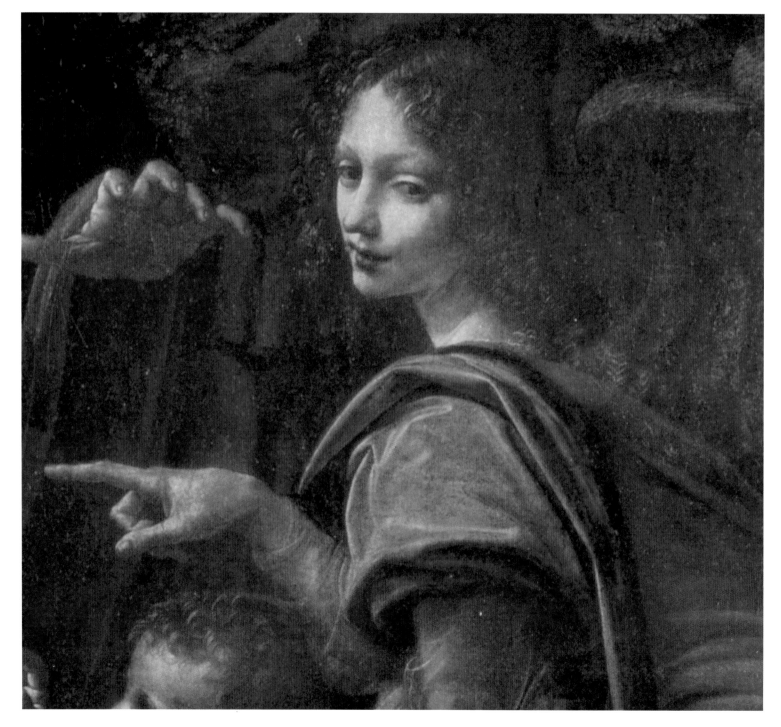

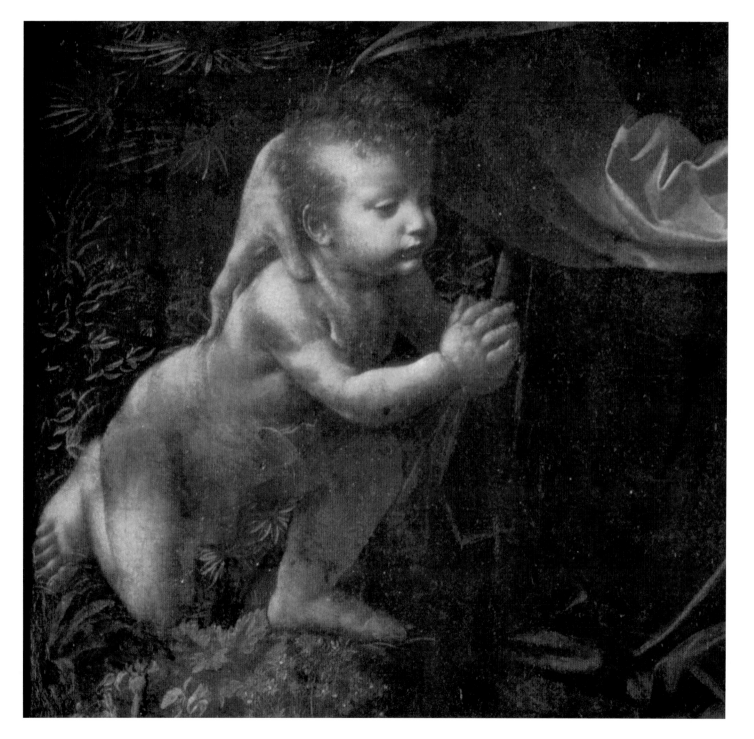

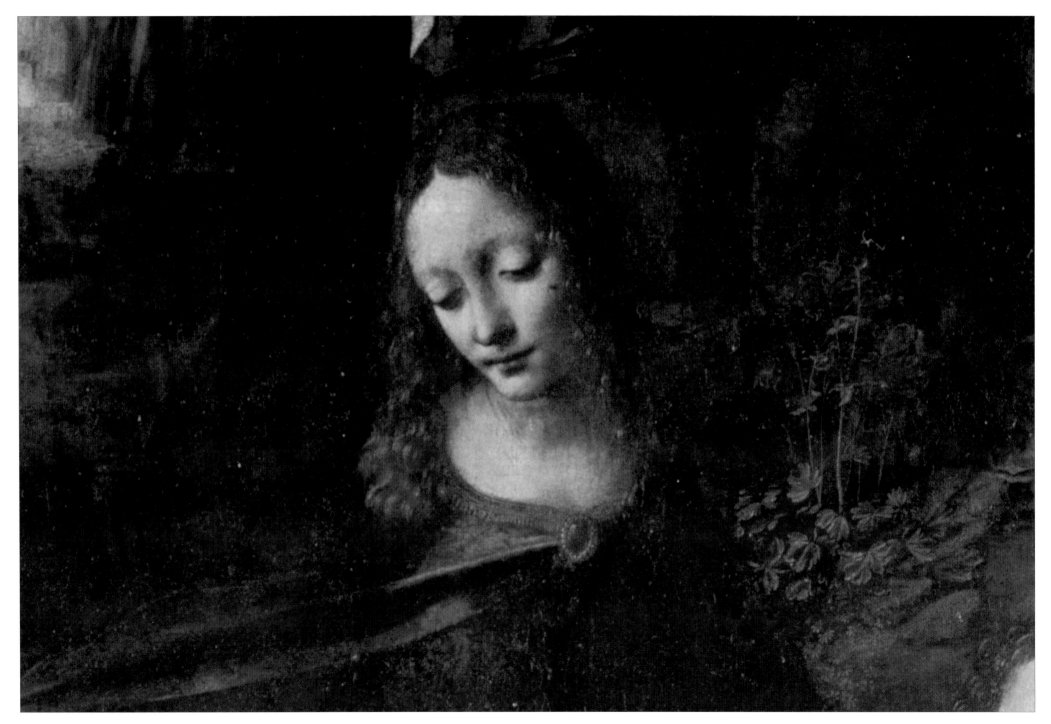

Leonardo da Vinci

Immaculate Conception, the feast of which had been approved by the pope in 1480, shortly after the foundation of the Confraternity, for whom strict iconography – for instance the exact colour of the Virgin's robe – was very important. There is no record of any objections being raised to these changes, so they must have been agreed with the Confraternity. Leonardo's reputation for both tardy delivery and unproven technique seems to have been known already, hence the deadline set for the following December and the provision for the return of part of the fee if the work showed early signs of deterioration.

In earlier centuries, many legends and stories concerning events in the life of Jesus, which had no biblical authority and are now mostly forgotten, circulated freely. One such story, not known before the 14th century, described a meeting between the Holy Family and the future St. John the Baptist in the desert under the protection of the Angel Uriel, after they had fled to escape King Herod's slaughter of the innocents. This episode is the subject, an unusual one, of Leonardo's picture. The

tremendous, almost Gothic, rocky background that gives the picture its name may relate to a mountain that miraculously opened to give the Holy Family shelter, or to the grotto where St. John the Baptist, despite being not long out of swaddling clothes, was sheltering (the pool in the foreground is a precursor of the baptismal pool).

The four figures depicted in the painting are the Virgin Mary and the two infants, with the Angel supporting the Christ Child, and emphasizing his divinity. They appear in more or less identical poses in both versions with the exception of the Angel who, in the Paris version, points towards St. John and seems to look almost straight out of the picture, though not quite at the spectator. The significance of the gesture is mysterious, although undeniably the London version, in which the Angel's arm is lowered and he looks passively toward St. John, inevitably loses some impact.

Nearly everyone agrees that the Louvre's version belongs in style to Leonardo's early, Florentine manner. Some scholars hold that it was actually painted in Florence and accompanied Leonardo to

The Virgin of the Rocks

One small point which, though hardly conclusive, tends to strengthen the thesis that the Louvre version is more wholly Leonardo's is the absence of a nimbus or halo, of which Leonardo disapproved, from the heads of the Virgin and the holy Children.

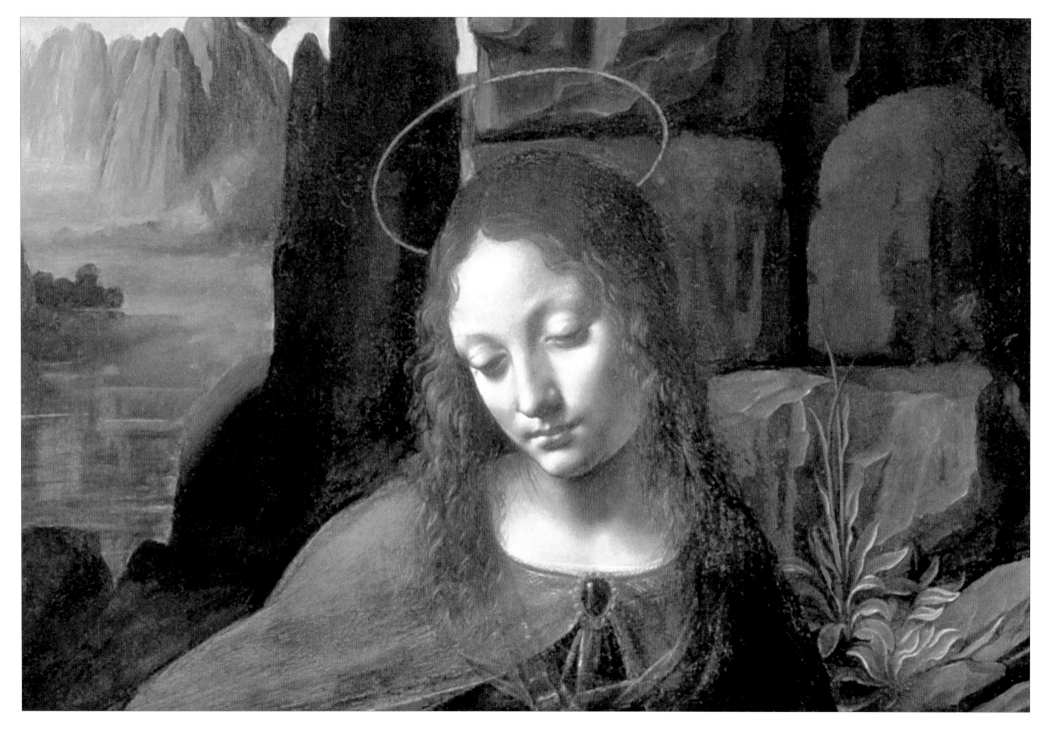

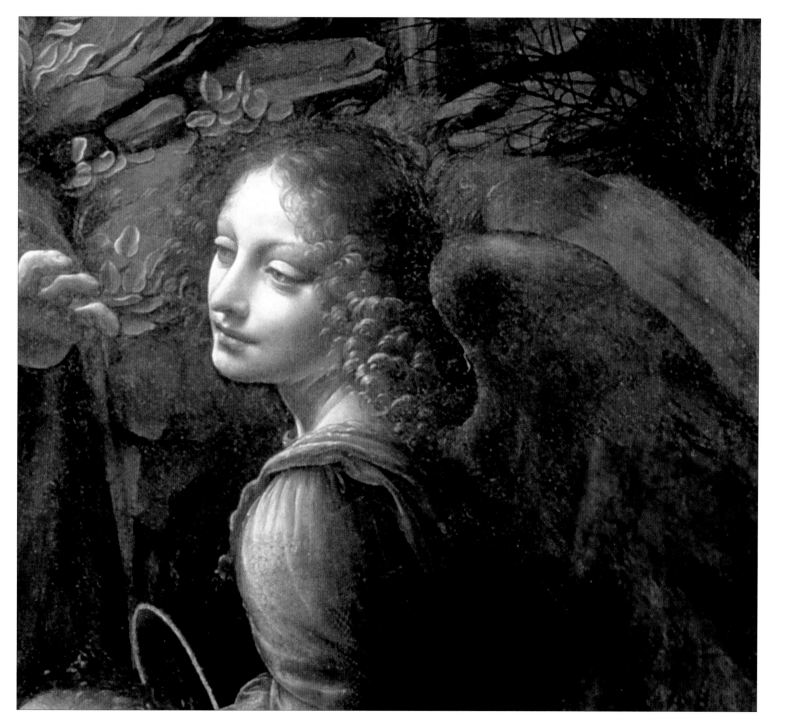

The Virgin of the Rocks

OPPOSITE
Detail of the Virgin's head from the National Gallery painting. The change in Leonardo's style in the longish period between the two paintings is evident in many details, the chief feature, potentially a loss, being the disappearance of quattrocento *charm from the later, National Gallery painting.*

LEFT
The Angel in the National Gallery version of the Virgin of the Rocks. *No one can doubt that this face was painted by Leonardo.*

The Virgin of the Rocks

Detail of the infant St. John from the National Gallery version of the painting.

Leonardo da Vinci

Milan. It would have been eloquent witness to his ability, although, measuring about 6½ft (2m) in height, not easy to transport on a mule.

The most remarkable feature of the composition is the outspread arms of the Virgin, her hands hovering protectively over the infant Jesus and, on the other side, actually touching St. John, a gesture which gives unity to the figures and draws them together in that favourite Renaissance form of a strong triangle.

A page of drawings in the Metropolitan Museum, New York, contains four separate studies that, since they include the arched top, must be for the *Virgin of the Rocks*. They indicate how Leonardo arrived at the original composition. In the first stage, the Virgin bends forward protectively with hands loosely clasped in front of her. This is the pose of an orthodox Nativity, the original subject requested by the Confraternity. In the second (the sketches do not appear in this sequence on the sheet but their order can easily be deduced when one remembers that the left-handed Leonardo worked from right to left), her right arm is extended over the Christ

Child, while her left arm remains inactive. In the third, both arms are outstretched, more or less as in the painting, but while one hand hovers above the child, the other is stretched over nothing. Finally, in the fourth version, the second baby appears to fill this awkward gap and draw the whole group together.

It is a mysterious, slightly ominous picture, very beautifully painted (though now dulled by several coats of old varnish), which may have been hard to understand even for contemporaries (they would, however, have recognized the symbolism of the plants that eludes most of us today). We hear nothing of its reception, nor can we be certain when it was received, for it became the object of a long-drawn-out legal argument. Leonardo, of course, did not deliver on time. He and Predis applied for higher payments on the grounds that their expenses had exceeded what they had been paid, and were refused – not unreasonably, one feels. Some time later, after Leonardo had left Milan, Predis made another appeal for extra cash, again without success, though in 1506 extra payment was

OPPOSITE

The Virgin of the Rocks

Detail of the background of the London version. It is not certain whether or not the rocky background has some specific reference, but the stern and rugged scenery augments the grand solemnity of this powerful painting.

promised if Leonardo would come back and finish the picture within two years. That seems to have been the reason for Leonardo's return to Milan in 1507. Records of this dispute throw some light on, though they do not explain, the reason for the two versions and the identity of the one eventually delivered to the Confraternity.

If the Confraternity's picture was unfinished in 1506, it is highly unlikely, on grounds of style, that it could have been the Paris version. Moreover, the London version has a definite connection with the church of San Francesco Grande, whence it was acquired in 1785, while the whereabouts of the Paris version are not known before the 17th century. The painting eventually received by the Confraternity had been in its possession for some time, in whatever state it was then, before 1503. It must have been returned later to the artist's studio, perhaps not until Leonardo arrived to finish it. It seems most probable that this was the painting now in London, that it was designed by Leonardo, and that he also completed the underpainting and some of the finished painting (e.g. the head of the

Virgin). Most of the rest (notably the head of the Christ child, who is markedly unattractive compared with the Paris painting), was probably finished by Predis.

But if all that is true, what of the Paris version? In this long and complicated argument, the main stumbling block has been that the documentary evidence and the evidence of style contradict each other. For the Paris version is by universal agreement earlier than the London version; moreover, the two versions are the same size, the same shape, and both have the light source in the same direction (it was customary to copy, in an altarpiece, the direction of the light in the actual building). This strongly suggests that both were intended for the same destination. The only possible explanation seems to be that the original painting (i.e. the Paris version) was sold or disposed of elsewhere and the later, London version, which was far from finished when Leonardo left Milan, probably at the end of 1499, was substituted, with, or more likely without, the knowledge of the Confraternity.

Such an act, which puts Leonardo in a rather poor light morally, would have been uncharacteristic, although an intention to sell the picture elsewhere might be read into the claim made in the original joint complaint of Leonardo and Ambrogio da Predis that they had been offered a much higher price for the painting as it was then (the early 1490s) than the Confraternity had paid. Also, Leonardo might have had no choice. He was not easily pressured into acting against his will, but there was one person who could have compelled him to renege on the contract with the Confraternity, Il Moro. We know from three separate sources that at about the appropriate time, a painting by Leonardo was sent by the Duke of Milan to the German emperor-elect, Maximilian I, as part of the dowry of his niece, Bianca Maria Sforza, on her marriage to Maximilian in 1493. The painting was said to be an altarpiece, a work of outstanding quality, and Vasari, who could not have seen it, believed it was a Nativity (which the Confraternity's painting was originally intended to be).

The Virgin of the Rocks

The instinctive sign of blessing from the Infant Jesus makes a powerful emotional impact in both versions of the painting.

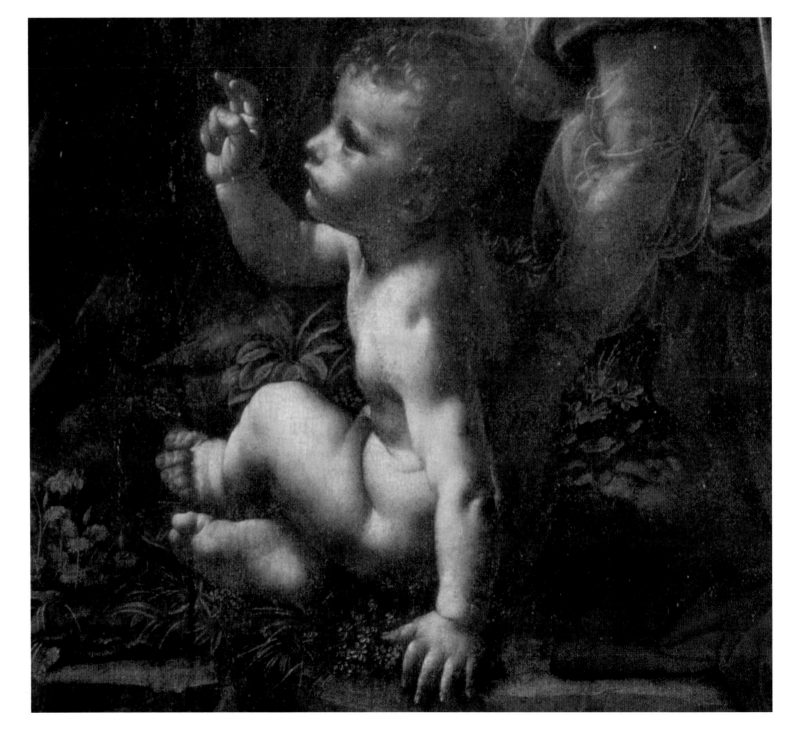

Leonardo da Vinci

The suggestion that this picture was the *Virgin of the Rocks* (Paris version) was actually made exactly 100 years ago and, in spite of all the new evidence, the proliferation of theories and the mountainous debates that have taken place since, we might say we have not got much farther, for this still seems to be the theory that best accounts for all the discrepancies in the evidence.

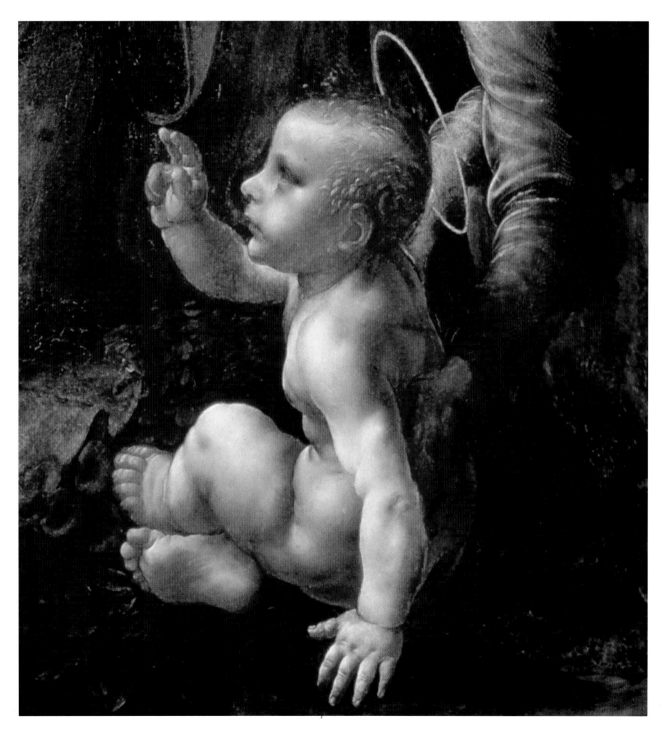

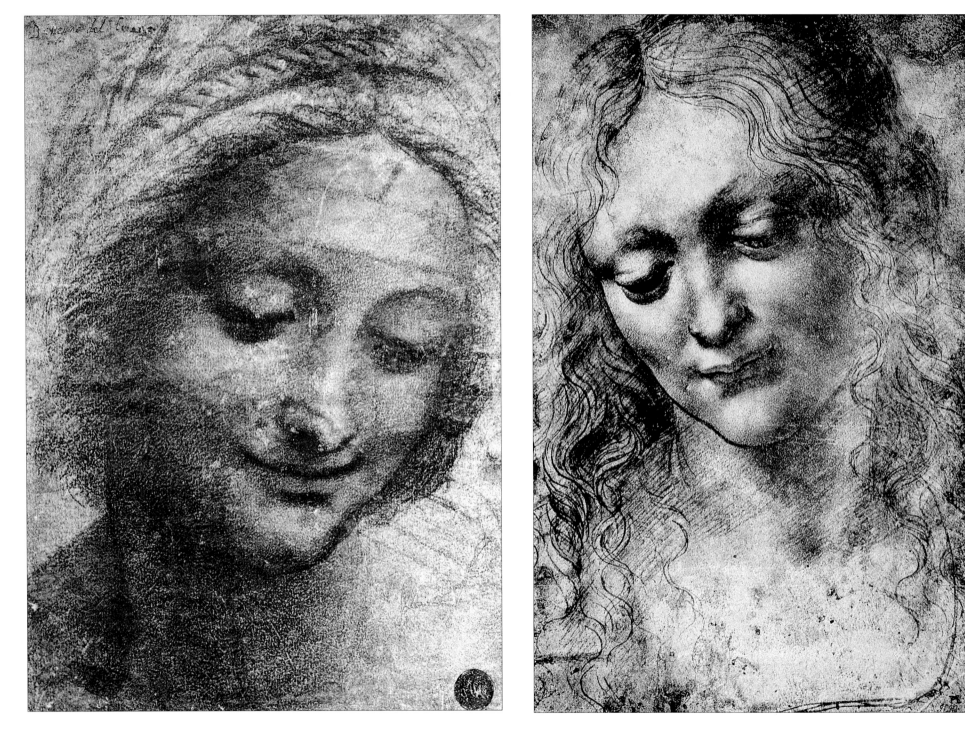

Leonardo da Vinci

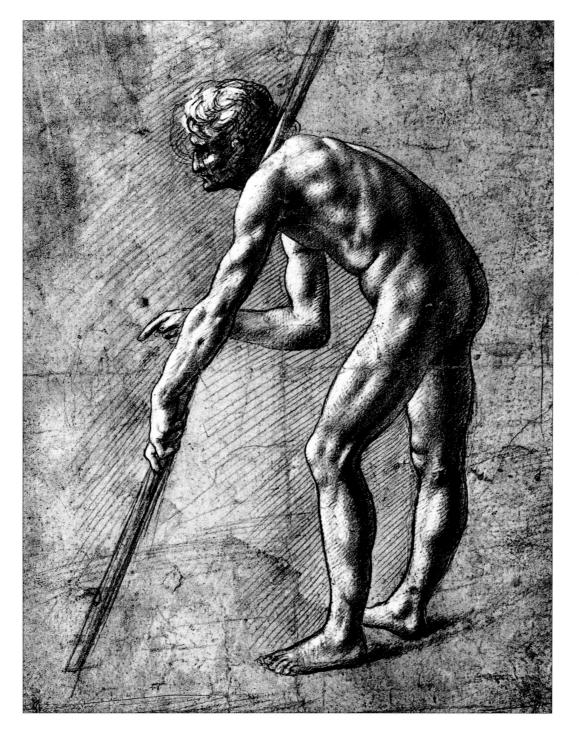

OPPOSITE LEFT

Head of a woman

Charcoal on paper

Galleria dell' Accademia, Venice

OPPOSITE RIGHT

Head of a woman

Charcoal on paper

British Museum, London

LEFT

Study of a man

Pencil on paper

Pinoteca Ambrosiana, Milan

Chapter Five
Plans and Projects
1482–99

OPPOSITE

The Castello Sforzesco, Milan

Given what we know of Leonardo's work in the early years in Milan, and the intense, painstaking devotion that he brought to the art of painting, we might assume that it demanded most of his attention, but in fact it probably formed a relatively small part of his activities. After all, he had not been hired primarily as a painter, or so it seems, although the offhand mention in his letter to Lodovico of his abilities in that field must be balanced with the lavish praise that his art received from contemporaries, the wide demand for his work, and the plain fact that he was incomparably the finest painter in Lombardy, if not all Italy.

He must have spent many hours and days in the great Sforza castle (in what is now the Parco Nord). Built by Francesco Sforza, it incorporated parts of an earlier Visconti palace, which was destroyed during the brief period of the republic after the death of the last Visconti duke, and included the splendid tower of 1453 over the entrance, demolished by a gunpowder explosion in 1521 but later restored in the original style.

The Castello formed a spacious complex of buildings within a walled rectangle with towers at each corner. The main apartments were in the inner fortress, the Rochetta, which could still be defended even if the outer castle was in enemy hands. Overall the castle, built largely in the pinkish stone characteristic of the region, was more notable for strength than beauty, but besides chambers of extraordinary luxury, furnished with rich Eastern carpets and fabulous French tapestries, it included pavilions, arcades, waterways, and gardens with dovecotes and lily ponds. From upper windows, it may have just been possible to see, over the outer walls, the snow-clad summits of the Alps (such a contrast to the comfortable hills of Tuscany) rising in the distance.

Decoration of the court rooms in the richest style accelerated under Galeazzo Maria Sforza in the 1470s, with the star-spangled ceiling of the Sala Celeste, followed by the Sala delle Colombine with doves and flames, the Sala degli Scarlioni in white and purple, and the hunting scenes of the Sala delle Caccie. The work was under the direction of

Milan Cathedral

Milan's gigantic Gothic cathedral, a unique building started in 1386 and which required centuries of work and the contributions of many generations. Its lantern above the crossing tower, for which Leonardo among many others contributed plans, has been described as a triumph of Renaissance engineering.

Leonardo da Vinci

Benedetto Ferrini, who also built the ducal chapel, where faint remains of the frescoes may still be seen. Furnishings became even more lavish under Il Moro. New construction was directed by Donato Bramante who, originally trained as a painter, became the greatest architect of the High Renaissance. In the Sforza castle he was responsible for the Ponticella, spanning the moat, and the fresco of Argus in the Sala del Tesoro.

Bramante entered Lodovico's service about 1479 and remained in Milan until 1499. He thus knew Leonardo, who was eight years younger, very well and was influenced by him. Both men submitted designs for a central tower or dome for Milan's vast, unfinished, Gothic cathedral, and both worked extensively on the cathedral of Pavia. Bramante's interest in centrally planned churches, most notably enshrined in his plans for St. Peter's, Rome, can be traced to the Florentine master. Leonardo's surviving studies for such a building, which look almost as though they belong to the Baroque period rather than the Renaissance, date from the late 1480s.

We know for certain that Leonardo was at work in the Castello in 1495–98, and no doubt earlier. He probably took part, if only in a supervisory role, in the design of a pavilion for the Duchess's garden and, among his drawings, are designs for fortifications and an extraordinarily high tower that, if built, certainly would have offered a fine view of the Alps. He is said to have been involved in the decoration of the Saletta Negra, which owed its name to the black hangings in which it was shrouded after the death of Beatrice d'Este, at only 22, in 1497, but no trace of his work here remains.

So far as we know, his main task was the decoration of the Sala delle Asse, a very large room under the north-west tower. It was painted, no doubt wholly or mainly by assistants, with trees around the walls. Their roots and trunks emerge from rocks, which crack from the pressure, and their interlacing branches, painted with botanical precision and extending all over the vaulted ceiling, are interwoven with knotted gold cords that recall Leonardo's fascination with hair and headdresses and the intricate patterns made by knots. It is now not quite certain, however, that the walls and

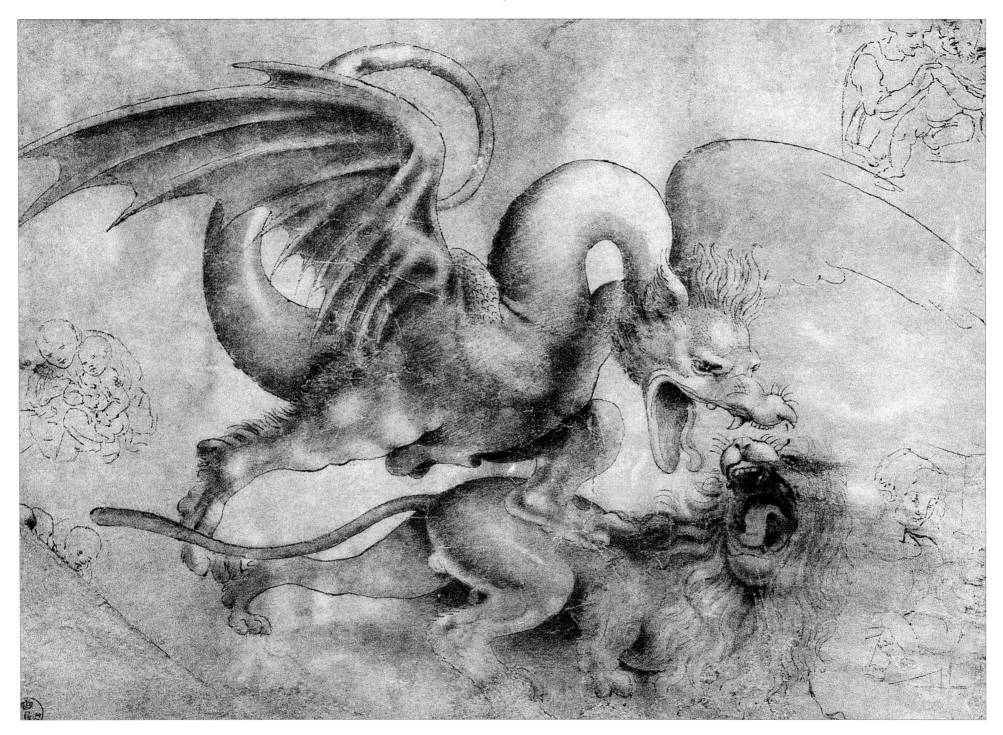

ceiling are actually part of the same composition, for their history is chequered. The walls were for many years painted over and, when revealed in 1901, were found to be so damaged that they were completely repainted. Fifty years later much of the repainting was itself removed.

The vicissitudes they have endured makes it difficult to comment in detail on these frescoes, but the amazingly original and imaginative design is still clear enough. It is unique because, although ceilings had been painted before with foliage against an open sky, they still spanned an architectural structure, such as a loggia. Such rooms did not pretend to have no walls and were clearly within some kind of building, whereas in Leonardo's scheme we find ourselves in the middle of a forest! The way in which the main branches follow the steepest curves of the vault may owe something to a notion current in Italy at this time that the Gothic ribbed vault had originated in an effort to replicate the effect of trees in a thick forest.

In our cosseted age, it is easy to forget the constant threat of disease and the relative helplessness of physicians in earlier times: malaria was endemic in Rome into the 19th century. In the mid-1480s plague hit Milan. This scourge, which had decimated the population of Europe in the middle of the 14th century, had made frequent, sporadic, more localized attacks since then. Florence suffered an outbreak in 1479 but it was mercifully brief. The epidemic that began in Milan in 1484 was far more serious. It lasted for two years and killed at least one-quarter of the population. Lodovico and his court followed the advice of Cosimo de' Medici and left the city, certainly the best precaution. Although no one knew what caused the plague, or how it was carried by the fleas on black rats, people had a remarkably good idea of the conditions that encouraged its spread in fetid and overcrowded cities, such as Milan, which was still essentially a close-packed, irregular, medieval city.

It was in the aftermath of this epidemic that Leonardo drew up his plans for rebuilding Milan. However, given that public health was a motive, we

Fight between a dragon and a lion

Pen and ink on paper
Private collection

RIGHT

RIGHT

An architectural sketch for an 'Ideal City'

Pen and ink on paper
Bibliothèque de l'Institut de France, Paris

Leonardo's sketch of buildings in an ideal city were connected with his grandiose plans for redesigning Milan as a city on two levels.

would hardly expect Leonardo to produce a scheme that was exclusively based on that requirement, and in fact, as in so many of his projects, his vaulting imagination carried him into realms far removed from these considerations, or even from practical town planning at all. Naturally, his ideas were imaginative, original, grand and provocative, but they were also extremely expensive and, it must be said, impossible to realize in the circumstances of the time, however fruitful as a stimulus to future planners. It is hard to believe that they were composed under the illusion that they would, or could, be carried out.

Leonardo was far from being the only man of his time to produce schemes of town planning, which were generally devised with defence as the primary consideration. This was a common preoccupation of architects from Leon Battista Alberti onwards. Many fine schemes were proposed, but comparatively few were realized. Some were built and one or two, such as Palmanova, having been spared the general reconstruction of fortified towns in the 19th century, survive to this day.

Leonardo da Vinci

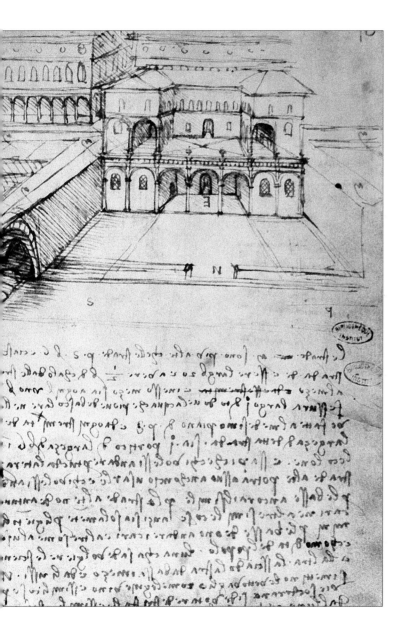

Leonardo envisaged a decentralized city along the banks of the river and built on two tiers, divided into partly autonomous sections of 5,000 dwellings each. Every subsidiary settlement would have its own civic centre and market place. The pollution-free upper level, from which traffic was banned, would be reserved for the better class of citizens, while the 'carts and barrows of ordinary folk' and the sordid vehicles of commerce were to be confined to the lower tier. There was also provision for a network of partly underground canals. The height of houses and the width of streets were calculated for a maximum of light and fresh air; tall chimneys would expel smoke into an upper level of the air. Finer details were considered too. For instance, public buildings should have spiral staircases to discourage people from using corners as urinals. Latrines had seats ('like those in convents') whose position was controlled by a counter-weight, though no flushes. It is possible that a pilot scheme based on Leonardo's proposals was carried out in one of the poorer sections in about 1490, though there is no evidence,

Leonardo da Vinci

documentary or physical, of its existence now. Leonardo even considered the financial aspects that would be of interest to the government, but he seems to have been indulging a dream, and probably knew he was.

Given their marked differences in social status and temperament, Leonardo and Duke Lodovico (legitimately so called because he held the title duke of Barri before he became officially duke of Milan) had more in common than Leonardo and Lorenzo de' Medici. Leonardo was a good courtier, reserved and courteous but not overawed. He also proved extremely useful in a variety of practical ways. He shared Lodovico's interest in 'science', which was reflected in his keen engagement in various progressive projects, though Lodovico must have come to recognize his drawbacks: his tendency to leave things unfinished and his weakness for momentous projects on a scale that was beyond the financial and technical means available. There is no evidence, for example, that Leonardo's many designs for war machines played any part in assisting the defence of Lombardy or,

for the most part, that they were ever constructed.

That the two men apparently got on so well may have owed something to Leonardo's growing maturity and confidence. They seem to have genuinely liked each other, though they did not altogether trust one another. Lodovico, with his fear of assassination, trusted few people.

Among Lodovico's virtues as a ruler was his interest in technical improvements to confer social benefits. He recognized that the basis of his dukedom's prosperity was the agricultural productivity of Lombardy, which he endeavoured to improve. He appointed a commission to study ways to increase production of wheat, and set up experimental projects on his private estates near Vigevano, where he built himself a fine villa next to his model farm. This was a relatively arid district which had hitherto produced poor crops and contained large areas that were uncultivated.

Contemporary descriptions of the farm were universally enthusiastic, and in many respects it seems to have been run on surprisingly modern, scientific principles. Leonardo made several visits.

OPPOSITE
Perpetuum Mobile *(study for a perpetual motion device)*
Pinoteca Ambrosiana, Milan

173

He noted with interest the experiment of burying vines to protect them from winter frosts, the unusual, uniform construction of mills and – an aspect that particularly impressed other visitors as well – the system of irrigation, in which 'thirty-three streams of fair, clean water' were fed by a canal from the Ticino river. Lodovico also set out to improve Milan's water supply, especially the canal from the Adda, which had fallen into disrepair. Leonardo became involved in advising on these projects long before he was appointed court engineer in 1498. Needless to say, most of his plans, like those for rebuilding the city itself, were never carried out.

Irrigation schemes and the construction of navigable canals had been going on in Lombardy for centuries, whereas they were unknown in Tuscany, and it seems likely that Leonardo's lifelong interest in hydraulic engineering – the manipulation of water – was kindled by his arrival in Milan, when he was stimulated by what he saw around him. His work on the dams and locks of Lombardy was rewarded with the proceeds of a tax levied on water use in one of the canals, presumably one that he had improved, and this may be connected with his design of a meter to measure water flow.

His interest in water was not, of course, exclusively practical. As Carlo Zammattio pointed out, he was one of the first to study the dynamics of water, and it is tempting to draw a parallel with what can only be called his obsession with the movement of water, and especially with great floods and storms, for which his later notebooks provide so much evidence. Some writers have postulated a childhood trauma at the back of this: the hurricane that devastated much of the Arno valley in 1456, when he was four, is a favourite candidate, and at a later age he would certainly have had first-hand experience of disastrous floods.

Characteristically, Leonardo's hydraulic-engineering works in Lombardy peaked in a grandiose, super-expensive project for a navigable canal that involved driving a tunnel through a mountain. Like his later, even grander scheme to divert the flow of the Arno, it was never fulfilled.

Detail showing water moving around obstacles, from the Codex Leicester

Here Leonardo lists water flow topics and problems to explore. Some are experiments to perform, and some are his conclusion on water currents. He discusses the use of harmonic time to calculate water speed and explores ways to protect riverbanks from erosion. Leonardo offers a generalized discussion on maintenance and control of a river: *It is possible to devise obstacles that will protect the riverbanks against the friction of the water current.* This is the most important statement on this page. Leonardo proposes establishing a practical branch of engineering dedicated to the creation and use of obstacles to control the flow of the river and the deposition of sediment. His plan is to shift the main current of the river toward the middle of its channel to protect its banks. His drawings are meant to show how currents of water are affected by well-placed impediments to their flow. Leonardo often relates small and large events of the same nature and explores the differences: *How the swollen waters of great floods make the same revolutions in their occurrences as do the small waters in their own; but the water engaged in the small one, which is little, makes little movement from the upper to the lower part of its wave; and that same quantity of water, in the very great wave, makes great movement, so that it is no longer to be seen as transparent water, but it turns into smoke or mist, or foam, on account of its great revolution.*

***Sketches of water staircases, from the* Codex Leicester**

River control is the main focus as Leonardo discusses where to place obstacles to direct the flow to the middle. He also outlines a proposed book on water. He lists many behaviours of water under varying conditions and suggests constructing water staircases to replace waterfalls. The 29 cases of water formation described on this page demonstrate Leonardo's search for principles for his science of water. He acknowledges that weirs may create problems: *How the impetus of rivers can be controlled by frequent weirs and dams; but this is not useful to the neighbours, because the waters often overflow to inundate their land.* He also recognizes how to mitigate adverse consequences; *The whirling of the waters reunited after the object which had divided them will circle back toward the percussed obstacle; and so this tortuous motion will proceed, like an auger shell, up to the water surface, always slanting with the water current. Thus, rivers should not have places from which water falls, unless they are in the form of staircase steps, well dovetailed together and chained; and firmly set one on top of the other.* The symmetry that he sees in eddies studied for the sake of science are elaborated elsewhere in beautiful synthetic drawings of his enduring experience with water.

Detail showing water moving around obstacles, from the Codex Leicester

Here Leonardo discusses the confluence of currents and analyzes this phenomenon by means of a controlled experiment. The text and illustrations are concerned with the flow of water around obstacles. This is an elegant page of studies on the physical nature of water, including he explanation of a method to measure the force of a stream of falling water. Leonardo experiments with the physical properties of water, its resistance and cohesion: *How water has a tenacity in itself and cohesion between its particles; this can be seen in its drop which, before it separates from the rest, stretches down as much as it can, holding up at the point of contact until it is overcome by the excessive weight of water which goes into increasing it.*

Detail showing movement of water by a dam, from the
Codex Leicester

Here Leonardo devotes the text and illustrations to practical hydraulics, particularly pile driving. He describes how to drive piles with a device that employs a man as a counterweight to raise the ram and then describes how to arrange the slope of a weir so that it will not be subject to erosion. Concerning weir construction, Leonardo says: _In front of river dams made of hollow and spaced-out piles, a lower dam ought always to be made to a height just above water level, so that water falling from it at flood time comes to dig out the bottom and on its rebound carries with itself what it had lifted from the bottom and deposits it in front of the higher dam, providing it with a shield made of the carried material; and the water rising from that depth will reach the top of the dam from below along a slant, so that it produces no percussion or damage._

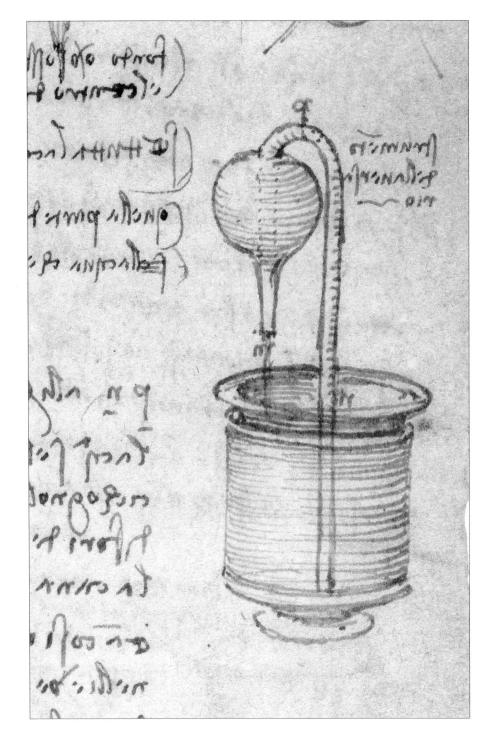

Detail showing the operation of a siphon, from the
Codex Leicester

Here Leonardo considers how water rises to the summits of mountains. He offers a thoughtful theory likening human existence to that of the earth, while testing a traditional theory of the composition of the earth. On this page Leonardo offers a poetic and quite personal observation, likening human existence to the vital life of our planet earth: *Nothing grows in a spot where there is neither sentient, vegetal, nor rational life ... We may say that the earth has a spirit of growth, and that its flesh is the soil; its bones are the successive strata of the rocks ... its cartilage is the tufa stone; its blood the veins of its waters. The lake of the blood that lies around the heart is the ocean. Its breathing is by the increase and decrease of the blood in its pulses, and even so in the earth is the ebb and flow of the sea.* He also offers an observation about the circulation of water with accompanying geometric diagram that relates to Ristoro d'Arezzo's conception of the composition of the earth, describing the relationship of the land to the sea on the basis of the sphere's geometry. In Leonardo's illustration, the circumference of the semicircle represents half the surface of the earth. A line is drawn to connect the two endpoints to create a curved segment. The endpoints represent two points of land, and the part of the circumference between them represents the sea. Ristoro argues that the sea is 'higher than' the land because it bulges 'above' the land. Leonardo questions this geometric model with an analogy of a bowl of water and concludes that anything that projects above the surface, such as a mountain, is higher than the sea.

Leonardo da Vinci

***Detail showing action and reaction demonstrated on a seesaw, from the* Codex Leicester**

This sheet concerns the movement of projectiles through air and water. Leonardo explores the changing velocity of falling water which is linked to his interest in the problem of the body of the earth. Here Leonardo works with the principles of impetus and percussion. This page begins with the axiom that water flows downhill. A passage accompanying the drawing of the seesaw discusses the effect of two men balanced on it. When one attempts to jump, they find that it requires co-operation – a stoop and jump by the first man must be co-ordinated with a push by the second. This study of changing equilibrium and balance introduces a more difficult problem: how does water act when it falls (as in a waterfall) – the logical endpoint of water's downhill course.. Leonardo is interested in explaining the causes in changing velocity. He defines the problem in Aristotelian terms as a study in compound motion. The changing velocity of falling water is due to the combination of two simple motions: flow of water downhill and pull of gravity. He explains several aspects of this compound motion, including both the increase in the force of the water as it falls and the change in the width of the stream as the water acquires velocity. Understanding this interaction requires that Leonardo first observe the effects and then extract the principles involved. He explains the increasing force and velocity of the water as a result of acceleration caused by gravity. But his understanding of gravity differs from ours. He inherited a concept of gravity as a force which attracts dense objects to the centre of the world. This concept was inseparable from the theory that each of the four elements has it own level, or sphere, with earth, the heaviest, at the centre of the world. This central core is surrounded by the sphere of water, then air, and then fire. Such was the make-up of the sublunary world.

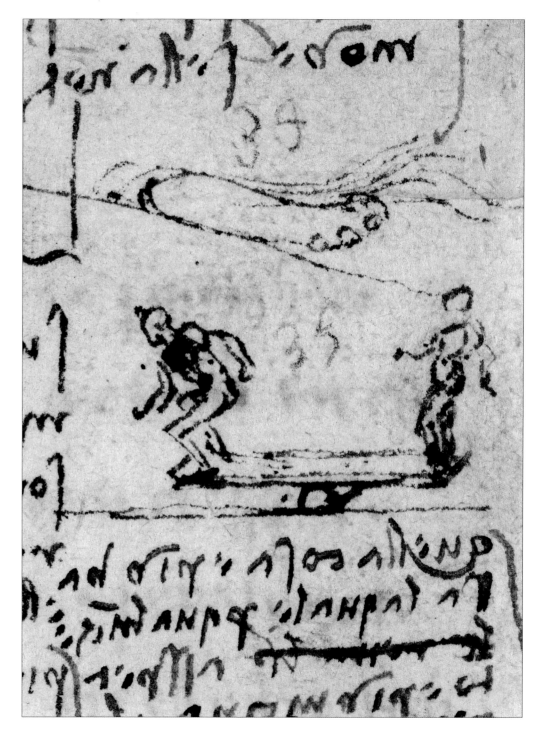

Leonardo da Vinci

Sheet discussing the movement of water on the earth, from the Codex Leicester

Here Leonardo considers how water rises to the summits of mountains. He offers a thoughtful theory likening human existence to that of the earth, while testing a traditional theory of the composition of the earth. This page is probably the last Leonardo wrote about the circulation of water in the body of the earth. He considers two explanations for water rising to the summits of mountains: water could be absorbed upward as into a porous sponge; and within the caverns of the earth, water could evaporate from the sun's heat and form vapour, much as the sun's heat generates clouds above the earth. Using prevailing climatic conditions and differences in temperatures to reason this second argument, he eventually rejects it. In so doing, he is led to the analogy of the process of distillation, a connection made by Ristoro d'Arezzo. Leonardo also theorizes that the heat generated from the centre of the earth would effect the levels of the oceans. He imagines a glass model of the earth as a still to explain how the

condensation of water is a 'downward process'. Next Leonardo poses a riddle in his description of distillation. The diagrams of inverted glass flasks and the accompanying text describe what happens when a burning coal is placed inside a vessel inverted over water. In the ancient version of this experiment, described by Heron of Alexandria, combustion consumes the air inside the vessel, and the water level rises. However, Leonardo places the burning coal 'on top of the vessel' rather than within, and he draws the diagram accordingly. Despite this deviation, he accurately describes that a vacuum effect, not heat, draws the water up. He applies the specific result of the experiment to the real world, arguing that in an open system – with the necessary hole on the side of a mountain as an outlet for water – the application of heat from above would not draw water up, but air in: *And if you want to convince yourself that water is not drawn up by fire, make a hole in the vessel m at point p, and you will see that the water will not leave its place.*

Sheet discussing the movement of water on the earth, from Codex Leicester

Leonardo advances from the general to the particular in his quest to explain watery spheres. As noted previously he concludes that siphoning is an inadequate concept to explain water on the tops of mountains. The left page with a dozen sketches of vessels and siphon systems, gives the impression that Leonardo worked in his laboratory, conducting imaginative experiments. In the main text, Leonardo contrasts two ways of calculating the location of the centre of the earth. In this context, he distinguishes between the 'universal watery sphere' and the 'particular watery sphere'. The Aristotelian distinction between the universal and the particular is one of the most important principles governing the conceptual organization of the entire codex. Generally speaking, the universal concerns that which endures forever, unchanging, like geometry for instance, the underlying form of a perfectly round sphere is universal. The particular concerns the individual, physical manifestation of form in matter. Leonardo names two conditions that pertain to the universal watery sphere: all universal waters are without movement, and the boundaries of their surfaces are equidistant from the centre of the world. His examples of universal 'centres of the sphericity' include canals, ditches, ponds, fountains, wells, stagnant rivers, lakes, marshes, swamps and seas. As for particular watery spheres, *the centre of a particular sphere of water is that which occurs in the tiniest particles of dew, which are seen in perfect roundness clustering upon the leaves of the plants on which it falls; it is of such lightness that it does not flatten itself upon the spot on which it rests, and it is almost supported by the atmosphere that surrounds it, so that it does not itself exert any pressure or form any foundation.* To explain the location of the centre of the drop of water, Leonardo describes, with characteristic precision, the action of a dewdrop as it grows in size and changes shape. Its spherical shape flattens, due to increasing internal pressure on its surface tension. Text and illustrations together explain that as the dome of the drop flattens out under these conditions, its surface comes closer to the perfectly round shape of the universal sphere. This argument has its root in the belief that geometric form is the defining force of nature. The governing factor is the attraction of the curve of the dewdrop to the curve of the universal sphere of water. With this force, mass overcomes surface tension. Leonardo directs this argument against, among others, Pliny the Elder's belief that the height of the seas is higher than that of the mountains, which is the key to the entire theory of the circulation of water in the body of the earth.

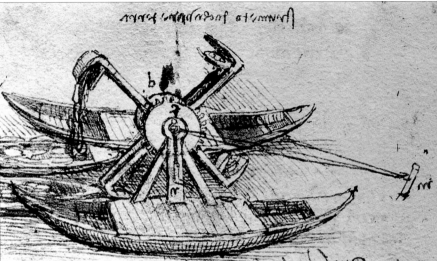

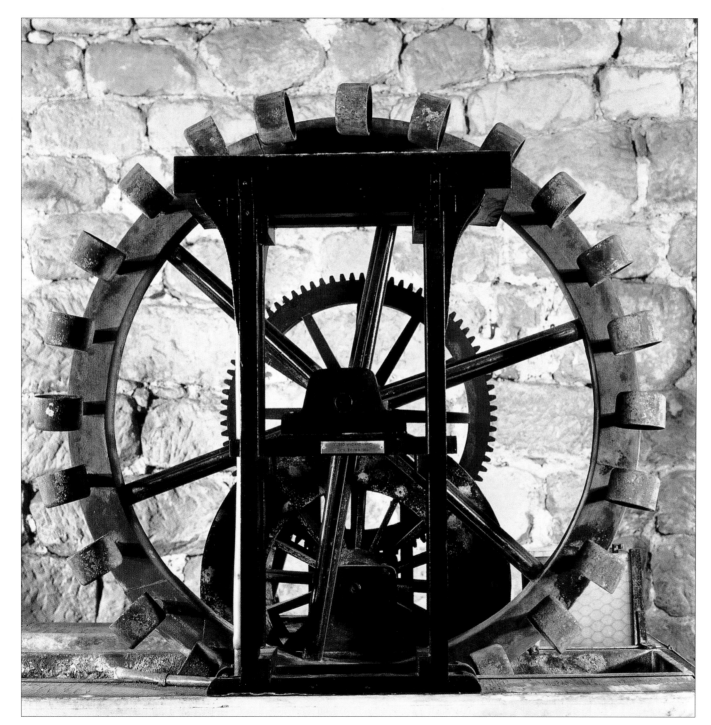

OPPOSITE

Design for a dredger and various hydraulic machines
Pen and ink on paper
Bibliothèque de l'Institut de France

LEFT

Model of a water wheel constructed from one of Leonardo's drawings
Leonardo da Vinci Museum, Vinci

RIGHT

Study for a dragon fight and studies of horse

Louvre, Paris

OPPOSITE

Studies of horses

Louvre, Paris

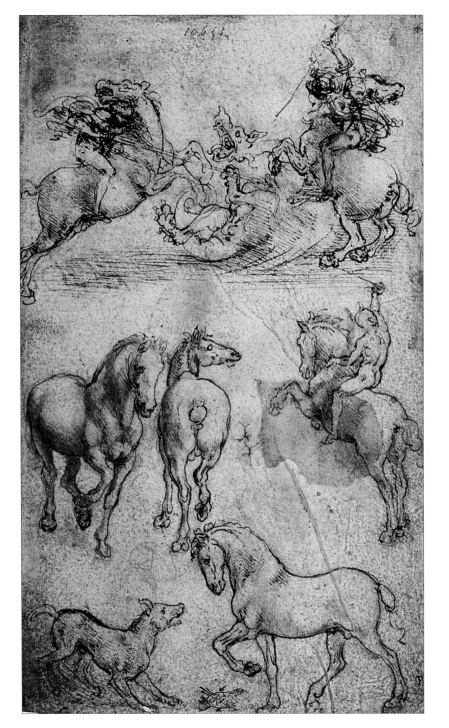

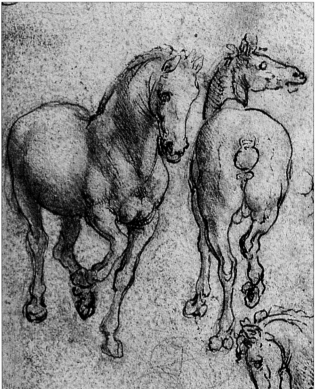

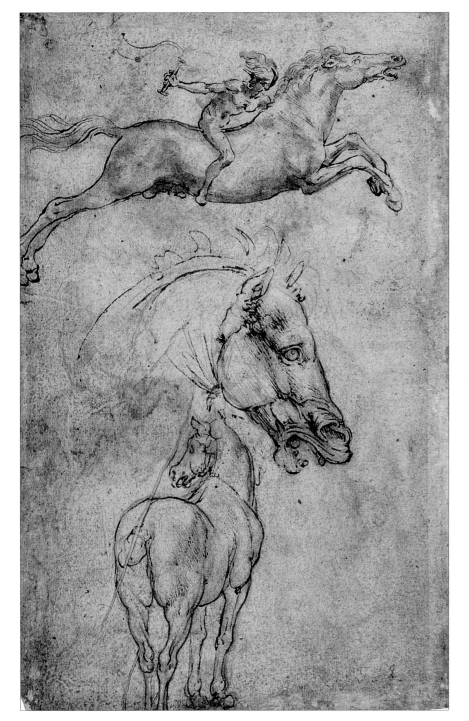

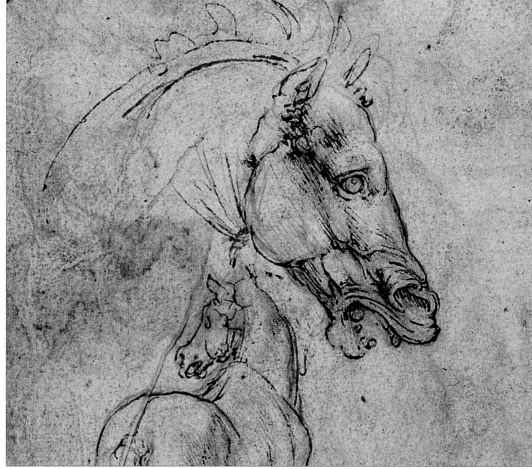

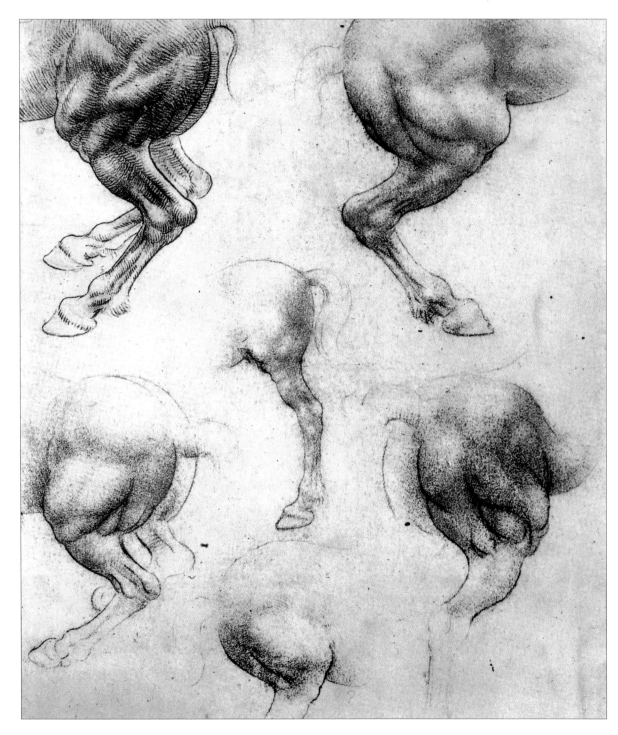

THE HORSE

In his letter to Lodovico listing his capacities, Leonardo said he was able 'to undertake the work of the horse, that will be to the immortal glory and eternal honour of my lord your father, of happy memory, and of the illustrious House of Sforza'. He referred to a planned equestrian statue of Francesco, the first Sforza duke, which had been projected by Galeazzo Maria and, after his murder, was enthusiastically taken up by Il Moro. Even if that letter were written, as some think, after Leonardo's arrival in Milan, the project was no doubt common knowledge elsewhere. Several artists had already been engaged for it, including, at some stage, Antonio Pollaiuolo, but not much progress had been made.

Lodovico had big ideas: this was to be an enormous work, and since the statue was to be bronze, not marble, it posed great technical difficulties. It therefore presented Leonardo with the kind of challenge he embraced with enthusiasm, but in this case he may well have felt hesitant. Vasari remarked that most people believed it was

OPPOSITE
Study of horses

These were probably executed in
preparation for the Sforza monument.

LEFT
**Sculpture drawing of a horse's
head, from the Codex Madrid**

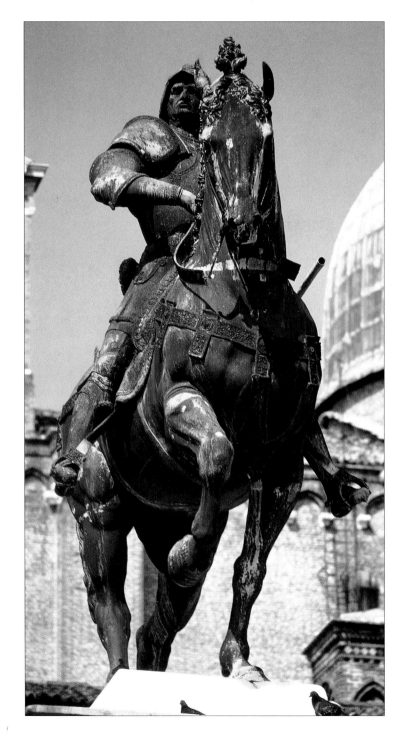

**The equestrian figure of
Bartolommeo Colleoni, by
Andrea Verrocchio** *(1481)*
Bronze
*Campo di SS. Giovanni e Paolo,
Venice*

**The equestrian figure of
Gattamelata, by Donatello** *(1453)*
Bronze
Piazza del Santo, Padua

*Bronze equestrian statues were rare,
but Leonardo had two successful
contemporary examples to study
(though neither of them was on the
scale of his own project). Bartolommeo
Colleoni and Erasmo Gattamelata were
both* condottieri *and Donatello's
Gattamelata was probably the stronger
influence on Leonardo by this time.*

impossible, and some thought Leonardo took it on
with no intention of completing it because, 'being
of so great a size, an incredible difficulty was
encountered in seeking to cast it in one piece'.
Such deceit on Leonardo's part is most unlikely,
and more probably, as Vasari suggested, 'one can
believe that his vast and most excellent mind was
hampered through being too full of desire, and that
his wish ever to seek out excellence upon
excellence, and perfection upon perfection, was the
reason [why it was never finished]'.

According to another near-contemporary,
Leonardo spent 16 years on 'the horse' (as he and
others always referred to it), and if so he must have
started work on it soon after he arrived in Milan.
But at some point the project languished, for
Leonardo noted on 23 April 1490, 'I resumed work
on the horse.' Some drawings of horses (at
Windsor) that appear to be studies for the statue
are of earlier date than that, so for whatever reason
there must have been a hiatus. In 1489 Lodovico
had inquired, through his envoy in Florence, about
the possibility of hiring one or two others to work

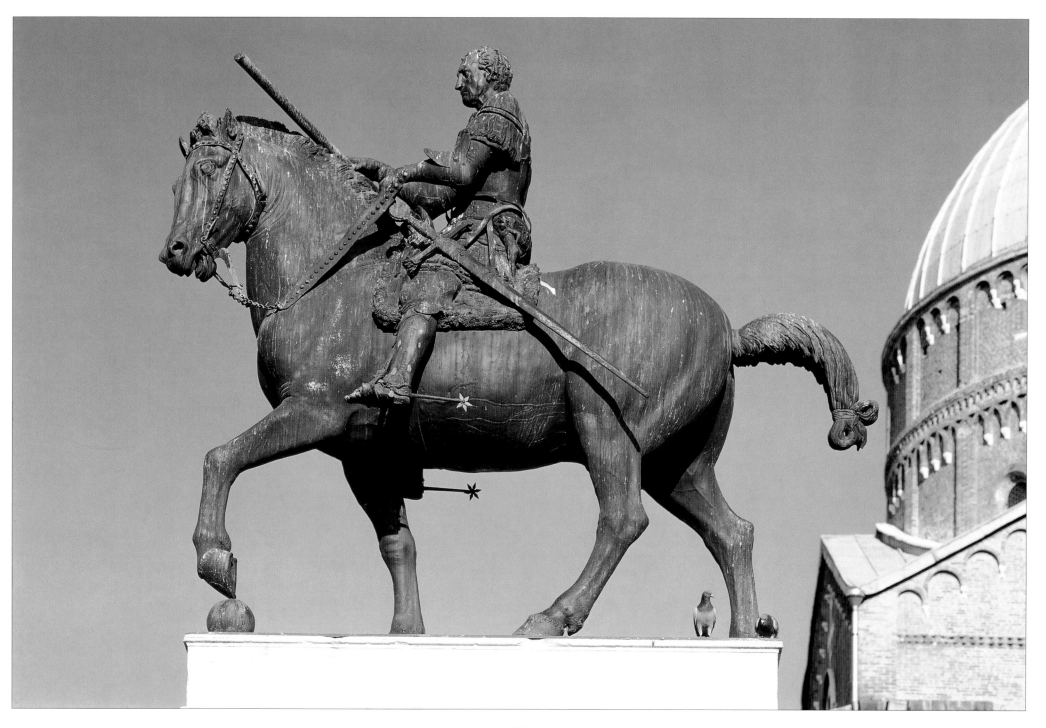

CATERINA

Leonardo expressed his deepest feelings not in words but with brush or pencil. As he tells so little of his personal life, every hint in his notebooks has been seized on eagerly by generations of writers, who have analyzed, interpreted and reinterpreted it, often building large hypotheses on the slenderest foundations. Some puzzles remain unsolved. Who, for instance, was the 'Caterina' whom he recorded as joining his household on 16 July 1493?

The artist – any artist – often tends to appear a solitary figure, largely through the nature of his or her work, and Leonardo, though he had many friends, had few intimates – so far as we know. But it would be wrong to picture him in his large studio in the Corte Vecchio, working away all day silent and undisturbed. Art was not produced like that during the Renaissance. Leonardo's studio, like Verrocchio's in Leonardo's youth, was a lively place, with students and assistants busily engaged on different projects. In 1493 he took on more, no doubt because he needed more hands. They included a goldsmith and a metalworker, while another man, a German craftsman known as Giulio who had his own workshop, made tools and locks for Leonardo on a part-time basis. There were several others, including of course the ubiquitous Salai, and Leonardo must also have employed a number of servants to cook and clean. The woman named Caterina may have been one of these. On the other hand, she may have been Leonardo's mother.

We are told that Caterina is an uncommon name in contemporary baptismal registers (though it surely cannot be called rare: we know of a number of people of that name). That is said to strengthen the supposition that she was Leonardo's mother, although others have suggested, rather flimsily, that her name may have been the reason why Leonardo hired her as a servant. He was not so sentimental. Leonardo's mother would have been in her mid-60s in 1493, old certainly, and an age when she may have been in need of constant care. Though she had other children, they were all daughters (her only other son was dead by this time), and none was so easily able to provide that care as her eldest son. But he could have done it without bringing her to Milan.

As we have seen, there is very little reference to Leonardo's mother elsewhere in his notebooks, though a few years earlier he had copied a passage from the *Metamorphoses* of Ovid about old age and on the same page jotted a question, 'Can you tell me what la Caterina wants to do'. The entry of 16 July 1493, which, coincidentally or not has on the reverse a number of names of people from Leonardo's childhood, is the next appearance. Her name appears again as the recipient of two small sums in a list of minor expenses on 29 January 1494, but is not repeated until it is seen on a list of expenses, undated but probably at least a year later, in connection with her funeral. There is no other comment, and it is said that the amount Leonardo laid out was generous for a servant who had not been in his service very long, but rather mean for a mother.

There is simply not enough evidence to say that Caterina was Leonardo's mother, and the balance of judgment among writers on Leonardo is weighted against it. But there is no evidence either that directly contradicts it.

on the horse, which suggests that he was losing confidence in Leonardo's ability to complete it without assistance.

An equestrian statue was the traditional form of commemoration for a great military leader (generally portrayed riding a stallion to emphasize his macho image) and several marble ones had been made in the 14th century, indeed earlier (the superb *Bamberg Rider*, admittedly less than life-size, dates from about 1230). At one time they were more numerous but, if erected in public spaces, as they usually were, they were too tempting a target for vandals and revolutionaries, and many perished. There was a well-known equestrian sculpture in Rome, but Leonardo may not have known it at first hand.

One that he certainly did know was the *Regisole*, a bronze of the 5th-century Germanic ruler of Italy, Odoacer, in Pavia, which he admired, especially 'for its movement'. It was destroyed in 1796 but two more famous and more recent examples survive: Donatello's statue of the *condottiere* Gattamelata of 1453, and – no doubt the monument with which

Studies for St. Mary Magdalene
(c.1480)
Pen and brown ink on paper
Courtauld Gallery, London

This small study (5½ x 3in/14 x 8cm) has two studies of the Magdalene (identified by her box of ointment), which cannot be connected with any known work. On grounds of style it seems to belong to Leonardo's first Florentine period, although the great Leonardo expert, Carlo Pedretti, put it as late as 1508.

Leonardo was most familiar – the statue that occupied Verrocchio's last years of another Venetian *condottiere*, Colleoni. That project was already under way before Leonardo left Florence and must have occupied a prominent place in Leonardo's thoughts, especially in 1488 when his old master, after a day spent at the foundry superintending the casting of his final masterpiece, caught a chill and died.

The Windsor drawings show that Leonardo's original intention was for a rearing horse, a more dynamic pose than the striding horses of the Donatello and Verrocchio monuments. Naturally, Leonardo sought to excel them both. The difficulties – how to balance a horse standing on its hind legs only – are obvious, and a prancing horse had not been attempted in any of the statues of *condottieri*, though it was not unknown (but in marble, a very different matter) in Roman sculpture.

The early drawings show how Leonardo tried to solve the problem. In one, a fallen enemy lies under the horse with right arm raised, holding a

shield that supports the horse's forelegs. A similar figure appears in the *Adoration of the Magi*, and, according to Vasari's written description, in a drawing for the Sforza monument by Pollaiuolo. The latter is possibly earlier than Leonardo's though equally possibly not seen by him, while in a surviving drawing by Pollaiuolo the figure on the ground is a woman whose uplifted left arm provides support. In another of Leonardo's studies, the human figure is replaced by a tree stump, a rather mundane and uninspiring device. At some stage Leonardo must have reluctantly concluded that a rearing horse was simply impractical, and reverted to the established model of a proudly striding horse.

Naturally, Leonardo did not confine his studies to sculpture, the work of man, but sought guidance in the work of nature, paying many visits to the ducal stables and making innumerable beautiful drawings, chiefly in silverpoint, from every angle. Their number and quality testify to his affirmed affinity with horses and justify Vasari's encomium on 'his incredible mastery of form and line in

Sketch of a horse and various other diagrams
Pen and ink on paper
Bibloteca Nacional, Madrid

Sketch of a horse and other devices from the Codex Madrid, *possibly connected with efforts to determine weight and stress in an equestrian monument.*

dealing with horses, which he made better than any other master, with their powerful muscles and graceful beauty'. He was particularly taken with certain individuals in Milan, which he mentioned by name, such as the large and splendid charger known as The Sicilian (drawing at Windsor). As so often, his research threatened to carry him far from the project in hand. He is said to have written a treatise on the anatomy of horses, though if so it has not survived, and his experience of the Milan stables prompted him to design cleaner, healthier accommodation for horses which, though not built in Milan, may be reflected in his later structure in Florence.

In the autumn of 1493 Leonardo made a full-size model of the Horse in clay, which was put on public view in the Castello for the wedding (by proxy) of Bianca Maria Sforza to the Emperor Maximilian. It was the size of a building, nearly 23-ft (7-m) high without rider or plinth. It caused a sensation. Never had anyone seen anything more magnificent. 'Neither Greece not Rome', declared Lodovico's chancellor Baldassare Taccone, 'saw any

finer work.' Unfortunately, no one described it in detail, but drawings show what it probably looked like and there are representations of horses by other artists that seem to derive from Leonardo's monument. They indicate a steadily pacing horse owing something to Leonardo's studies from life, something to classical models and something to the *Gattemelata* of Donatello, for Leonardo opted for the stately strength of Donatello's statue rather than the nervous, reined-in tension of Verrocchio's *Colleoni*.

The fate of the model, according to tradition, was depressing. It was still on display when the French took over Milan in 1499 and, though it prompted more admiration, that did not prevent it being used, some time later, as a target by French archers. Thereafter it was taken to Ferrara, where it gradually crumbled away from neglect.

Meanwhile, Leonardo devoted much of the next two years to the problems of casting, to which, as his notebooks confirm, he gave long and careful thought, while making many visits to the cannon foundries. It was always difficult for Leonardo to

undertake any task without introducing modifications and inventions of his own, but because the sheer size of the Horse was unprecedented, many aspects of the operation required new ideas. Of course, Leonardo also researched even areas where customary methods might have been thought perfectly adequate, from recipes for alloys to a kind of wire brush for polishing.

The *cire perdue* ('lost wax') method of casting bronze was ancient, known in Egypt in the 1st millennium BC and in China even earlier. But the art seems to have been lost almost completely in the Middle Ages, when bronzes were made by hammering a thin sheet of metal over a wooden core. In the *cire perdue* method, wax is poured into the narrow space between the core and the enclosing mould, the inner surface of which is a reverse impression of the surface of the final bronze, although a common alternative was to carve the solidified wax before covering it with a layer of clay. The wax is melted and drained, and replaced by molten bronze. When it sets, the mould

is removed (or simply broken, which means only one cast is possible) and the surface finished, perhaps being chased or engraved with chisels before filing and polishing.

It was common practice to cast a large bronze in several separate parts, which were then welded together. While technically simpler, this method had some problems of its own. It was difficult to avoid slight discrepancies between the thickness of the metal (and therefore its weight) in different parts, and it was almost impossible to eradicate all evidence of the welds. These are not very serious limitations, but they would irritate a perfectionist to whom accuracy of detail was vital. At any rate, with characteristic boldness, Leonardo concluded that his Horse would have to be cast in one piece. To ensure that the molten bronze, on being poured through narrow channels into the mould, would fill all parts quickly with no great disparities in temperature, a very large number of holes were necessary.

His original plan was to dig a large pit in which the mould would be buried upside down. The

Leonardo da Vinci

bronze would be poured in through the belly and the displaced air released through holes in the feet. He had to abandon this plan when he realized that the pit would be so deep that it would encroach upon the water table. A possible alternative was to bury it on its side, requiring a shallower pit. Many drawings survive of the experiments and techniques Leonardo toyed with. In the Madrid codex, only rediscovered in the 1960s, there is a remarkable drawing of the casing for the head, either for casting or as protection during transport.

We might say that all this effort was in vain, except that for Leonardo the acquisition of knowledge was never a vain exercise. And this time, though we may have serious doubts that the great Horse could ever have been successfully cast, he was not to blame for the ultimate cancellation of the project. For the French invasion of Italy, encouraged, ironically, by Lodovico for whom it would mean eventual ruin, was imminent. Had Leonardo's great Horse been a real animal in 1494 he might have behaved like the war horse in the Book of Job, which 'saith among the trumpets Ha, ha; [for] he smelleth the battle afar off'. The bronze that Lodovico had amassed for the Horse, all 70 tons of it, went to the cannon foundries, and Leonardo, in a letter to the duke pointing out that he had not been paid for a couple of years, added a forbearing note: 'about the horse I will say nothing, for I know what times these are.'

OPPOSITE

The Journey of the Magi by

Benozzo Gozzoli *(c.1460)*

Fresco

Palazzo Medici-Riccardi, Florence

Fresco was the finest art form of the Florentine quattrocento: this is a detail from Gozzoli's Journey of the Magi cycle in the chapel of the Medici palace.

FRESCO

Fresco, a form of mural, or painting on a wall, is associated primarily with Renaissance Italy from the 13th to the 16th centuries. A kind of fresco was used in ancient times, for instance at Pompeii. After its last great exponent, Tiepolo in the 18th century, the technique declined. It was revived in the 19th century, with mixed success (a scheme to decorate the British Houses of Parliament with frescoes failed, partly due to industrial air pollution), and the Mexican mural painters of the early 20th century used a form of fresco.

There are two types, 'dry' fresco (*fresco secco*), something of a contradiction in terms since fresco means 'wet', and 'true' or 'good' fresco (*fresco buono*), far more important, in which the paint is applied to wet plaster. The great advantage of true fresco is that it is extremely hard-wearing, owing to a chemical reaction which bonds the water-based pigments and the wet plaster as it dries. The painting will thus last as long as the wall or, more precisely, as long as the plaster.

The usual procedure, though there were variants, is as follows. A thick coating, called the *arriccio*, is applied all over the rough plaster. On this the design is drawn, either as *sinopia*, the name of the reddish chalk used and hence of the actual drawing, or transferred from a fully detailed cartoon. The cartoon can be transferred in one of several ways, by rubbing the back with chalk and going over the lines with a stylus, or alternatively by pricking out the lines in tiny holes and pouncing with fine charcoal dust. The method depends on the presumption that the final painting will follow the cartoon without variation, and allows the actual painting to be done by assistants. If working from a *sinopia*, more common in the early Renaissance, the artist may make changes as he paints, although not once the plaster has dried.

The final layer of plaster, the *intonaco*, is applied to roughly as much of the design as can be painted in one day (hence the term for such an area, *giornata*, 'a day's work'), and the cartoon is drawn again over it to link up with the rest. The pigment is mixed with water and applied to the wet plaster. The artist has to know exactly what he is doing, and he must proceed, as Vasari says, with 'vigour, certainty and promptness in decision', since

Leonardo da Vinci

he cannot make substantial corrections. The pigment quickly seeps into the wet plaster and within a few hours is permanent. As he paints, the artist must also keep in mind that the colours will dry to a lighter shade. At the end of the day, any of the *intonaco* that remains unpainted is removed to be reapplied, wet, the following day.

'Dry' fresco was sometimes used to make small alterations, but since the pigments are not integrated with the plaster as in 'true' fresco, it is

OPPOSITE
Ceiling of the Sistine Chapel
(1508–12)
Fresco by Michelangelo
Vatican, Rome

LEFT
The Lives of St. Stephen and St.
John the Baptist *(1452–65)*
Fresco by Fra Filippo Lippi
Prato Cathedral

The funeral of St. Stephen, a detail from the cycle.

RIGHT

The Crucifixion, by Giotto

(c.1305) detail of an angel

Fresco

Scrovegni (Arena) Chapel, Padua

OPPOSITE

St. Jerome Checks the Stigmata on the Body of St. Francis, by Giotto *(1296–97)*

Fresco

San Francesco, Assisi

subject to scaling. However, modern research techniques have revealed that it was more often used than had been thought, and on the whole survived rather well (much better, certainly, than the *Last Supper*). All fresco is vulnerable to humidity and weathering, but the climate of central Italy was particularly favourable, and it is probably significant that in Venice, with its damper climate, fresco was less popular than in Florence or Rome.

Fresco had certain limitations, most obviously the necessity to work fast and with perfect confidence. The colour range was also more limited than in oil paint, and dark tones were particularly tricky, in fact best avoided. That largely accounts for the spring-like brightness of Renaissance frescoes which, to us, is one of their chief attractions. Verrocchio never mastered fresco and therefore did not teach it to Leonardo. Although from what we know of Leonardo's way of working the technique would not have suited him, the fact that he never learned the method as a young apprentice may be connected with his disastrous experiments in mural painting.

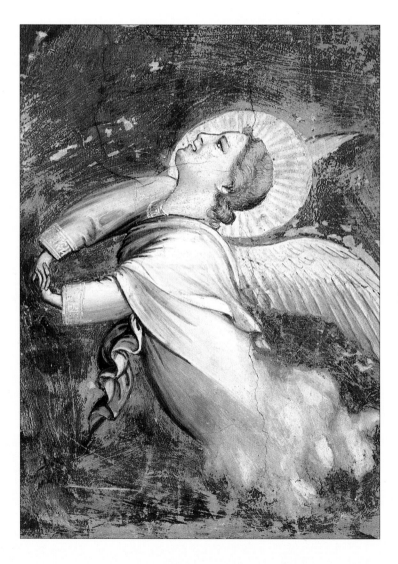

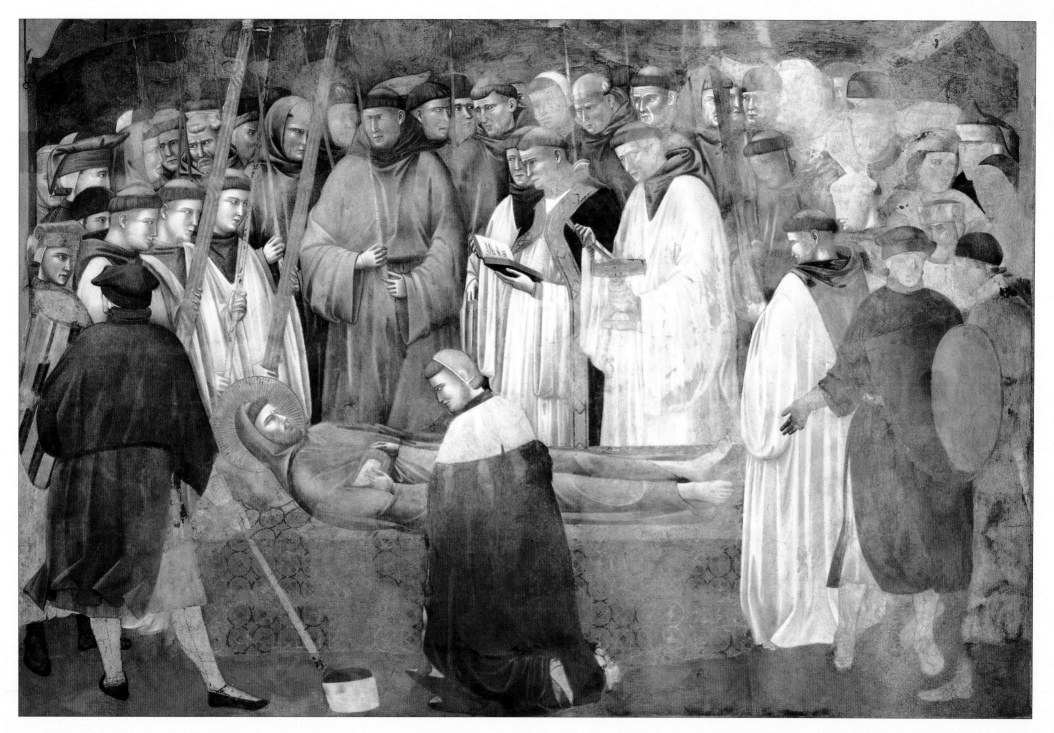

The Last Supper *(1495–97)*

Fresco

Santa Maria delle Grazie, Milan

The Last Supper *after the recent restoration. The painting, which measures roughly 29 x 15ft (9 x 4.6m), occupied Leonardo for three years. It replaced the Horse, abandoned after the bronze allotted to it had been diverted to the cannon foundry, as his major project. Although we can no longer admire Leonardo's paintwork, what is not obscured is the composition, which has been hailed as 'surely the most ingenious ... in the history of art'.*

THE LAST SUPPER

It is difficult to discuss one of the icons of our civilization ('the keystone of European art' – Clark) in terms of an ordinary painting, albeit by a great artist, and the *Last Supper* is not so much a painting as a legend, which has become all too familiar through innumerable reproductions for various, often inappropriate, purposes. Few pictures have been so endlessly printed, copied, embroidered on, satirized. (In Maurice Henry's amusing drawing, the reactions of the disciples are provoked by Christ's pulling off a card trick.)

In a curious way, the ruined state of the *Last Supper* is an important part of the legend, and its present fame has little to do with its qualities as a painting, for which, indeed, the evidence for a judgement barely exists. If you arrive early enough to head the queue, you may get a quick look at it before you are moved on, and it is inspiriting, as Goethe found when he saw it on his Italian tour, to see it in its original setting. You may still get a dim perception of Leonardo's design, but you will see virtually nothing of his brushwork.

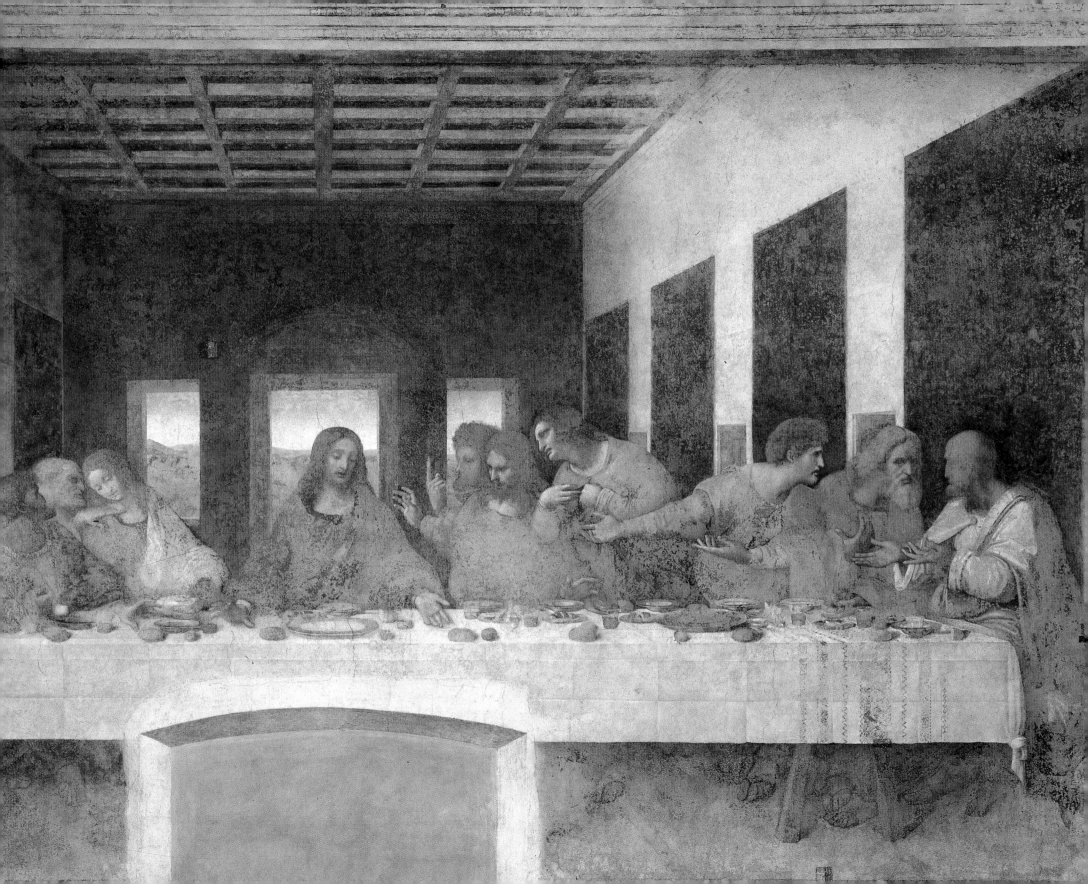

The Last Supper (restored)

This detail of the face of the central, divine figure presented Leonardo with a serious problem, and he apparently left the features deliberately vague.

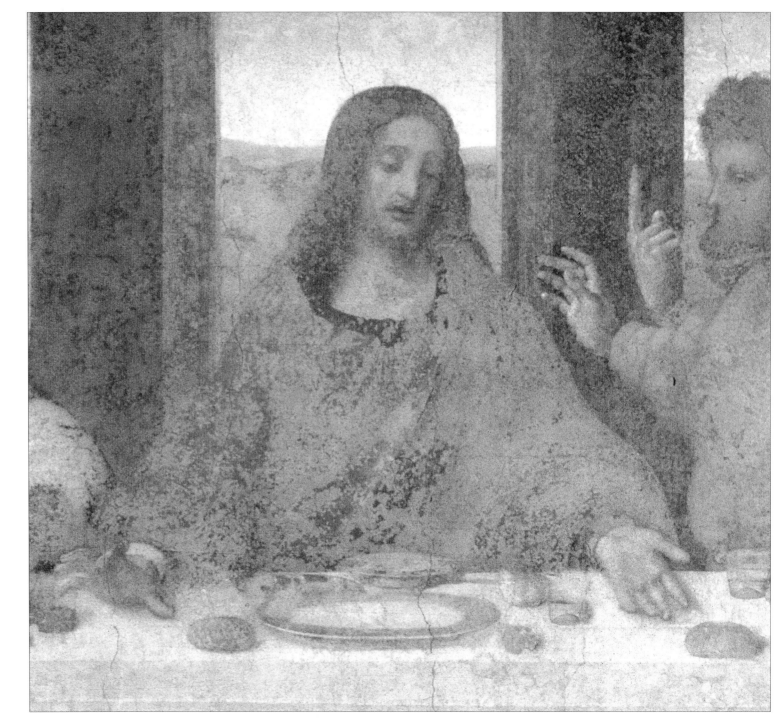

Leonardo da Vinci

Modern restorers can work marvels, no doubt, but Leonardo's masterpiece had deteriorated too far long before adequate techniques were developed. Up to a point you can restore damage; you cannot restore what does not exist. The latest restorer, Dr. Pinin Brambilla Barcilon, invited Leo Steinberg (as he relates in his *Leonardo's Incessant Last Supper*) to 'peer through a microscope while she aimed her scalpel at scattered flakes of original pigment. She would point to a chip, the size of your smallest fingernail, saying 'Here is a bit of Leonardo … What we see now if we look close are [tiny islands] of original pigment afloat in flat washes of pale, removable watercolour' applied by the restorer to join them up.

The *Last Supper* has been restored many times, exactly how many we do not know because only work done in the past two centuries is documented, and then fragmentarily. The painting is not an orthodox fresco. Leonardo devised a new medium incorporating oil, which had several advantages and did not have to be painted in a hurry, before the plaster dried, so that alterations could be made later. But it had the overwhelming disadvantage that it did not wear well. The trouble may have been due not only to the paint but to his own recipe for the preparation of the wall, the final coat of which included a damaging yellow clay. The dampness of the building and its low-lying situation did not help matters, but a Crucifixion painted in fresco on the opposite wall of the refectory a few years earlier by a Milanese artist is, by comparison, in depressingly good condition, while the Sforza family portraits which Leonardo added to it are now visible only as outlines. All survived several floods, desecration by troops of the French Revolutionary armies, and in 1945 a bomb that fell on the building.

In fact Leonardo's painting seems to have begun to crack and discolour very quickly, in his own lifetime. A visitor in 1517 noted that it had deteriorated even then, only 20 years after it was finished, and in 1556, it was described as mostly 'blots'. Less than a century later, in 1642, Francesco Scanelli reported that only traces of the figures remained and it was difficult to make out the subject of the painting. Yet, much later, the painting

The Last Supper *(restored)*
Detail of the apostles

The apostles are divided into four groups of three, two on each side of Christ, each group interacting. Leonardo's oft-stated emphasis on the importance of feature and gesture to convey character are still evident in spite of the state of the painting.

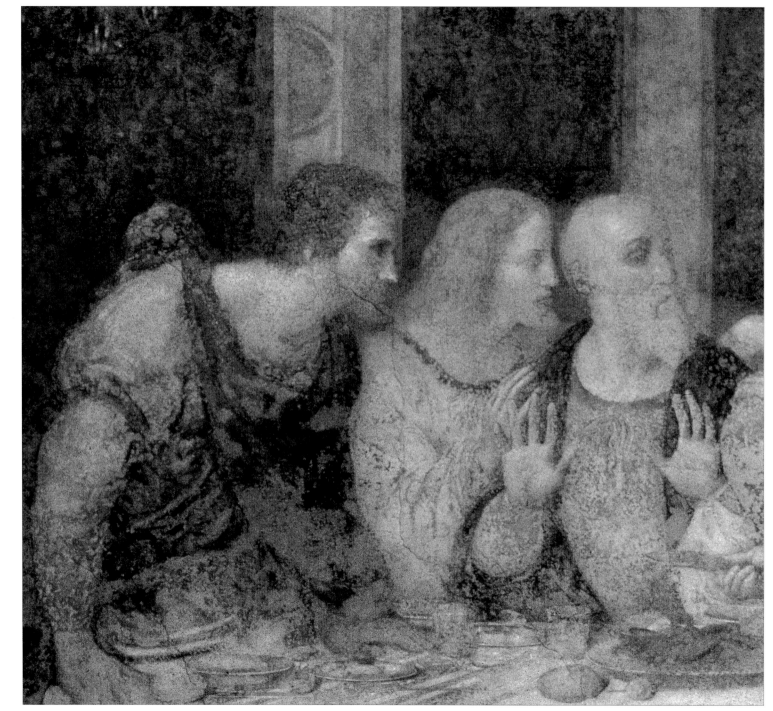

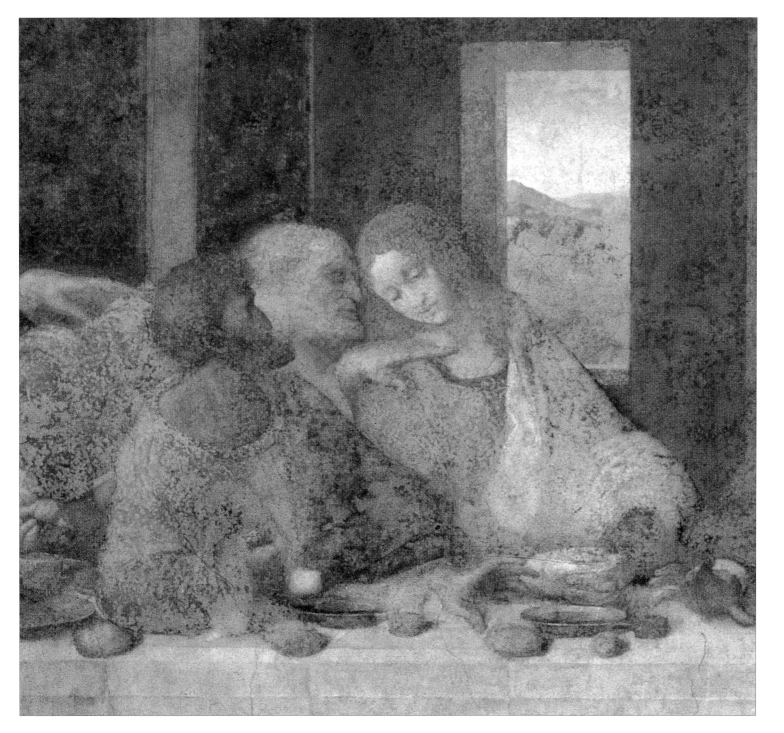

The Last Supper *(restored)*
Detail of the apostles

seems to have mysteriously recovered. When it was cleaned in 1908 by Luigi Cavenaghi, an expert of international renown, he reported very favourably and concluded that only one small area had been repainted. Since he also remarked that Leonardo had used a medium not usually found until the late 16th century, it is clear he was misled, interpreting repainting of about that date as Leonardo's original work. Kenneth Clark, making this point, indicated further evidence of extensive repainting in obvious differences, especially in some of the apostles' heads, between what was apparent in the 1930s (when he was writing) and what we know, from Leonardo's drawings and subsequent copies of the painting, was the original appearance – the result of a restorer's simple inability to follow Leonardo's subtle and technically difficult lines.

Since the latest, and no doubt best, restoration, it is to be hoped that the painting is now closer in appearance to Leonardo than before. But it is still not Leonardo. And – another point not often made – each restoration of a painting is one step further away from the original. One needs to think

carefully before obliterating an earlier restorer's work simply because it is a restoration.

The painting was commissioned by Lodovico himself for the refectory of the Dominican friars of Santa Maria delle Grazie, a house in which he had a special interest. Bramante designed the cupola and crossing of the church, and work was still going on while Leonardo was painting in the refectory. The monastery was said to be a favourite of Beatrice, who spent what were almost her last days there. After her death the day after New Year, following all-night revelry and a consequent miscarriage, masses were said for her every hour of the day.

The first written mention of the picture occurs in a memo of Lodovico in 1497, which speaks of it being almost finished. It was a conventional subject for a monastic refectory, although Leonardo did not treat it in a conventional manner. As always, immense thought and the most detailed studies preceded the work: Leonardo even noted the weight of each figure. His final composition – existing studies show him trying out various

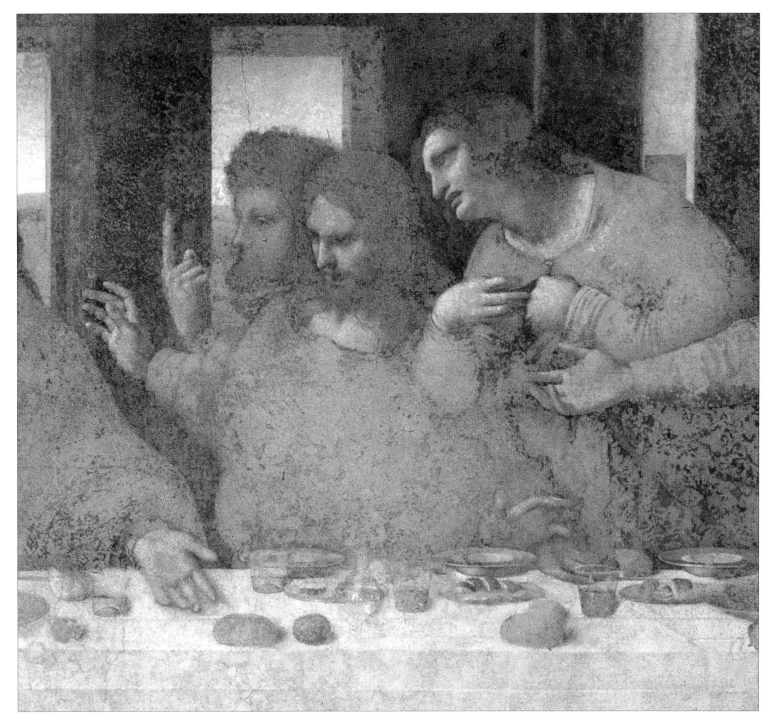

The Last Supper *(restored)*
Detail of the apostles

Alarm has driven St. Philip to his feet.

The Last Supper *(restored)*

Detail of the apostles

St. Bartholomew is also on his feet, questioning St. Peter, who denies any knowledge of a traitor among them.

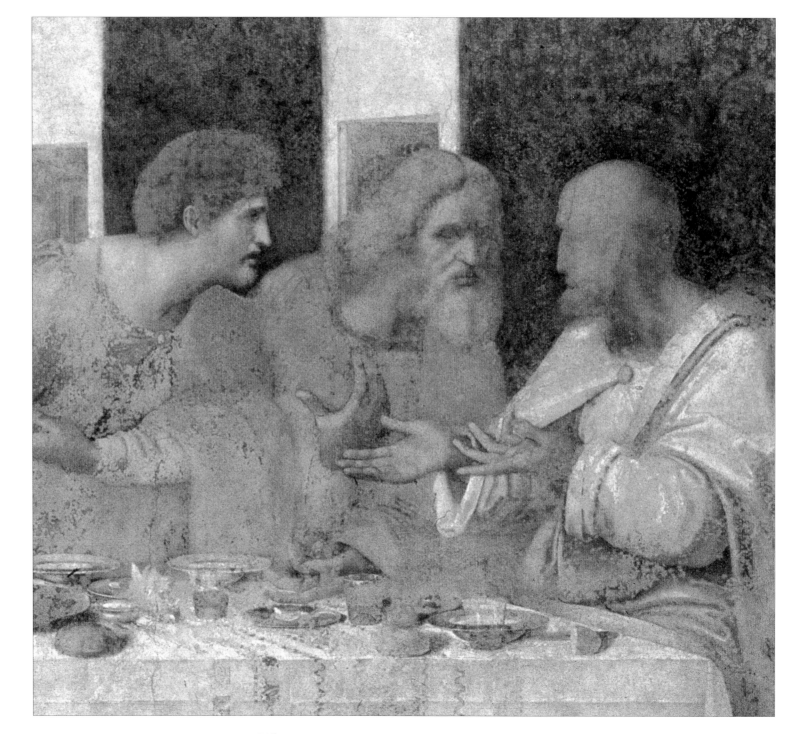

alternatives first – presents the scene as if a continuation of the actual refectory, and employs a dramatic perspective (it is theoretically 'incorrect') which shows the side walls opening out so sharply that one seems to be looking into one end of a hexagon rather than a rectangle. The 'vanishing point' is behind Christ's head, and the calm central figure is further emphasized by being framed against the central window and by the fact that his face is the only one seen frontally.

In conventional paintings of this scene by Ghirlandaio, Perugino and others, a line of 11 apostles appears on the far side of the table with Judas, isolated, on the near side. Drawings show that Leonardo's early ideas followed this tradition, before he moved Judas to the other side, partly no doubt for the sake of symmetry, creating thereby the wonderful assembly of four related groups each of three apostles that form the dynamic of the design.

It also changed the nature of the drama, since Leonardo chose not the solemn moment of the breaking of bread which, as the Eucharist, became the central ritual of the Christian Church, but the dramatic moment at which Christ declares, 'One of you will betray me,' causing the outburst of emotions – consternation, fear, anger, anxiety, doubt (St. Thomas with his lifted finger) – so brilliantly conveyed not only by facial expression (though we must take this largely on trust), but by gesture, which Leonardo insisted should always indicate character, thought or 'the passions of the soul': The painter, he said, must represent two things, first the person, second his state of mind. The second was more difficult, for it had to be done 'through the gestures and movements of the limbs'. He recommends studying the dumb, who express themselves better through gesture than those who can speak. In one of his notebooks he describes in minute detail the activities of the apostles as if from the finished painting: One ' twists the fingers of his hands together and turns grim-faced to his companion. Another with hands outspread showing the palms, shrugs his shoulders...'.

The usual interpretation of the painting as depicting the moment of Christ's announcement of his imminent betrayal has recently incurred criticism

Santa Maria delle Grazie, Milan

The scene in the refectory during the recent restoration, which took considerably longer than Leonardo took to complete the painting in 1495–97.

as too 'secular', ignoring the sacramental aspect of
the occasion, the mystery of the Eucharist. It is
difficult to accept that the moment portrayed is
actually the institution of the holy sacrament after
all (as it was in an early drawing), but it is easy to
feel some sympathy with the view (advanced by
Leo Steinberg) that the painting should not be
seen as fixed exclusively in a single moment, like
a photograph.

The *Last Supper* is a powerfully austere painting.
Cecil Gould lamented that as it had been done in
Milan it was not seen by the contemporary painters
of Florence who would have derived great
stimulation from it, not least Raphael, for whom the
more 'classical' side of Leonardo held a strong
appeal (it is also interesting to speculate what
impression it might have made on Michelangelo).
Everything is concentrated on the figures, and there
is a marked absence of any kind of decoration. The
room is as plain and bare as no doubt it would
have been in Jerusalem 15 centuries before, and as
the Dominicans' refectory certainly was in the 1490s

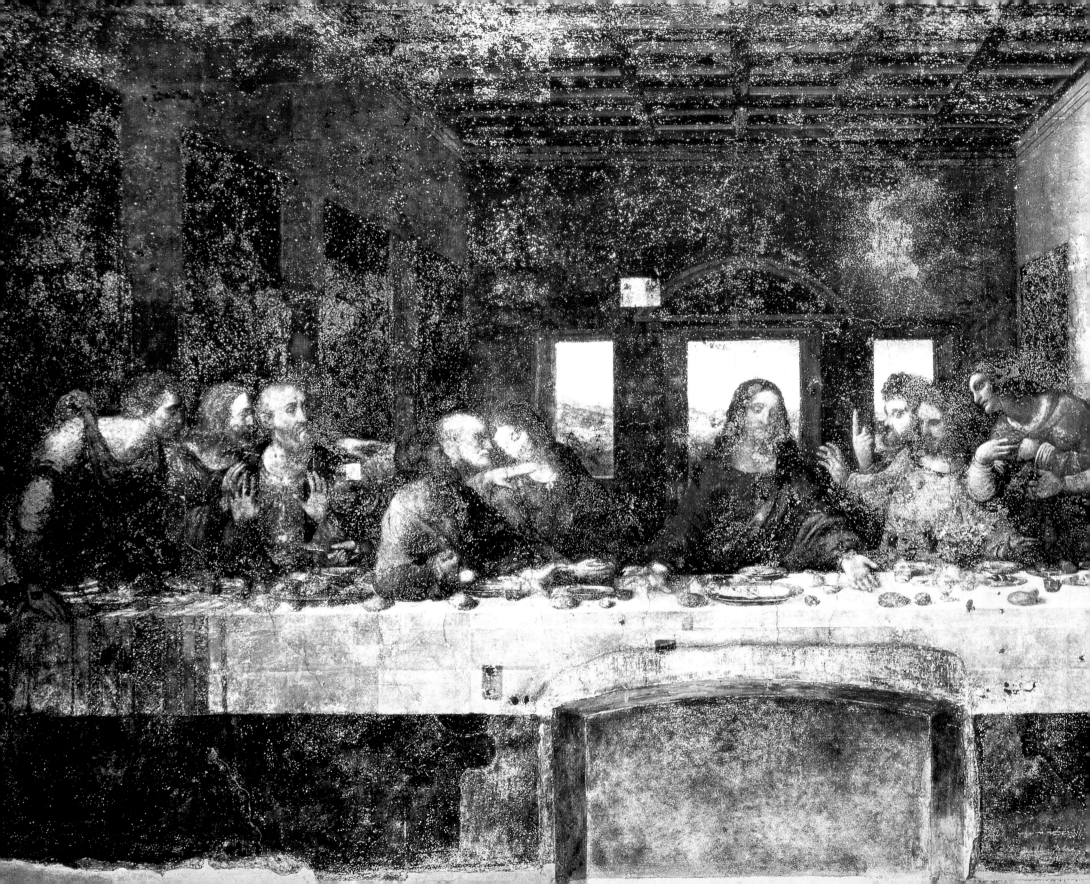

Leonardo da Vinci

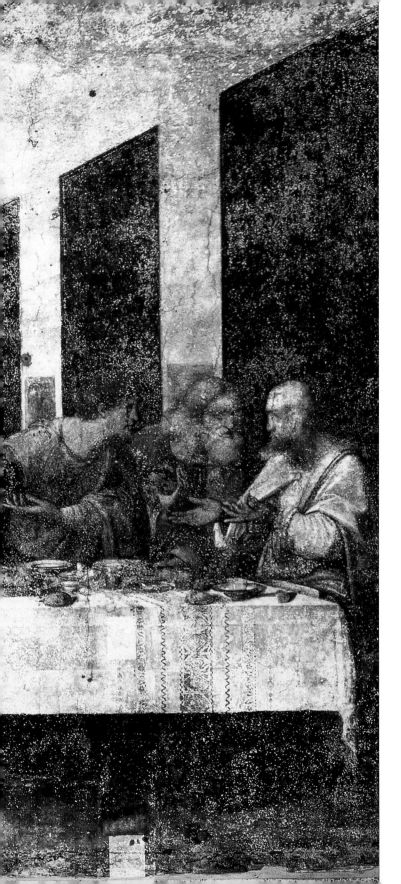

(Goethe suggested that the table and its contents reflected the actual refectory table). Not a sign can be seen here of Leonardoesque fantasy, nor of that element of queerish softness which in some pictures – the late *St. John* for instance – is the nearest that Leonardo comes to revealing a temperamental weakness as an artist.

Quite apart from Leonardo's irrepressible urge to experiment, it is obvious that traditional, true fresco would have been impossible for the *Last Supper* in the light of what we know of his work practices. A memorable account of these has survived from the writer Matteo Bandello, who recalled his experience as a boy-novice at the monastery, where his uncle was prior. He would see Leonardo arrive in the refectory early in the morning, climb the scaffolding (the bottom of the painting is above head height) and at once begin to paint.

He sometimes stayed there from dawn to dusk, never laying down his brush, forgetting to eat or drink, painting without a pause. Then for several days he might not touch a brush, spending an hour or two standing in front of the work with arms

The Last Supper *(as it looked before the recent restoration)*

RIGHT

The Last Supper

Detail of Christ before the recent restoration.

OPPOSITE

Detail of the apostles (unrestored)

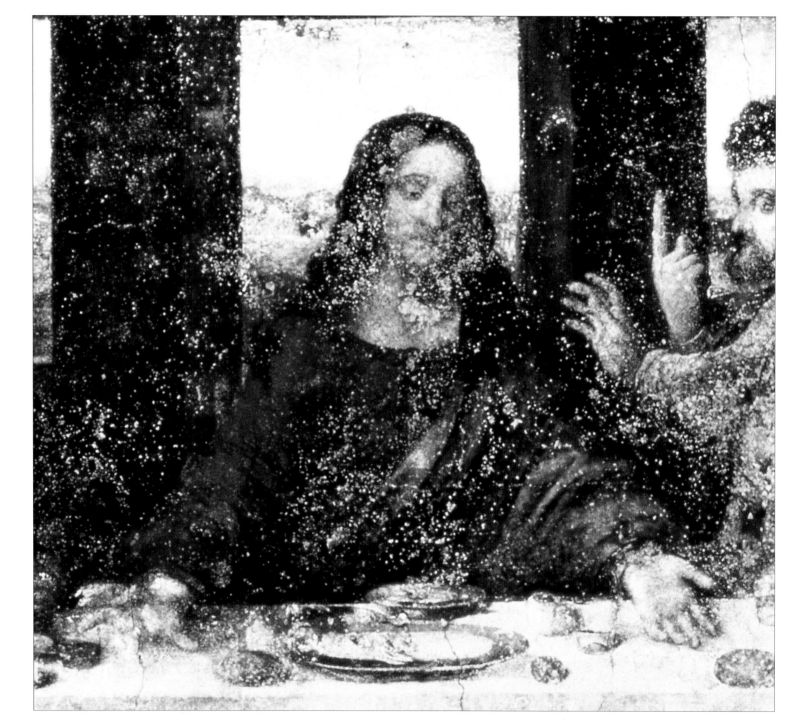

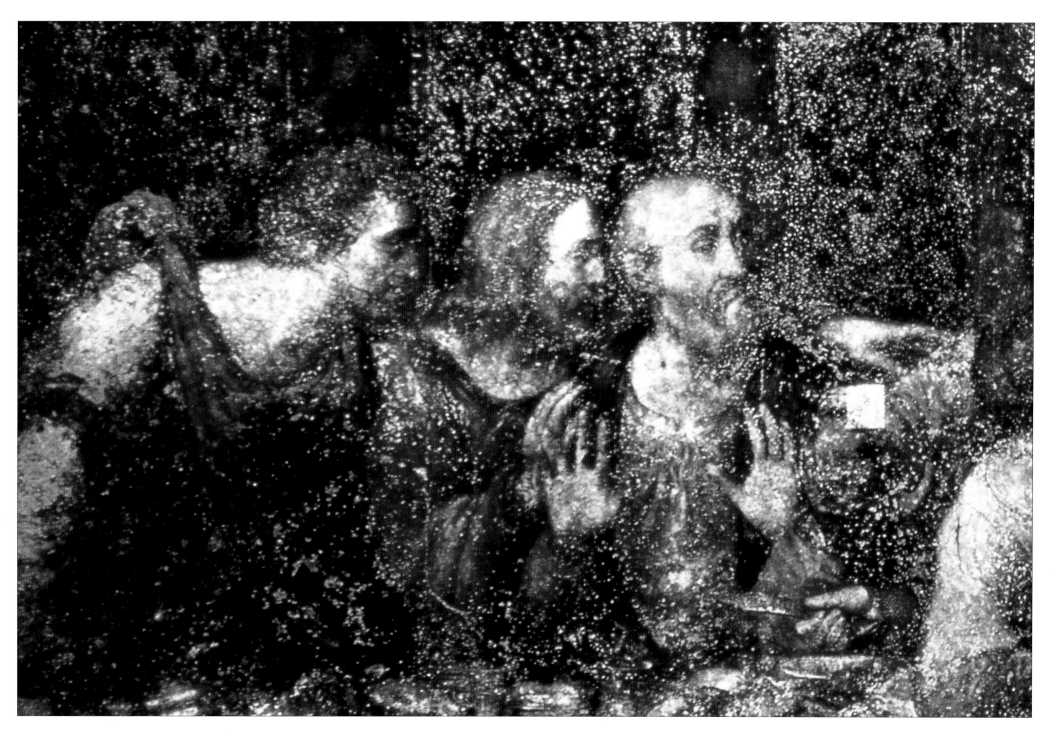

The Last Supper

Details of the apostles (unrestored)

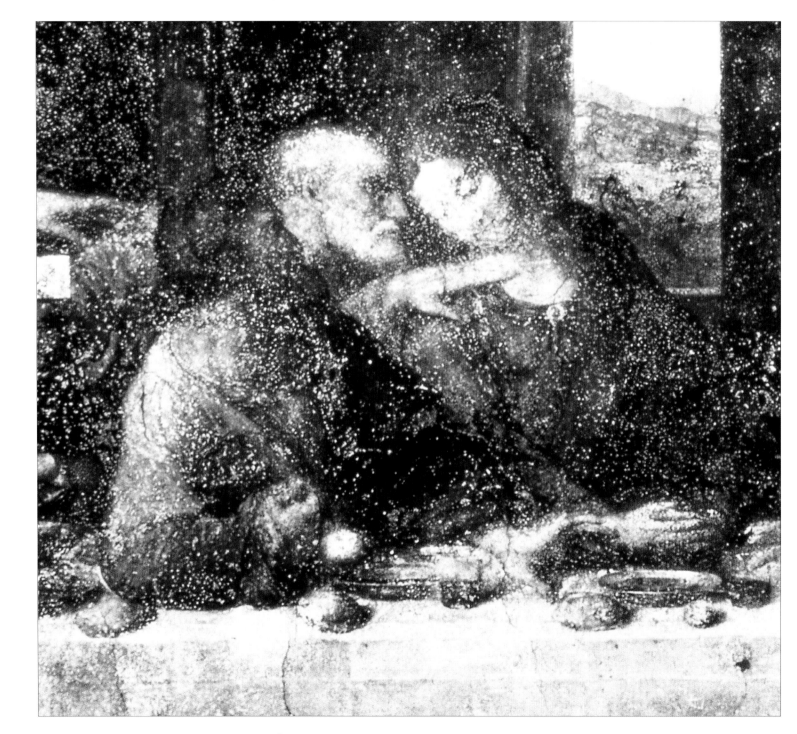

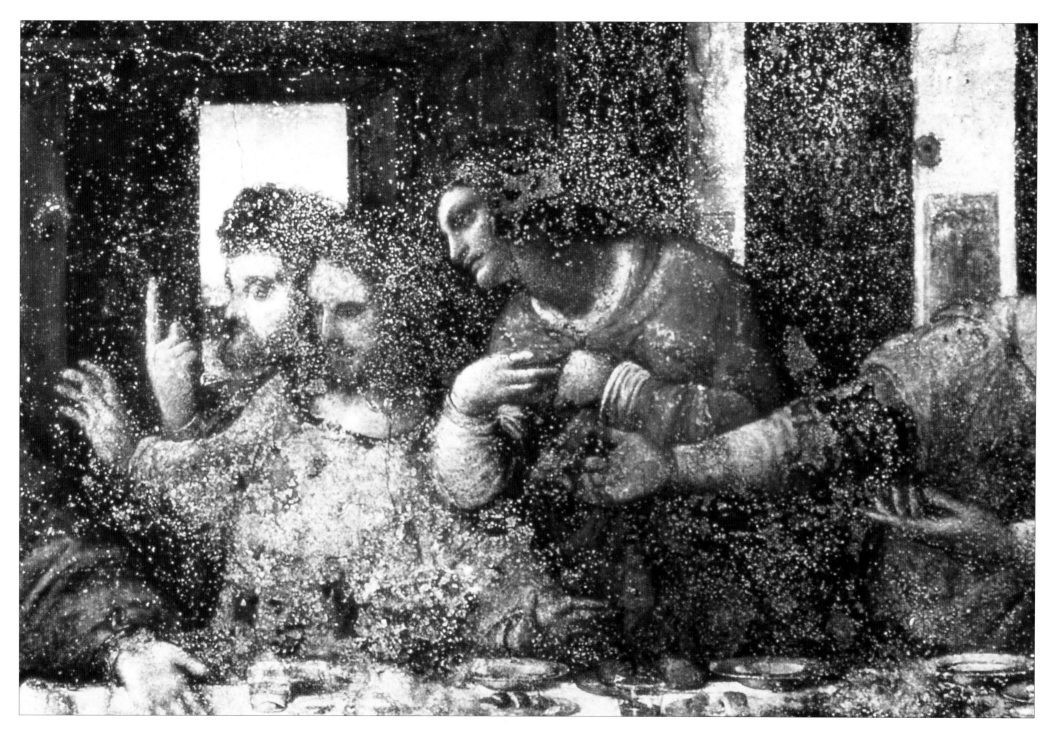

The Last Supper

Details of the apostles (unrestored)

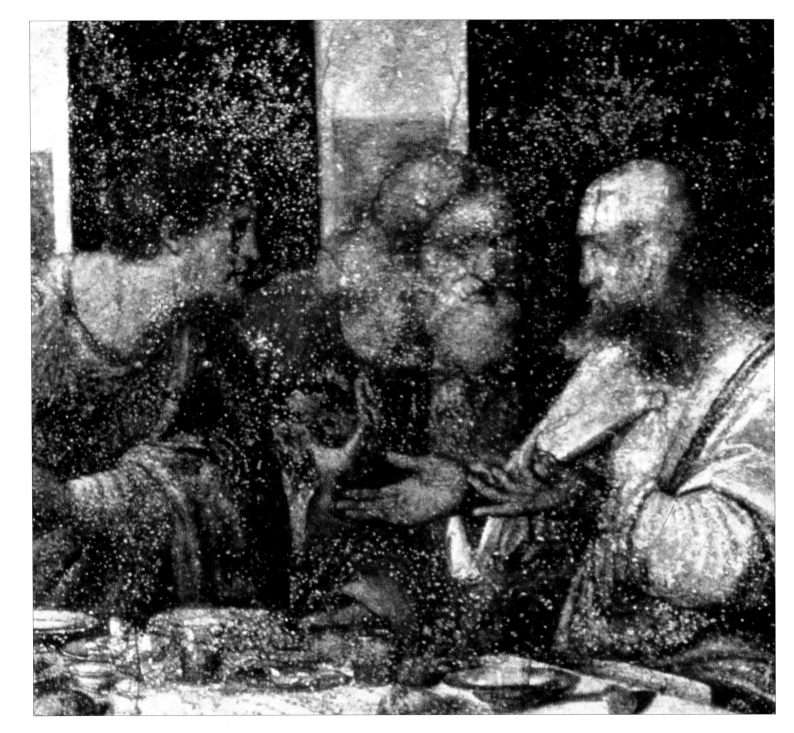

folded, examining, considering and criticizing the figures to himself. I also saw him, on a sudden impulse, at midday when the sun was hottest, leaving the Corte Vecchia, where he was working on his marvellous clay horse, to march straightway to Le Grazie ... climb up on to the scaffolding, pick up a brush, put in one or two strokes and then rush off again.

Overall, progress was predictably slow, and according to another contemporary witness, the poet Giovanni Battista Giraldi, the prior (presumably Bandello's uncle) grew impatient with all the painter's paraphernalia messing up his refectory for so many months. He complained to the duke who, he added 'was paying Leonardo very generously for the work' (Leonardo would not have agreed with that, though Lodovico made amends later). Lodovico summoned Leonardo and expressed surprise at the delay. Leonardo shrugged off the criticism, but some time later the prior repeated his complaints, saying that although only the head of Judas, for which Leonardo had said he could not find a suitable model, was left to be done, the painter had not touched the work for a year (perhaps an exaggeration).

Lodovico again took the matter up with Leonardo who, never a man to be browbeaten, exclaimed with some brusqueness that the monks knew nothing about painting and that a painter did not work like a labourer digging a hole, he sometimes made most progress when he did least. He admitted having difficulties finding a face for Christ (Vasari reported that this was never finished, but it is hard to tell now) and also a face evil enough to model for Judas, although he had been wandering in the roughest part of the city almost daily looking for one. He suggested – a rare joke – that perhaps he should model him on the prior, which made Il Moro laugh ... (Well, it's a good story, even if indebted to Giraldi's gift for narrative; Vasari also repeats it.)

No doubt there were other reasons for the delays. In a letter written a little later, Leonardo described himself as doing the work of ten men.

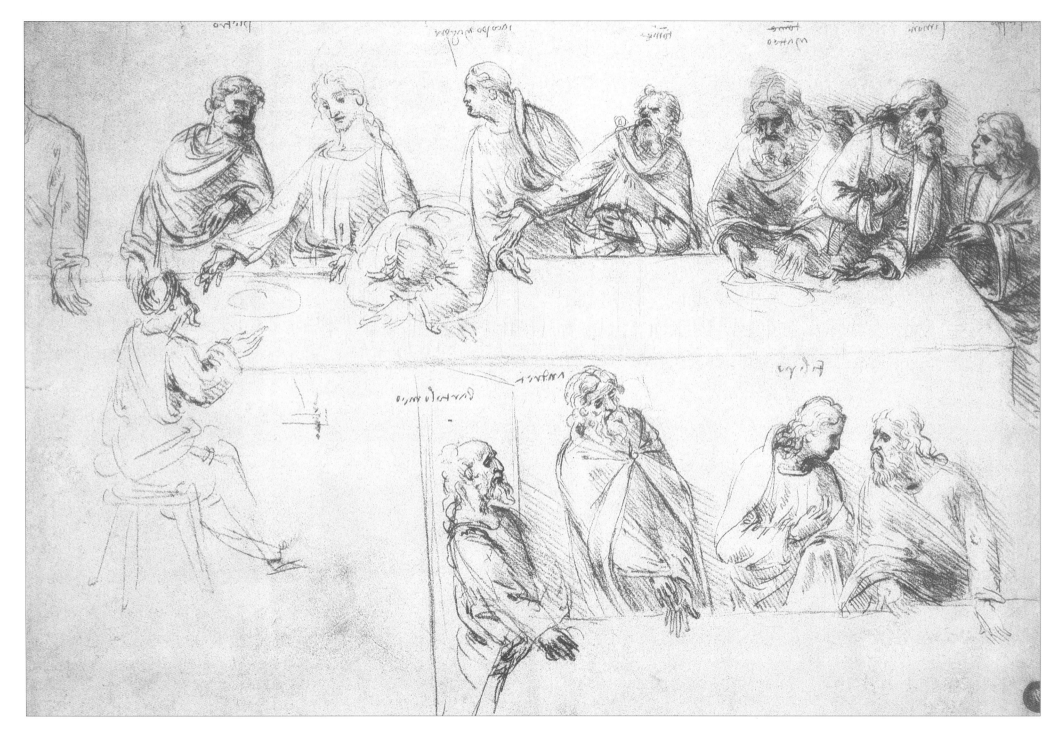

Leonardo da Vinci

He was organizing feasts and court functions, painting at le Grazie, working on the Horse, singing and playing at court, studying mathematics (a major interest at this time after the arrival of Pacioli), and working on a scheme to improve navigation between the Adda and Ticino rivers. Since he was painting in public, Leonardo had frequent visitors from the court, which also slowed him down, but he does not seem to have objected to their presence and often asked their opinion, a question we may think was prompted by his innate courtesy. Eventually, he found or invented a suitable face for Judas and finished the painting, with the exception of the face of Christ which he may well have been satisfied to leave in a faintly ethereal state.

Although Leonardo's reputation was already considerable, the completion of the *Last Supper*, together with the model of the Horse, vastly increased it. From this time, perhaps, we may date the beginning of the growth of an almost supernatural aura that by his last years transformed him into a venerable sage and magician possessing mysterious, perhaps superhuman powers. Visitors, including painters, came from far away to see Leonardo's masterpiece, and the French king, when he arrived in Milan in October 1499, inquired into the possibility of taking the whole wall back to France. By that time Leonardo was widely regarded not only as the greatest painter in Italy but also the greatest theorist of painting.

OPPOSITE
Studies for The Last Supper
Sanguine, 10¼ x 15⅜in (26 x 39.1cm)
Galleria dell' Accademia, Venice

Leonardo made innumerable preparatory studies for his masterpiece, taking immense pains and leaving virtually nothing unplanned. As he often did, he drew the figures nude to be sure of anatomical correctness, and even gauged the weight of each individual.

Study of an old man *(possibly for*
The Last Supper*)*
Private collection

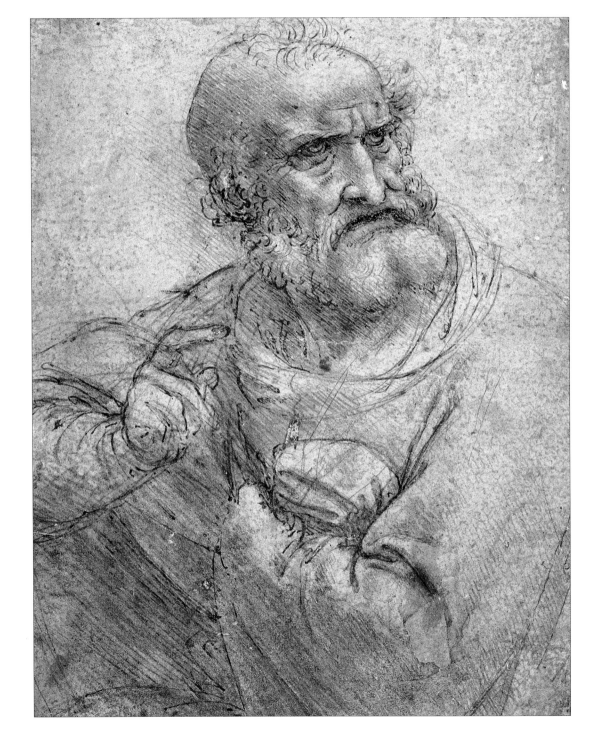

Leonardo da Vinci

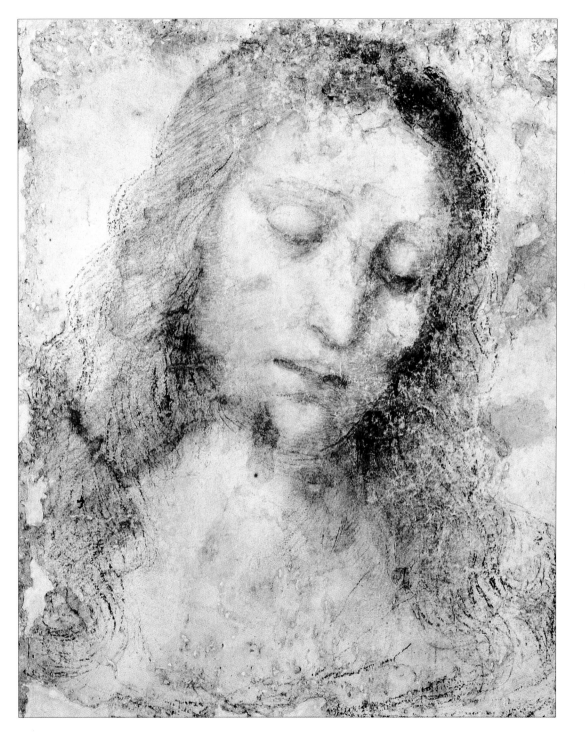

Head of Christ
Pencil and gouache
Brera Gallery, Milan

This sketch is possibly a study
for the head of Christ by Leonardo,
though authorship is disputed.

OPPOSITE

The Adoration of the Magi

(detail of Virgin and Child)

LEONARDO ON PAINTING

As is well known, Leonardo wrote a vast amount on a great many subjects, and more on painting and topics related to it than any other, but all we have are scattered, disorganized notes. Pacioli recorded in 1498 that Leonardo had recently completed a work on the human figure, and there is some evidence to support that in the numerous studies of figures dating from about that time, but the book itself is lost. The nearest thing to a comprehensive work on art is his so-called *Treatise on Painting (Trattato della Pittura)*.

After Leonardo's death, his papers passed into the possession of his devoted young friend and follower, Francesco Melzi, who made some efforts to edit his notes on art. According to Vasari, there were manuscripts in Leonardo's distinctive backwards handwriting in the possession of a Milanese painter (unnamed, probably Melzi) who consulted him and hoped to print them. He appears to have been disappointed, but these papers, again lost, probably formed at least part of a manuscript selection of Leonardo's writings on art made a

generation or so after his death. From this eventually came the *Treatise on Painting*, printed in 1651; but by that time the manuscripts had been copied and recopied many times, various editors had introduced their own ideas, and the printed book no longer bore much relation to Leonardo's work.

However, there are also early surviving manuscript copies of which the most important came from Urbino and is now in the Vatican Library in Rome. Parts of its contents also exist in Leonardo's hand and a comparison shows that the Urbino copyist was creditably accurate. Modern editions of the *Treatise* naturally restore the real Leonardo as far as possible, though what remains, while immensely valuable in understanding both Leonardo's art and his character, is disorganized and difficult, in parts chaotic, often repetitive, sometimes contradictory, and sometimes derivative, since he would copy a passage from some book he had read without distinguishing it from his own comments (there was of course no law of copyright). Among others, he was much indebted

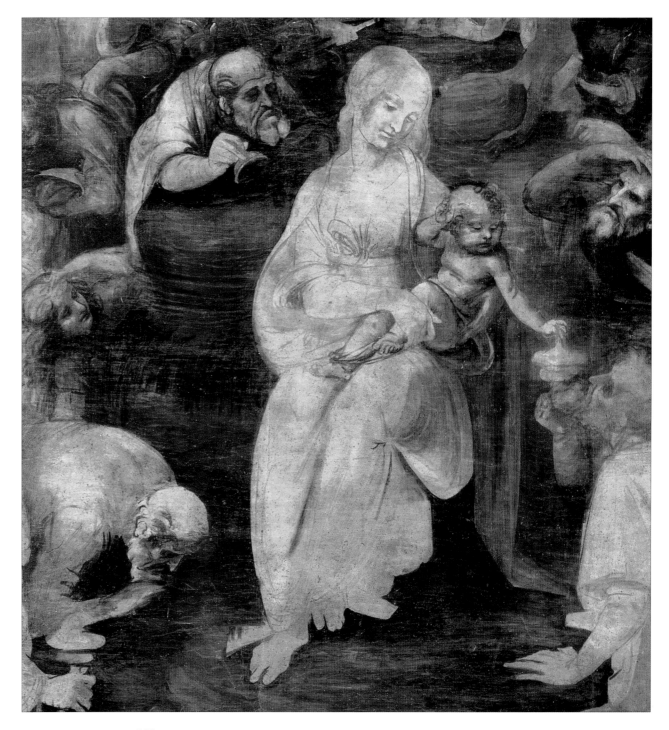

to Leon Battista Alberti, whose influential treatise on painting was written in 1435.

Leonardo is keen to establish that painting is a science and the painter must understand mathematics, the basis of perspective. It is the highest of the arts because it is the best means of representing nature, and he more than once compares the imagination of the painter with the mind of God. The painter must be a scientist because he must understand how things work: Leonardo would, like others, initially do nude studies of what would be clothed figures in the final painting – the apostles of the *Last Supper* being one example. Besides depicting what he sees, the painter must necessarily choose and arrange things to create a harmonious composition. He follows Alberti in seeing a link between painting and music, but considers painting superior because it is permanent, not fleeting. The captured moment may be contemplated and considered indefinitely.

Much of the advice Leonardo offers is highly abstruse, and on some vital matters he says nothing, possibly because passages are lost. He seems to

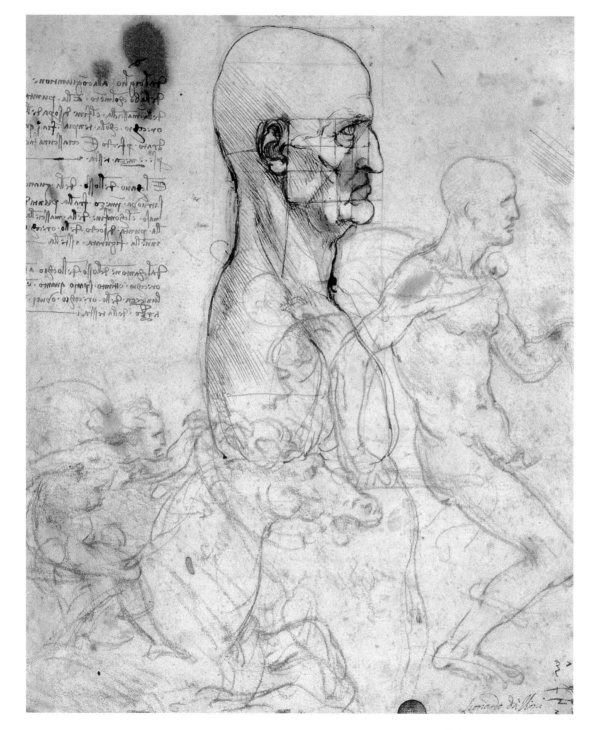

have written at length on perspective, for example, although what we have are only disconnected notes. On others, his advice conflicts with his own practice, while sometimes, as in so many of Leonardo's undertakings, he pursues a subject beyond the practical considerations necessary for a painter to a point at which he is seduced into research for its own sake alone. His scientific study of *chiaroscuro*, and his skilful studies of the way light falls on various surfaces, have been held responsible for a certain academicism in his later paintings. But perhaps without justice. In practice his handling of light and shade seems to be instinctive or empirical, owing little to his written efforts to establish its 'scientific' basis. When he comments on the beautiful effect of light and shadow on the face of someone sitting in the doorway of a dark house, he reveals a poetic eye rather than the illustration of a theory, and an idea that places him closer in spirit to the Baroque than the *quattrocento*.

His intense interest in and manifold studies of anatomy are more closely in line with the

Leonardo da Vinci

fundamentals of the Florentine school in which he began. For the Renaissance Platonists, man was 'the measure of all things' and therefore the perfect man was the measure of perfect beauty, and the proportions of the human figure have a mathematical basis corresponding with those ideal geometric forms (as illustrated in one of Leonardo's best-known drawings) of square, circle and the almost mystical golden mean – the proportions of a line divided in two in such a way that the relation of the smaller part to the larger is the same as that of the larger to the whole. But in this area too, Leonardo's studies of anatomy, and the dissections he performed on bodies provided by a hospital, go beyond the needs of art and, though the drawings are beautiful, they become purely scientific studies.

Besides complex theory, Leonardo gives much interesting advice on a practical level. He advises against dark shadow, advocating, as we have seen, the introduction of a mist when painting an object against the sun. For the same reason, indoors, he insisted on a studio with large windows since small windows cause darker shadows, though it is not

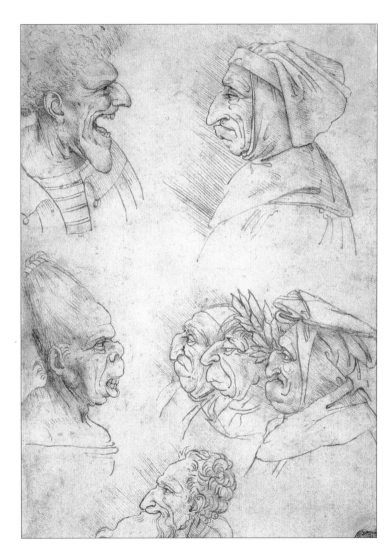

OPPOSITE
Anatomical studies
Pen and ink, red chalk and pencil on paper
Galleria dell' Accademia, Venice

Leonardo emphasized the importance of an understanding of human anatomy, though his own study of the subject far exceeded the knowledge necessary for an artist.

LEFT
Seven studies of grotesques
Red chalk on paper
Galleria dell' Accademia, Venice

The artist, said Leonardo, as he went about the town, should never be without his notebook to sketch any unusual countenances he might come across.

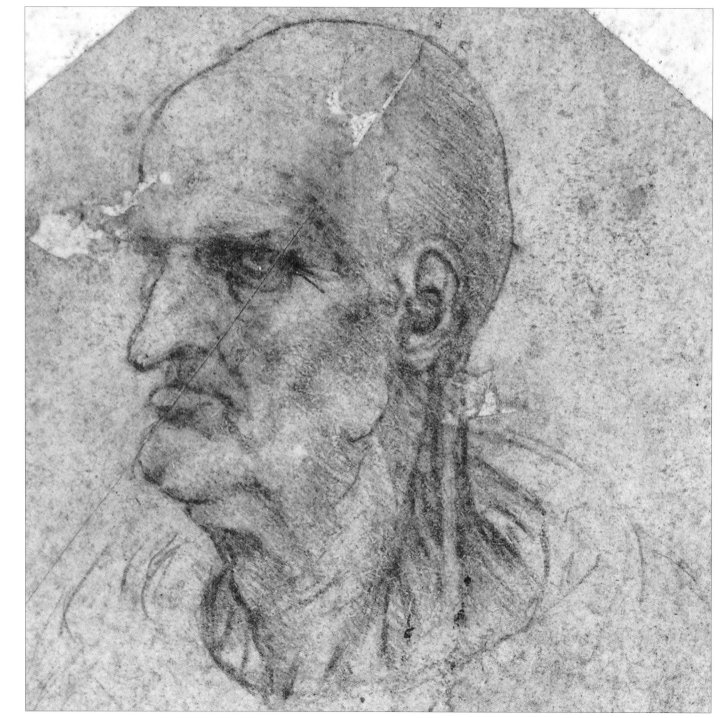

RIGHT

Head of a beardless man turned to the left

Red chalk on paper
Musée Bonnat, Bayonne

A portrait almost turns into an anatomical study as Leonardo indulges his interest in the attenuated tendons of the neck in an old man.

OPPOSITE LEFT

Eight caricatures

Silverpoint touched with white on cream paper
Windsor Castle, the Royal Collection

OPPOSITE RIGHT

Six grotesques

Leonardo's interest in the physically grotesque verged on the obsessive.

easy to align this advice with what he says about a face in a dark doorway.

Another aspect that he considered of great importance was appropriate treatment of a subject, for which gesture and expression are vital. He describes, as a warning, an Annunciation he had seen in which 'the Angel looked as if he wished to chase Our Lady out of the room with movements of such violence that she might have been an enemy'. Scholars have suspected a crack here at the later, unnaturalistic and increasingly neurotic Botticelli, a painter whose decorative style never appealed to Leonardo; he made several adverse comments on decorative painters who depend on 'the beauty of blue and gold' because they lack science (and, he intimates, need an excuse to charge high prices).

He advised the tyro to observe closely the postures and actions of people 'as they talk, argue, laugh or quarrel: their own actions and those of … onlookers'. He should make notes in a notebook, which he should always carry with him. In this respect there is plenty of indirect evidence of Leonardo obeying his own instructions in his

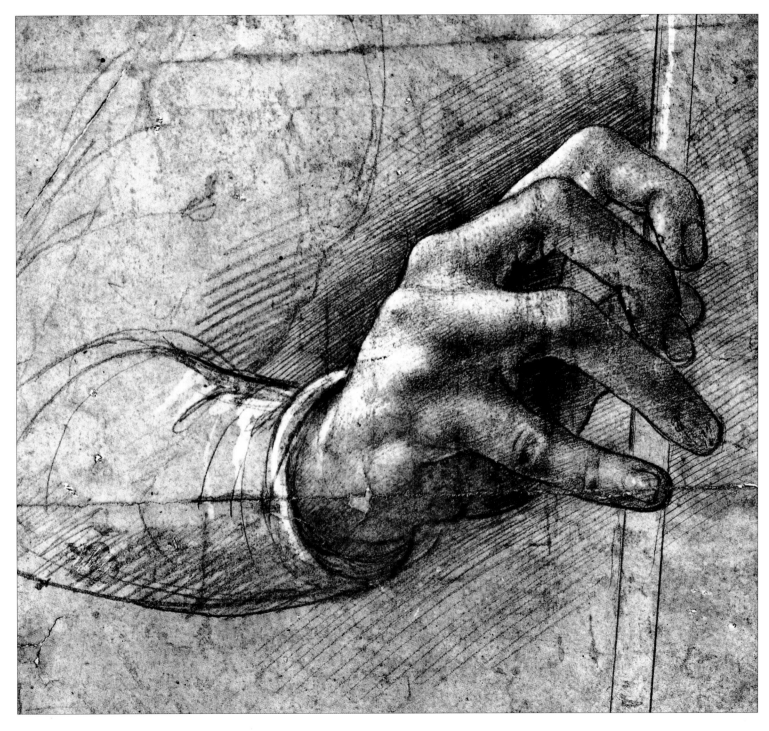

OPPOSITE
The Virgin and Child with St. Anne (c.1508–10) *detail of Child*
(See also page 340 et seq.)
Oil on panel
66⅛ x 51⅙ in (168 x 130cm)
Louvre, Paris

LEFT
Study of a hand
Pen and ink on paper
Biblioteca Ambrosiana, Milan

So fine was Leonardo's anatomical accuracy that in disputed cases it can sometimes offer incontrovertible confirmation of his authorship.

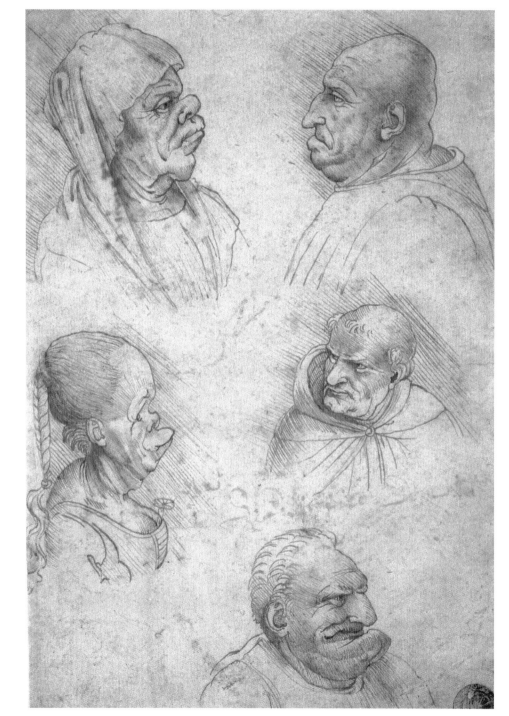

RIGHT

Five studies of grotesques

Red chalk on paper
Galleria dell' Accademia, Venice

OPPOSITE

The Annunciation *(detail)*

Leonardo's earliest surviving painting, the Annunciation *(see also page 74 et seq.). As Kenneth Clark remarked, 'The features are not felt as part of the structure of the face, but are drawn on it, and if we compare it with the* Mona Lisa *we may begin to realize the immense labour which Leonardo devoted to studying the science of his art.'*

Leonardo da Vinci

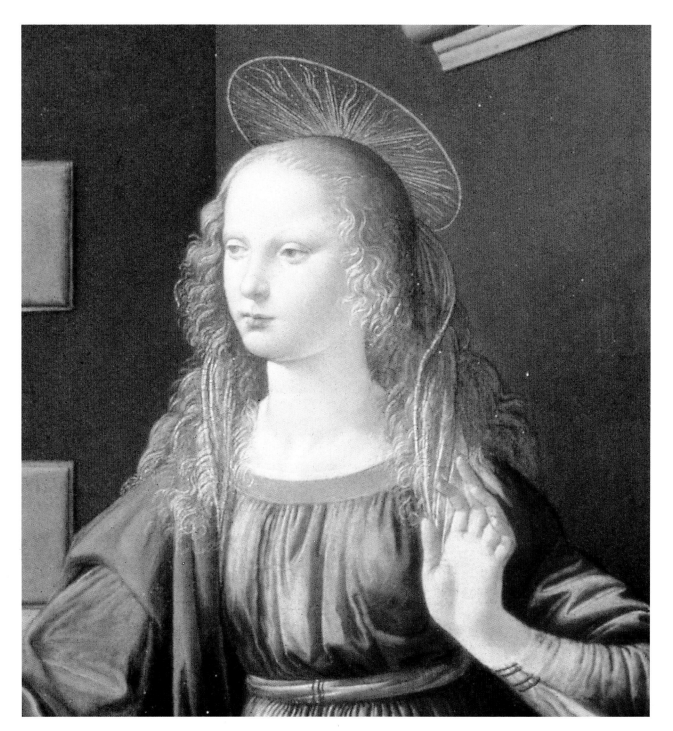

sketches of unusual heads, and we think of him wandering around Milan's rougher quarters seeking a face for Judas. In this vein his advice is sometimes quite basic. When drawing a detail of a figure, he says, you should first draw the whole figure so that you do not lose sight of the context. And don't make the outline too dark.

He advocates a solitary, austere life for the artist, so that 'the prosperity of the body shall not harm that of the spirit'. Leonardo quite enjoyed the luxury of court life, but he did not need it and his own existence was comparatively spartan, though his household included people such as Salai who depended on him for support. In fact he became relatively well-off (Lodovico presented him with a large property that included a vineyard) but he could have been much richer if he had wished to be, and his lifestyle does not seem to have changed significantly. In general, he expressed nothing but scorn for material wealth.

In the *Treatise*, as in the whole great bulk of Leonardo's writings, there is disappointingly little about his personal feelings. He does, however, reveal some of his artistic preferences. In a

RIGHT

Studies of heads

Pen and ink on paper

Biblioteca Ambrosiana

RIGHT

The Virgin of the Rocks

Silverpoint

Louvre, Paris

This study of an angel for the Virgin of the Rocks *(page 148 et seq.) is one of the most beautiful of all Leonardo's drawings.*

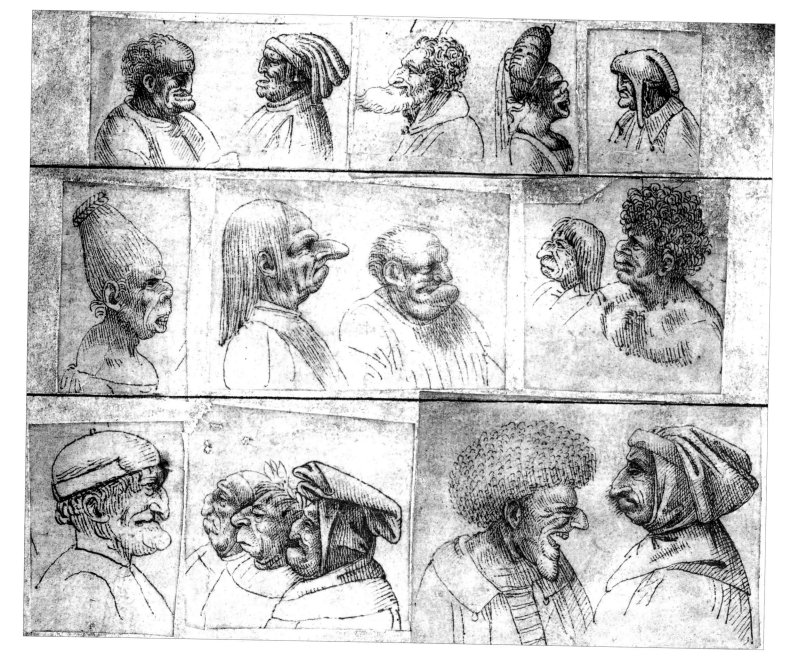

Leonardo da Vinci

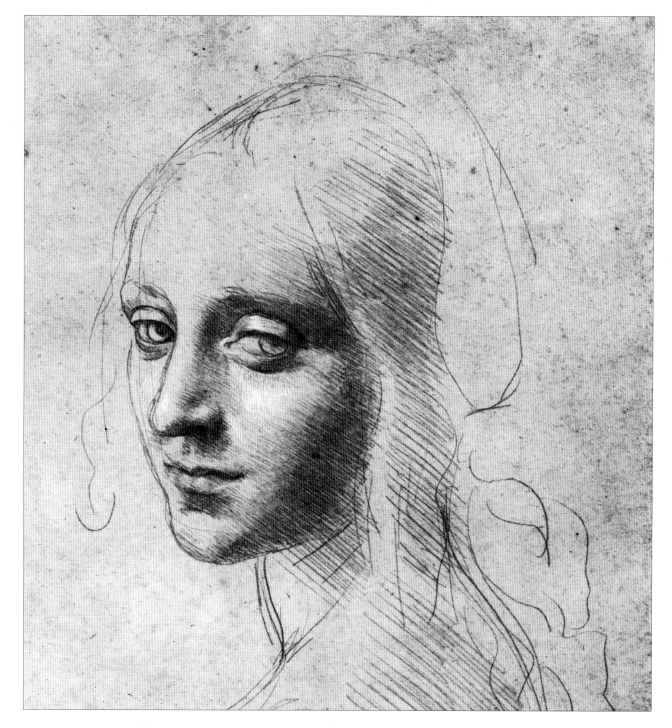

beautifully written passage, he says that the painter can choose any subject he likes: pleasant scenes of flowery meadows ruffled by a summer breeze, or 'fearful and terrible places which strike terror into the spectator'. A long passage follows about the violence of the elements, the destructive conflicts of wind and water, storms, floods, natural disasters. Clearly, the subjects that attract Leonardo are not Madonnas, or biblical and mythological scenes, not beautiful people in gorgeous clothing, not even compositions of figures; not, in short, the kind of paintings that most Renaissance patrons wanted. The subjects that please him most belong to 'this combat of the elements, a subject for Turner, [described] in the language of Melville' (Kenneth Clark).

This is the romantic element in Leonardo. It reappears in the famous passage in which he suggests, after remarking defensively that it may seem a trivial matter, that the artist should look at 'walls stained with damp or at stones of uneven colour'. In these, you may see 'divine landscapes, adorned with mountains, ruins, rocks, woods, great

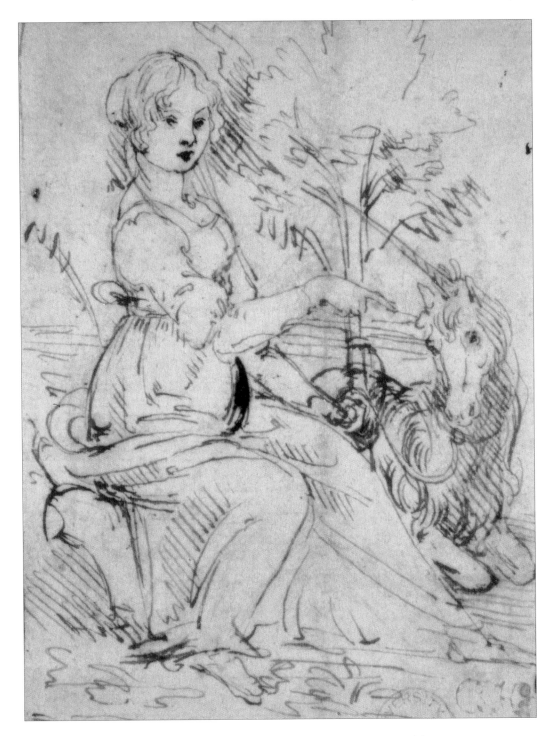

plains, hills and valleys …, battles and strange figures in violent action …, an infinity of things which you will be able to reduce to their complete and proper forms', and he makes a comparison with the vast vocabulary to be heard in the ringing of bells. All this is a very long way from Renaissance classicism! It reminds us of artists far removed from Leonardo – of Goya, of Constable perhaps, delighting in slimy fence posts, or of Max Ernst and his *frottages*. However, elsewhere, recollecting that art is a science, Leonardo points out that before you can realize the scenes that come to you by contemplating crumbling walls or the glowing coals of a fire, it is necessary to know how to represent the objects they suggest!

Leonardo da Vinci

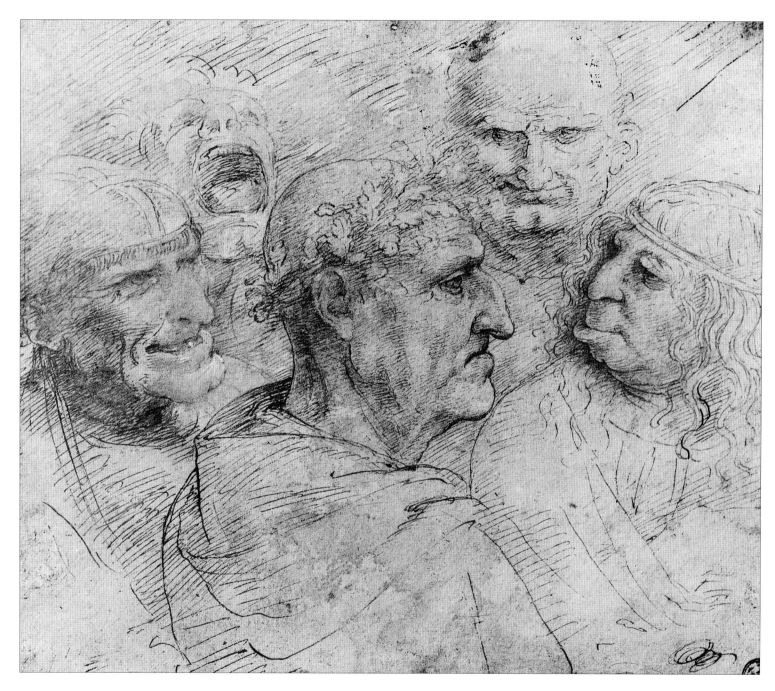

OPPOSITE
Lady with a Unicorn *(c.1480)*
Pen and ink
Ashmolean Museum, Oxford

LEFT
Five male heads
Pen and ink on paper
Louvre, Paris

Study for The Madonna of the Cat

Uffizi, Florence

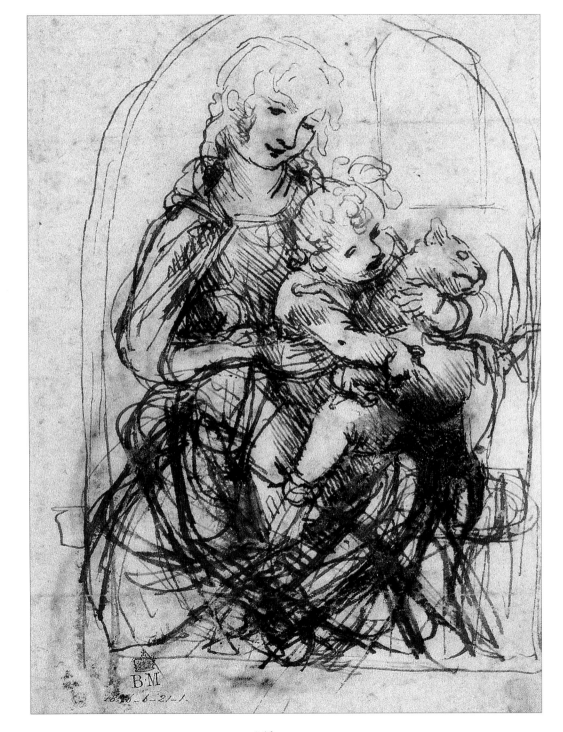

Leonardo da Vinci

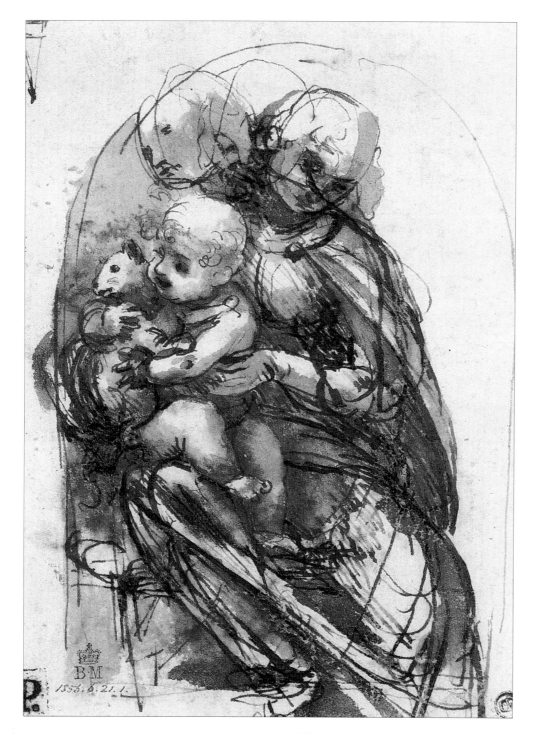

Study for The Madonna of the Cat

British Museum, London

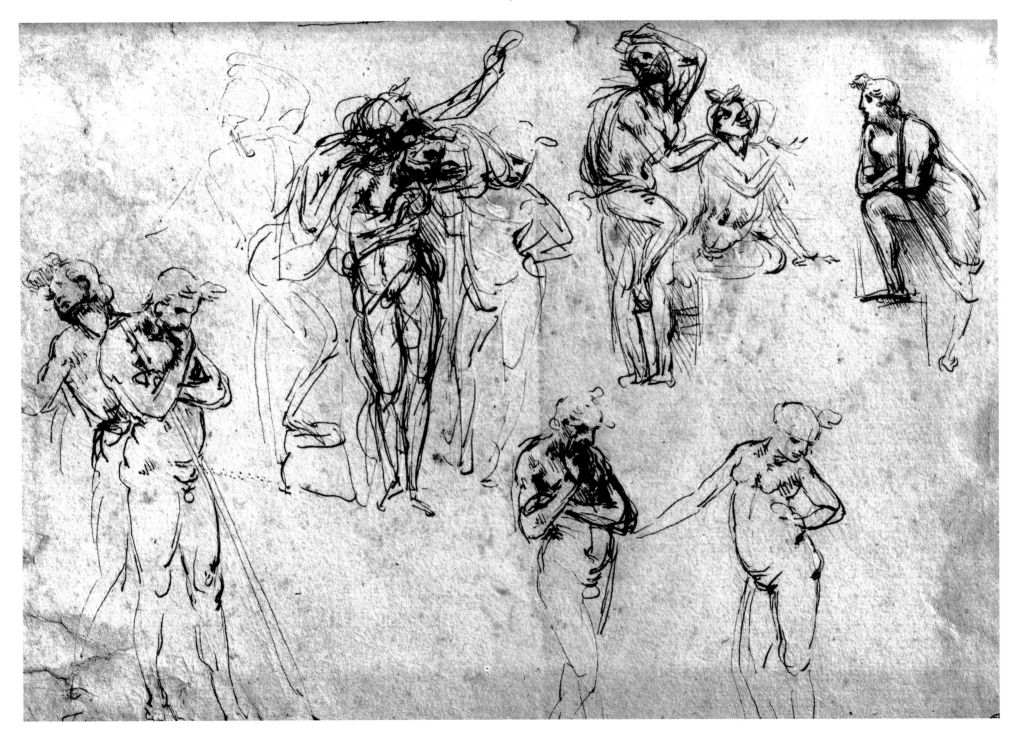

Leonardo da Vinci

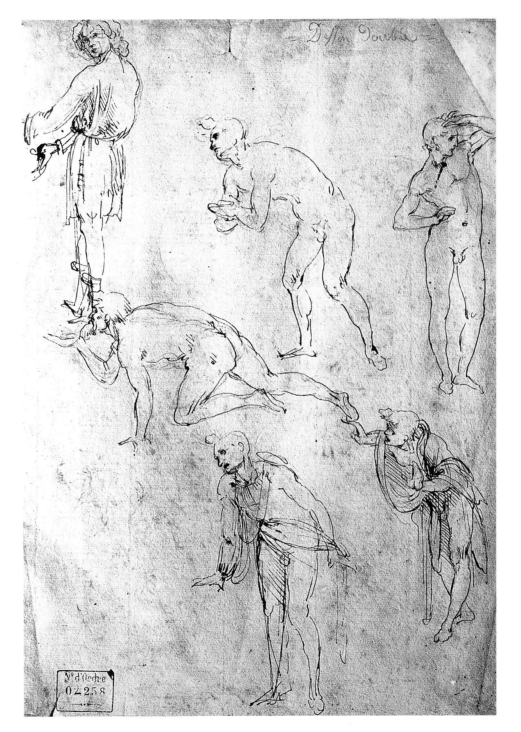

Text and sketches on the subject of bird flight

Pen and ink on paper
Bibliothèque Mazarine

Leonardo's studies of the mechanics of flight developed from his early love of birds and their movements.

FLIGHT

We have seen how in Leonardo's *Annunciation*, his first surviving work, the angel's wing is painted with great realism, and is clearly the work of a man who had studied birds closely. It was said that Leonardo used to buy caged birds in the market in order to set them free, and he must have spent many hours watching birds in flight, especially birds of prey. His earliest studies of the flight of birds date from the early 1480s and they continued throughout his life: it was the subject of his last surviving manuscript, written in 1513–14 and usually known as the Codex on the Flight of Birds. This was assembled at a time when he was ordering his notebooks with a view to publications on various subjects, and this was one, although it is relatively short and not all of it is about flight.

He was delighted by the sheer beauty of birds in flight but, even more, he was fascinated by the mechanics of flight, and how birds' wings moved at different stages of flight. For Leonardo, the bird was a perfect piece of natural design according to mathematical laws. In one of his notebooks there is a series of little drawings beginning with a naturalistic bird in flight and ending with a diagrammatic representation of the mechanics of bird-flight. He studied other flying creatures – insects, bats – as well as birds, and carried out dissections to discover the structure of wings. Of course he did not understand aerodynamics which, like other aspects of theoretical mechanics, are based on Newton's laws of motion, but he came to understand a great deal, including, it seems, the phenomena of 'lift' and 'drag', although not the principles behind them, and he appreciated that the laws governing the movement of air are the same as those governing the movement of water.

In fact Leonardo anticipated Newton's third law of motion when he noted, in relation to the flight of an eagle, that 'as much pressure is exerted by the object against the air as by the air against the body'. Another, typical observation that probably derived from his observation of birds of prey neatly expressed how a bird maintains height using the wind and without flapping its wings: '... when the bird is in the wind, he can support himself upon it

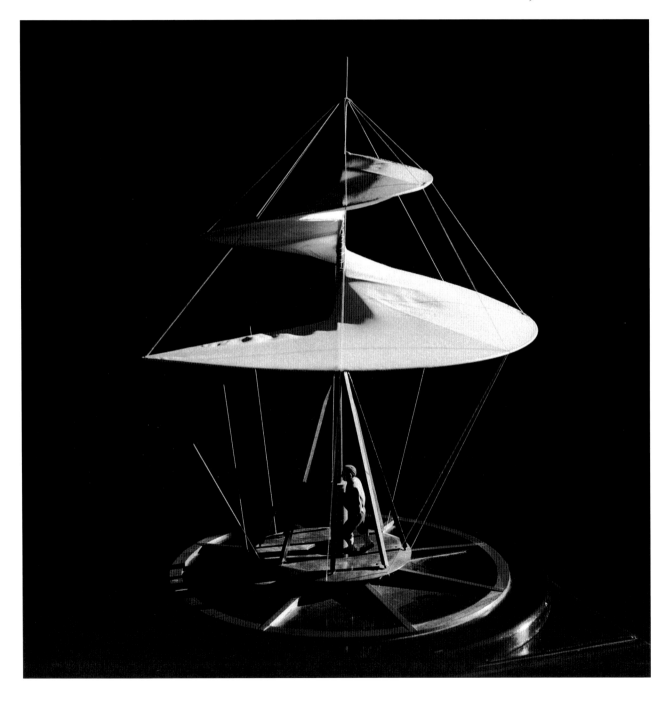

without beating his wings, for the function of wings that move against the air when it is motionless is performed by the air moving against the wings when they are motionless.'

Leonardo's studies of bird flight confirm his possession of an extraordinary quickness of eye. He could see movements that to others appear as a blur, because they happen too fast to be detected. As everyone knows, artists depicting galloping horses invariably got the movement of the legs wrong (showing them working in pairs) until the camera, with its ability to 'freeze' movement, revealed the truth. The speed of communication between his eye and brain allowed Leonardo to operate his own slow-motion replay.

Of course, Leonardo wanted to fly. He was far from the first man who tried to create a human-powered flying machine. The ambition went back at least as far as Icarus, and an English monk is said to have managed to glide a short distance in Wiltshire in the 11th century. The 13th-century philosopher-scientist Roger Bacon, who in some respects resembles a medieval Leonardo, considered

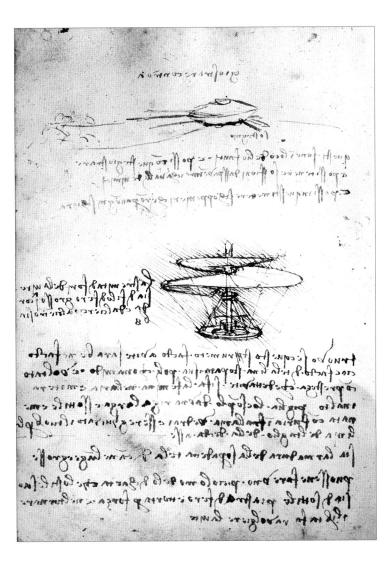

that the construction of a flying machine was at least theoretically possible, and an Italian, Giovan Battista Danti, launched himself from a tower only to crash on the church roof in 1503. There are several references in the notebooks to what Leonardo called 'the bird'. He wrote of it taking its first flight from 'the back of the great swan (perhaps a reference to Monte Ceceri, a hill near Fiesole), dumbfounding the universe....'. So far as we know, it never did.

Quartered in the Corte Vecchia in Milan, Leonardo thought he had found the ideal place to construct his flying machine. On the roof it would be safe from prying eyes, and the tower at one end would guard it against being spotted by men working on the cathedral. However, he did not intend to launch it over the city square. He told himself that he had better make the first test flight over a lake, to prevent himself being dashed to pieces, and that he should carry a wineskin as a life jacket to prevent drowning. There is some evidence – a statement of 1550 by the son of a friend of Leonardo – that he tried and failed, but that might

OPPOSITE
Model of Leonardo's screw

LEFT
Sketch for an aerial screw
(ancestor of the helicopter)
Bibliothèque de l'Institut de France

Sometimes called the ancestor of the helicopter, though the relationship, it has to be said, is a remote one. The blade was to be made of starched linen and Leonardo reckoned that if turned rapidly enough it would achieve lift-off.

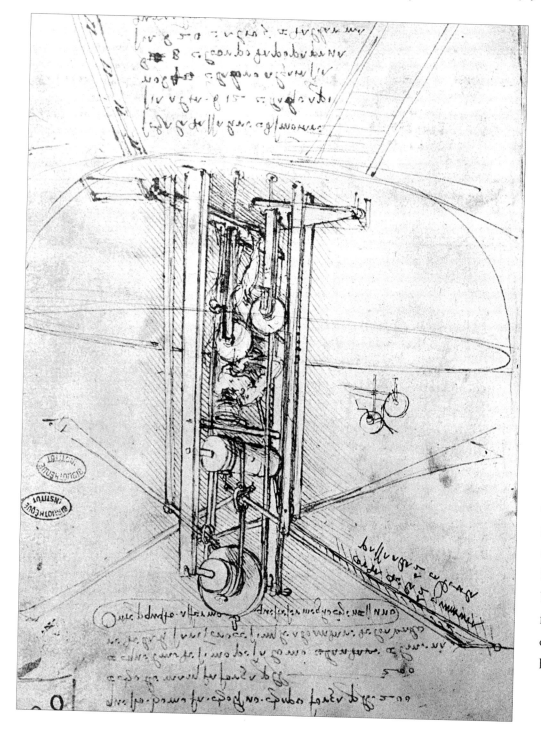

not necessarily refer to an attempt at an actual flight, and Leonardo himself does not mention it. While he may not have wished to remind himself of a failure, it does seem unlikely that, if Leonardo had ever got as far as launching one of his numerous designs, we should not have heard something about it.

Like all other aspiring aeronauts, Leonardo assumed that he must follow the example of birds; his belief in the importance of experience, that is, observation and experiment, and in the essential similarity of all natural processes, would have confirmed him in this natural, but mistaken, assumption. 'A bird is a machine that operates according to mathematical laws, and man is capable of reproducing such a machine with all its movements.' With his gift for analogy, he also drew a parallel with a ship that achieves motion by using its large sails to capture the power of the wind. But birds diverted him, so to speak, into the wrong flight path. In spite of one machine that is often described, perhaps rather fancifully, as a primitive helicopter, and various other types of flying

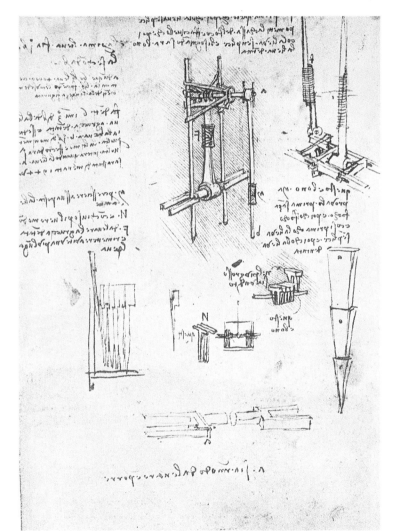

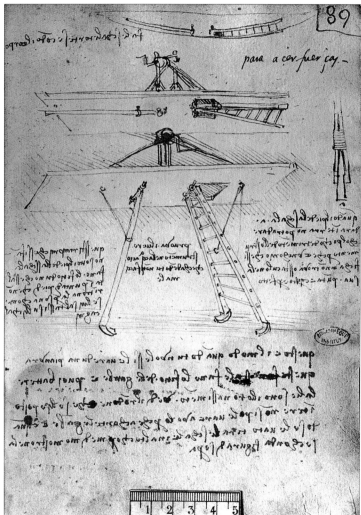

THIS PAGE and OPPOSITE
Studies for flying machines
Ink on paper
Bibliothèque de l'Institut de France

We do not know how far Leonardo took these ideas, though there is some suggestion that he did actually attempt a test flight, without success. Although it is obvious enough that Leonardo's flying machines would not fly, we would be wrong to dismiss all his notions on manned flight as mere pie in the sky. Leonardo was himself aware of many of the objections that occur to us, but his keen desire to succeed encouraged him in unduly sanguine rationalizations.

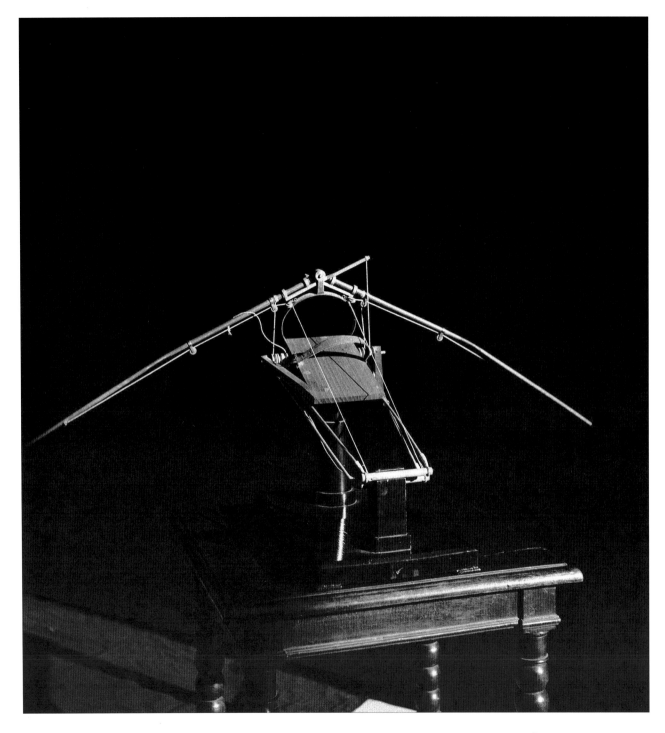

machine, he always returned to flapping wings that were operated by the arms or legs, or in some cases both.

It was not until long after Leonardo's death that it was conclusively demonstrated that human beings lack the muscle needed to operate wings by any method, and the motive power must come from elsewhere. Leonardo was well aware of the anatomical disparity between man and bird, but he optimistically believed that birds were greatly over-powered, and actually needed only a fraction of their potential for ordinary flying, while at the same time he never envisaged man flying as freely as a bird. Rather, he aimed for a partially powered glide, making use of air currents so that he might soar, however briefly, like an eagle over the Tuscan hills.

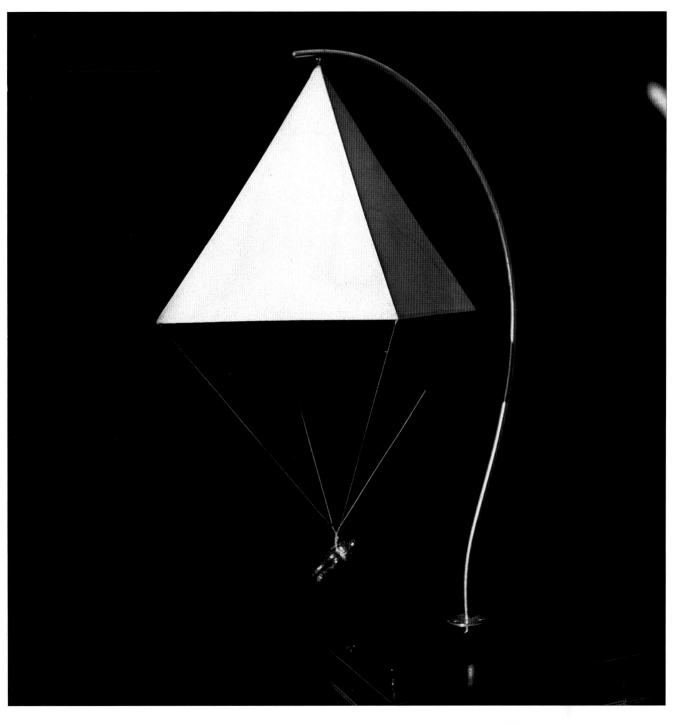

Models of flying machines
Leonardo Da Vinci Museum, Vinci

*Model of a flying machine and
(left) a kind of parachute, based on
Leonardo's drawings.*

Ornitottero *with nacelle*

A flying machine, designed along the lines of a boat, since Leonardo believed that air and water behave in similar ways, and with flapping wings resembling those of a bat. Like other pioneers of flight, Leonardo was led astray by what seemed the obvious example of bird flight.

Leonardo da Vinci

Studies of cats and dragons
Pen, ink and wash over black chalk
British Museum, London

A page of cats, clearly drawn from life. A panther-like couple look like miniature versions of big cats and, oddly, there is also one little mythical creature unrelated to cats, apparently a dragon. It is characteristic of Leonardo's notebooks that quite disparate images, sometimes probably done months or even years apart, appear on the same page.

Hand-drawn flowers with descriptive details

Leonardo da Vinci

Illustration of a tree against a pale background

Leonardo da Vinci's hand study drawing of a tree. This is an undated illustration.

OPPOSITE

Political map of Italy in the 15th century

THE FALL OF IL MORO

The disaster that fell upon Italy with the French invasion of 1494 opened a new era in which the small Italian states forfeited their freedom of action and became merely the counters in a board game played largely by the great powers beyond the Alps.

Warning signals were raised two years earlier in a succession of untoward events. The balance of power in Italy had long been maintained by a series of leagues and alliances. Sforza policy was to uphold the triple alliance of Milan, Florence and Naples while maintaining good relations with France. The French king, Charles VIII, while keen to renew the agreement with Milan, had other interests in Italy. In particular, he had inherited a claim to the kingdom of Naples, which he proposed to enforce. With French influence already established in places like Savoy and Genoa, the threat of war between two of his allies was bad news for Il Moro.

Another destabilizing factor was the death of Lorenzo de' Medici in April 1492. He was always a force for moderation and compromise, but his son Piero, who replaced him, was inexperienced and arrogant. A third blow was the election, as Pope Alexander VI, of Rodrigo Borgia, the very epitome of all the most shocking characteristics suggested by the phrase 'Renaissance pope'. His election was largely engineered by Cardinal Ascanio Sforza, Il Moro's brother, in order to scotch the chances of another candidate who was favoured by King Ferrante of Naples. By thus antagonizing another Sforza ally, the cardinal had placed his brother in a difficult situation, which Il Moro attempted to calm by suggesting that the three allies should send a joint embassy to congratulate the new pope, which would be headed by the representative of Naples. This diplomatically adroit move might have retrieved the situation had not Piero de' Medici persuaded Ferrante to reject it. The bonds between the three Italian states were thus further weakened.

Il Moro had troubles nearer home. The Duchess Isabella, wife of Gian Galeazzo Sforza, was a princess of Aragon, the royal house of Naples. She had grown increasingly restive at the dominance of

Lodovico and Beatrice in Milan at the expense of herself and her husband, the rightful duke. She found strong support in Naples, where some demanded war, although Ferrante was only willing to go so far as to suggest to Lodovico that he should stand down in favour of his nephew. Lodovico returned a soft reply saying he could not actually step down just at the moment, which was correctly interpreted as a plain negative. In Naples, preparations were made for war, while in Milan, Lodovico looked around anxiously for new allies.

He had some success, creating a new league that included, besides Mantua and Ferrara, Venice and the papacy, but these two were undependable, and he concluded that it would be politic to treat Charles VIII's threatened expedition more encouragingly, while at the same time pressing the emperor to invest him formally with the ducal title to strengthen his position in Milan. When he heard that the emperor and the French king had themselves signed a treaty, Lodovico concluded that he had no alternative but total support for the French attack on Naples. He hoped to manipulate

Charles to his own advantage, but it was the French king who dictated policy.

The last chance of resurrecting the old alliance with the Italian states was doomed when, first, Venice declined to become involved and, second, Ferrante of Naples died and was succeeded by his son, Il Moro's bitter enemy. In the summer of 1494, the French troops crossed the Alps. Lodovico hoped they would invade Naples by sea, but Charles preferred to go via Lombardy, where he was joined by a reluctant Lodovico. The death of Gian Galeazzo, aged only 25, confirmed his authority as duke, in title as well as in practice, but other problems had become more threatening than the Milanese challenge to his authority

To Lodovico's rising consternation, the French advanced with ease. Florence offered no opposition: Piero was driven out and replaced by a pro-French republic under the domination of the fanatical monk Savonarola. The pope submitted, and Alfonso of Naples promptly abdicated. Most of Italy had fallen to the French and Lodovico feared that Milan, to which Charles's cousin, the Duke of

Leonardo da Vinci

Orléans, had a claim through his Visconti grandmother, was next. But he was not the only one panicking. The Venetians too were alarmed by the ease with which the French had marched through Italy; the Emperor Maximilian was angry at this intrusion on what was, if only nominally, imperial territory; the pope was equally resentful. A new Italian alliance was hastily stitched together.

The immediate danger was Orléans, ensconced less than 60 miles (100km) from Milan in Asti. He was said to be about to march on Milan, and Lodovico, in a funk, shut himself up in the castello contemplating flight and leaving Beatrice to organize the defence.

But Charles VIII's dominance in Italy collapsed as fast as it had been established. The Aragonese king of Naples was restored by forces of the recently united Spanish kingdoms, and the French – probably with the aid of Lodovico, still playing both sides – narrowly escaped defeat by the Italian allies, augmented by imperial German troops, at Fornovo. Within a year Charles was back in France where he died three years later. But his expedition was not

an isolated episode. He was succeeded by Orléans, an altogether more formidable character, as Louis XII. He proclaimed himself duke of Milan, and wasted no time in enforcing his claim.

As the French forces prepared to cross the Alps, we might assume that Leonardo was heavily engaged in planning the defences of Lombardy, but it seems that he was also busy with various mechanisms to improve the bathhouse of the Dowager Duchess Isabella, installing a boiler and pipes to provide her with constant hot water. Since the death of her husband, Isabella was confined to one wing of the Corte Vecchia, the old ducal palace in the centre of the city. Leonardo also had his studio there, though he was considering buying a house. It seems that he was slow to recognize the looming threat to his patron who, never as bold as he seemed, deprived by death of the support of his wife and aware of his unpopularity with the Milanese population, was unlikely to put up much resistance.

Deserted by his former allies, Venice and the papacy, and by most of his Milanese subjects – who

expressed their feelings by lynching his friend, the Court Treasurer – Lodovico left Milan in September 1499, a few hours before French troops under the *condottiere* Trivulzio entered it. The commander of the castello, which was equipped to withstand a long siege, swiftly surrendered the fortress for a hefty bribe. Louis XII arrived to claim his dukedom in person two weeks later.

It would be wrong to suppose that Leonardo felt any special loyalty to Lodovico, any more than he did to the Medici, nor would he have been expected to. In the first place, Lodovico was a tyrant and, reasonably or unreasonably, was currently disliked by nearly everyone outside his court. Italian citizens might be proud of their city, though even that commitment was not guaranteed, but their feelings towards their ruler, Sforza or Medici or lesser lord, were governed by their degree of satisfaction with their current circumstances, which were subject to rapid change. Artists and scholars were even less committed to ruler or state. The first practical need of an artist was, as always, a patron or patrons. Without them

he simply could not make a living. But artists did not consider that they were in some way in debt to the patrons who made their existence possible. Most of them probably felt that they were giving very good value for not very much money, as indeed they were: by modern standards they were seriously underpaid!

So we should not be surprised to learn that Leonardo considered entering French service. Notes suggest that he may have been approached for his knowledge of the defences of Tuscan cities at this time, and he recorded some hints on technical details he picked up from conversations with a French painter. He must also have appreciated Louis XII's admiration for the *Last Supper*. But he did not enter French service then, whether or not the opportunity was offered. After all, he was admired throughout Italy, and he had invitations elsewhere. He could afford to be choosy.

Meanwhile, Lodovico took refuge with the emperor who, in spite of his reputation for changeability, remained a constant friend to the Sforza. The outlook was black but in the course of

Leonardo da Vinci

time, after Louis had returned to France, the Milanese found that, besides the usual offences committed by an occupying army, French rule was more onerous than Lodovico's. Lodovico began to collect new forces, mainly Swiss mercenaries. Some Lombard cities promised support, and in one of those reverses characteristic of Renaissance wars, Trivulzio withdrew from Milan in February 1500 shortly before Lodovico marched in to a hero's welcome.

But his triumph was short-lived. He was short of funds, and mercenaries require pay, especially if they are forbidden, as they were by Lodovico, to loot a town they had captured. While Lodovico's troops began to melt away, a new French army was gathering on the other side of the Alps. Il Moro tried to escape disguised as one of his absconding Swiss foot soldiers, but was recognized and captured. The story that he was kept in an iron cage appears to be false, but he was closely guarded in France, especially after an attempt to escape, and he eventually died, still a captive, at the age of 57, in 1508.

Chapter Six
Travels
1499–1505

Leonardo eventually decided not to take up any hypothetical offer from the French, and prepared to leave Milan. He took some steps through French officials to ensure he would not lose his vineyard and deposited a substantial sum of money in a bank in Florence. He compiled a list of the books he wished to take, made some purchases, including a chamois overcoat, and sold some items that were too cumbersome to take with him.

Although we cannot tell how much of his 17 years in Milan Leonardo spent away from the city, we know he visited many other places. He spent longish periods in Pavia, where he found intellectual stimulation in the conversation of the learned scholars of the university and in its splendid library. We have seen evidence of his visits to the Sforza model farm at Vigevano, and his notebooks contain a reference to the clock tower at Chiaravalle, a few miles south of Milan, which interested him. He was also in Genoa, where he witnessed a great storm, but otherwise there is no evidence that he ever left Lombardy. Nevertheless,

it seems likely that he visited Florence, where of course he still had many contacts (including his father and his uncle, Francesco), and possibly also Venice, since there is some evidence that he had studied the famous horses of St. Mark in connection with his equestrian statue of Francesco Sforza.

Late in 1499 Leonardo left Milan accompanied by Luca Pacioli, Salai, and, no doubt, servants. Although Florence was his eventual destination, they went first to Mantua, which Leonardo had a standing invitation to visit.

LEONARDO IN MANTUA AND VENICE

Mantua had been ruled by the Gonzaga since the 14th century (and they would do so until the 18th). The current ruler, who held the title of marquis (raised to that of duke in 1530) was Francesco II Gonzaga, under whom Mantua began its growth to unrivalled power and prestige, and his successors presided over what was said to be the grandest court in 16th-century Europe, adorned by artists such as Giulio Romano. The prime mover in this ascent, however, was Francesco II's wife, Isabella

d'Este, elder sister of Beatrice, the beloved wife of Il Moro.

This remarkably gifted pair were the daughters of Ercole d'Este, of the princely family of Ferrara, a dynasty that rivalled the Gonzaga in the longevity of their rule. Their taste and intelligence were no doubt inborn, but they also received, through their father's insistence, an excellent education in literature and the arts, and became among the greatest patrons of art in Italy. Beatrice seems to have been the more amiable and generous, perhaps because she was hardly more than a girl when she died, whereas Isabella was at the centre of Mantua's affairs for over 30 years (she died in 1539), a position that only a tough character could have maintained.

As we have seen, Isabella had written to Cecilia Gallerani three years earlier asking to borrow Leonardo's portrait of her, and although Cecilia had demurred, on the rather odd grounds that the portrait no longer looked like her, the painting had apparently been sent. Isabella's purpose for asking was, she said, to compare the painting with others

in her possession, which included works by Andrea Mantegna, the now-elderly court painter in Mantua, Perugino and Giovanni Bellini.

Having visited Milan more than once, she had met Leonardo and she was keen for him to paint her own portrait. Isabella was a patron on the grand scale, but she was not an easy-going one. She wanted her own way and, however sensitive to talent, she shared with other princely patrons a vision of art as a means of heightening her own prestige. She had put a lot of pressure on Bellini to get him to paint exactly the picture she wanted, even taking him to court, and she gave the mild-mannered Perugino a very hard time, requiring him to paint an allegory of her own devising that was designed to promote her own virtues. She was to prove equally determined in her pursuit of Leonardo.

If Leonardo left Milan in December 1499, as Pacioli recorded, he could not have stayed in Mantua long, since a letter written from Venice in the following March remarks on his presence there. In those two or three months, however, he did

complete the cartoon for a portrait of Isabella, the head in profile. This, somewhat damaged, is presumably the drawing in black lead and red chalk now in the Louvre. There must have been two copies, for Leonardo was said to have been in possession of such a drawing in Venice though he certainly left one with Isabella, and the Louvre drawing has pricked outlines suggesting that it was copied. There are also several copies by others extant.

A suggestion that the sitter in the famous painting known as *Mona Lisa* might be Isabella d'Este was made some years ago but it has not met with much support. Barring that, it seems certain that Isabella's portrait was never painted. For several years she and her husband, Francesco, continued to pester Leonardo in Florence. He was required, first, to provide a sketch of a house in Florence that Francesco had admired (which Leonardo sent), later to advise on the value of some vases that had once belonged to Lorenzo de' Medici. Isabella's agent in Florence was Fra Pietro da Novellara, to whom she wrote early in 1501

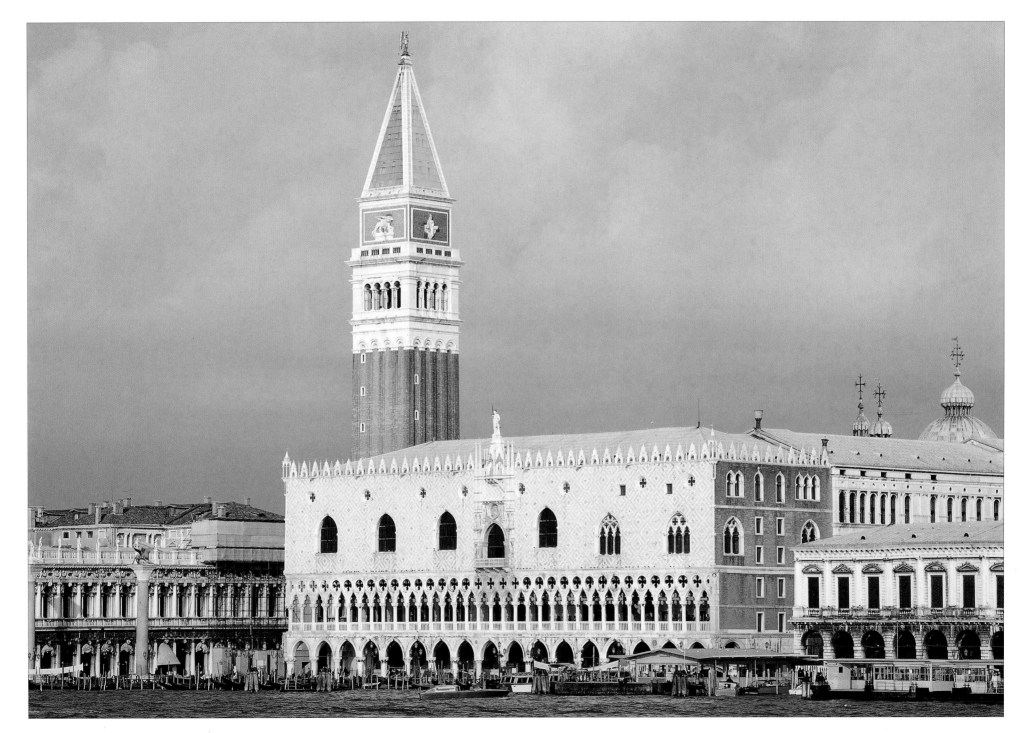

asking him to let her know what work Leonardo was currently engaged on, and asking, 'as if the request came from you', whether he would paint something for her 'studio', choice of subject to be his. If not, perhaps he would consider 'a little Madonna full of faith and sweetness'. She had apparently given up hope of her own portrait.

Fra Pietro, as tactful as he was intelligent, replied that Leonardo was exceedingly busy, and that he was so deeply immersed in his studies of geometry – a sign of the influence of Pacioli – that he could hardly bare to pick up a paint brush, except to add the odd touch to paintings being done by his pupils. He also mentions a cartoon of a *Virgin and Child with St. Anne*, which we know caused a sensation in Florence. In a later letter Fra Pietro also mentions that he was doing a 'little picture' for Louis XII's minister, Florimond Robertet (the *Madonna with the Yarn-winder*), so his alleged disgust with the very idea of painting was no doubt exaggerated by Fra Pietro to assuage the persistent Isabella.

But she was not to be put off. A year later

Leonardo da Vinci

another of her agents in Florence was told to offer Leonardo a large salary in the hope of luring him back to Mantua, and two years after that we find her writing in person to Leonardo, reminding him of the portrait he was going to paint from the cartoon but conceding that it would be hard for him to do it without returning to Mantua. But she felt he owed her something and, as the suggested Madonna had brought no response, now suggested 'a picture of Christ as a child of about twelve years old', for which he could name his own fee. In 1506 she tried a new approach, through the brother of Leonardo's stepmother (the first wife of Ser Piero). Leonardo should have felt flattered: she was far more peremptory, and less generous, with other artists. But he was not to be bought, nor forced into work that did not appeal to him. Isabella would bag Raphael and Titian in due course, but Leonardo eluded her.

Some writers have suspected some kind of sexual motive at work in Isabella's pursuit of Leonardo and his determination to stay out of her clutches, but there is no evidence for such an

OPPOSITE
Pope Paul III and His Nephews, by Titian (1545)
Oil on canvas
Museo e Gallerie Nazionali di Capodimonte, Naples

Titian was one of the great painters of the coming age, whose presence in Rome overshadowed the elderly Leonardo. Nevertheless, Titian, like other Venetians, was influenced by the example of Leonardo, whose work he presumably came to know during Leonardo's visit to Venice.

LEFT
Judith, by Giorgione
Oil on panel
Hermitage, St Petersburg

Vasari bracketed Giorgione, who died in his 30s in 1510, with Leonardo as one of the founders of modern painting. Since mystery shrouds Giorgione's entire career, it is dangerous to speculate, but Giorgione certainly absorbed many lessons from Leonardo's work, for instance his handling of light and shade, and it would not be surprising to learn that the two men had met in Venice or perhaps in Rome.

idea, which seems intrinsically most unlikely.

By 13 March 1500 Leonardo was in Venice. Pacioli was well known there, and even if Leonardo had never been to Venice before, he was certainly familiar by reputation. Their brief visit coincided with the final defeat (8 April) and capture of Il Moro. Perhaps, when Lodovico made his short-lived comeback, Leonardo had thought that his own career under the Sforza might soon be resumed, although he betrayed no evident regret at the upheaval in his own life resulting from his patron's ill-fortune, and there is evidence that he regarded the French, if anything, more favourably than the Sforza. As usual, few clues to his feelings can be extricated from his writings, but there is one rather enigmatic sentence relating to his former patron: 'The duke lost his states, his personal fortune and his freedom [and] none of his projects was completed.' Among them, he was no doubt thinking, many of his own enterprises, not least the bronze Horse.

According to Vasari, Leonardo's painting made a powerful impact on Venetian painters, most notably

Leonardo da Vinci

the young Giorgione, aged about 22 at the time of Leonardo's visit, whom Vasari regarded as, with Leonardo, one of the founders of modern painting. Since we know so little of Giorgione, who died of plague in 1510, and so few authenticated works of his have survived, it is hard to make a firm judgment, though most modern art historians confirm Leonardo's influence on the young Venetian, particularly in the use of *chiaroscuro*.

Venice was currently at war with her ancient enemy and ultimate nemesis, the Ottoman Empire, which turned Leonardo's thoughts again towards engines of war. The Venetian oligarchy was a reasonably cultured and intelligent group, but they were merchants first and foremost, and in spite of the presence among them of Bellini, Giorgione and the young Titian, to name only the most notable, they still regarded artists simply as skilful artisans. They were not overwhelmed by Leonardo's reputation, possibly not fully aware of it, and there is no mention of Leonardo's visit in any of the state records.

The Turks, whose attack had been encouraged by Lodovico Sforza to prevent Venice joining France against him, were invading Friuli, in the east, and some units were encamped not far east of the Isonzo river. Leonardo himself went to Friuli, presumably by invitation, and subsequently presented proposals for the defence of the province, which he submitted to the Venetian senate. His characteristically ambitious plan required the building of a mobile wooden dam, which could be operated to flood the valley wherever the Turks tried to cross. 'With the help of such a river', he told the Venetians, 'a few men are worth many without it.' This plan came to nothing, probably because it was considered impractical, perhaps because peace negotiations were underway and, although they collapsed on this occasion, a truce was signed not long afterwards.

Leonardo's designs for submarine warfare also probably date from his time in Venice, although his interest in diving can be traced back to a drawing made in Florence about a quarter of a century earlier. His first suggestion of means to attack the Turkish fleet seems to have involved mini

***Pulley system for the construction of a staircase, from the* Codex Atlanticus**
Private collection

275

OPPOSITE
Olive press
Leonardo da Vinci Museum, Vinci

Working model of an oil press based on a design by Leonardo. Below it he wrote, 'I promise you that the olives will be so well pressed that the residue will be almost dry.'

submarines – interesting in view of Italy's effective use of such craft during the Second World War – but he soon decided that divers could do the job better. His earlier drawings envisaged the use of short tubes to enable the divers to breathe without breaking surface, but the objection to that was that the tubes might be spotted. Leonardo's final plan foreshadowed Jacques Cousteau's aqualung. The divers, clad in all-encompassing, watertight, leather diving suits with glass goggles, would carry their own air supply in wineskins on their backs. They would advance along the shallow seabed carrying tools to make holes in the hulls of enemy ships and long knives to cut through defensive nets.

Whether he advanced this plan to the Venetians we do not know. There is no record of it being proposed, let alone enacted, and Leonardo himself apparently had doubts about the morality of the exercise. 'I do not wish to publish [my method for remaining underwater without coming up for air] because of the evil nature of men, who might use it for murder on the sea floor.' In spite of the efforts he made in designing weapons and fortifications,

Leonardo regarded war as 'beastly madness'.

Disappointed or not, Leonardo left Venice. But he was not immediately bound for Florence. He made a note to himself to contact the Comte de Ligny, one of the French leaders, with whom he had friendly contacts before leaving Milan (it was Ligny who saw to it that Leonardo continued to receive rent on his vineyard). He noted, ... 'tell him you will wait for him in Rome, and that you will go with him to Naples to get the donation.' Clearly, he was planning to visit Rome and then Naples, and he was involved in some kind of project for the French for which he anticipated payment. He may in fact have visited Rome briefly in 1500, but whatever the business with Ligny was, it did not result in employment.

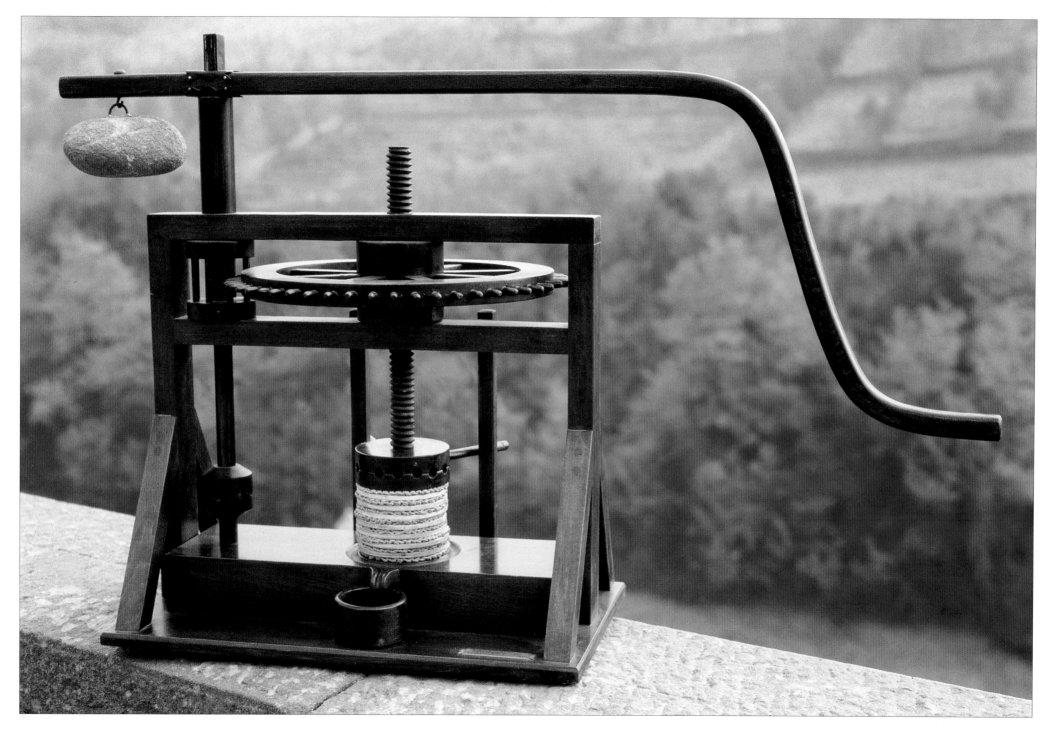

THE REPUBLIC OF FLORENCE

In the time of Lorenzo de' Medici, Il Magnifico, Florentine society was becoming more aristocratic, its culture more elitist, and there were signs of impending material decline; but in later years people came to think of this as a golden age. Whether Lorenzo, who died in 1492 aged 43, could have avoided the troubles that began within two years of his death is doubtful, but he was surely better qualified to combat the crisis provoked by the French invasion than his undistinguished son Piero.

As we have seen, Charles VIII's objective in 1494 was Naples, but he elected to reach it by marching through the Italian peninsula. As the ally of the king of Naples, Piero de' Medici had opposed the French plan, but when Charles's forces marched into Tuscany he was forced to make a hurried peace. The terms were humiliating. He was compelled to surrender several strongholds on the coast, including the important city of Pisa, and the effect of these concessions was a drastic weakening of Florence's strategic situation and a sharp economic slump. The sacrifice of Pisa, in particular, was too much for the citizens of Florence, who rose in fury against the Medici and drove Piero out, even before the final arrangements had been made with the French. Florentine efforts to regain Pisa, which gained independence when the French left, would occupy Leonardo in the future.

Although the restoration of a popular republican government was widely welcomed, the outlook for Florence was gloomy. The French invasion had demonstrated, not only to Florence but to all the Italian states, that they had long been living in something of a fool's paradise. The era of peace and independence under the restraining influence of Lorenzo had lulled them into a false sense of security. As now appeared, the security and prosperity the Florentines had enjoyed was not, after all, the direct result of their own actions, but was largely accountable to circumstances outside their influence. With the departure of the French army, the economy recovered but the sense of vulnerability remained. Some of the sparkle went out of Florentine culture, and the bright

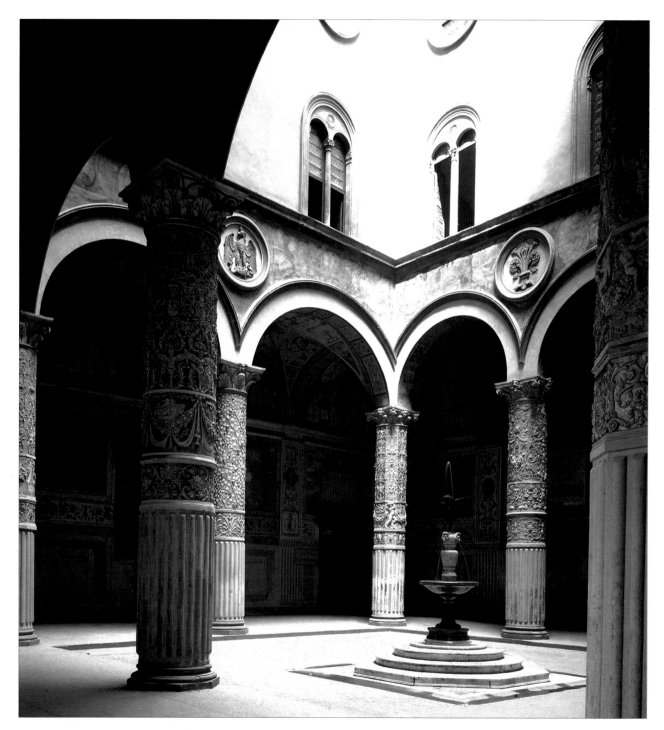

confidence of earlier times was gone for good.

Such judgments are more easily made in retrospect. Certainly, the liveliness of politics showed that the Florentines had not lost their civic spirit and devotion to republican government (nor their propensity for vigorous political conflict), inspired by their history preceding the long interval of Medici rule. The new government was more widely representative than any since the days of the medieval commune, and it included a new legislative Great Council of 3,000 members, comprising about 20 per cent of the male population aged 30 and over. A new chamber was constructed for this body as an extension of the Palazzo della Signoria (Palazzo Vecchio), where in due course one of Leonardo's greatest works would begin to take shape.

In spite of its more representative government, the new republic also fell under the dominance of a single gifted individual. That apart, however, Lorenzo de' Medici and Girolamo Savonarola had little in common.

A native of Ferrara, Savonarola served his initiate

Portrait of Savonarola, by Fra Bartolommeo *(detail)*
Panel
Museo di San Marco dell' Angelico, Florence

The failed revolution in morals and manners led by Savonarola, following the disaster of the French invasion, marked a watershed in Florentine history. The city that Leonardo returned to early in 1500 was much changed.

as a monk in Bologna, where he wrote fine poems full of anger at the corruption of the Church. He was posted to St. Mark's in Florence in 1482, but his extraordinary power as a preacher did not become evident until nearly ten years later, when he was elected prior of St. Mark's. His apocalyptic visions of the coming wrath of God struck a chord among a people whose confidence was shaken and whose hearts were fearful of the future.

Savonarola was seen as a divine prophet (indeed his predictions, which could be said to have included a forecast of the Sack of Rome in 1527, were remarkably accurate). Crowds packed the church and surrounding streets when he preached, and his influence expanded rapidly, even among artists: Botticelli was one notable convert. He gained further prestige by the part he played in ensuring that the revolt against the Medici was carried through without bloodshed, and by negotiating the withdrawal of the French – whose invasion he had long predicted as the instrument of divine punishment of a sinful city – in 1494.

Savonarola's aim was a Christian society of

perfect peace, order and justice, nothing less than total moral revolution. This was not practical politics anywhere, least of all in the quarrelsome, faction-ridden city of Florence. That he was driven to pursue it by political means was fatal. His advocacy of popular government and his attacks on the rich and on the Church made him many powerful enemies, and his criticism of the pope eventually led to his downfall. Leonardo had no time for Savonarola or any other religious visionary, and posterity has generally regarded him as a puritanical zealot, guilty of burning books and destroying works of art. But in his quarrel with Alexander VI, a spectacularly immoral person even by the low standards of the Renaissance papacy, it is impossible not to feel some sympathy for Savonarola who, given his principles, displayed restraint and honour, not to mention great courage.

No Italian ruler could afford to seriously antagonize the pope because, however disgraceful the individual, his office still commanded the respect and reverence of the people. When at last Alexander excommunicated him and Savonarola

Portrait of Rodrigo Borgia, Pope Alexander VI
(16th century German School)
Musée des Beaux-Arts, Dijon

Roderigo de Borgia was elected, largely through lavish distribution of bribes, as Pope Alexander VI in 1492. Sympathetic historians have failed to moderate his reputation as the most immoral and the most corrupt of Renaissance popes, and, unlike others, he contributed little to the support of the arts.

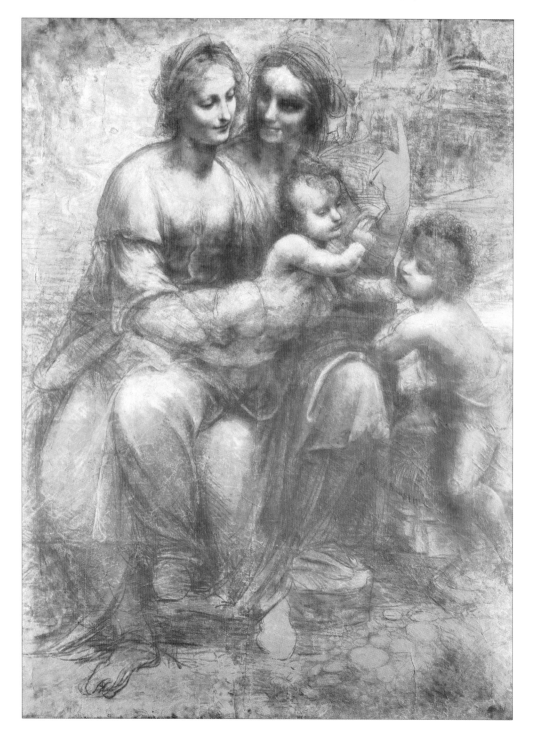

defied the ban, his grip on the people of Florence weakened. At the pope's prompting, he was arrested by the Signoria, now dominated by his enemies, and subjected to savage tortures until forced to admit that his prophecies did not come from God – though he always immediately withdrew his confession afterwards. Crowds as large as those he had preached to gathered to watch in May 1498 when he and two courageous followers were hanged and their bodies burned.

Leonardo was in Florence by April 1500, and he would remain there for two years. He can hardly have been to Naples in the meantime, though it is just possible he might have briefly visited Rome. But since the French project, whatever it was, had not materialized – the Comte de Ligny had returned to France – he was, for the moment, without a patron. That did not mean he was idle. On the contrary, his fertile mind was, as always, occupied by many subjects, and his talents were in great demand. He was called in, for example, to advise on attempts to shore up the church of San Salvatore (now San Francesco al Monte), which was

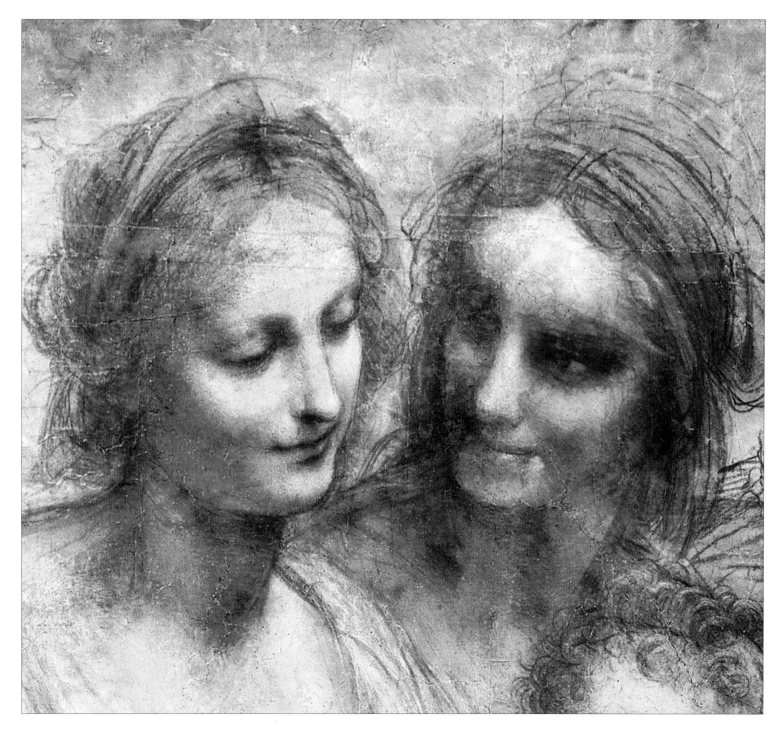

Virgin and Child with St. Anne and St. John the Baptist
(c. 1500)
*Black chalk heightened with white on brown paper, 55¾ x 41⅙in (141.5 x 104.6cm)
National Gallery, London*

It is clear that this is not the work seen in Leonardo's studio in 1501 and described by Fra Pietro da Novellara. Nor is it related to the painting in the Louvre (see page 340 et seq.). There may have been yet other versions, for Leonardo puzzled over it with his usual intensity, frequently readjusting the composition.

*LEFT
Detail of the heads of the Virgin and St. Anne. The Virgin's mother is an apocryphal figure, not mentioned in the Bible, and was conventionally represented in Renaissance art as a young woman, like her daughter.*

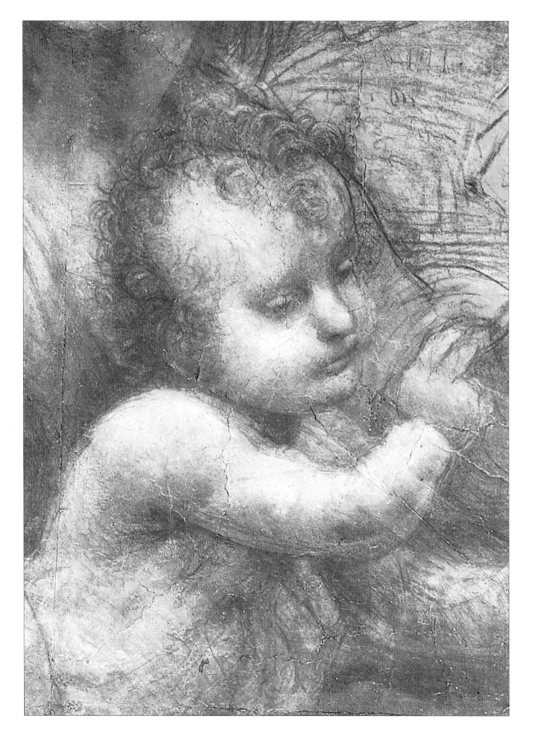
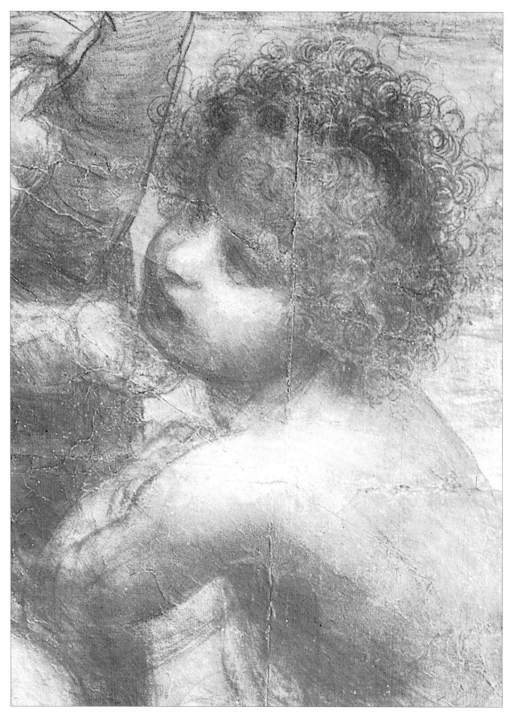

Leonardo da Vinci

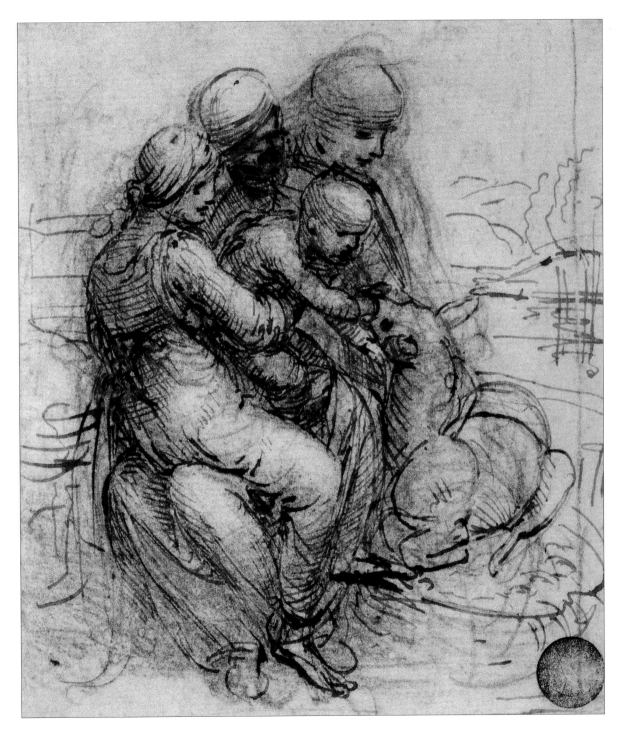

OPPOSITE

Virgin and Child with St. Anne and St. John the Baptist

(Details of the heads of the Infant Jesus and St. John)

LEFT

Virgin and Child with St. Anne

Pen and ink on paper
Galleria dell' Accademia, Venice

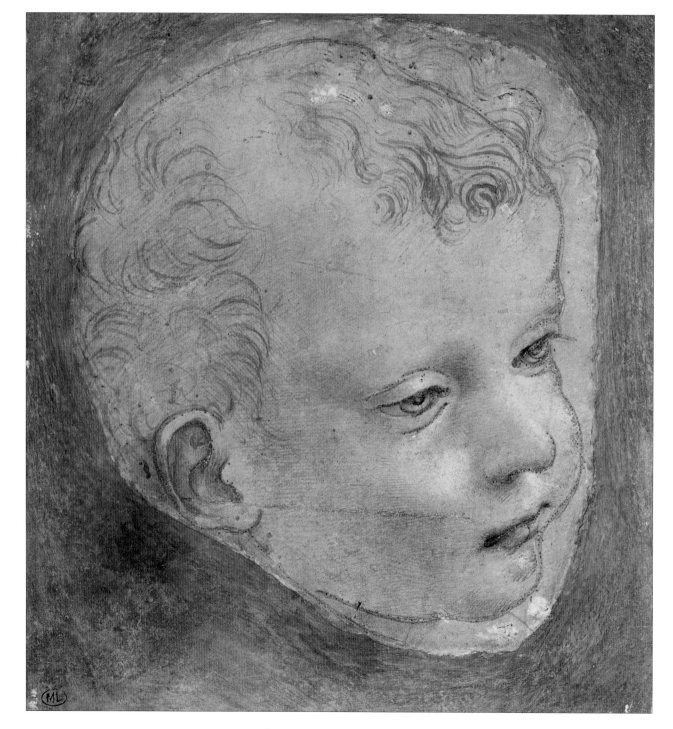

Leonardo da Vinci

threatened by subsidence, and his extensive notes on construction materials suggest that this was another subject on which he set out to write a never-completed treatise.

According to Vasari, he took over a commission for an altarpiece to be installed in the church of the Servite brothers, Santissima Annunziata, gracefully surrendered to him by Francesco Lippi, who had in the past himself taken over at least two paintings that Leonardo failed to deliver. A magnificent carved frame which had been designed by Lippi was already being made by Baccio d'Agnolo. The brothers provided him with a studio and suite of rooms for his household, which still included Luca Pacioli, but Leonardo characteristically did not feel obliged to turn his energies immediately to the painting. However, we know from Fra Pietro da Novellara's letters to Isabella in April 1501 that he had almost completed a cartoon of the *Virgin, Child and St. Anne*, which may or may not have been intended for the altarpiece. The eventual subject, painted by Perugino after Leonardo had defaulted, is different; on the other hand, if the

Virgin, Child and St. Anne was not intended for the Annunziata, what was it intended for?

Whatever its purpose, the cartoon must represent the first step in the genesis of the painting now in the Louvre. Over the course of two days a mass of people passed through Leonardo's studio to see it, 'men and women, young and old', Vasari says, who were 'stupefied at its perfection'. On stylistic evidence, the painting has been dated as at least seven years later and the cartoon, which unfortunately has not survived, appears to have been quite different in design: at least as far as we can tell, for there are discrepancies between the descriptions by Fra Pietro and Vasari. But Fra Pietro has earned a reputation as a highly accurate observer while Vasari, not yet born at this time, was sometimes imprecise in such matters.

The other painting that Fra Pietro told Isabella Leonardo was working on in the spring of 1501 was the 'little picture' for the French minister Florimond Robertet, the *Madonna with the Yarn-winder*. The version of this painting, in the collection of the Duke of Buccleuch at Boughton

House, Northamptonshire, was once thought to be the original, but is now seen as the best of several surviving copies, made in Leonardo's studio after his design, with some touches, or perhaps rather more than that, from his own hand, though the dull landscape background surely cannot be Leonardo.

Fra Pietro described the lost original as showing the Madonna seated as though winding yarn but the Child, 'who has put his foot in the basket of yarn, has taken the yarn-winder and gazes attentively at its four spokes which are in the form of a cross and, as though coveting such a cross, holds it firm and does not want to give it up to his mother, who seems anxious to take it from him'. Doubt is reflected in her expression and her right hand hovers hesitantly.

When Fra Pietro saw the painting it was presumably unfinished because, in the Boughton picture and all other known copies, the Child does not have his foot in the basket, but in other respects Isabella's agent faithfully registers the subtle forewarning of the Crucifixion. An act of babyish playfulness, such as we have seen earlier in the *Benois Madonna* (page 88), here takes on a profound symbolic character. The picture is a perfect example of how Leonardo took a conventional and uncomplicated subject and endowed it with new, narrative resonance, empowered by his psychological penetration and his intricate, condensed composition, to which the novel and daring *contrapposto* poses of both figures impart nervous tension. The painting evidently influenced Raphael, among many others, and it would be interesting to know what Giovanni Bellini would have thought of it, had he been able to see it. We can fairly deduce from the large number of surviving copies that the *Madonna with the Yarn-winder* was, as we would expect, very popular at the time.

Leonardo da Vinci

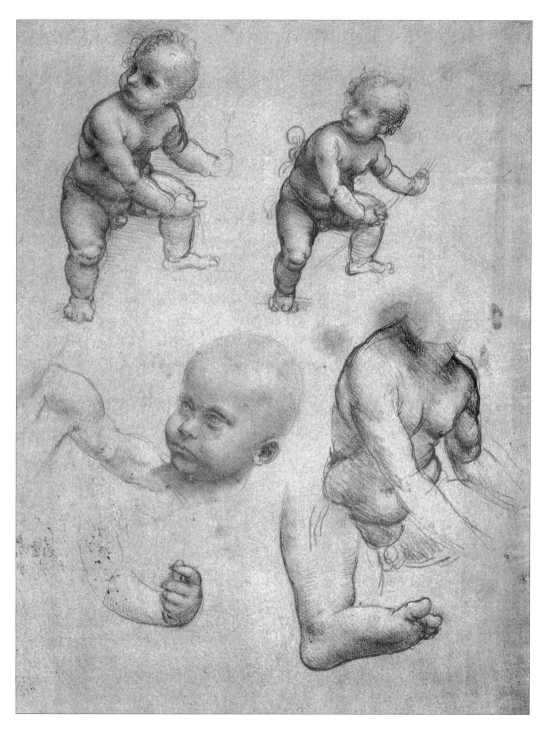

Study for a portrait of a child
Galleria dell' Accademia, Venice

Studies of a child, probably for the Louvre painting of the Virgin and Child with St. Anne *(page 340 et seq.).*

**Cesare Borgia, Duke of
Valentinois, by Altobello Meloni**

*Galleria dell' Accademia, Carrara,
Bergamo*

*During the Renaissance artists
could hardly afford to make
judgments about the
political morality of their patrons,
but it seems likely that Leonardo
eventually revolted against Borgia's
cruelties.*

CESARE BORGIA

The suggestion has sometimes been made that Leonardo welcomed what we might call consultancy work, for which he received payment, as relief from the need to complete a painting. True or not, the reason for his taking employment with Cesare Borgia in the spring or summer of 1502, when he was 50 (nearly twice his employer's age) must have been materialistic. They had no doubt met before, as Cesare, who usually signed himself 'Caesar', had been with the French in Milan, and although the two men had little in common, they shared a 'scientific' approach to problems and a liking for plans on a grand scale.

Cesare is traditionally seen as the most villainous member of a villainous family, although it is possible that he was not guilty of some of the more sensational crimes of which he was accused, such as the murder of his brother and of the husband of his sister, Lucrezia, with whom he was said to have had incestuous relations. An illegitimate son of Pope Alexander VI, he was associated throughout his relatively short career with the empire-building schemes of his father, for which he was the chief instrument. His father made him a cardinal in 1493, when he was about 16, but he left the Church in 1498 in order to enter politics, get married and succeed his murdered elder brother as general of the papal forces. King Louis XII made him Duke of Valentinois, hence the name by which he was commonly known in Italy, 'Il Valentino'.

In a sensational career, Cesare conquered many of the cities of central Italy by a mixture of force, craft and treachery. There was no limit to Borgia ambitions – except the life expectancy of the pope – and Cesare was undoubtedly a man of extraordinary personal charisma and considerable intelligence. Most of the cities he conquered were ruled by tyrants as bad or worse than he. Cesare at least was usually careful not to antagonize the citizens unnecessarily. Nevertheless, as a contemporary described them, his methods encompassed 'murder, bribery, force, every kind of corruption'. Murder he regarded as a legitimate weapon but one to be used sparingly when, he might have said, the end justified the means, and it

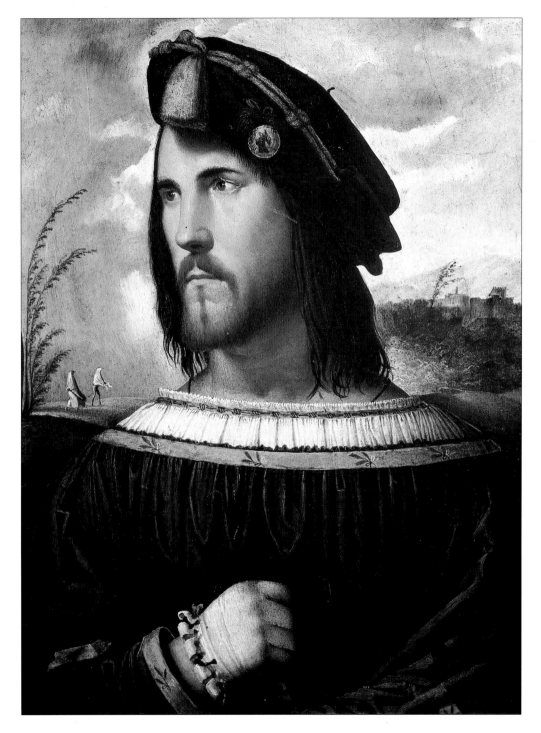

should be committed by a subordinate who could afterwards be blamed for the crime.

As he abolished surviving forms of feudal oppression, instituted civil government and brought, temporarily at least, reasonable peace and stability, in many places the inhabitants welcomed Cesare Borgia's conquest. He was widely admired in Italy, not least by Machiavelli, for whom he provided the model for *Il Principe* ('The Prince'), probably the most famous work on politics between Plato and Karl Marx. We do not know what Leonardo thought of him, though the murder, at Cesare's instigation, of the *condottiere* Vitellozzo Vitelli, a friend of Leonardo, in December 1502 must have shocked him and may have prompted his departure from Cesare's service soon afterwards. There is only one reference to 'Il Valentino' in his surviving writings, a note querying his whereabouts, for they were both on the move, but separately, and therefore they only met occasionally in the period of less than a year when Leonardo was employed as Cesare's official military architect and engineer.

Leonardo was at Urbino in July 1502, some time

Plan of the town of Imola

*Windsor Castle, the Royal
Collection*

*Leonardo's wonderful map of
Imola, an example of his
scrupulous accuracy combined
with creative originality.*

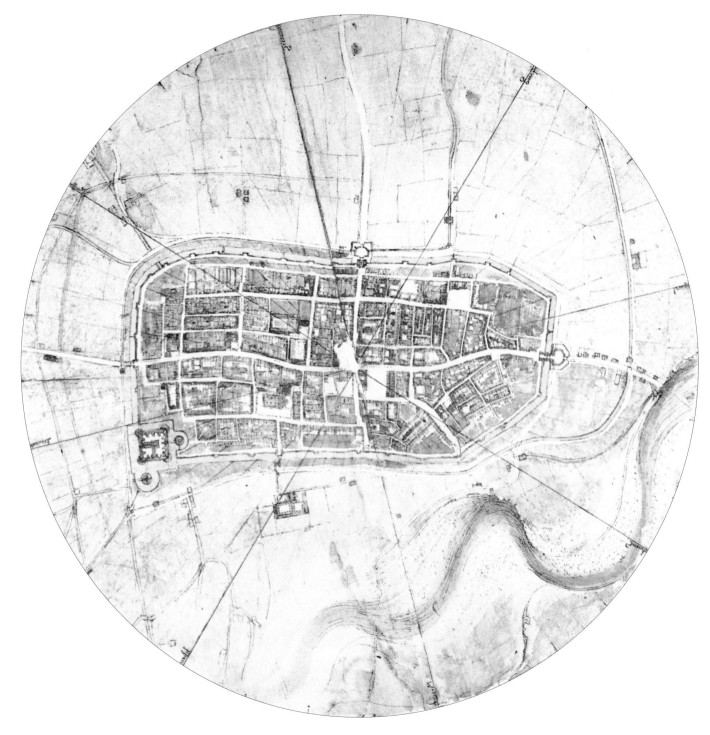

Leonardo da Vinci

after Cesare Borgia's conquest of the city. That was a particularly notorious example of Borgia procedure, for Urbino was not some tyrant's fief. It had long been well governed by the cultured Montefeltro dynasty, and it could not be accused of failing to pay its duties to the papacy, a frequent excuse for Cesare's depredations. He took it by trickery, without firing a shot, and carted away many treasures and manuscripts from the famous library.

Leonardo occupied himself making quick sketches of various architectural features that attracted him, some of them the work of his friend Bramante, and was especially intrigued by a dovecote. Wherever he went, surveying fortifications in a dozen or more different places, in Pesaro, Cesena or Rimini, he found things that interested him: a novel type of window frame in Cesena, windmills and the design of local farm carts, which he thought very ill-conceived, in the Romagna, a bell in Siena (a city briefly held by Cesare, to the consternation of Florence), the movement of the tide on the coast at Piombino.

What practical results his recommendations had we do not know and few of his plans now exist, presumably because they were handed over directly to the builders.

He also made maps, and some of these have survived, notably an astonishing circular map of Imola (where he was again present with his master), using a new surveying technique apparently invented by himself although deriving from the work of Leon Battista Alberti. Bearings of outstanding topographical features were taken from a central point, like points on a compass. Combined with careful measurement of distances, the result was a highly accurate map that is also a work of art, described (by Martin Kemp) as 'the most magnificent surviving product of the Renaissance revolution in cartographic techniques [which also] perceptibly stirs with life … like a greatly magnified picture of a micro-organism'. It shows not only roads and squares and individual buildings but even the interior plan of certain large buildings, and different features – houses, open spaces, water, for example, are represented in different colours.

OPPOSITE

Battle chariots armed with scythes

Pen and ink on paper
Palazzo Reale, Turin

Leonardo copied the designs of earlier war machines, incorporating his own modifications and improvements. Much of the advantage lies, perhaps, in Leonardo's superior draughtsmanship, as against the rather crude woodcuts in a work such as Valturio's De Re Militari.

In June 1502 Florence sent as envoy to Cesare Borgia a man who was destined to become a friend and associate of Leonardo. This was another great genius of the Renaissance, Niccolò Machiavelli (1469–1527). He and Leonardo had first met in Urbino, and they met again at Imola later in the year.

Machiavelli's formidable intellect penetrated custom and convention to reveal the reality of things. *The Prince*, a work of what used to be appropriately called political science, is coolly realistic, designed to demonstrate how a ruler might preserve both his own authority and the material well-being of the ruled. It has been described as 'the first … objective study of mankind: the study of the passions conducted dispassionately, as if dealing with a mathematical problem', words that could almost be applied to the work of Leonardo. Incidentally, *The Prince* does not reflect its author's own political preferences since, as his *Discourses on Livy* make clear, Machiavelli preferred a relatively democratic form of republic, like that of ancient Rome, not a state in which all political power was vested in the ruler. However, the results of political action are never certain, and therefore, Machiavelli said, a ruler cannot be governed by moral absolutes. He was concerned with consequences, not values.

But there was another, more romantic side to Machiavelli, as there was to Leonardo. He would have liked to have played a larger political role himself, as actor, not commentator or civil servant. His other written works included one of the finest Renaissance 'serious' comedies (*commedia erudita*, as distinct from the popular *commedia dell' arte*), the witty and satirical *Mandragola*, and, again like Leonardo, he was stimulated by great schemes.

WAR MACHINES

Weapons, fortifications and military contrivances of various kinds fill many, many pages of Leonardo's sketch books. Mechanical devices, including weapons, are the subjects of some of his most-often reproduced drawings. Together they demonstrate Leonardo's 'advanced acquaintance with the language of gears, pulleys, ratchets, cams, wedges,

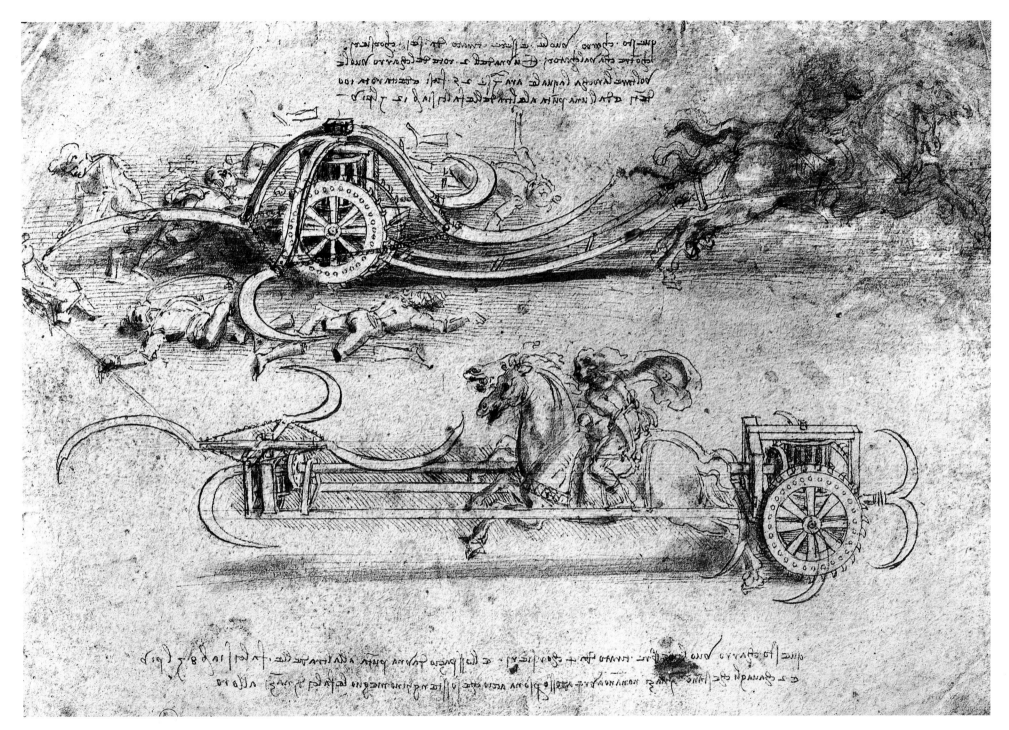

Drawing of the shell of tanks

British Museum, London

Another improbable slashing machine, the practicality of which even its designer doubted, appears to be Leonardo's famous design for what we would call a tank.

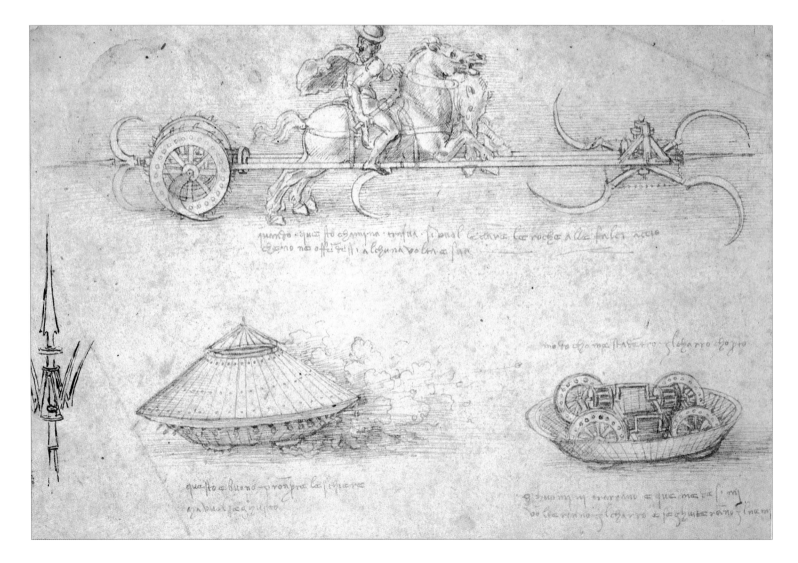

Leonardo da Vinci

linkages, cranks, and racks and pinions' (Bern Dibner).

For a man who was a vegetarian on moral grounds, a man who loved animals and loathed war, this may seem strange. But war was a part of everyday life in the turbulent times of the Renaissance, as natural as shopping, and the possibility of banishing war from human society would have seemed not only absurd but, to many, undesirable. Leonardo's war machines were just that, machines, and machines of all kinds fascinated him, especially as a means to save on human effort. He treated weapons in much the same way as mechanical devices for more peaceful purposes, such as handling water. Nor was this preoccupation unique. The Florentine artist-engineer was a well-established figure who went back to Giotto and included – perhaps the most accomplished of them – Brunelleschi, the architect of the cathedral dome.

All the same, there is evidence of the inventor's misgivings in connection with the design of weapons, such as his comment already quoted on why he preferred not to publish his invention of a diving suit – for fear it would be used for murderous purposes. The most striking feature of the well-known drawing (at Windsor) of men trying to raise a gigantic cannon in a foundry is the desperate efforts of the little nude figures that, like Frankenstein, struggle to control the monster they have made. (It also presents a convincing argument for replacing human labour by machines!)

We have seen how Leonardo, in his letter addressed (though possibly never sent) to Il Moro at the time of his move to Milan, stressed his accomplishments as a military engineer and listed various objects he could design, including portable, fire-proof bridges, scaling ladders, bombards or mortars ('very practical and easy to transport [which] will plunge the enemy into terror, to his great hurt and confusion'), armoured ships, 'covered vehicles which will penetrate the enemy ranks with their artillery and destroy the most powerful troops', flame-throwers, giant catapults, and 'other machines of marvellous efficiency'. Of course Leonardo was aware that a military engineer could command more clout than an artist,

especially in Milan, a city with a major armaments industry, and that was why he placed such emphasis on his abilities in this field; but we must wonder just how much of an expert he really was.

He was probably better qualified than appears from the limited evidence available. He was certainly thinking about such things in the 1470s. Sketches of what appear to be instruments for testing and cranking a crossbow date from about 1478; a more finished drawing, of a clever device to dislodge attackers attempting to scale a fortified wall from a secure position at ground level inside the wall, is probably not later than 1481. In his letter he also claimed to have studied the work of 'those who claim to be skilled inventors of machines of war' (adding that most of their alleged inventions were actually nothing novel).

Among ancient authors, Vitruvius, who devoted one of his ten volumes on architecture to military machines, was the most important. The standard contemporary work, summing up ancient writings on the subject, was *De Re Militari* by Roberto Valturio, which was published in 1472 – but in Latin. An Italian translation did not appear until 1483 and as Leonardo did not know Latin at that time he could hardly have read it before he went to Milan, although he probably had some knowledge of it.

For all his intense interest in mathematics, Leonardo was not an accomplished mathematician like Luca Pacioli; for all his emphasis on motion, 'the cause of every life', he did not always grasp basic mechanical principles. It is clear that some of his inventions, however beautifully drawn, would not have worked because he miscalculated the relationship between cause and effect, and his mechanical devices often enter 'a world of gadgetry, in which utility and delight are inextricably combined'. Many, if theoretically sound, were far beyond the capacity of contemporary technology to construct. In a 16th-century context, they are dreams and notions fizzing from Leonardo's boundless imagination.

Most of Leonardo's weapons fall into one of three types: giant catapult (ballista), cannon, and arquebus (early musket). One of the best-known is

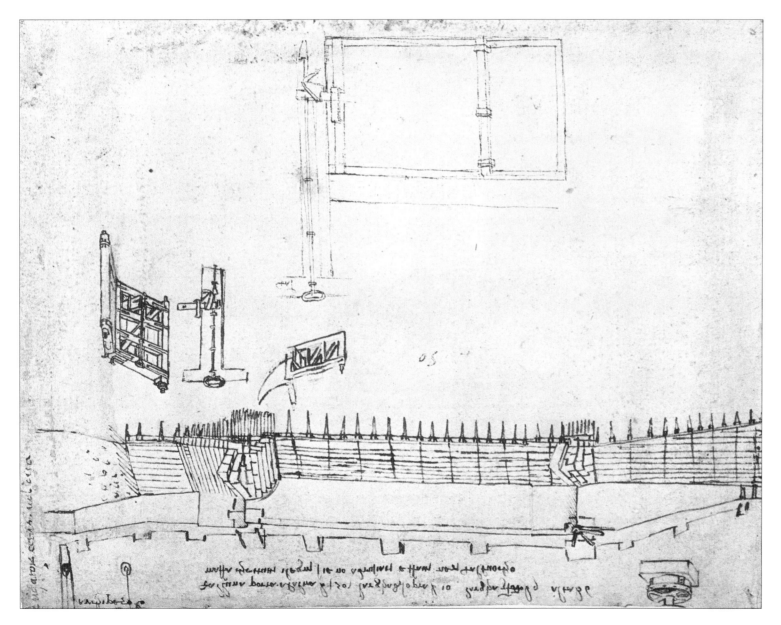

Design for fortifications, from the Codex Atlanticus
Private collection

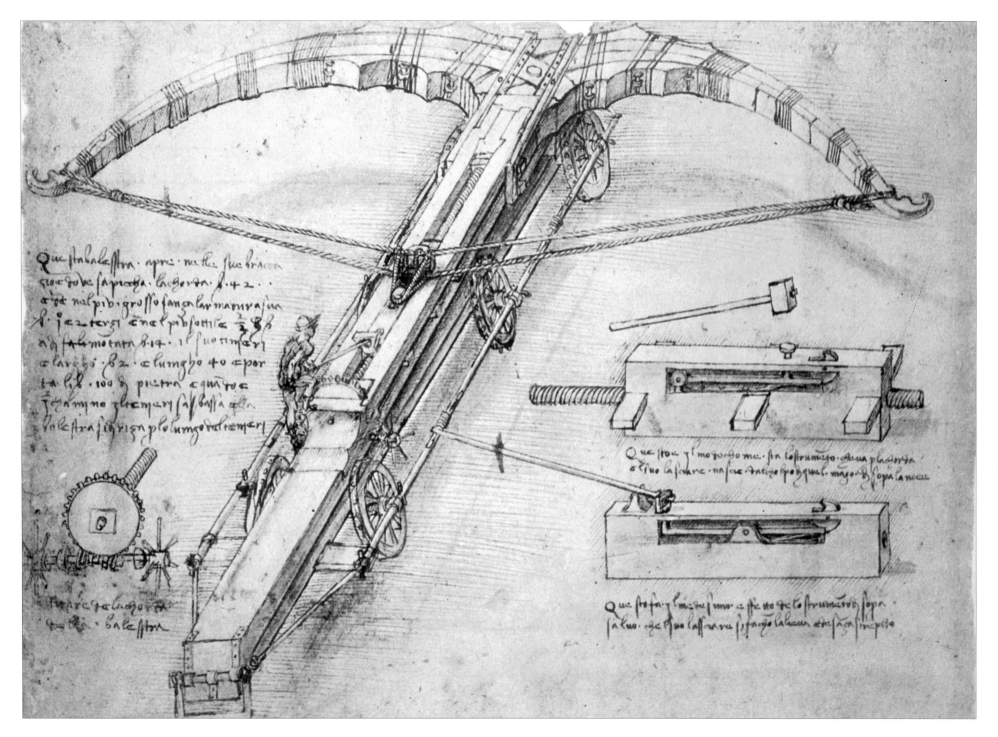

Leonardo da Vinci

the giant ballista in a wonderful drawing – 'a classic of graphic representation in engineering' (Bern Dibner) – with innovations that include canted wheels, a technique later adopted by cart- and coachmakers. Other designs for this type of weapon include a rapid-firing catapult operated by a gang of men on a large treadmill and firing a bolt with fins packed with gunpowder – prototype of the artillery shell. Aspects of small arms design included a water-cooled gun barrel, a method for faster firing of a matchlock and what appears to be an illustration of a wheel lock, several years earlier than its supposed date of invention.

Besides a rapid-firing piece of field artillery with revolving groups of barrels that closely resembles a Gatling gun, Leonardo invented a cannon fired by steam. It must have been built because he says that, when tested, it fired a 55-lb (25-kg) ball about 3,600ft (1,100m): one would not have cared to be the gunner (though steam cannon were used in the American Civil War). He remarks on the need to allow for air resistance when firing a missile (something that Galileo failed to do over a century

later), hence the fins on his ballista bolt. He had an advanced understanding of ballistics, and he seems to have been the first to understand correctly the trajectory of a missile such as a cannon ball, which is a parabola rather than, as generally accepted until the time of Isaac Newton, a straight line upward and outward, followed by a sharpish curve ending in a vertical descent.

Although we have no evidence of any of Leonardo's weapons being put to practical use, that is not particularly surprising, and the rise in his reputation as a military engineer from his appearance in Milan until he was sought out by Cesare Borgia in 1502 strongly suggests that, although Cesare was primarily interested in defence works, some of Leonardo's weapons must have been used in war and found effective.

Leonardo may have scoffed at military engineers who claimed to have invented weapons that, in fact, were no different from existing ones, but many of his own were not, basically, outstandingly original. Like most effective machines, they were based on well-established types (the ballista, which

Giant Catapult (c.1499)
Silverpoint, pen, brown ink and white highlights on paper,
6³⁄8 x 11³⁄8in (16.3 x 29cm)
Biblioteca Ambrosiana, Milan

Leonardo's famous drawing of a giant ballista. In view of the growing efficiency of cannon, many of his siege machines appear on the edge of obsolescence, and it may be that his wonderfully detailed drawings and the improvements he made to an old design were prompted by his own curiosity and enjoyment rather than a genuine effort to produce more effective weapons of war.

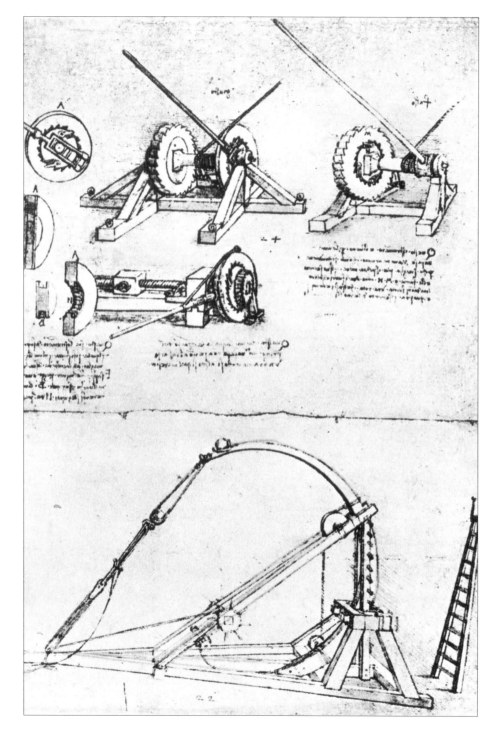

the Romans found handy, was by 1500 on the brink of obsolescence). The scythed chariot that appears on a page now in the British Museum is an elaboration of an even older device, and its efficacy was doubted by Leonardo himself: he thought it would be as dangerous to one's own side as to the enemy. More interesting is the drawing below it on the same sheet, of what is legitimately described as an early prototype of a tank, memorably described by Professor Kemp as 'a deadly wood-louse, which was intended to scuttle across the battlefield on its four wheels, dispensing a hail of shot from around its rim'. It is but one of many examples of weapons and machines that seem to forecast those of five centuries later, although, as with other inventions, he was stymied by the lack of a modern powered engine.

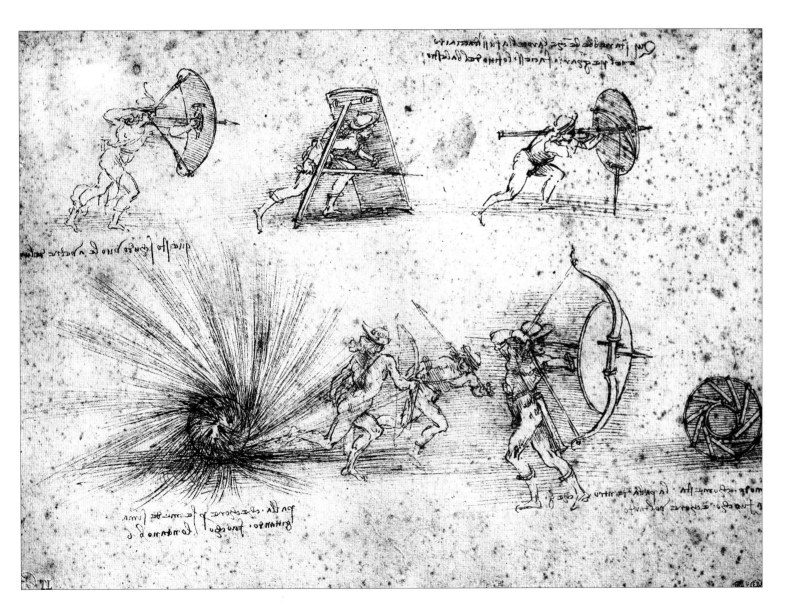

OPPOSITE

Study for catapults

Pen and ink on paper
Biblioteca Ambrosiana, Milan

Catapults intended to hurl missiles over city walls.

LEFT

War equipment

Pen and ink on paper
Bibliothèque des Beaux-Arts, Paris

Defensive shields for infantry adapted to enable the soldier to dispatch a missile while remaining fully protected by the shield; also a bomb.

Drawing based on an armament crane *(c.1500)*

Leonardo's magnificent drawing of the scene in a foundry, as men struggle to raise a hefty cannon with a crane. This is a work of art, not an engineer's design.

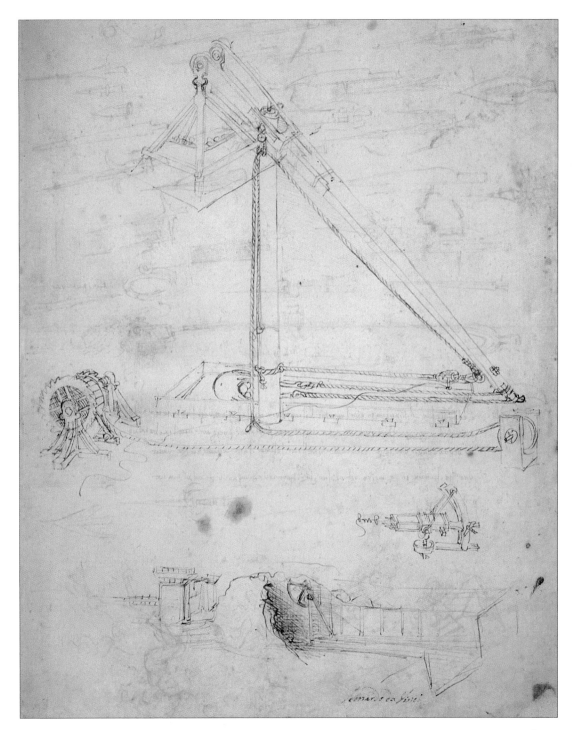

War machine

Pencil on paper

Galleria dell' Accademia, Venice

OPPOSITE

The Ponte Vecchio, Florence

The river Arno as it flows through Florence, passing under the Ponte Vecchio, is the main artery of the city; it is also a menace, its tendency to flood having brought the city close to total disaster more than once.

THE ARNO CANAL

Cesare Borgia's empire soon collapsed as a result of the death of his father in August 1503 and the election of Giuliano della Rovere, member of a family antagonistic to the Borgia, as Pope Julius II. Earlier in that year, by March at the latest, Leonardo returned to Florence where, fresh from his endeavours for Cesare in central Italy, he was asked to advise on an ambitious project of military engineering. The scheme was backed by Machiavelli, possibly influenced by earlier discussions with Leonardo, who may well have originated the idea.

Ever since Pisa had regained its independence by buying it from Charles VIII (in spite of his promise to return it to Florence), the Florentines had endeavoured to reclaim it, and had blockaded the city and its port. The Pisans were unwilling to surrender their independence and put up stout and effective resistance. Leonardo's scheme was designed to end the war without further bloodshed by diverting the course of the River Arno, from a point upstream of Pisa, so as to deprive the Pisans of both their fresh-water supply and their harbour on the estuary. It involved constructing a huge wooden dam across the Arno and diverting the flow into two large channels, each about 7$\frac{1}{2}$-miles (12-km) long, with locks, that emptied into a lake before discharging into the sea north of Pisa.

Perhaps rather surprisingly, the Signoria, encouraged by Machiavelli, approved the scheme. Leonardo made extensive surveying trips and drew maps of the region, but after construction began, in late August, he appears to have taken no further part in the enterprise, and from October onwards he was occupied in the city with preparations for the *Battle of Anghiari* project (page 312), which was commissioned – again, probably through Machiavelli's influence – in that month. When difficulties arose, two Milanese hydraulic engineers were called in.

And difficulties soon did arise. Two thousand labourers were engaged on the work, but another 1,000 men were needed to guard them from forays by the Pisans. It seems that the Signoria skimped on expenses and wages were paid irregularly at best. The river flooded, the dam proved inefficient, the water refused to flow into the channels, though

it flowed dispiritingly everywhere else, and when it did, the sides of one of the channels collapsed. After six months, when the work should have been finished, it was scarcely half done, and the Florentines, concluding that it would be foolish to throw more money into it, called it off.

As usual, the planning of the canal had inspired Leonardo with even bigger ideas, the genesis of which may be traced back to his experience of the great canals of Lombardy. For some distance below Florence the Arno was twisty and unnavigable except for small boats. A direct link with the sea would have been immensely valuable, as the conflict with Pisa demonstrated, and the matter had first been considered a century earlier. Leonardo proposed to divert the river into a navigable waterway from Florence to the sea, following a great northern curve through Prato and Pistoia, cutting through (or possibly tunnelling through, like the modern motorway) the heights west of Pistoia, passing to the east of Lucca and returning to the Arno either above Pisa, or alternatively bypassing that troublesome city, whose harbour

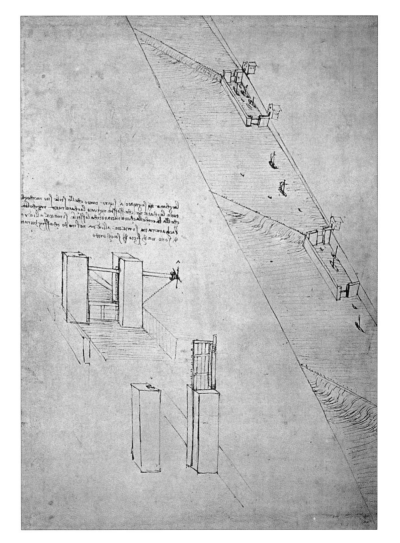

was in any case beginning to silt up. This would bring great benefits to the towns along the route: in Leonardo's imagination a scene appeared of flourishing waterside industries, mills and workshops that suggests to us the Industrial Revolution rather than the Renaissance – and would provide irrigation for a notoriously dry region. Leonardo also reckoned that, because of the Arno's twists and turns, the new waterway would actually be shorter.

But this was only half the plan. In order to maintain the level of the Arno and its new canal, Leonardo proposed to link the river Tiber, far to the south-west, to Lake Trasimeno by a tunnel, thence into a vast new reservoir to be formed in the marshy Val di Chiana to the north-east, linked at the northern end to the Arno near Arezzo. As planned, with the Tiber outlet near Perugia, this would not have worked because at that point the Tiber is lower in altitude than Lake Trasimeno, but even if a higher point had been chosen, in reality the whole scheme was far too big an enterprise to be seriously considered. Nevertheless, it would be

wrong to suppose that it was entirely a pipe dream, the idle thoughts of a visionary carried away by the idea of harnessing the power of nature for the benefit of man. Leonardo designed many practical machines and devices to be used in construction, notably a useful excavator in the form of a giant vertical wheel with buckets carrying the spoil from trench to bank in a continuous process. He even carried out costings, though how accurate they were it would be hard to assess. He reckoned the navigable waterway from Florence, by raising the value of land, would be worth 200,000 ducats a year to the city.

THE BATTLE OF ANGHIARI

In October 1503 Leonardo received his most notable commission from the city of Florence, to paint a picture of a patriotic scene on the wall of the chamber created for the Great Council in the Palazzo Vecchio. It was an offer conferring huge prestige on the artist and one he could not possibly refuse, not that there is any reason to suppose that he had doubts about it. Had he

Leonardo da Vinci

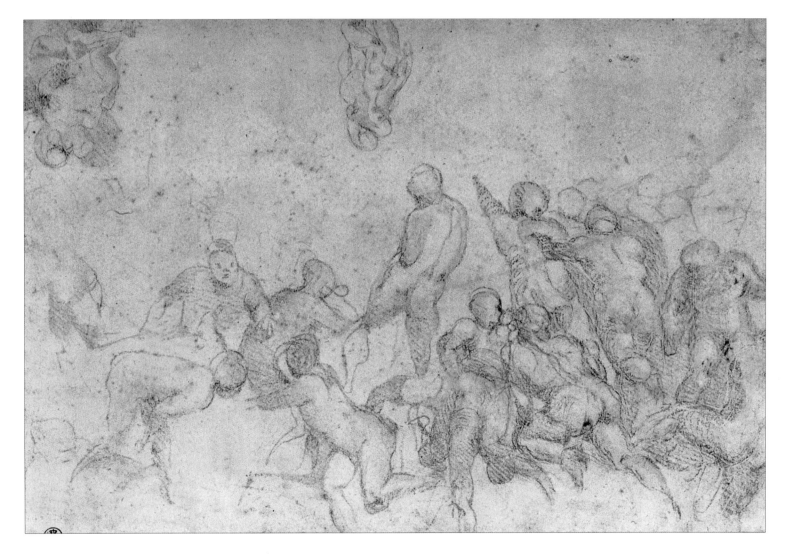

A preparatory sketch for The Battle of Cascina by Michelangelo

Pen and ink on paper

Two studies for The Battle of Anghiari *(1503–05)*
Pen and ink on paper
Galleria dell' Accademia, Venice

We do not know if Leonardo had ever witnessed a battle at first hand, but the impression of dust and smoke, violence and disorder, suggests that he had.

Leonardo da Vinci

known at the time that a similar painting had been commissioned for the opposite wall (possibly the same wall, which is 197-ft/60-m long) from Michelangelo (page 311) and it would have made no difference; he might even have welcomed what was bound to be seen as a competition between the two greatest artists of the time.

Kenneth Clark, echoing Benvenuto Cellini, sees the battle cartoons of Leonardo and Michelangelo as 'the turning point of the Renaissance … a whole book could be written on them', and nowadays, the episode would have been billed as some kind of super-contest and shown on worldwide television. But there was an evident risk of anticlimax in view of Leonardo's growing reputation for failing to deliver and Michelangelo's total lack of experience, at that time, of large-scale painting, besides the pressure of other commitments on both men. Otherwise, the choice was not difficult, since the greatest days of Florentine painting were past, and the current crop of painters did not include any of the first rank apart from Fra Bartolommeo, who was currently

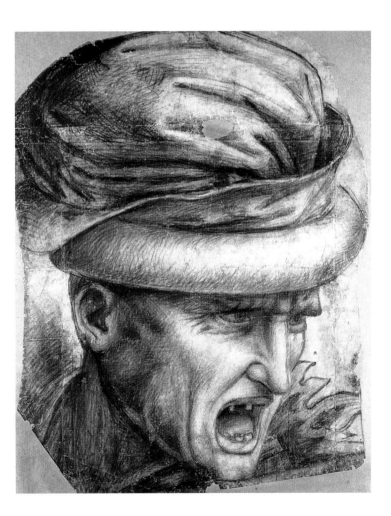

Head of a warrior, after Leonardo
Black chalk on paper
Ashmolean Museum, Oxford

inactive though he was later commissioned to do an altarpiece for the chamber, and the two great rivals themselves.

Leonardo's subject was the *Battle of Anghiari*, a Florentine victory over the Milanese in 1440. Battle scenes, advocated by Machiavelli, had been agreed with the Signoria, and the subjects must have been adopted to suit the known strengths of the two artists. The *Battle of Anghiari* had been a cavalry engagement, and no one depicted horses better than Leonardo. Michelangelo's subject was an incident during the Battle of Cascina (1364) when some Florentine soldiers had been surprised by the Pisan enemy while bathing, and Michelangelo's recent *David* had established him as the supremo of the male nude. In short, this promised to be about the greatest dual project in the history of Western painting, but if anyone thought so at the time, he was going to be disappointed.

The story of this work extends over seven years, during which Leonardo was frequently moving about, mainly between Florence and Milan. Yet in the same period he was extremely active as

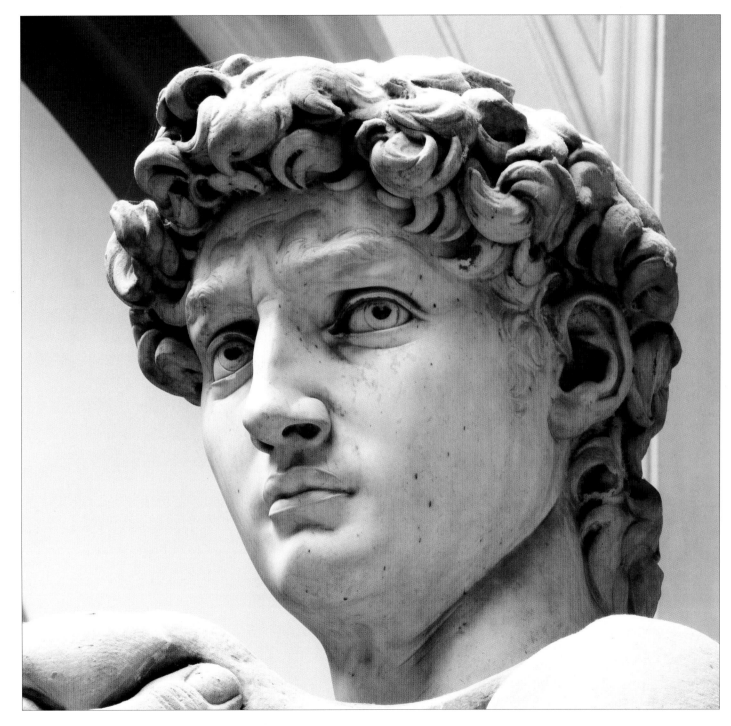

OPPOSITE and LEFT
David, by Michelangelo
Marble
Galleria dell'Accademia, Florence

*Michelangelo's gigantic figure of
David confirmed his reputation as
the master of the male nude.*

a painter. It is best to deal with his major activities individually, as to follow them in strict chronological sequence would be confusing.

Leonardo was given accommodation in Santa Maria Novella, with the Sala del Papa as his studio. Michelangelo was elsewhere. Large rooms were required to draw up the enormous full-size cartoons and, contrary to the suppositions of many later writers, the two artists probably met seldom, since Michelangelo, who was summoned to Rome by Julius II early in 1505, never began the actual painting. As the preparation of the wall was in itself a lengthy task, the two men might have been found working in the same place together at that early stage, but even that is uncertain as Michelangelo started work later than Leonardo.

Leonardo was presumably preparing his wall in the winter of 1503. He began the cartoon in the spring of 1504, under a revised contract reflecting concern at his lack of progress, which held him to a deadline. He began painting the wall 'on the sixth day of June, 1505, a Friday, on the stroke of

13 hours … and when I raised my brush a storm broke out … [the sheets of the cartoon fell apart], there was heavy rain until evening and it was dark as night.' An omen, perhaps.

Each painting seems to have been designed as three groups of figures, and what we know of them now through others' copies is in each case the central group. In Leonardo's painting this is the so-called Battle of the Standard. In Michelangelo's case it was the bathers – the actual battle group would have been to the right. Although the whole design would have been worked out in detail first, it is likely that a full-size cartoon existed for the central group only.

Since neither painting nor cartoon survive, it is difficult to judge the effect of Leonardo's battle scene, although we have a few of his studies, notably of the central soldiers' heads, and various copies made by others (including, interestingly, a sketch of the horses by Michelangelo), besides written descriptions. The copy that probably best conveys the spirit of the painting is the famous

Leonardo da Vinci

work by Rubens, which was based on an engraving, since both painting and cartoon had disappeared long before Rubens was born. Leonardo also made detailed notes on painting battle scenes that are clearly relevant to this work: 'make the conquered and beaten pale, their brows raised and knit, and the skin above their brows furrowed with pain...'. They enter into details to a degree beyond what painting can convey but which are meaningful to the artist, as in his description of 'some of the victors leaving the fight and issuing from the crowd, rubbing their eyes and cheeks with both hands to clean them of the dirt made by their watering eyes smarting from the dust and smoke'.

As so often, Leonardo was breaking new ground in this picture. He was indebted to a bronze relief by Bertoldo di Giovanni, a great authority on classical art who had once supervised the young artists at work in Lorenzo de' Medici's garden of sculpture and had died in 1491. His work in turn was based on a Roman sarcophagus

at Pisa. It incorporated three features relating to the horses that were adopted by Leonardo though not found in earlier Florentine battle scenes: most of them are rearing, most are seen from the side, and most are facing in the same direction, so that the opposing sides do not meet head-on. These were classical conventions which were passed via Leonardo to later artists including Giulio Romano and Titian, but they can be seen as early heralds of the Baroque.

By 1505 Leonardo must have been aware that his *Last Supper* was showing worrying signs of deterioration, but such was his dislike of the restrictions that fresco imposed on the painter that he indulged in another experimental medium. It seems to have been basically a form of the ancient method of encaustic, which he would have read about in Pliny, though he also again included oil. Encaustic involved mixing the pigment with wax which, when heated, bonded with the wall. It apparently worked in ancient times, but it has not been successful since and it did not work in 1505.

OPPOSITE

The Battle of Anghiari, by Rubens

Louvre, Paris

Though not a direct copy, and the work of a quite different artist, this probably best conveys the spirit of Leonardo's lost masterpiece. It pictures the central episode of the Battle of Anghiari, the Battle of the Standard. We do not know what the whole work looked like, but surviving studies provide useful clues.

Periodically he received payments and supplies, in vast quantities (88lb/40kg of flour just to make the paste to attach the cartoon to its backing), and according to one contemporary account he was cheated by his supplier of linseed oil, which was in some way faulty. Drying the paint proved tricky, perhaps because of the unsatisfactory oil, and when braziers were lit to dry it the colours in the upper part of the painting began to run. We hear of no further supplies or payments after October 1505, and it is likely that either then or soon afterwards he stopped working on the painting. The following May he left for Milan, and was gone longer than expected. The chief official of Florence, the *gonfaloniere* (literally 'standard-bearer') Soderini, complained to the French in September 1506 that Leonardo had been paid a great deal of money but had only done a fraction of the work promised. By the time Leonardo did return, the project was dead.

Judging by the copies, and the engraving of 1558 which was Rubens's source, he had painted a considerable amount, more than Soderini implied.

The tremendous force and passion of the painting made a profound impression on young artists who saw it, notably Raphael, and visitors to Florence as late as 1549 were advised to 'climb the stairs to the Great Hall and look carefully at a group of horses … which will seem a marvellous thing to you'. The cartoon had disappeared in 1512. The painting survived, protected by a wooden frame ordered by the Signoria, until the reconstruction of the Great Council chamber in the early 1560s, when it was painted over by – of all people – Giorgio Vasari. (In the second edition of his *Lives*, published in 1568, Vasari does not mention this fact.)

OPPOSITE

Pietà, by Michelangelo

Marble

St. Peter's, Rome

The work that established Michelangelo's reputation, though he was in his early 20s, was made in Rome before 1500.

LEONARDO AND MICHELANGELO

In 1503 Leonardo was 51, Michelangelo 28. The two Florentines (at least, by adoption) are seen today as the giants of the High Renaissance, and at the time they were engaged upon the decoration of the Great Council chamber they were widely recognized as the greatest living artists. They recognized, silently at least, each other's gifts: we have seen that Michelangelo made a sketch of Leonardo's horses in the *Battle of Anghiari*, and Leonardo copied Michelangelo's *David* in a drawing. But they profoundly disliked each other.

In character and temperament they could hardly have been more different. Michelangelo was an outwardly forceful character troubled by inner demons, suspicious of others and prone to quarrels (as his broken nose, inflicted by a fellow-sculptor, suggests). He was plain to the point of ugliness and careless of personal comfort, dress, even hygiene – indications of his single-minded devotion to his work. He was profoundly religious, dedicated to the reform of the Church, and his mind was dominated by great moral ideas – the problem of good and evil, the individual's relation to God, the quest for inner peace.

Leonardo was almost the total reverse. Though reserved, he was charming, courteous, peaceable and unaggressive, handsome not plain, and though equally careless of material prosperity, appreciative of the comforts of civilized society. He was equally dedicated to 'work', but not necessarily to the work in hand since his intellectual interests drew him in so many different directions. The spiritual turbulence of Michelangelo was foreign to him, and he was only superficially a Christian. As for religious reform, he scorned the faith people put in religious images not from some proto-Calvinist conviction but because he scorned all forms of superstition and 'unscientific' belief.

The only record we have of a direct clash (though a one-sided one) relates to an incident that has probably, through frequent repetition, acquired greater significance than it had at the time. Leonardo was crossing the Piazza Santa Trinità with a fellow-painter when they encountered a group who were arguing about the meaning of some

lines of Dante. What did Leonardo think? At this point Michelangelo (a fine poet himself incidentally) appeared in the square. 'Ask Michelangelo,' said Leonardo, 'he will tell you.' This seems a perfectly innocent remark, even a flattering one, but it may have been loaded. Anyway, Michelangelo thought it was and reacted angrily. 'Explain it yourself, you modeller of a horse you could not cast and which you gave up on, to your shame!' and he marched off, leaving Leonardo flushed and silent.

The fact that the particular accusation was unjust – it was the French invasion after all which prevented casting – made it worse. But Michelangelo was probably not the only person to think that Leonardo, with his record of work unfulfilled, was to blame.

Leonardo was a painter, and he regarded painting as superior to the other arts. Michelangelo, as he frequently said himself, was a sculptor by preference. He regarded sculpture as the superior art form because, being three-dimensional, it could more accurately portray reality. Leonardo

RIGHT

The Last Judgment, by
Michelangelo *(detail)*
Sistine Chapel, Vatican, Rome

In his rivalry with Michelangelo, Leonardo might have considered himself superior to a sculptor, but Michelangelo's painting of the Sistine Chapel ceiling made him the painter of the moment, with Raphael second and the ageing Leonardo very much yesterday's man. Michelangelo returned to the Sistine Chapel more than two decades later to paint his grim and gruesome fresco of the Last Judgment, *a striking contrast with the painting on the ceiling.*

OPPOSITE

The Doni Tondo, by
Michelangelo
Tempera

An early work of Michelangelo, the Doni Tondo was painted in about 1503.

disagreed. He argued that painting could represent three dimensions by careful gradations of tone and could also make use of subtleties of space, light and colour, and those qualities of veiled translucence he urged upon landscape painters, all of which were unavailable to the sculptor.

Michelangelo concentrated almost exclusively on the human figure, in particular the male nude. This was soundly based on antiquity, but to Leonardo it seemed a very limited approach. One of the scenes on the Sistine Chapel vault is the *Deluge*, which Michelangelo treats in terms of human figures. Leonardo, with his obsessive drawings of thunderous, apocalyptic tempests and churning waters, would have tackled it very differently! While appreciating the need to express emotions through aspects of the pose and physique, he warned painters – in a manuscript probably written when he was in Rome in 1514 at the time Michelangelo was painting the Sistine vault – not to overdo it, for fear of 'wooden' results. He cannot have liked the muscular, Herculean figures of the Sistine vault, all of whom,

human or divine, old or young, male or female, seemed to belong to the same type.

On a lower level is his comparison of the sculptor and the painter at work in his *Treatise on Painting*, which is so daft that one suspects Leonardo, though not usually a great humorist, had his tongue in his cheek.

Sculpture, he declared, is basically a mere mechanical exercise. The sculptor, as he attacks the marble block, sweats heavily and the cloud of marble dust mixes with his sweat to form a dirty paste spotting his face. Covered in white dust, he looks like a baker. Flying chips shower down on his back, and his whole house is fouled by dust and chippings. Compare this poor creature with the painter, who sits down to work, at ease and well dressed, and works with a small brush dipped in delicate colour. His house is spotless and filled with attractive pictures, and while working he may listen to music or the reading of beautiful literature, which is not drowned out by the banging of hammer and chisel.

In other words, Michelangelo is a barbarian!

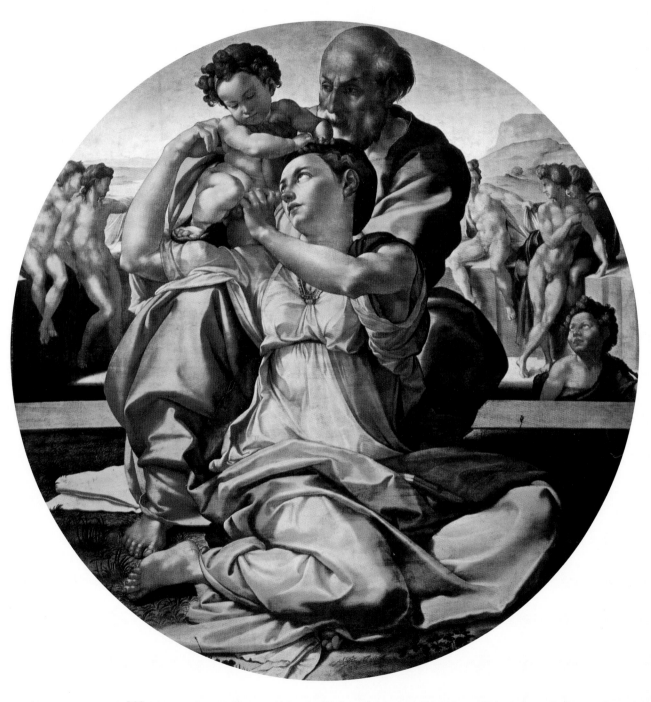

Chapter Seven
Art and Anatomy
1502–08

In spite of Fra Pietro da Novellara's report to Isabella in 1501 that Leonardo was tired of painting, the period between about 1500 and 1508 seems to have been Leonardo's most productive as a painter. Although the number of finished works is small, and others are known only from the work of lesser artists, or from pupils' copies, he was engaged on at least a dozen significant works, most of which were taken some distance, though seldom all the way, towards completion. Even if some allowance is made for the fact that any work by Leonardo now aroused intense interest in Florence and was therefore more likely to be widely reported, this was a period of sustained activity in art, all the more remarkable in view of his pursuit of his numerous intellectual interests and his involvement in other tasks, such as Cesare Borgia's fortifications, the matter of the Arno Canal, and his personal business affairs that necessitated frequent journeys between Florence and Milan.

The greatest of these projects was of course the *Battle of Anghiari*, which was discussed in the previous chapter, as was one of two finished paintings from this period, the *Madonna with the Yarn-winder* (not, in surviving versions, exclusively Leonardo's work). The other finished painting was the portrait known as the *Mona Lisa*, which was begun at this time although probably not completed until after 1508. We know, too, that Leonardo was still occupied, off and one, with the *Virgin and Child with St. Anne*, for which he made several cartoons and possibly began the painting. There was also an *Angel of the Annunciation*, probably a workshop production, which was in the church of San Salvi in 1510. Leonardo may have done more work for the insistent Isabella of Mantua than we know of. Since his drawing of her is pricked, as if to prepare it for transfer to another surface, he may have begun a painting, although it never resulted in the desired portrait. Her request for a 12-year-old Christ seems to have made some progress, because there is evidence of it in the work of the Milanese second-raters who, we may suppose, did rather well from copying or following Leonardo's works, often in poor taste

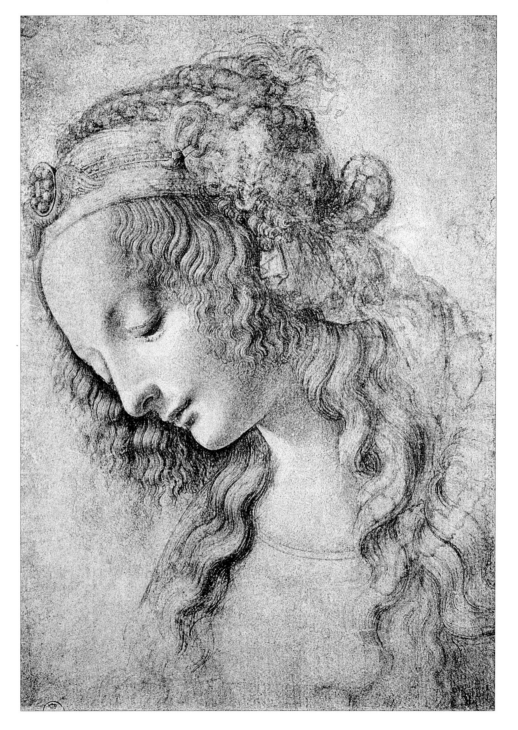

(there was a plethora of nude Mona Lisas!).

Drawings or copies by others suggest the existence in some form of several other works, a *Saviour of the World*, possibly connected with the *Young Christ, Hercules and the Nemean Lion, Mary Magdalene* and a *Madonna*. For Antonio Segni, a well-known patron, poet and scholar, Leonardo did a finished drawing of *Neptune*, no doubt a design for a fountain. It is known chiefly from a dynamic sketch in the Royal Collection at Windsor, in which the figure of the god has an affinity with Michelangelo's *David*. Incidentally, Segni was also the director of the Papal Mint, and he appears to have consulted Leonardo about machines to print coins, designs for which appear in his notebooks. Finally, there is the lost *Leda and the Swan* which, apart from the *Hercules* and the *Neptune*, also belonging to this period, is the only Leonardo painting of a classical subject.

THE VISIT TO MILAN

In the spring of 1506, while Leonardo was occupied with the *Battle of Anghiari*, the French governor of

LOYS XII^E·PERE DV PEVPLE AV PARAVANT·DVC DORLEANS

Milan, Charles d'Amboise, requested Leonardo's presence there. The Signoria, fretting at the lack of progress in the Great Council chamber, were reluctant to let him go, but could not afford to antagonize the French. He left in May, on three months leave of absence, with financial penalties for any absence beyond that.

We can hardly doubt that Leonardo was pleased to return to Milan. In spite of his ties to Florence, his native city, he had always felt more at home, and more thoroughly appreciated, in the Lombard capital, and Charles d'Amboise was likely to prove a more indulgent and more generous patron than the government of Florence.

When the three months were up, the French governor wrote again politely requesting the Signoria to grant a short extension to Leonardo's leave, remarking that he was engaged on 'certain work' and speaking of him in glowing terms. This was the letter that prompted the irritated complaints of the *gonfaloniere* Soderini. They did not, however, secure Leonardo's return.

The 'certain work' on which Leonardo was

Leonardo da Vinci

engaged was probably the *Virgin of the Rocks*. The long dispute between the Confraternity and the artists (since Leonardo's departure, with Ambrogio da Predis alone) had finally reached a compromise, a settlement perhaps arbitrated by the French authorities. The brothers promised more money if Leonardo would return to finish the painting.

It soon became clear that Leonardo had thrown in his lot permanently with the French. In January 1507 the Florentine ambassador to the French court reported that King Louis XII was no less taken with Leonardo than the governor of Milan and, having seen a small picture of his (probably the *Madonna with the Yarn-winder*), was determined to get him to paint several pictures for him, mentioning, when asked, some 'small panels of Our Lady and other things as the fancy takes me, and perhaps also my own portrait'. A letter written on the King's behalf soon followed confirming his intention to employ Leonardo. In May Louis arrived in Milan in person, to a grand reception largely designed by Leonardo. Two months later, Leonardo was confirmed as 'painter and engineer' to the French

king, with a salary commensurate with the office.

Leonardo did return to Florence, with French permission, in August 1507, but not at the demand of the Signoria, now demanding the return of payments for the *Battle of Anghiari* (which Leonardo probably made), nor to resume work on his great mural. He was involved in another legal tussle. His uncle Francesco had died, leaving everything to his favourite nephew, and although it was not a large estate, the will was disputed by Leonardo's half-brothers. As his father had died intestate in 1504 and the brothers, quarrelling among themselves, had secured a judgment in 1506 that excluded Leonardo, Francesco's will seems only fair recompense, though Leonardo, who eventually won the latter case, bore no grudge and seems afterwards to have taken the lead in restoring friendly relations with his father's family.

Then as now, the law worked slowly, and the legal proceedings kept Leonardo in Florence until the early summer of 1508, with the French in Milan now the suitors for his swift return.

In Florence Leonardo stayed in the house of the

OPPOSITE
Portrait of Louis XII, King of France, by a member of the French School *(16th century)*
Oil on canvas

OPPOSITE LEFT

Two studies of a hanging skeleton

Pen and ink with wash
Uffizi, Florence

OPPOSITE RIGHT

Anatomical study

Pen and ink on paper
Louvre, Paris

mathematician and patron of artists, Piero Martelli. As usual he pursued his scientific studies, especially of human anatomy, which increasingly dominated his later years, and the authoritities seem to have left him alone, suggesting that he had complied with the demand for return of payments made for the *Battle of Anghiari*. Another lodger in the Casa Martelli was Gian Francesco Rustici, a sculptor with a slightly louche reputation: he dabbled in alchemy, his studio was packed with animals that included a talking crow and a pet porcupine, and he belonged to a loose association of artists who held informal feasts at which they fashioned works of 'art' out of the food. He became close to Leonardo, always favourably inclined to inventive eccentrics, and seems to have benefited from his assistance.

Since two of Leonardo's biggest projects were sculptures, and we know he made wax or clay models as part of his studies for paintings (including the *Battle of Anghiari*), the absence of any surviving work in this field, and his notorious criticism of sculpture, should not mislead us into thinking he avoided it. He had, after all, been trained by

Verrocchio, and later became an admirer of Donatello, the study of whom he recommended to another sculptor at this time, the 15-year-old Baccio Bandinelli.

Rustici was engaged on the clay model for his life-size bronze group of *St. John the Baptist Preaching to a Pharisee and a Levite*, which now stands above the north door of the Florence Baptistery. According to Vasari, while he was working on it, he wanted nothing to do with anybody except Leonardo, who assisted him actively in every stage of the work right up to casting the bronze. Art historians have generally agreed that Leonardo's influence is strongly evident in the finished group, especially in the figures of the Pharisee and the Levite. The drapery in particular, according to Kenneth Clark, 'was either executed by Leonardo or taken directly from his drawings [for the various versions of the *Virgin and Child with St. Anne*]', and the Leonardo 'trademark' of the pointing finger appears too. It has also been suggested that Rustici's sculpture may have influenced the cartoon of that work in London, whose sculptural quality is marked.

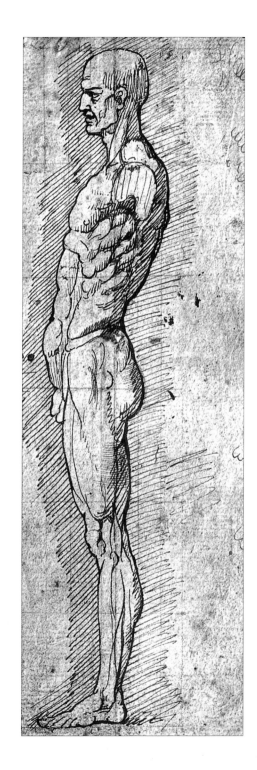

ANATOMY

During the ten months of his stay in Florence while the lawsuit was settled, Leonardo probably gave more time to his studies of anatomy than anything else. He was able to carry out dissections at the Hospital of Santa Maria Nuova, a handy institution for him as it also acted as his bank.

Naturally, any artist who portrays the human figure must have some knowledge of anatomy. As Ghiberti said, it was necessary to 'know the arrangement of bones, muscles, nerves and tendons in the body and to make statues accordingly', as was demonstrated by the masters of antiquity. Artists generally studied the human anatomy from live casts, and studios like Verrocchio's were well furnished with models of limbs and torsos for the benefit of pupils, who also worked with live models. Leonardo knew the works of earlier scholars, of which there was much more available in the vernacular, and seems to have known Galen, the great classical authority on anatomy, although most of Galen was only available in Greek. Leonardo therefore could not have read him, but

RIGHT
Study of arms
Pen and ink on paper
Louvre, Paris

OPPOSITE
Anatomical study of the muscles
of the neck and shoulders
Drawing with text, $11\frac{1}{2}$ x $3\frac{7}{8}$in
(29.2 x 9.8cm)
Windsor Castle, the Royal
Collection

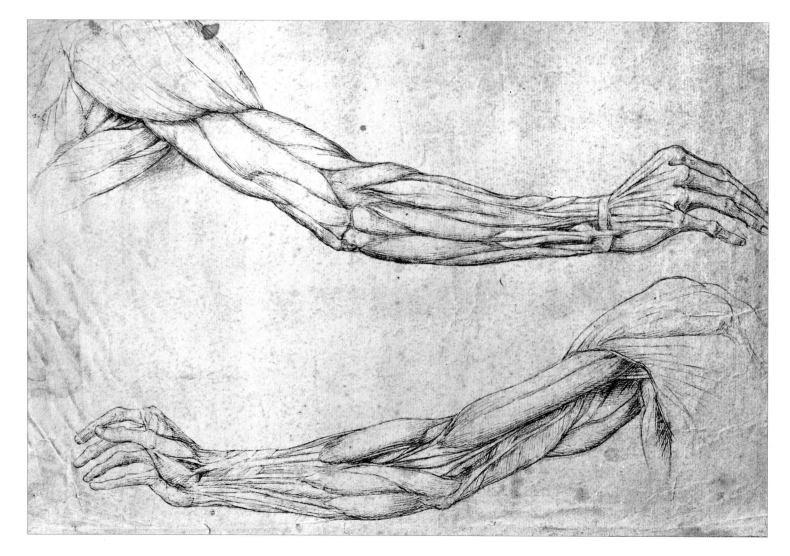

possibly knew his work through some intermediary such as Marcantonio della Torre, professor of medicine in the University of Pavia, with whom he became friendly during his later residence in Milan.

Leonardo may have been the first artist to undertake dissection, a practice, unconventional to say the least, that encouraged his reputation as a semi-magical figure of esoteric learning. According to his own estimate, made towards the end of his life, he had dissected about thirty bodies, young and old, male and female.

Of course, Leonardo's anatomical studies, however useful in his art, were not conducted solely, or even primarily, for that purpose. Anatomy was one of the subjects on which he planned to write a book, although his description of its intended contents suggests a work of wider scope, as much philosophical as biological, reminding us of his vision of the universal, interlinked relationship of everything in nature. It was one of the earliest and most persistent of his specifically scientific interests, and probably represents his greatest achievement in scientific research. He set

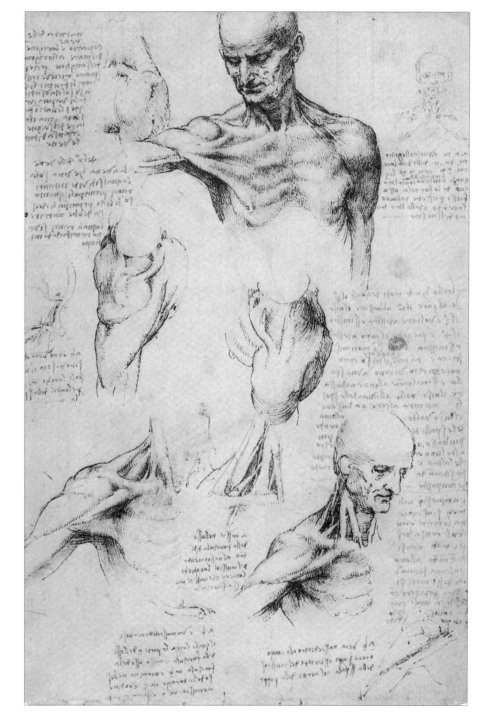

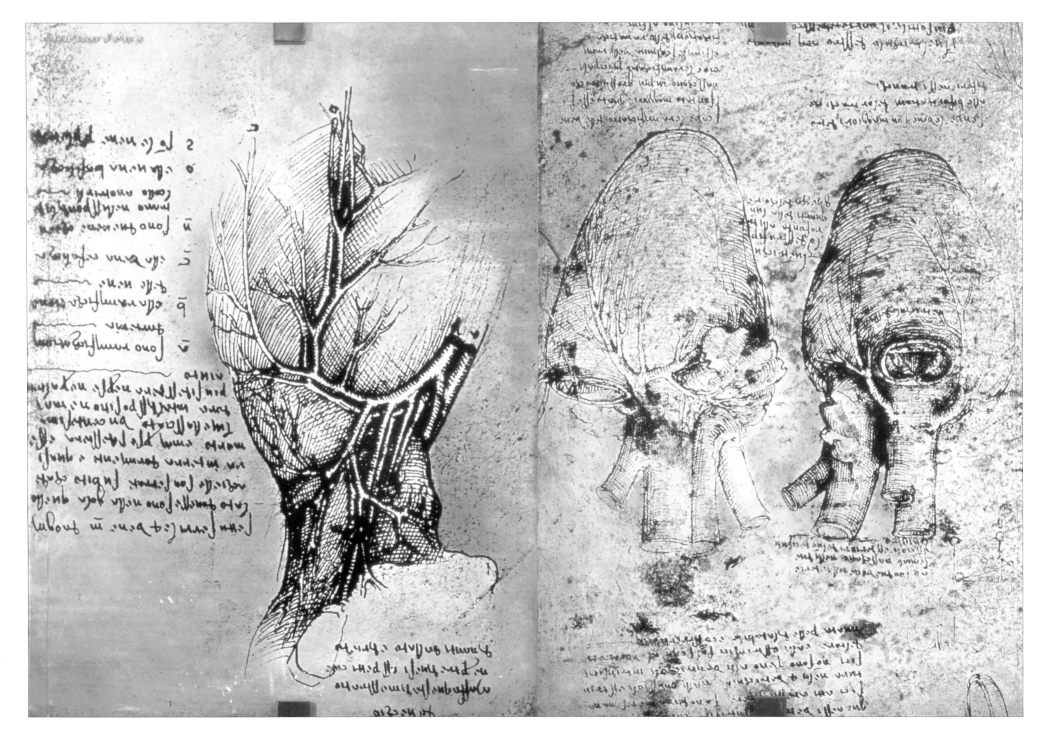

Leonardo da Vinci

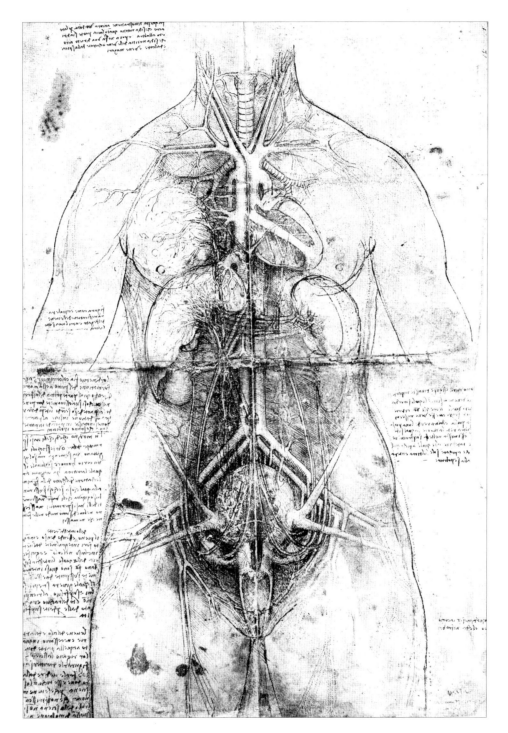

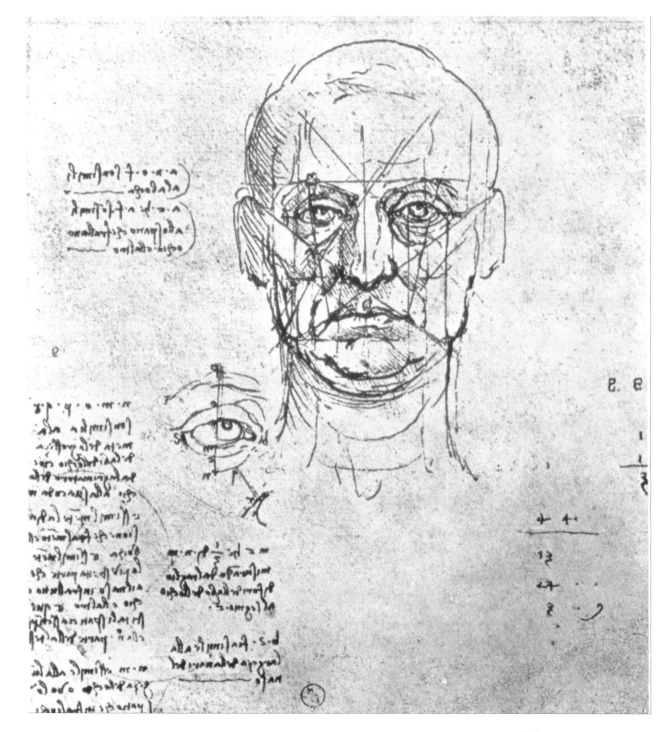

new standards in the quality of technical illustration in his finely finished anatomical drawings, some of them superior even to the famous illustrations to Andreas Vesalius's standard work on the human body published in 1543. Like a sculptor, he realized the importance of different viewing positions, as in a drawing of the muscles of a human arm at Windsor, in which the arm is pictured successively – one could almost say 'scanned' – from slightly different angles.

Following Vitruvius and other ancient scholars, Leonardo pointed out that the proportions of the human body are similar to architectural proportions. He compared a well-designed building with a healthy body, suggesting that God's creation of a human body corresponds with man's creation of a building. This became a general principle applicable to the whole of nature. In Leonardo's universe, mountain streams are the blood vessels that give life to the mountain. The dynamics of the cities Leonardo designed in Milan equally reflect organic processes, with great importance placed on healthy circulation of traffic (we should say

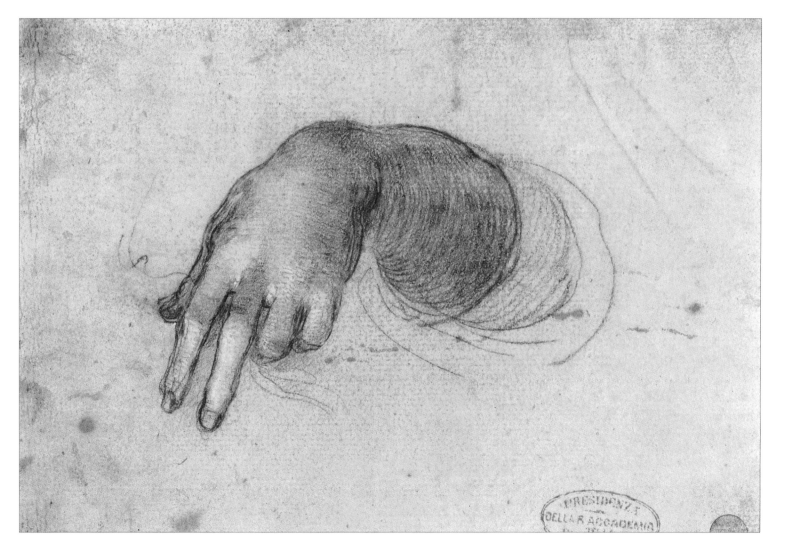

OPPOSITE

Drawing of the proportions of the head and eye

Biblioteca Nazionale, Turin

LEFT

Study of a hand

Red chalk on paper

Galleria dell' Accademia, Venice

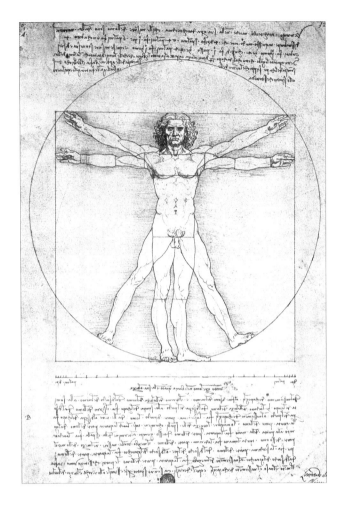

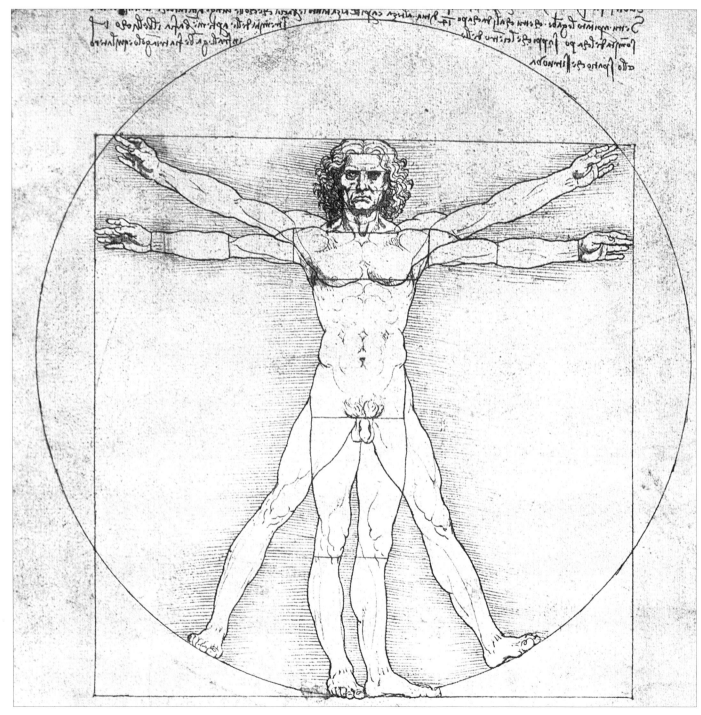

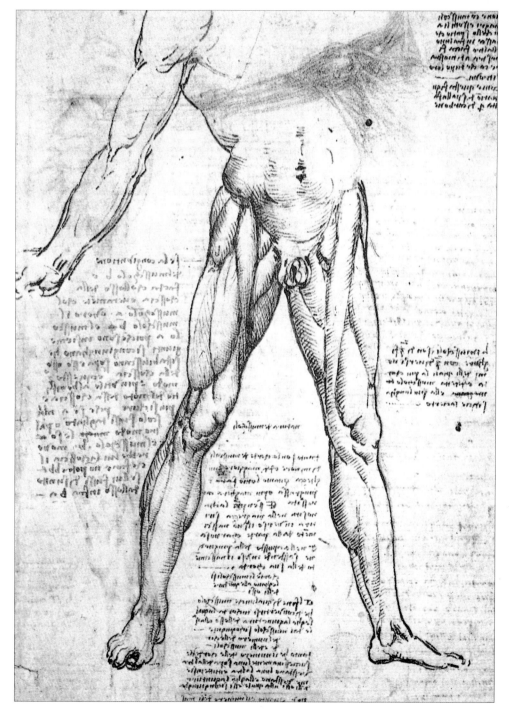

OPPOSITE

Vitruvian Man

(c.1492)

Drawing in pen and ink with text,
13¹⁄₂ x 9⁵⁄₈in (34.3 x 24.5cm)
Galleria dell' Accademia, Venice

This famous drawing illustrates the
proportions of the human body
related to a square and a circle
according to the canon of
proportions described by the
ancient Roman architect Vitruvius.

LEFT

Thigh muscles

Pen and ink, black chalk, wash
11³⁄₈ x 8¹⁄₃ inches (28.9 x 20.7cm)

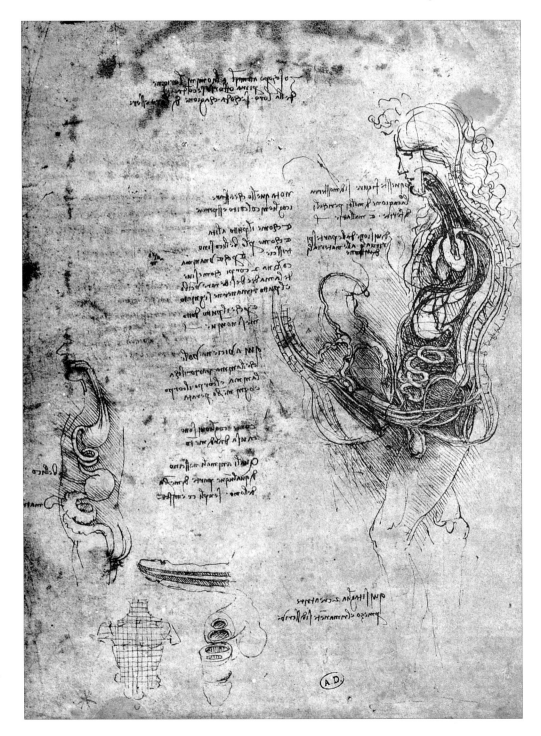

arteries), sewers (veins) and fresh air (lungs).

We must remember that this is not mere metaphor, in the sense that parks today are described as the 'lungs' of a city, but an expression of his profound, all-encompassing view of nature, which was based on the medieval Aristotelian tradition. Man is 'an analogue of the world: [he is] composed of water, earth, and fire'. Bones, blood, veins, etc. – all are reflected in nature. The only exception, Leonardo thought, was nerves, 'which are made for the purpose of movement'. Because 'the world [is] permanently stable, movement does not occur [and] the nerves are not necessary, but in all the other things they are very similar'. Copernicus, of course, had not yet published his revolutionary theory on the the earth's movement around the sun.

Thanks to the co-operation of the Hospital of Santa Maria Nuova, anatomy was Leonardo's chief interest while he was in Florence in 1507–08. It was there that he performed an autopsy on a very old man. He reported his findings in a famous passage that, perhaps more than any other, demonstrates his

unique gifts as a brilliantly perceptive and innovative research scientist.

Leonardo had talked to the man not long before he died. He told him he was 100-years-old, and felt no physical pain, only great weakness. He died peacefully in his bed only hours later. Leonardo was keen to determine the cause of 'so sweet a death'. He found that the weakness resulted from 'failure of blood and of the artery which feeds the heart and lower members, which [was] very shrunk and withered', due largely to 'the thickening of the walls' of the blood vessels. We would call this arteriosclerosis or hardening of the arteries.

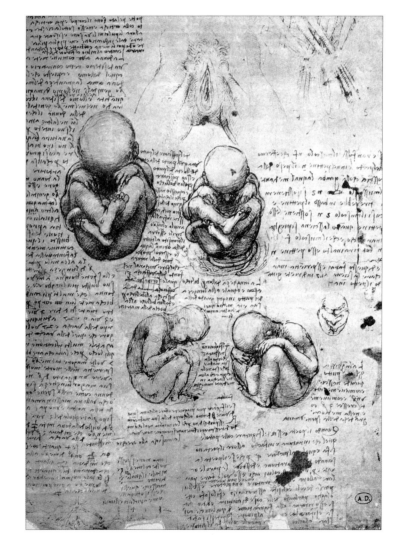

OPPOSITE

Coition of a hemisected man and woman

Pen and ink on paper (facsimile copy)

Bibliothèque des Arts Décoratifs, Paris

LEFT

Five views of a foetus in the womb

Pen and ink on paper (facsimile copy)

Bibliothèque des Arts Décoratifs, Paris

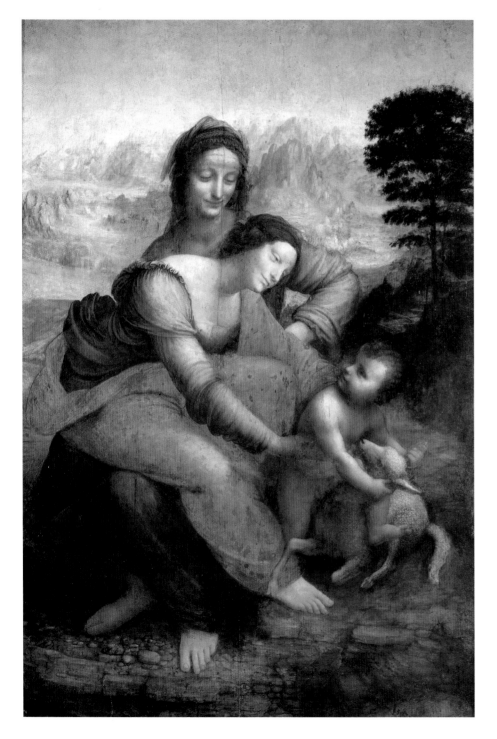

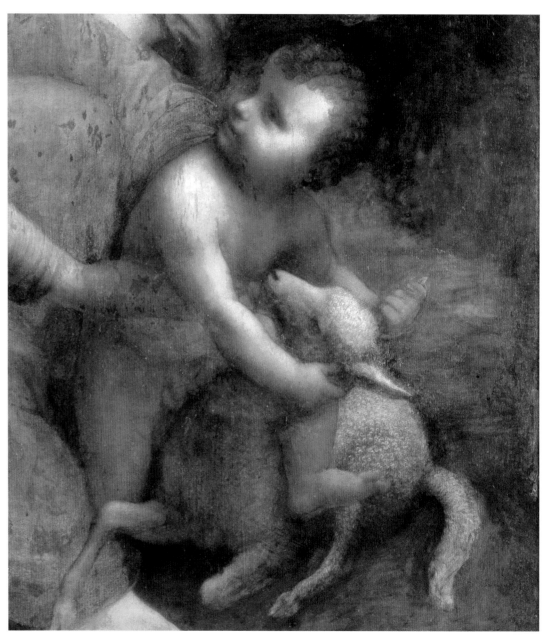

Leonardo da Vinci

THE VIRGIN AND CHILD WITH ST. ANNE

The subject of the Virgin with the Child and her mother was, if not common, not particularly unusual. It was based on sources in the *Apocrypha*: St. Anne is not even mentioned in the New Testament. It was conventional that St. Anne and the Virgin both appeared as young women – this is not, after all, a historical subject and does not represent a moment in time – and that the Virgin sat on St. Anne's lap. Otherwise, Leonardo's version of the subject is far removed from the conventional type.

We know, or know of, three versions of this long-gestated work, besides various sketches, some of which illustrate the problems Leonardo wrestled with when attempting to arrive at the composition. There is, first, the unfinished painting in the Louvre in Paris (opposite). There is also a cartoon of the same subject in the National Gallery, London (page 282 et seq.), which is different in composition and includes the Infant St. John the Baptist instead of the lamb (symbol of the Passion) of the Louvre painting. In addition, there is the cartoon of 1501

described in detail by Fra Pietro and later by several others, including Vasari. Although, like the Louvre painting, it had the lamb without the Infant St. John, it appears otherwise to have been markedly different from both extant versions of the picture. These discrepancies have been the basis of lengthy arguments among art historians, particularly in reference to the relative dating of the two surviving works, though most agree that the Louvre painting is later, and may not have been completed (insofar as it was completed) until as late as Leonardo's sojourn in Rome, in 1513–14. Nevertheless, it probably evolved from the London cartoon.

Another slight mystery surrounds the intended origin of the lost 1501 cartoon that, according to Vasari, created such excitement in Florence about the time Fra Pietro saw it. For whom or what was it intended? It is said to have gone to France eventually, but that cannot have been its destination originally. If we agree that it now seems unlikely to have been the commissioned altarpiece for the Annunziata that Leonardo took over from Filippino Lippi, the answer may be that it was not a

The Virgin and Child with St. Anne (c.1510)
Oil on panel, 66¹/₈ x 51¹/₆in (168 x 130cm)
Louvre, Paris

Leonardo struggled to overcome problems of composition posed by this subject, rather similar to those so triumphantly overcome, in a different medium, by Michelangelo in the St. Peter's Pietà. *The painting, somewhat wider than the earlier cartoon in the National Gallery, London, demonstrates, like the earlier version, that Leonardo had not entirely lost the serene, domestic charm of his earlier, Florentine period, and the effect is enhanced by his decision to replace the figure of the infant St. John with a lamb. In spite of the*

Continued overleaf

relatively long time gap between them, it seems unreasonable to deny that this painting, in the Louvre, Paris, evolved, perhaps through many stages (we know at least four), from the London cartoon.

RIGHT
The Virgin and Child with St. Anne (detail of the head of the Virgin)

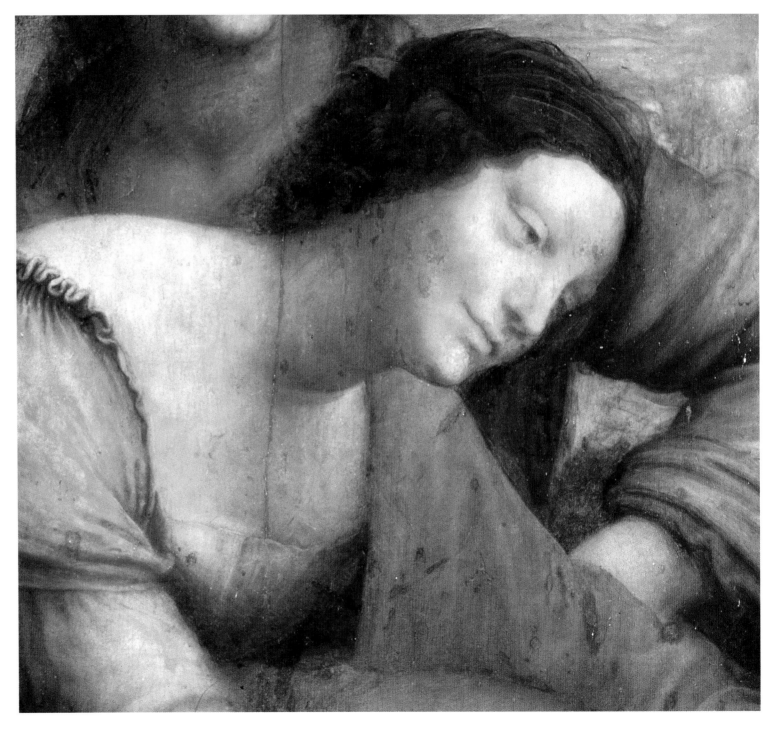

commissioned work at all and that the subject was therefore chosen by Leonardo. We know it was one that interested him, and several arguments have been put forward in favour of the view that it was his own choice. For instance, it may have been intended to re-establish his reputation in the new Florentine Republic, for which St. Anne's Day (26 July) had a special relevance, marking the victory of the medieval republic over the 'tyrant' Walter de Brienne, Duke of Athens, in 1343.

The London cartoon, unfinished like the Louvre painting, was originally probably in Milan, where there is a version of it by the prolific Milanese painter, Bernardo Luini, although, since it was known to Raphael, it may have been done in Florence, perhaps while Leonardo was there in 1507–08. In the latter year Leonardo remarked that on his return to Milan he intended to bring with him, for King Louis XII, 'two Madonnas', and as there is no other trace of them, it is just possible that they were the London cartoon and the cartoon for the Louvre painting. Leonardo says that the two Madonnas were 'of different sizes', and the painting

in the Louvre is larger than the London cartoon, though the difference is not great and the London cartoon has been trimmed.

The London cartoon has been greatly admired for its beauty, and its sculptural, 'Greek' quality, for its humanity and its detail, such as the masterly handling of the draperies for which Kenneth Clark found no intervening example since the female figures of the tympanum of the Parthenon. Leonardo, although thoroughly unGreek by temperament, had absorbed the lessons of Greek art. But the London *Virgin and Child with St. Anne* is also expressive of the more romantic qualities most often associated with him as a painter, 'the shadowy, smiling heads, the tender mysterious glances, the pointing hand, and those two high-sounding devices, chiaroscuro and *contrapposto*, devices that Vasari picked out as a turning point in the history of painting.

Of the Louvre painting, one of the most striking aspects is the landscape background which, with the intricately patterned pebbles at St. Anne's feet (now dulled by time), are incontrovertible evidence of Leonardo's exquisite touch, although the final

painting of the heads, some think, may have been done by an assistant. Studies for the drapery show that this would have been as fine as in the London cartoon, but much of it is either unfinished or has suffered from the disintegration of the blue pigment ('ultramarine sickness') of the Virgin's robe, though in that case it looks as if something similar has happened to St. Anne's skirts, which are brown. The Virgin's upper dress and sleeve are very different. The main figures are the same, except that a lamb replaces the Infant St. John the Baptist, but in nearly all respects their relationship is changed, and the composition is altogether more daring. There is little of the classical 'sculptural' quality of the London cartoon; all is dynamic motion. The Virgin, instead of sitting astride her mother's knee, sits across her lap and bends down to restrain the Child, who has moved from her arms to the ground, perhaps trying to ride the compliant lamb. This establishes a strong diagonal and avoids the close proximity of the two female heads on the same level. St. Anne's heavenward gesture has been abandoned.

We know from sketches – one in particular is so reworked that it is scarcely decipherable – what trouble Leonardo took with the composition of this picture, in all its stages, and we may appreciate his struggle to create a complex series of interlocking rhythms within a single shape. But while we respect his science, our strongest feeling is admiration for his loving humanity.

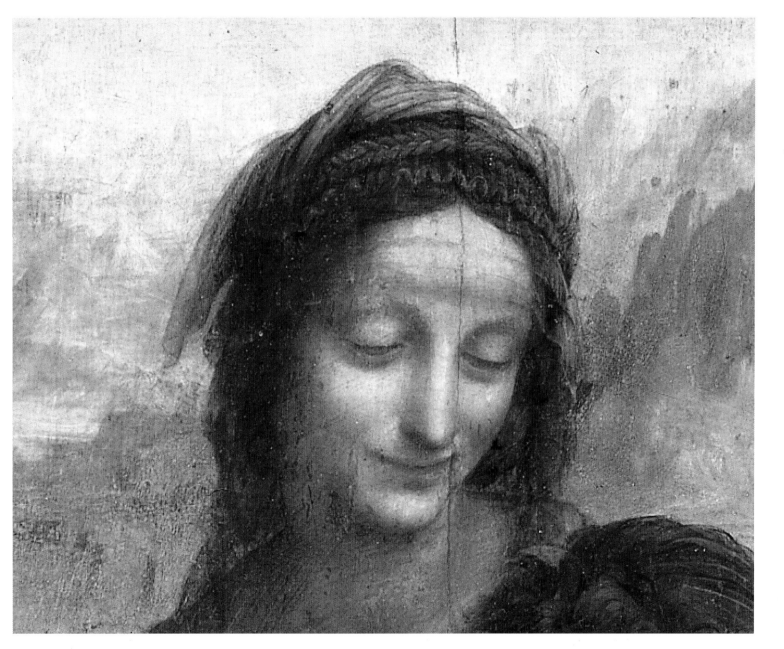

The Virgin and Child with St. Anne (details)

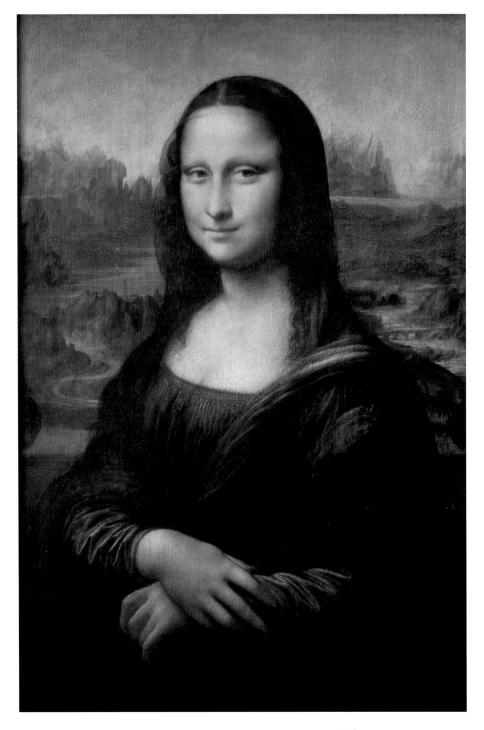

THE MONA LISA

It is difficult today to see the *Mona Lisa* (Louvre, Paris) as purely a painting. It is certainly the most famous painting in the world, 'the one truly universal megastar of art', according to a journalist in the London *Times*, an image as familiar as the Taj Mahal or the Pyramids, endlessly copied and appropriated (to advertise 'among other things, condoms, board games, deodorant, chocolate, toothpaste, cigars, cheese and wine'), satirized and mocked (Marcel Duchamp added a neat moustache) and, on one notable occasion, stolen (in 1911, by an Italian who wanted to return it to Italy). Even if we could shed all the clamouring associations, the picture is in a literal sense difficult to see. Although it hangs on public view in the Louvre in Paris, the crowds, the security and, not least, the layers of dirt together largely obliterate the painting as it was in the early 16th century. Even the favoured scholar who is able to examine it without the crowds and the intervening double layer of bullet-proof glass will not be able to make out the delicate effects he or she expects to find on the basis both of

Leonardo da Vinci

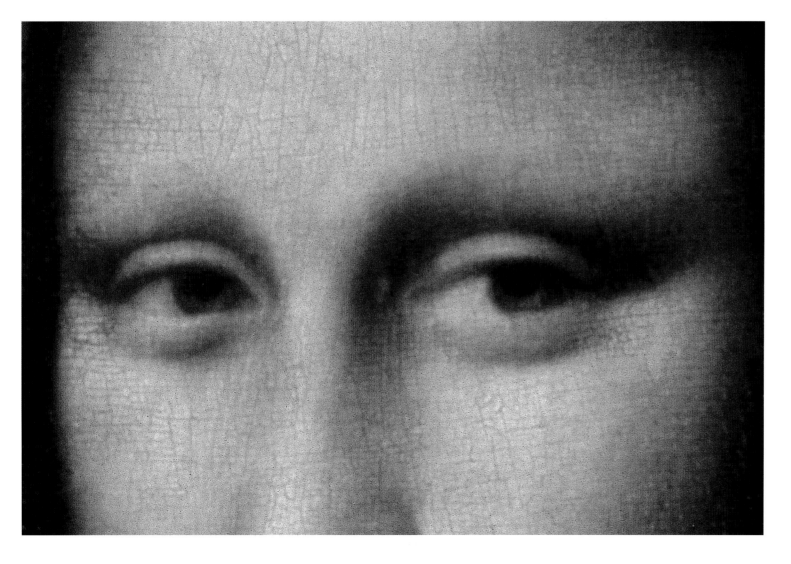

The Mona Lisa (1503–07)
Oil on panel, 30¼ x 20⅞in
(77 x 53cm)
Louvre, Paris

The Mona Lisa, 'a beauty wrought out from within upon the flesh, the deposit, little cell by cell, of strange thoughts and fantastic reveries and exquisite passions' (Walter Pater). This captivating painting has long since passed beyond objective criticism. It might be said that there are hundreds of other Renaissance portraits of more or less similar proficiency, so what accounts for the special status of this rather small painted board? Well, something does, or did. Its reputation was made without the assistance of admen or spin doctors. And, although it is so

Continues on page 351

347

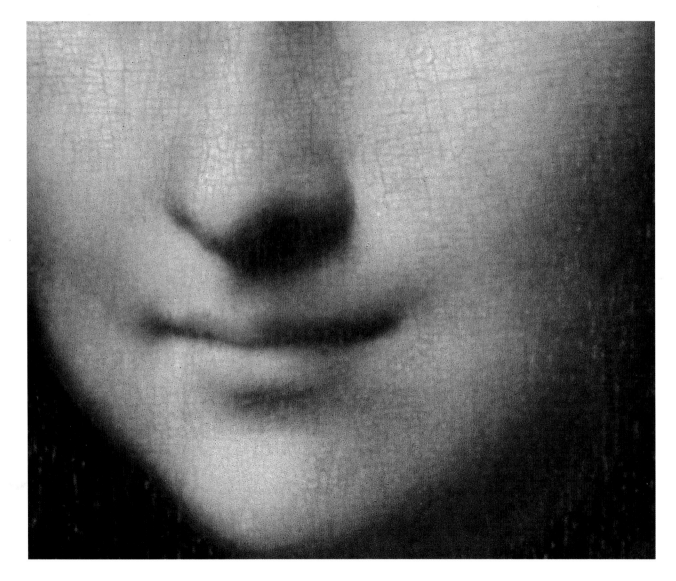

contemporary reports and even of other work by Leonardo. Might the darkened coats of varnish be removed, perhaps? Restoration is always controversial, and some purists believe that it should not be attempted whatever the circumstances, but especially if it involves – as it usually does – any repainting. In the case of the *Mona Lisa*, it would seem that only the lifting of the layers of darkened varnish is required to render it at any rate much closer to its original appearance. But who dares meddle with an international icon?

A corollary of the huge fame of this picture is the argument over its subject. We have dozens of portraits of Renaissance ladies whose identity is unknown, but it seems quite impossible to accept that the subject of the world's best-known picture should be anonymous. Our authority is again Vasari, who says: 'For Francesco del Giocondo, Leonardo undertook the portrait of Mona [short for Madonna] Lisa, his wife, and left it incomplete after working at it for four years,' i.e. probably between 1503 and 1507. This is the sole basis for the name 'Mona Lisa' (alternatively, 'La Gioconda', as she is known in Italy).

Leonardo da Vinci

Francesco Giocondo was a rich silk merchant, a holder of minor public office, and something of a patron of art. He was considerably older and of somewhat higher social status than Mona Lisa, née Gherardini, who was his third wife (the previous two having died young). She must have been about 25. Vasari was writing many years later (he is often unreliable on detail) and there is no corroborative evidence whatever to support his identification of the sitter.

The earliest documentation of what must surely have been this painting (although some art historians disagree) comes from the generally reliable Antonio de' Beatis, secretary to the Cardinal of Aragon, whom he accompanied on a visit to Leonardo in France in 1517. He described it as a portrait of 'a certain Florentine lady, made from nature at the instigation of … Giuliano de' Medici', who was Leonardo's chief patron in Rome until his death in 1516. Stylistic evidence confirms that the painting is late, but given Leonardo's notorious reluctance to finish a work, it would not be surprising if it were begun in Florence about the time Vasari says, and not finished until Leonardo

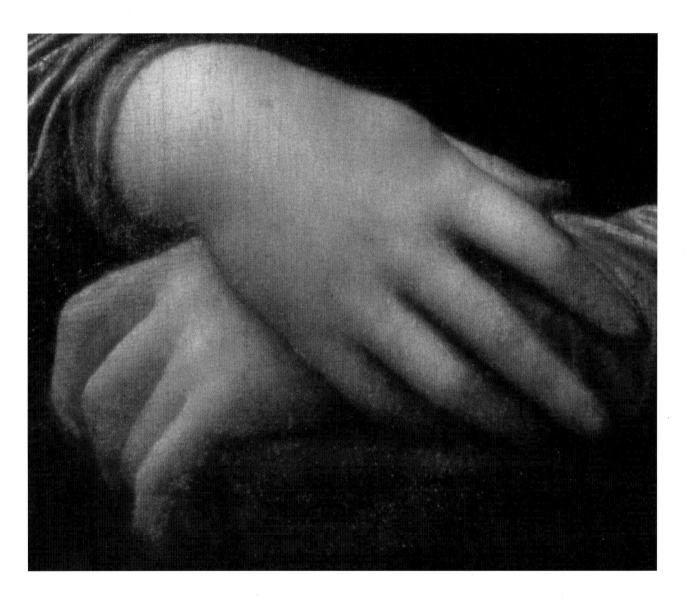

Leonardo da Vinci

was in Rome five or six years later. This seems to be confirmed by a painting by Raphael, the *Maddalena Doni* (page 353), in the Palazzo Pitti, Florence, which adopts the pose of the sitter in Leonardo's portrait – indisputable evidence that Raphael had seen it, in some form, about 1506–08.

On one point, however, the report of Antonio de' Beatis cannot be reconciled with Vasari's – that Giuliano de' Medici commissioned it. That may have been a mistake, but perhaps it was Giuliano who encouraged him to finish it (it cannot ever have been delivered to Francesco del Giocondo) and perhaps owned it briefly before it passed back to the artist on Giuliano's death. Some who think that Vasari was mistaken in reporting that La Gioconda was the subject suggest that he was confusing it somehow with a portrait by Leonardo of Francesco del Giocondo himself, which other sources mention. Vasari goes on to describe the painting in some detail, and what he says (apart from details now obscured) applies to the Louvre painting ('to look closely at her throat you might imagine the pulse was beating'), but it could apply equally to many other paintings, and his description surprisingly omits some of the very features that made it so original. And then, of course, since the picture was in France, as Vasari says (and presumably it had been there since Antonio de' Beatis saw it in 1517, when Vasari was only six years old), he could never have set eyes on it.

Whether or not the smiling lady in the Louvre is Mona Lisa, there is no other realistic candidate (there is a profusion of 'possibles', including Isabella d'Este), and Mona Lisa she is likely always to remain.

While he disdained wealth, Leonardo liked courtly comforts, and we may think of him, while painting the *Mona Lisa*, in the attitude he describes in his piece contrasting the professional activities of the painter with the noisy and violent working conditions of the sculptor. Vasari tells us that while at work on this portrait, 'he engaged people to play and sing, and jesters to keep her merry'. No doubt the atmosphere engendered contributed to her manifest confidence and satisfaction, and perhaps also to her extraordinary communication – she

familiar, so hackneyed almost, so much part of 'the culture', yet, with all the present drawbacks (its murky condition not the least of them), its mysterious, haunting, universality casts a powerful spell.

OPPOSITE
The Mona Lisa *(details of the landscape background)*

Despite the dark and rugged crags, familiar from the religious paintings, there are reassuring indications of human occupation – a bridge, a winding road.

Portrait of Maddalena Doni, by Raphael

Pitti Palace, Florence.

This is an example of the 'new' type of portrait inspired by the Mona Lisa.

seems to be sharing an unspoken secret – with the painter and hence with the viewer. Few painters had attempted anything like this before, certainly none with such success.

In many other respects this painting was almost or entirely without precedent. The pose, so apparently simple and obvious but in fact 'a great formal discovery' (Kenneth Clark), was copied immediately, not only by Raphael but by hundreds of others. One unfortunate result was a host of nude Mona Lisas, which 'transform the near-sublime into the near-ridiculous' (Cecil Gould). In the hands of imitators, even the famous smile became a revolting leer.

Much has been written about the equivocal smile. Its enigmatic quality has persuaded some that she isn't really smiling at all (others insist she is a man in drag), and it is certainly not conveyed simply by the lips, nor by the eyes, nor indeed by any combination of physical features exclusively, but 'wrought out from within upon the flesh little cell by cell' (Walter Pater). No wonder that contemporaries thought that the painting 'seemed rather divine than human'. Of course it is far from being, as some have

supposed, the first painting of a smiling subject. Leonardo had done many others, and he was not alone. The origins of this serene but mysterious expression can be traced back to 13th-century French sculpture, notably the angel at Reims Cathedral known as the *Sourire de Reims* and the *Vierge Dorée* on the south transept at Amiens.

An unusual feature is the extreme simplicity of the dress. Whether or not this was the wife of Francesco del Giocondo, she was bound to have been a wealthy young woman by marriage, but her dress is plain, her head is innocent of jewelled headdress or chain of pearls and her hands of rings. 'Never make so many ornaments on your figures', said Leonardo, 'that they obscure the form and pose…' Her hair is simple – though we know how Leonardo enjoyed intricate hairstyles – but painted with customary fineness, and its only covering is a plain dark veil.

The painting was unusual in other trend-setting ways. It is almost the first Italian example of a portrait painted against a landscape background that is lower than the subject, because the latter is situated on a balcony or an elevated terrace. This

Leonardo da Vinci

was more obvious in the original because at some time the panel was trimmed slightly at the sides with the result that most of the flanking columns were cut off. The landscape itself is characteristically romantic and, as in earlier portraits, suggests a distant Flemish influence transformed by Leonardo's personal vision into a misty, mystical scene. (It has also been linked to a contemporary geological theory, the two large lakes suggesting those that were thought to have once existed in the Arno valley, one near Arezzo, the other, lower one between Florence and Pistoia.)

Leonardo's masterpiece has been described as 'bathed in a liquid atmosphere of muted blue-greens', though the greenish tinge is largely the result of discoloration. The use of thin, diaphanous glazes marks it as a late painting. With an extraordinary, butterfly touch, using the finest of brushes, the painting is built up from the most delicate of layers. The darker areas have now lost most of that quality of translucence that we know they once had, but we can still recognize Leonardo's command of his *sfumato* technique at its most assured.

Leonardo da Vinci

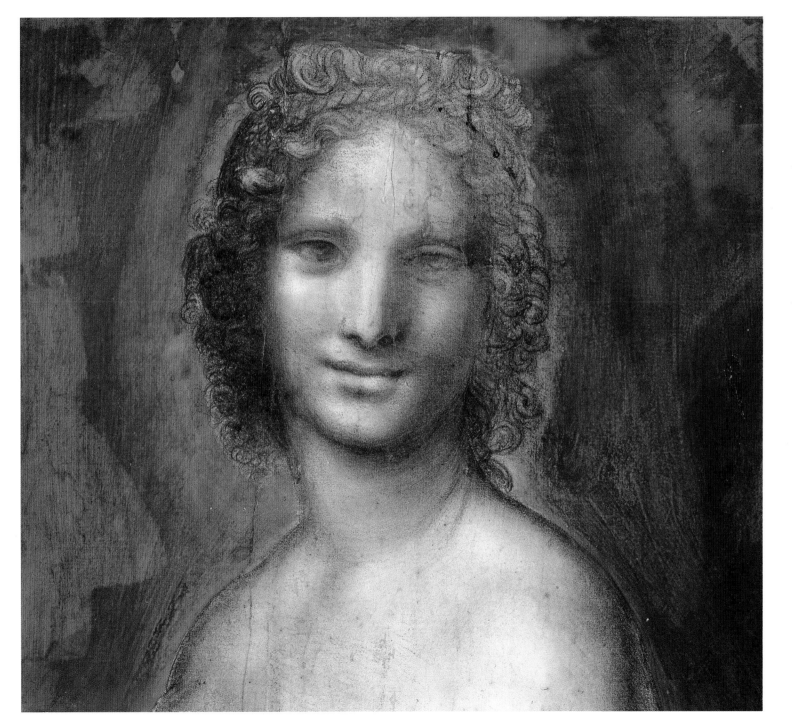

La Gioconda Nude

Gouache and black chalk on paper
Musée Condé, Chantilly

Imitations of the Mona Lisa *began to appear even before Leonardo's painting was finished, and later copies included a large crop of nudes, such as this sketch in chalk and gouache.*

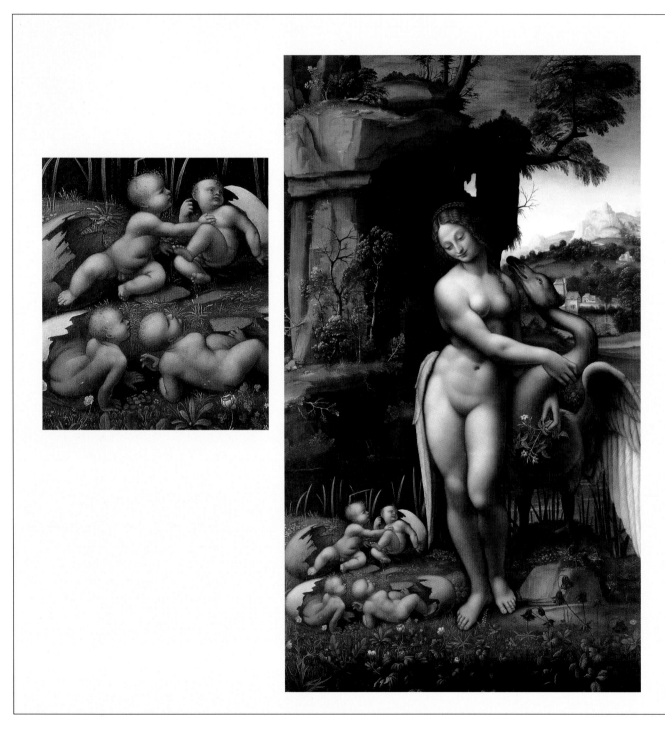

LEDA AND THE SWAN

In a way Leonardo's *Leda and the Swan*, a major venture into classical mythology and his only known essay in the female nude, is the counterpart of the *Mona Lisa*. He worked on the *Leda* over a similar number of years in about the same period. It may well have been a ground-breaker in Florence, since the nude, and pagan mythology in general, had disappeared from Florence along with the Medici. Leonardo's *Leda* may have been the first revival, and if so, it was rather ironic that it should come from his hand. But Leonardo's supposed antipathy to antiquity was only relative: he was perfectly well aware of the virtues of classical art, which he admired, especially at this period, when he was also engaged on the *Neptune* drawing and the design for *Hercules and the Nemean Lion*.

In Greek myth, Leda, the beautiful daughter of the king of Aetolia, was seduced by Zeus in the guise of a swan. She was married to King Tyndareus of Sparta, and had several children by him as well as offspring of Zeus. Among the latter, who hatched from eggs laid by Leda, were two sets of twins, Castor and Pollux, and Helen and Clytemnestra. There were many variations of the myth, which was a popular subject in ancient art.

Like the *Mona Lisa*, the painting was taken to France, and in 1625 it was at Fontainebleau, where it it was seen and described by Cassiano del Pozzo as:

'a standing figure of Leda, virtually nude, with the swan at her feet and two eggs, from the broken shells of which four babies emerge. [The painting], though rather dry in style, is exquisitely finished [and] the landscape and plant life are rendered with the greatest care'. The painting was still at Fontainebleau in the 1690s but some time later it disappeared. According to unsubstantiated legend, it was destroyed by order of the prudish Mme. de Maintenon, mistress of Louis XIV.

Fortunately, there is plenty of evidence of what it was like, including studies by Leonardo himself, a copy of the cartoon by Raphael and several copies by contemporaries and pupils. Most of these were Milanese, not Florentine, suggesting that the final painting was done in Milan. The original design, known from drawings of 1504–06, was of a kneeling Leda, known from classical examples, in an exaggeratedly twisted pose. This may have reached the stage of a finished drawing, but during his visit to Florence in 1507–08 Leonardo rejected it in favour of a standing figure, her out-thrust hip caressed by the swan's wing, in which the extreme *contrapposto* could be more elegantly accomplished.

Perhaps the most faithful copy is one at Wilton House, Wiltshire, generally attributed to Cesare da Sesto, although, like other copies, it has a highly sensual charge that was probably not present in the original. For Leonardo, Leda is not an erotic figure, a symbol of desire, or a sex object. She is a fertility goddess. The female reproductive organs were a major feature of his anatomical studies at this time, and one drawing in particular, showing the womb as a globe, has been (perhaps fancifully) linked with the *Leda*. She represents the great mystery of nature, reproduction and regeneration, the signs of which are all around, in the vigorous, newly hatched babies, the profuse, heaving foliage, and the plants and grasses bursting with life – though to appreciate that we have to look at his drawings, particularly the famous drawing of a *Star of Bethlehem*, with its narrow leaves writhing like the tentacles of a lively octopus.

Although the painting found its way into the French royal collection at Fontainebleau, it is unlikely that *Leda and the Swan* was painted for Louis XII (though it would have been more to the taste of his successor, François I). Judging by the average size of the copies, it was a comparatively small panel, which could therefore have easily accompanied Leonardo on his travels. It must have been begun in Florence, where Raphael made an early copy; we can deduce that it was well known in Milan, and if Correggio saw it, as seems likely in view of the powerful effect it, or some version of it, had on him, it must have gone with Leonardo to Rome, the only place Correggio could have seen it, before it made the final journey to France.

Leda and the Swan, by Francesco Melzi
Uffizi, Florence

Although Leonardo's painting disappeared towards the end of the 17th century, we can judge it from several copies. This one, in the Uffizi Galley in Florence, is by Francesco Melzi, Leonardo's most faithful pupil and friend. Comparison with the copy by Cesare da Sesto shows that the figures are more or less identical, but the background entirely different. From surviving studies, including a beautiful head in the Royal Collection at Windsor, we know that Leonardo originally toyed with a quite different composition, with Leda kneeling.

Chapter Eight
Milan
1508–13

Life in Milan under the French was much as it had been under the Sforza, in one respect better. D'Amboise, the governor, was keen to revive the glory of Il Moro's court, and once more Leonardo was plunged into a hive of activity. Again he was called upon to organize masques and entertainments on a grand scale, such as the visit of Louis XII in 1507, and in even greater number than in Lodovico's time.

He designed a palatial villa for his patron, Charles d'Amboise, of which only drawings and notes survive. A feature of the gardens was a windmill that would create a breeze on hot summer evenings and provide the power to activate some kind of artificial musical instruments. They would be augmented by birdsong from a large aviary (made from plaited copper wire), while the fish ponds, Leonardo suggested, would also be suitable for keeping the wine cool. Orchards and gardens would provide sweet scents. There was also a touch of rough Tuscan humour, recalling the pranks of the Florentine apprentices, in the hidden fountains that would activate unexpectedly to

sprinkle the dresses of passing ladies, 'for fun'. Leonardo was now getting on, approaching 60 and looking his age, but he was still delighted by ingenious frivolities.

There was no shortage of people wanting pictures, but he was not tied down to tiresome commissions, and perhaps found it more congenial to act as consultant and adviser to those who asked for his help on – it would seem – an impossibly wide range of subjects. He resumed his work on canals and waterways, he was involved in military projects, he designed a town house and maybe a church, he advised on the construction of choir stalls for the cathedral, he examined with interest stone from a new quarry brought to him by a young Milanese sculptor. He was thinking of putting his notes in better order, and of getting some of his inventions into profitable production. Surprisingly, he still found plenty of time to pursue his more personal intellectual interests, for instance mathematics (he was up all one night trying to square the circle). He continued his anatomical dissections, and he also travelled a lot, probably in

**Plans for an Etruscan
monument: elevation, floorplan
and detail**
*Pen and ink, grey wash and pierre
noire
7³/₄ x 10¹/₂in (19.7 x 26.7cm)
Louvre, Paris*

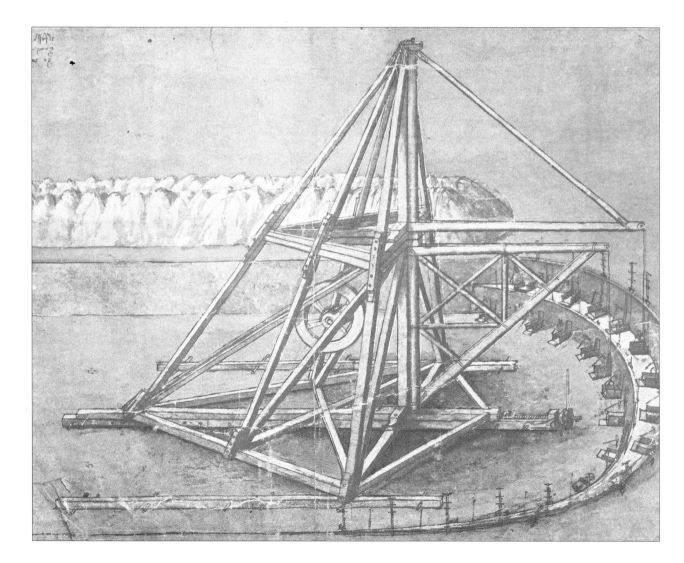

connection with his growing interest in geology. The presence of seashells and marine fossils hundreds of metres above sea level convinced him that the land had once been covered by the sea, but how and when?

Life was even better than it had been under the Sforza because his situation was more comfortable – he had a generous regular income and he still owned the vineyard – and he was treated with even greater respect. The French were enthralled by the Italian Renaissance. Its allure was partly responsible for the invasion of 1494, and they regarded Leonardo as its ultimate personification. He was more admired and revered than he was in Sforza Milan, let alone Medici Florence. In a letter to the Florentine authorities, Charles d'Amboise wrote:

The excellent works of Master Leonardo da Vinci, your fellow citizen, have made all those who have seen them love their maker, even if they have never met him … For ourselves, we loved him before ever meeting him, but now that we have shared his company and can speak from direct acquaintance of his many talents, we see truly that although his

Leonardo da Vinci

name is famous for painting, he has received little of the praise he deserves for his other abilities, which are of extraordinary power ...

Though true, and prophetic in the sense that posterity, like his contemporaries, largely ignored his talents except in painting, this must have made galling reading for the Signoria.

Leonardo was now a man of influence. The King of France himself intervened on his behalf in Florence, and he was also able to call on French support in his lawsuit with his half-brothers, though what probably swayed the judges in his favour was the intervention of the Archbishop of Milan, Cardinal Ippolito d'Este (brother of Beatrice and Isabella), whose help Leonardo had also entreated, knowing the Cardinal had useful connections in Florence.

In about 1508–09 another beautiful young man entered Leonardo's household as his pupil. This was Giovanni Francesco Melzi, then about 16 years old. A most fortunate addition he proved to be, not only for Leonardo, with whom he remained until the day he died, but for posterity, since he became

Leonardo's literary executor and, without his efforts, we should probably not have the *Treatise on Painting* as well as other notebooks. Unfortunately his heirs were less meticulous.

The young Melzi was an entirely different character from Salai who, at nearly twice his age (and still sometimes troublesome), must have been less than overjoyed at this new arrival. He came from a well-known family, his father was an officer in French service, and there was a large family villa at Vapprio d'Adda which Leonardo made plans to enlarge further and where he seems to have spent a good deal of time in about 1512–13. It was unusual for such a well-born youth to enter a painter's studio, but clearly Leonardo found favour with the family no less than with the son. The young man was devoted to him, and in time he even became a competent painter – in the manner of Leonardo, naturally.

OPPOSITE
Excavation machine, from the Codex Atlanticus *(1503–04)*
Pen and ink
Biblioteca Ambrosiana, Milan

One of Leonardo's designs for an excavator, in connection with his canal-construction projects.

ARCHITECTURE

Leonardo's interest in the problems of architecture, along with what he and other Renaissance scholars regarded as the closely allied subject of anatomy, is apparent from his early years in Milan, though his most extensive writings on the subject date from about 1508, during his second residence. Besides his interest in town planning, he was also involved in many practical matters, often more engineering than architecture, most frequently in the capacity of a consultant or adviser.

So far as we know, no complete building designed by Leonardo was ever built (if we except his temporary lath-and-plaster structures for court entertainments that were not designed to last more than days), but there is plenty of evidence of his involvement in architecture, in practice as well as theory. We have seen that he was concerned with various improvements and alterations to the Sforza castle, among other buildings, that much of his work was concerned with restoration or preservation, and that he made many sketches of buildings, of which, besides his ventures into town

planning, his designs for centralized churches are the most notable. He was also engaged for some time on work for the great Gothic cathedral of Milan, and later for the cathedral of Pavia.

The Italians tended to remain faithful to their classical heritage, and the Gothic style that dominated northern Europe from the 12th to the 15th century was, in any case, less suitable in the sunny south, where large windows were not desirable. It is sometimes said that there are no true Gothic buildings in Italy, but that is to take too French a view of Gothic, and even those who make such a generalization have to make an exception for Milan Cathedral even though, from a purist point of view, it is not a total success ('sublime folly' according to the 19th-century critic Hippolyte Taine, and Ian Sutton, in his recent review of Western Architecture, calls it 'weird').

Gothic did offer one advantage, which even Bramante recognized, great interior space, and this was certainly exploited in Milan Cathedral. Begun by the Visconti in the late 14th century, it was the largest building project in Europe at that time and,

Plans and elevations of churches
Pen and ink on paper
Bibliothèque de l'Institut de France

Plans and elevations for a centrally planned church.

RIGHT

Architectural drawing for a church (such as that of San Sepulcro in Milan)

Pen and ink in sketchbook

Bibliothèque de l'Institut de France

OPPOSITE

Designs and plans for a church

Pen and ink in sketchbook

Bibliothèque de l'Institut de France

Leonardo's designs for a centrally planned, domed church date from his residence in Milan and were probably influenced by Bramante. They are likely to have been academic exercises, arising from efforts to solve the contemporary problem of how to fit a round dome onto a square base.

not surprisingly, it took a long time to finish. The west front or main façade was not begun until the 17th century and the building was not completed until the 20th century, though the original design was largely followed. Numerous people worked on it, including many from France and Germany, who generally arrived in hope but all too often left in frustration, puzzlement, even rage.

In Leonardo's time, the main task was the construction of the dome or cupola over the central crossing, a structure sometimes called the *tiburio*. Of course there must have been some kind of structure there already, but apparently it was only temporary. Leonardo, who considered that it needed a 'physician-architect', submitted a design for it, and enlisted a carpenter who spent six weeks making a model. So, among others, did the two other outstanding artist-architects in Lodovico Sforza's service, the great Bramante, and the highly accomplished Francesco di Giorgio. For some unrecorded reason Leonardo withdrew his design before the judging stage; he was, however, paid for his work. Bramante and Francesco di Giorgio were

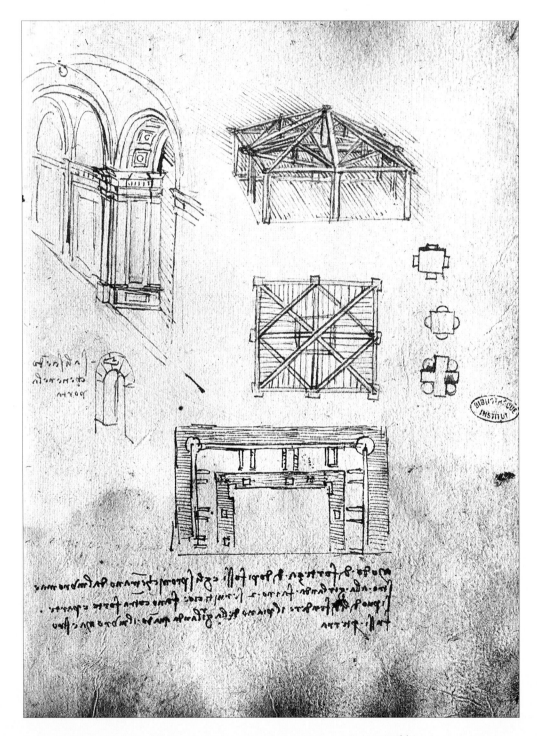

not successful either, and the judges eventually chose a native Milanese.

The gifted Francesco di Giorgio had a powerful influence on Leonardo, who was about 12 years his junior. Francesco was a Sienese, known first as a painter and sculptor, later as a military engineer (alleged inventor of the land mine) and architect. He had worked on the ducal palace of Urbino and was the author of unpublished works on architecture and engineering; we know that Leonardo owned a manuscript of his architectural treatise. We have no record of their interaction, but they had a great deal in common: Francesco's crowded pages of sketches of clever devices are reminiscent of Leonardo's fertile inventiveness, and the two men appear to have worked in partnership in Milan – and also in Pavia in 1490.

Francesco di Giorgio may have prompted Leonardo's famous drawing known as *Vitruvian Man* (page 336), which illustrates the divine harmony of proportions. He wrote: 'For if a man is placed flat on his back with arms and legs straight, and a pair of compasses centred at his navel, the

Leonardo da Vinci

fingers and toes of his hands and feet will touch the circumference of the circle described by them. And just as the human body fits a circular outline, it also fits a square'. Leonardo's comparison of the roles of architect and physician, though it can be traced back to much earlier writers, may have echoed a remark by Francesco, who compared a city with a human body, and his designs for centrally planned churches corresponded with Francesco's ideas.

Alberti had taught that an understanding of the ideal proportions that governed all God's works was the answer to designing beautiful buildings, and the central plan – square, circular or polygonal – seemed the most beautiful form for a church. The ancient Romans were believed to have proportioned their buildings according to the proportions of the human body, and the antecedents of the centrally planned church were to be found in classical temples (most famously the Pantheon in Rome). Although Brunelleschi had designed one in Florence, and there was another, San Lorenzo, in Milan, the idea was still a little ahead of its time because of the long tradition of

the basilica as the exclusive form for a Christian church and the resulting evolution of ceremonials that depended on that kind of space. Leonardo's first attempt was a rather clumsy medley of different geometrical forms that obliterate scale, but it developed, perhaps under Francesco di Giorgio's influence, perhaps also under Bramante's, into a highly integrated structure, for which Leonardo drew up, besides the ground plan, a fully realized image in the form of an artist's three-dimensional picture rather than an architect's elevation.

Although one of the most intriguing of these designs may have been for a Sforza mausoleum, it is clear that they are mainly academic exercises, not plans for specific buildings, although he also drew details of architectural elements such as columns and capitals. The delight he took in ground plans reflects Leonardo's fondness for geometrical puzzles.

OPPOSITE
Building constructions
Text and drawing in pen and ink on paper
Bibliothèque de l'Institut de France

Studies of structural techniques.

Study for the Sforza equestrian monument *(c.1490–91)*
Silverpoint, 8¹/₂ x 6¹/₄in
(21.6 x 16cm)
Windsor Castle, the Royal Collection

This study was probably made in the ducal stables in about 1490 and, if so, was connected with the Sforza monument.

THE TRIVULZIO MONUMENT

Coincidentally, Leonardo's biggest artistic project during his second extended residence in Milan was, as in his first, an equestrian monument. On this occasion, the subject was still living, in fact he commissioned the statue.

Gian Giacomo Trivulzio was the scion of a well-known Milanese family and a *condottiere* in the traditional mould. His career began in Sforza service, and he must have been acquainted with Leonardo, his junior by 12 years, in the 1480s; but when his younger rival, Galeazzo Sanseverino, was promoted over his head in 1488, he shook the dust of Milan from his feet and, swearing vengeance on Lodovico Il Moro, took himself off to serve the king of Naples. The French conquest in 1494 led him to switch allegiance again, although this time it was for good. Subsequently he led the attack which drove Il Moro from his capital and himself took up residence in his chambers in the Castello Sforzesco. Unpopular in Lombardy, he seldom ventured far from Milan where, on the death of Charles d'Amboise in 1511, he achieved his long-cherished ambition by becoming, although briefly, governor. He was eventually supplanted in the affections of King François I (who succeeded to the French crown in 1515) by the same man who had supplanted him in the esteem of Lodovico Sforza, Sanseverino. Trivulzio died at the age of 80, a few months before Leonardo and in the same country, France, where he had been summoned to answer a charge of treason.

Leonardo seems to have welcomed the chance to compensate for the failure of the Sforza 'Horse' by creating another great bronze equestrian statue, though this one was to be more modest in size. He worked out a long and detailed list of costs, to ensure that the work remained within the allotted budget, which incidentally tells us what the monument would have consisted of. The statue, life-size, was to be raised on a large, free-standing architectural base in the form of a tomb in classical style, with a stone effigy of the Milanese general enclosed by eight columns and eight figures of prisoners, representing defeated enemies, an idea possibly influenced by Michelangelo's slave figures from his tomb for Julius II.

Leonardo da Vinci

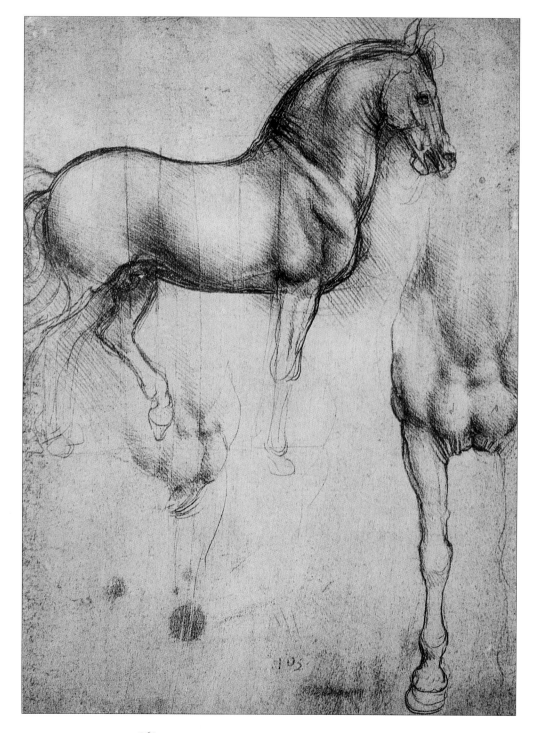

Leonardo spent long hours working on the design, and many sketches survive although no finished drawings, so that we do not know what the final design would have been, or even if it ever reached that stage. In view of the vast number of sketches and drawings of horses he had made throughout his life, most recently for the *Battle of Anghiari*, these sketches may be taken as evidence of Leonardo's infinite capacity for taking pains. Equally, in view of the reappearance of some of the same problems that had arisen over the Sforza Horse, they may be seen as indications of Leonardo's perennial difficulty in reaching conclusions.

For the Trivulzio monument, he reverted to the possibility of a rearing horse, which he had long contemplated, but reluctantly discarded, for the Sforza statue. Again, he planned to support the horse's raised forelegs with the body of a fallen opponent, and this is the form adopted in what appear to be some of the latest sketches. Often, sketches of rearing and pacing horses appear on the same sheet, showing how unwilling he was to

Rearing horse

Sanguine, 6 x 5⅝in
(15.3 x 14.2cm)
Windsor Castle, the Royal
Collection

Not even Leonardo considered quite
so rampant a pose for the Sforza
monument, and this drawing has
been variously linked with
studies for the Adoration the Magi
and, at the other end of his career,
the Trivulzio monument, the
former being more likely.

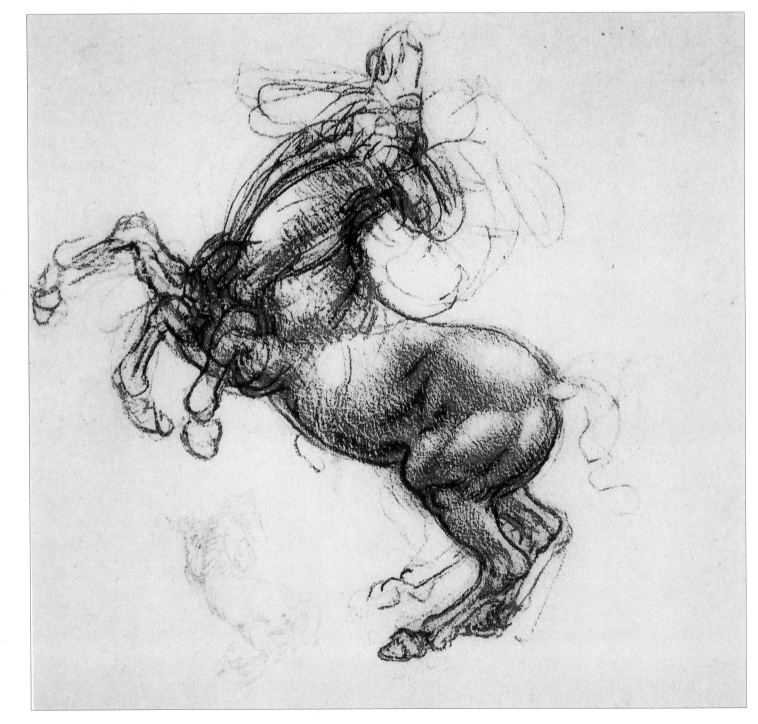

give up the idea. In one example, a compromise appears in which the rider reins in his rearing horse, thus 'combining the advantages of both poses – the dynamism of the rearing horse, the structural security of the pacing one' (Cecil Gould). Another similarity with the earlier monument is Leonardo's indecision over the position of the rider's free arm, sometimes stretched out behind him, sometimes pointing forward, and as with the Sforza statue, there are also many beautiful sketches of horse alone. The rider, not intended to be a likeness of the craggy old *condottiere*, appears variously garbed, sometimes nude and garlanded as a classical hero.

The project was cancelled long before Leonardo was able to demonstrate whether or not he could successfully cast the bronze horse and rider. We do not know exactly when or why. It may have been due to Charles d'Amboise. His relationship with Trivulzio was frosty at best, and he may have discouraged a work designed to bolster the prestige of a man who had an eye on his own office. Trivulzio's actual tomb in Milan,

incidentally, is a much more modest affair.

Trivulzio was virtually the last of the old *condottieri*, which is one reason for the decline of the equestrian statue. When it was revived towards the end of the 16th century, it was again in the form of a pacing horse. Small bronzes of rearing horses were not uncommon, but the technical difficulties of the subject in a large, free-standing sculpture seemed to rule it out. The first sculptor to bring it off was Pietro Tacca in 1640, with the aid of a concealed cantilever provided by Galileo.

During his last residence in Milan Leonardo had several invitations, both from his patron, Charles d'Amboise, and indirectly from Louis XII, to work in France. He declined, preferring to remain in Lombardy which had become his second home, the more so as there was now less to lure him back to Florence. However, political events, which had driven him from Milan in 1499, were about to disrupt his life again in a similar manner.

The arbiters of the fate of the duchy in these years were the Swiss. It was the defection of the Swiss mercenaries to the French, their traditional

employers, that had caused the final defeat of the Sforza, and in one of the many ironies of Italian history, it was Swiss support of the Sforza against the French that led to their retreat from Milan. Indeed, the star of France in Italy was already fading (though her decisive defeat at Pavia did not come until six years after Leonardo's death). The main strategic interest of the Swiss was the control of the commercially vital Alpine passes into Lombardy, and they had spent much of the 15th century endeavouring to gain the strongpoints south of the Alps that controlled the St. Gotthard and Simplon passes. The Swiss may even have contemplated making the duchy of Milan a Swiss canton, though that proved a little too ambitious.

France was generally very unpopular in Italy. Both the pope, Julius II, and the Venetians saw the French as the major obstacle to their plans for territorial expansion. However, the Venetians were even more unpopular than the French and in the League of Cambrai formed in 1508, the pope formed an alliance with France and the Emperor Maximilian against Venice. The Venetians were

defeated, but in 1510 Julius changed sides, resulting in the formation of a new alliance called the Holy League, in which Venice and France changed places, Venice becoming one of the allies and France the enemy. A Swiss army laid siege to Milan, whose citizens, having suffered considerably in the previous two years from the drain imposed on them by the French war effort, were thoroughly disillusioned with French rule. In a rare note on public events in December 1511 Leonardo noted that the Swiss had set fire to Desio, on the outskirts of the city. He retired to the Melzi villa on the Adda, out of harm's way.

The Swiss, on behalf of the emperor, the overlord of Milan, proclaimed that their intention was to oust the French and restore Milan to the eldest of Lodovico Sforza's sons, Massimiliano, who had been brought up, with his brother Francesco, in exile and was now aged 19. It is curious how the Italians, though often fickle, nurtured a fundamental affection for their ruling princes, despite numerous disappointments, for generations. The prospect of a Sforza restoration was greeted

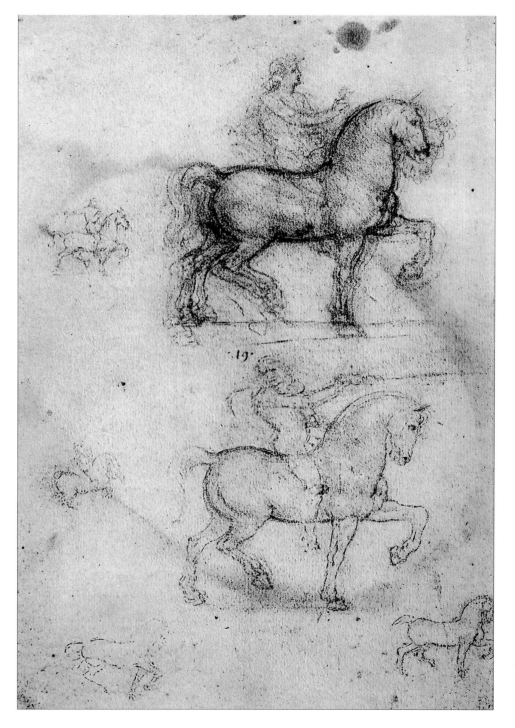

with intense enthusiasm, and anti-French sentiment approached the threshold of open rebellion. It was clear to Trivulzio and the French that their rule in Milan was no longer tenable. They evacuated the city, apart from a garrison in the Castello that held out for months, and Massimiliano Sforza entered Milan to a rapturous reception.

Leonardo must have been less delighted. The death of Charles d'Amboise and the flight of the French left him once more without a powerful patron. For the time being he remained the guest of the Melzi, drawing up plans for improving the estate and continuing his studies in comparative anatomy by dissecting animals. The Sforza were not the only dynasty making a comeback. When the warrior-pope Julius II died in 1513, he was succeeded by Leo X, a Medici, younger son of Lorenzo the Magnificent. His brother, Giuliano de' Medici, became commander of the papal forces. In Florence, the Republic had collapsed and, backed by Spanish arms, the Medici returned to power there. Once more, some optimists foresaw the unification of the Italian states under the Medici,

RIGHT

A horseman in combat with a griffon

Silverpoint on paper
Ashmolean Museum, Oxford

OPPOSITE

Sketches for the monument to Marshal Trivulzio

Windsor Castle, the Royal Collection

Leonardo was reluctant to abandon the ambitious idea of a rearing horse.

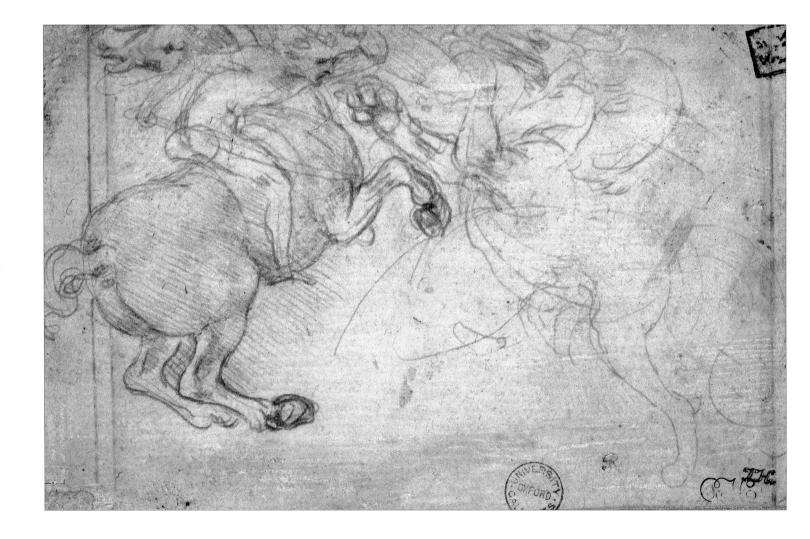

Leonardo da Vinci

but in reality there was little prospect of such an outcome in view of the close involvement in Italian affairs of the great continental powers – not only the expanding kingdom of Spain, currently supporting the Medici, but also the Empire and France.

Rome
1513–16

'On the 24th September I left Milan for Rome,' Leonardo noted in 1513. With him went Francesco Melzi, Salai, an apprentice from Florence called Lorenzo and a young man called Il Fanfoia, either another apprentice or a servant. On the way they stopped in Florence, now once more restored to the Medici. There he deposited a sum of money in the bank, which suggests that he had met with Giuliano de' Medici, Pope Leo X's brother, because, we can safely assume, it was at his invitation that he was making his way to Rome and the money was no doubt an advance on future services.

Giuliano, whom Leonardo sometimes referred to as 'Il Magnifico', ought to have been well attuned to Leonardo since, like him, his interests embraced art and science. He seems to have treated him well – like a friend according to one observer – though Leonardo's retainer was not large. As for Giuliano's older brother, the pope, he was, like his predecessors, unconvincing as a spiritual leader, though he was reasonably pious and willing at least to think about reforming the Church. A sensible

statesman who had knocked about the world while the Medici were in eclipse enduring hard times, some of them in a French prison, he was an intellectual of wide-ranging interests and a keen patron of the arts.

Rome was full of artists. At the top of the pile and in their prime were Michelangelo, who had recently finished the vault of the Sistine Chapel to the wonder and astonishment of all who saw it, and Raphael, now at the height of his fame after completing his Stanze in the Vatican palace, works that represented the very peak of the High Renaissance. Leonardo, although at 62 he was much older than Michelangelo (39) and Raphael (31), could boast no comparable achievement. In Florence ten years earlier, where he had last encountered them, Michelangelo's fame was only just beginning to spread and Raphael was almost unknown. Leonardo must have been uncomfortably aware that in fame and reputation he had slipped sharply down the rankings.

For the first time since 1482, Leonardo found himself in a city where he was not the unrivalled

Giuliano de' Medici, by Michelangelo

This is the head of a statue from Giuliano's tomb in the New Sacristy in San Lorenzo, Florence. Giuliano was a younger son of Lorenzo the Magnificent and brother of Pope Leo X. He was Leonardo's patron in Rome.

Leonardo da Vinci

master, and to the many ambitious young artists milling about the Vatican he must have been seen as a figure of the past, now out of fashion. He was an old man, and seems to have looked even older, if we can judge by the famous self-portrait in red chalk (page 385), now in Turin, and the tendency of others to assume he was older than he was. Like the climate, the society of Renaissance Rome, which apart from the clamouring artistic circle around the Vatican was a rich but philistine city, was no better suited to him than the Florence of Lorenzo de' Medici. He had never been pushy, nor was he greatly interested in fame or fortune.

In Rome, fter a lifetime of hearty vigour, Leonardo suffered some health problems. The oppressive Roman climate did not appeal to him and, although he had a justifiably low opinion of doctors, he seems to have consulted a physician, or at least thought of doing so, since some unknown person noted down for him the name and address of a doctor in Rome. In a letter to the absent Giuliano in the summer of 1515 Leonardo himself reports that he has 'recovered' his health. He

apparently made use of spectacles. He had first mentioned them many years earlier in the Romagna; his Roman ones had glass tinted blue.

His eyesight was not bad enough to inhibit his work, and although no great works lay ahead, he had not altogether stopped painting. He had with him, we can assume, several pictures of which some still required finishing touches, including the *Mona Lisa*, *Leda and the Swan*, and probably the Louvre version of the *Virgin and Child with St. Anne*, while he may have worked also on his *St. John the Baptist*. According to Vasari, he did two small pictures for a Vatican official, one a *Virgin and Child*, which apparently fell victim to some error in the preparation of the materials (a familiar tale), and the other of a young boy, but no trace of either now exists. The pope, who preferred Raphael and showed little enthusiasm for Leonardo, is also said to have commissioned a painting. Hearing that Leonardo had been preparing the varnish, Leo made the oft-quoted remark that this was a man who would 'never do anything, as he is thinking of the end of the work before he begins'.

Sheet discussing cosmology and light on the sun and the moon

Perhaps stimulated at first by Toscanelli in Florence, Leonardo was throughout his life profoundly curious about the heavenly bodies. This drawing may be connected with the eclipse of the sun in March 1485 which he probably witnessed.

OPPOSITE
The Belvedere, Rome

The courtyard of the Belvedere, an adjunct to the Vatican, where Leonardo had his lodgings.

Besides successful rivals, he also encountered some old friends in Rome. His extensive quarters in the Belvedere, an adjunct of the Vatican palace, were prepared very thoroughly – the windows were enlarged and new furniture bought including a special table for mixing colours – by an assistant of Bramante, who had been Rome's leading architect for many years and had redesigned St. Peter's on an uncompromisingly central plan. Not much of his work in the Vatican has survived, barring the spiral ramp in a tower of the Belvedere, and he died not many months after Leonardo's arrival.

An even older friend was Giuliano da San Gallo, the architect-engineer whom he knew as a young man in Florence. He was completing his church of Santa Maria dell' Anima and had also been involved with St. Peter's, but he was now a very old man (seven years older than Leonardo) and he died in 1516, not long before Leonardo left Rome. Among his sketches is one of Cardinal Grimani, a discriminating patron whom he had met in Venice, now in Rome.

There were also visitors, no doubt a great many

381

of them. Leonardo, after all, influenced most of the early 16th-century painters of Italy, and he may have met many of them. Raphael must surely have called on him. Another painter, then still unknown, who may have seen him at this time (though there is no evidence except style) was Correggio. One of his half-brothers, a notary like his father, came to see him in Rome, all animosity over family inheritances apparently forgotten.

Some writers have seen Leonardo in Rome as a sad figure, moping about the echoing passages of the Vatican, superannuated, disregarded, idle and, since Giuliano was away a lot, under-employed. This is a most improbable picture. Leonardo was never idle and, as he had told his critics in Milan, he often accomplished most when he did not appear to be doing anything. His huge range of intellectual interests continued to occupy him as they did until the end of his life. His interest in plants, evident in his earliest paintings, was stimulated by the Vatican's botanical garden. He was still devising new instruments, including a machine for minting coins, still carrying out studies in anatomy, mathematics and physics.

OPPOSITE

A page of notes on the sun and the moon

From a notebook partly written in Florence in 1508, and mainly concerned with dynamics.

LEFT

Study of the different aerodynamic qualities of varying forms with a sketch of a man and two birds

Brown chalk on paper
Bibliothèque de l'Institut de France

SELF-PORTRAITS

We have no portrait of Leonardo, by himself or by another artist, which can with perfect confidence be declared an authentic likeness, but we have several that are generally accepted as such. If we take all the alleged portraits together, we end up with a fair picture of Leonardo, first, as a beautiful youth, then as a handsome if worn and craggy old man, much like the two types that predominate in his numberless sketches of anonymous heads. There is almost nothing that may indicate what Leonardo looked like in the prime of life, although some have seen a possible likeness in that of the younger (but not youthful) soldier in the two hugely admired studies of two heads for the *Battle of Anghiari*, now in Budapest.

Leonardo's most familiar self-portrait is the marvellous red-chalk drawing in the Royal Library of Turin, measuring 13¹/₈ x 8³/₈in (33.3 x 21.3cm). The medium was one particularly suited to Leonardo and he handled it almost like oil paint. Today the drawing is not on public view owing to its fragile condition and is therefore known to all but a favoured few only through reproductions, which are, curiously and perplexingly, extremely varied in their effect, presumably owing to the circumstances and technical details of the different photographs and printing. It has an inscription asserting Leonardo's authorship, although the note is not in Leonardo's hand and is now very difficult to read; but it is accepted as genuine by most (though not all) authorities. It dates from about the time of the artist's departure from Milan for Rome in 1513.

Though a magnificent face, it is that of a man who appears older than Leonardo, who was not long past 60 at that time. However, we know from other evidence that in later years he looked older than his years. One acquaintance described his image as 'venerable' over a decade earlier, in reference, it seems, to a vanished drawing. Leonardo perhaps encouraged that impression by growing a beard, though he appears to have grown it when still a young man, before his first move to Milan. One feature that lends a little support to those who deny that the Turin drawing is a self-portrait is that, unlike nearly all other self-portraits by famous artists, the eyes are not directed at the spectator – the result of painting from a reflection in a mirror. However, as we know, Leonardo was much involved with mirrors about this time, including an octagonal one that presented multiple images, and he might have used such a device to get the angle he desired. Perhaps he wanted to avoid the direct gaze in order to gain a greater sense of objectivity.

A drawing at Windsor of slightly later date shows an old man in profile, seated with legs crossed, one hand supporting his head, gazing into the distance and deep in thought – not a very joyful thought judging by his expression. Of this figure, which like the Turin drawing is an example of that category, so liberally represented in Leonardo's notebooks that Kenneth Clark called it 'nutcracker man', Clark perceptively remarked, 'Even if this is not strictly a self-portrait we may call it a self-caricature, … a simplified expression of essential character.' Something similar might be said

of alleged portraits by others, in which Leonardo may be the model but the result is not seriously intended as the deliberate, true-to-life likeness to be expected in, for instance, a court portrait by Titian and may indeed be that of a different individual (Verrocchio's *David* and Raphael's Plato in the *School of Athens* being just two examples).

Even the numerous prints and copies of his face in profile amount to no more than a generalized picture of an elderly sage. That is the popular image of him today, thanks largely to the Turin drawing. At one time, he was generally pictured wearing a hat, an image that derived from an engraving made to illustrate the second edition of Vasari's *Lives* in 1568. About 70 years ago, the Uffizi in Florence contained a portrait in oils of Leonardo also wearing a hat. It was believed to be a self-portrait until the doubts raised by its mediocre quality were confirmed by X-ray photographs showing that it had been painted over a 17th-century painting!

Over the years great efforts have gone into the search for possible self-portraits in Leonardo's works, such as the youth looking aside in the *Adoration of the Magi*. Leonardo, in encouraging painters to seek suitable features among the faces of people seen in the streets, himself remarked that painters who relied on their own imagination tended to create types that resemble themselves. Some students have found among his drawings done in middle age faces that they are convinced are self-portraits, but they are of much older subjects and thus must again be regarded as, at best, self-caricatures.

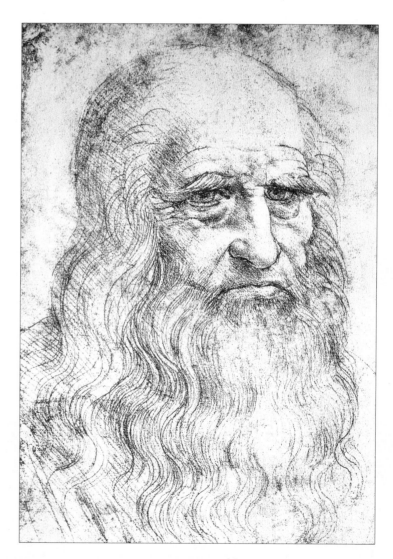

OPPOSITE
The Adoration of the Magi
The detail shows a youth at the edge of the picture looking away from the min action, and may be self-portrait of Leonardo as a young man.

LEFT
Portrait of a bearded man (possibly a self-portrait) *c.1513*
Red chalk on paper
Biblioteca Reale, Turin

We cannot be certain that this hugely familiar drawing actually is Leonardo's portrait of himself, but it is widely accepted as such by contemporary scholars. Even if he was his own model, it is not necessarily an exact likeness.

WORK IN ROME

Certain persons were assigned to assist Leonardo. Two of them we know by name, but only because they proved such unsatisfactory assistants. Moreover, as they were adult Germans, and in one case fat, they lacked the charm and beauty of Latin youth to compensate for their bad behaviour. Georgio Tedesco was a metal worker who was supposed to make the devices that Leonardo designed, but from the start he showed no enthusiasm for the job. Instead he would go off with members of the Swiss Guard (the papal bodyguard) to shoot birds in the ruins of the Forum, an activity unlikely to make him any less obnoxious to Leonardo. When Leonardo sent his young assistant Lorenzo to look for him, Georgio sent a message to say he was working in Duke Giuliano's armoury, which was untrue. Moreover, he was under the influence of his compatriot, Giovanni degli Specchi ('of the mirrors'), a glass- and mirror-maker with a workshop near Leonardo's in the Belvedere.

Leonardo was working on mirrors and lenses in various connections: for instance, he was hoping to harness solar energy to heat the huge vats used by dyers of cloth with an immense parabolic mirror, and he also toyed with the idea of a giant reflector that would give him a closer look at the stars. Giovanni appears to have been jealous of the favour Leonardo enjoyed from their master, Duke Giuliano, and considered that Leonardo had unduly spacious premises that ought to have been allotted to him. According to Leonardo, Giovanni was keen to steal his ideas and persuaded Georgio to make wooden copies of the instruments he made in metal (so he did do some work!) according to Leonardo's designs, with the intention of smuggling them back to Germany.

In a world without patent office or law of copyright, Leonardo was acutely sensitive to intellectual thieves, and he took steps to prevent prying by giving minimum information to Georgio and recording details of his projects in a rudimentary code. Presumably from sheer malignancy, the mirror-maker spread gossip to the effect that Leonardo was a sorcerer who performed sacrilegious rites. The upshot was that the pope, probably just to stop scandalous gossip, banned Leonardo's anatomical work, and he was forced to

The Swiss Guard

The Swiss Guard today. The pope's private army was founded by Julius II (1503–13), and its uniform was said to have been designed by Michelangelo.

OPPOSITE

Portrait of Leo X, Cardinal Luigi de' Rossi and Giulio de' Medici, by Raphael *(1518)*

Oil on panel
Uffizi, Florence

Pope Leo X (1513–21) was more deeply concerned with the welfare of the Medici than the Christian commonwealth. The figure on the left is Giulio de' Medici, nephew of Lorenzo the Magnificent and thus first cousin of Leo, who would himself become pope as Clement VII (1523–34).

give up the dissections he had been pursuing in the hospital of San Spirito.

One reason why the climate of Rome was so unhealthy – and remained so until remarkably recent times – was the proximity of the Pontine marshes, an area of low-lying, swampy ground covering about 300sq miles (775km²) in south-west Latium. A line of low sandhills prevented it from draining into the sea, and it was a place where malarial mosquitoes thrived.

The first effort to drain the marshes was made by the ancient republic at the time of the construction of the Appian Way, which crosses the area, in the 4th century BC. Many later rulers of Rome had considered the possibility of reclaiming what, in the 20th century, became highly productive agricultural land, among them Pope Leo X. He entrusted his brother with the task and Duke Giuliano, who must have been aware of Leonardo's wide experience in hydraulic engineering, naturally involved him in the project, for which preliminary plans had already been made.

Helped by the admirable Melzi, Leonardo mapped the entire region. The task required him to spend some time there, which may have had

something to do with his poor health. The surviving map shows how he intended to drain the marshes by canals leading to the sea, and work on it soon began, though Leonardo was not directly involved (the man in charge was a Lombard and thus likely to have been familiar with canal building). It seems to have continued for some time before petering out, probably after the death of Duke Giuliano, who footed the bill in return for a promised share of the reclaimed land, in 1516.

Leonardo was connected, in one way or another, with numerous other building enterprises both in Rome and further afield. Like many others, he may have been consulted about additions to Brunelleschi's Medici church of San Lorenzo in Florence, and may have submitted plans for the façade. The only survival from his architectural activities in Rome itself is what was the Medici stables (now housing an academic institute), based on his unused design in Milan. He also travelled a good deal, to Civitavecchia, where he may have taken over the plans for the harbour after Bramante's death, to Parma and elsewhere, probably on Giuliano's business, as well as to Florence and possibly even Milan.

Leonardo da Vinci

Leonardo always liked to astonish people, and was more than ready to employ his ingenuity and expertise in ways designed to entertain rather than instruct. According to Vasari, 'he made a paste with wax and constructed hollow animals which flew in the air when blown up…'. More remarkable was his pet lizard, an unusual one found by a servant employed in the Belvedere. On this unfortunate creature 'he fastened [as wings] scales taken from other lizards, dipped in quicksilver, which trembled as it moved, and after giving it eyes, a horn and a beard, he tamed it and kept in in a box. All the friends to whom he showed it ran away terrified'. This anecdote, reminiscent of the story about the device he painted as a boy on a piece of wood given to his father by a peasant of Vinci, seems odd, even improbable. A better joke, perhaps, was his trick with the gut of a ram, or bullock, which he would 'dry and purge and make so small that it might be held in the palm of the hand. In another room he kept a pair of smith's bellows, and with these he would blow out one of the guts until it filled the room, a large one, forcing anyone there to take refuge in a corner… He perpetrated many such follies…'.

OPPOSITE

Archimedes screw and water wheels, from a facsimile of the Codex Atlanticus

Private collection

Copy of a Leonardo drawing of an Archimedes screw and other devices for raising water to a higher level.

WATER AND FLOOD

It was probably during his brief years in Rome that Leonardo made the series of drawings of the Great Flood, depictions of overwhelming catastrophe, which have come to be seen as his most intensely personal works. They have special significance for the modern age, with its experience of destruction on a hideous scale.

Leonardo was always fascinated by force, and particularly by the immense power of nature as manifest in storm and flood, for which, as noted earlier, many writers have assumed that some childhood trauma was responsible. He regarded water as the great indispensable life force, comparing its functions with those of the blood, as well as a mighty engine of destruction, not only when it ran out of control but also in a slower, steadier way, by erosion, a phenomenon of which Leonardo seems to have been aware (water, he said, would reduce the earth to a perfectly smooth sphere if it could).

Throughout his life he frequently devoted his powerful intellect to the study of hydrodynamics – the movement of water – with a view to harnessing it for the benefit of humanity. His drawings of eddies, currents and whirlpools contrive to be both works of art and scientific diagrams, and they remind us of his equally intricate drawings of hair; indeed, he himself remarked on the similarity of the movement of water to human hair. Projects to control water were a major professional occupation, and he expended much thought and effort on schemes such as digging canals, draining marshes, designing pumps, and building dams and locks. Water is almost invariably an element in the landscape backgrounds of his paintings.

The Great Flood was the form which his visions of the apocalypse generally took. This became almost an obsession. In a letter to a friend, he wrote of a terrible nightmare in which he was consumed by an inconceivably vast monster emerging from the ocean depths. But he contemplated the total destruction of the world not with horror exclusively. Of course, apocalyptic visions of Hell were common, and the preaching of Savonarola or others like him may have had some

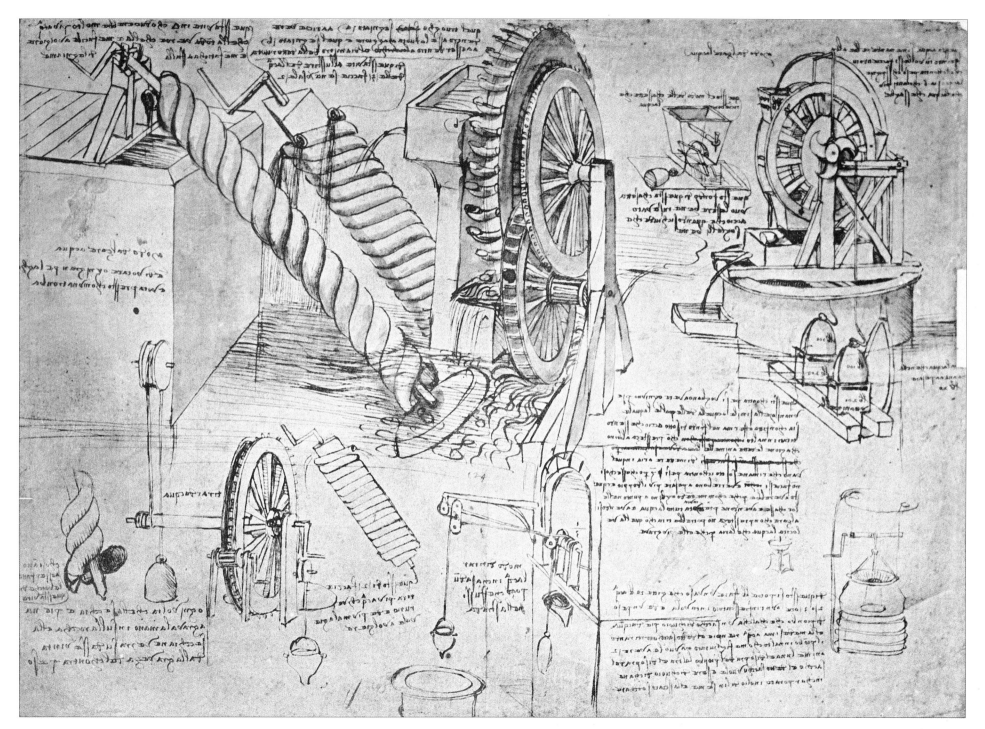

OPPOSITE

Destruction and beauty: The Wave, by Hokusai (1760–1849)

effect on Leonardo, but Leonardo was also stimulated by the violence of human conflict, as in the *Battle of Anghiari*, which was both abhorrent and fascinating.

An earlier drawing, done in Milan, shows an obliterating downpour in which it rains not cats and dogs but a collection of heavy household objects such as tools and cooking pots that have been caught up by a tornado and hurled violently to earth. One of the Rome drawings shows a town annihilated by the collapse of a mountain undermined by the overpowering deluge and, as one of Leonardo's biographers has remarked, his lengthy written commentary, which purports to be an essay on how the Biblical Flood is represented in painting, reads like a screenplay for a disaster movie.

One will see whole mountain sides, already ravaged by foaming torrents, collapsing and filling the valleys, covering great plains and their inhabitants ... On many mountain tops we will see terrified animals of all kinds and families marooned, while everything that floats becomes an improvised boat on which men, women and children huddle together crying and lamenting, terrified by the furious hurricane that whips up the waves and with them the corpses of the drowned ... Some people block their ears and cover their eyes to blot out the violence of the wind, rain and thunder that shakes the dark air, others lose their reason, unable to bear such torture, and kill themselves, hurling themselves from ridges or attempting to strangle themselves with their own hands, while others seize their children and kill them, as mothers shake their fists at heaven and howl curses on the gods.

This is a terrible vision, genuinely disturbing, yet somehow the drawings are less terrible. In a sense, science and artistry undermine the effect of these tremendous drawings, as the powers of destruction assume delicate patterns that remind us inevitably of Hokusai and Japanese paintings.

A deluge

Windsor Castle, the Royal Library

A wall falling under the pressure of water
Windsor Castle, the Royal Library

Detail showing bridge construction difficulties, from the Codex Leicester

Here Leonardo deals with practical problems on the subject of rising and falling water. How does one arrange the escarpments of bridge pillars so that the current's movement won't destroy them? This question provides a context for understanding his intense interest in water currents, including the complexity of eddies and whirlpools that form around obstacles, the configurations of riverbanks, and the confluence of separate water flows. The last paragraph on this page is about the moon. Referring to action of light and the observer's static position, Leonardo notes that light travels in all directions but the observer stands in one place and sees only a small part of the cosmic whole. His logic is directed against the traditional theory that the surface of the moon is polished like a mirror. In that case, the observer would see one large reflected image. However, if the moon's surface were faceted – broken up by waves on the surface of its water – the observer would see a softer radiance, not a single, large mirror reflection of the sun. He employs a sketch, placing the human eye between the sun and the earth to illustrate how rays of light travel and are reflected:

But a single eye consists of a point to which the rays converge from the boundaries of the solar image. And as this concourse of pyramidal rays comes to be intersected by water surface, it will show how such a large image will appear on the intersecting water surface. And the size of the intersection will be smaller the closer the eye that sees such an image is to the water surface on which the sun reflects itself.

***Detail showing bridge and weir construction, from the* Codex Leicester**

Continuing his water studies, Leonardo here relies on observation and analysis of effect to explain the causes of what he sees. His faith in the geometric structure of the universe underlies his scientific method. On this page, titled 'Of the water of the moon,' Leonardo sets out to prove *how in some aspect of the sky the shaded side of the moon has some luminosity, and how in some other part of the sky it is deprived of such luminosity*. He notes the need to take into account the reflection of the light from the waters of the earth to explain the radiance of the moon. Later in the 16th century, Galileo, who was familiar with Leonardo's manuscripts,

proposed the light from neighbouring bodies reflected the light of the moon. Here Leonardo claims that when the moon is at its brightest it receives strong solar rays reflected from the earth's ocean. The argument is a good example of Leonardo's faith in the underlying geometric structure of the universe which led him to construct theoretical experiments based on analogies. his proposal could be verified, but it encouraged further speculation that countered the prevailing notion that the moon had a shiny mirror-like surface. Here Leonardo's aim is to account for variations in the brightness of the moon over the lunar cycle. Near the bottom of the page, he moves from his astronomical studies to bridge and weir construction: *The pillars of bridges should always have escarpments stretched out against the oncoming current of the rivers, otherwise the bridges will soon collapse toward the oncoming current.*

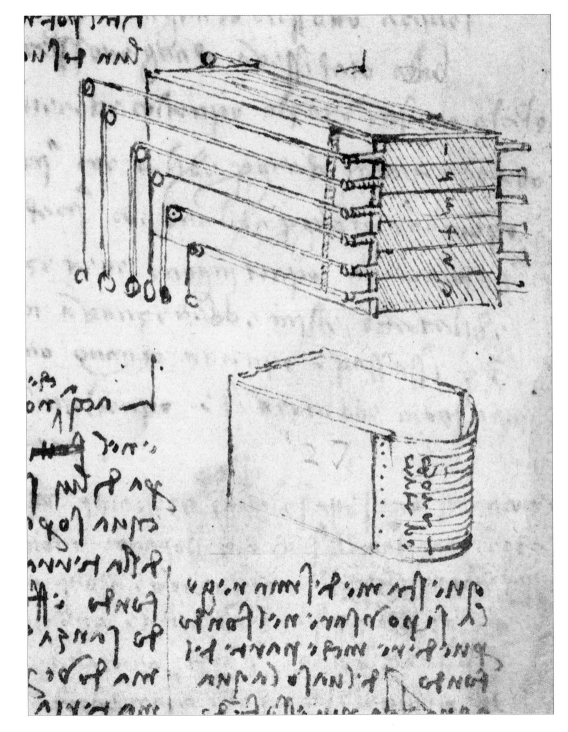

Detail showing an experiment to test water velocity and pressure, from the Codex Leicester

Here Leonardo rejects conventionl thinking about the descent of water from mountain tops and questions the source of underground rivers. Then he studies the flow of rivers and the gravity of moving water as differing from that of still water. Here, as in related passages in the *Codex Atlanticus*, Leonardo studies the relationship between water velocity and its pressure. He records an experiment to test the movement of water at different levels in rivers and then sets out to prove that water pressure, and therefore velocity, increases. He tests this hypothesis in another laboratory experiment described in another page. His approach is scientifically interesting for taking into account the complexity of forces that contribute to the flow of water. He analyzes the rate of water flow at various depths in order to gauge water pressure. He then compares the nature of moving water flow and still water, reasoning that still water does not exert pressure on the bottom. His evidence for this conclusion is the waving motion of the grasses that grow on the bottom *and the very light mud at the bottom of marshes, which has almost the lightness of water itself; instead, had the water gravity over it, it would be compressed and almost petrified; the contrary being shown, the axiom that water does not weigh over its bottom is proven by the said experience.* Leonardo concludes that water pressure must therefore be due to what he calls percussion, the impact of moving water.

***Detail of stairways and dams used to mitigate erosion, from the* Codex Leicester**

Here Leonardo provides a geometric analysis of riverbank erosion. He synthesizes many aspects of hydraulics, including riverbank erosion, and constructs a cascade of intertwining currents of water for the steps of La Sforzesca, his patron's country villa. In this discussion of problems that erosion causes homeowners who build their houses on riverbanks, Leonardo demonstrates how he has synthesized many aspects of hydraulics studied elsewhere in the codex. He devises a series of barriers and dams that move the flowing water left and right and finally deposit the material *in the hollow where your house is.* Applying the same principle of intertwining currents of water, he creates a cascade for the steps at La Sforzesca, the luxurious country villa of his patron, the duke of Milan, at Vigevano. These still-functioning steps are a tribute to Leonard's inventiveness. They turned the potentially damaging action of rushing water to productive, aesthetically pleasing purpose.

Leonardo da Vinci

Sheet discussing the properties of air and water, from the Codex Leicester

While not directly concerned with the body of the earth theme, Leonardo's considerations here are much clearer if we keep in mind that the four elements are essential to theories of the macrocosm. Leonardo explores the interrelationships of three of the four elements – air, water, and fire – both visually and through thought experiments. He begins with a simple observation on the pattern of surface waves in a bowl of water. The last example on the page concerns not water, but air. Leonardo writes that smoke, like water, moves at first fast, and then more slowly because *it becomes colder and heavier, owing to the fact that a great part of it is condensed through the parts striking against each other and being pressed together and made to adhere one to another.* Leonardo's comparision of the elements is made explicit in the text where he mentions Heron of Alexandria's steam-driven rotating ball, the Eolipile, as a demonstration of applied pressure created by heat. He compares this to the action of wind striking a mountain peak, illustrated at the bottom of the page. Three points may be made about this discussion as a whole: first, Leonardo is looking for ways to describe rates of change for two variables. His method of quantification is rooted in geometric ratios, not absolute units of measurement. Second, the underlying scheme for his structural analogy of air and water is the four elements. And third, his accounts of the behaviour of particles suspended in a medium were unprecedented: the subject is still a challenge in the modern science of fluid dynamics.

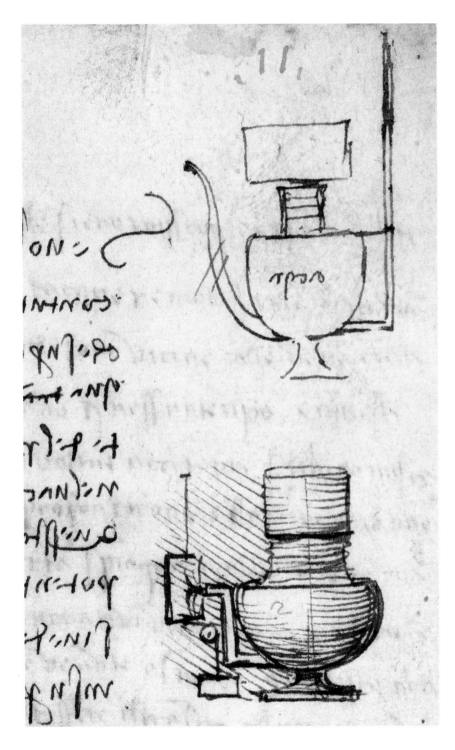

Detail showing a water pressure experiment, from the Codex Leicester

One of the main problems in Leonardo's studies of hydraulics was how water acquires power in proportion to its velocity. His discussion here includes an experiment about water pressure, illustrated in the margin by a drawing of a device that prophetically resembles a kind of coffee maker in use today. Although he leaves out the element of heat, or fire, Leonardo's description of the device sounds curiously similar to a modern espresso machine: *The mouth of the pipe which pours the water pressed out of a vessel will have such proportion to the total amount of the vacuum of its vessel as the weight of the water which is found in the pipe, and which is brought up above all the water left in the vessel, has to the weight pressing over the vessel.* He continues with a discussion of measuring that water pressure, referring to the storage of wine in barrels, and theorizes that the weight of the water at the bottom of a barrel is quite a bit heavier than that at the top: *Water in itself gives more weight to the hole made at the bottom of the vessel than water does at the surface, and at every degree of depth it acquires degrees of weight; and the proof is seen in the wine casks.* He adds a direct admonition to readers about his final draft: *See to it that the examples and the proofs that have to be given in this work be stated and defined before you present them.* Leonardo proceeds with an example of the measurement of pressure: *The air that fills a ball has power uniformly distributed within the ball, although, mathematically speaking, it should be heavier at the bottom than at the surface because 'Compressed air acquires weight within the air which is not compressed, and more so at the lower than at the upper support.'* He then reveals a vivid analogy between the explosions of the natural water-based fumarole, or geyser, and that of the man-made, gunpowder-based bombard, or mortar: *Water overcome by the heat in the bowels of the earth evaporates and increases in volume, similarly to gunpowder ignited in a bombard, and it splits the earth open where it is weaker, and it puffs out at intervals, because it is constrained by the weight of the earth, which had opened up to give way to its first impulse; and when the impetus of an exit is lacking, the impetus of the weight prevails and shuts the opening, hence the building up of steam pressure again, which again causes the earth to split open suddenly.*

***Detail showing bridge construction, from the* Codex Leicester**

This page is considered the beginning of a compilation on water because a note Leonardo wrote at the top: '10 sheets and 853 conclusions'. Even though Leonardo's descriptions of locations appear to be based on actual visits, in some cases he was indebted to the written accounts of others. The present page is a good example: Giovanni Villani's *Historiae* of 1348 is the source of Leonardo's account of the formation of the gap at the Gonfolina rock. Villani argued that the gap was artificially made; Leonardo disagrees. He studies in detail how the churning deluge water would have affected the deposit of shells and considers a variety of conditions that make water powerful. He determines to write his own book (or what would be to us as a chapter) on the subject of places occupied by fresh water. This discussion concerns the problem, frequently encountered in the codex, of accounting for the presence of shells on mountaintops. Leonardo the hydraulic engineer draws from his own experience. *A great quantity of shell may be seen where the rivers empty into the sea.* Citing two examples the rivers of the Apennines, which empty into the Adriatic, and the Arno tumbling from the rock of Gonfolina – he concludes that the shells in the mix of fresh and salt water came down the rivers from the mountains: *The waters which came from the earth to the sea, although they drew the sea toward the earth, were those which smote its base, because water which comes from the earth has a stronger current than the sea, and as a consequence is more powerful and enters beneath the other water of the sea, and stirs up the bottom and carries with it all the moveable objects which are to be found in it, such as the above-mentioned shells and other like things; and as water which comes from the land is muddier than the sea, it is so much the more powerful and heavier than it. I do not see therefore in what way the said shells could have come to be so far inland unless they had been borne there.*

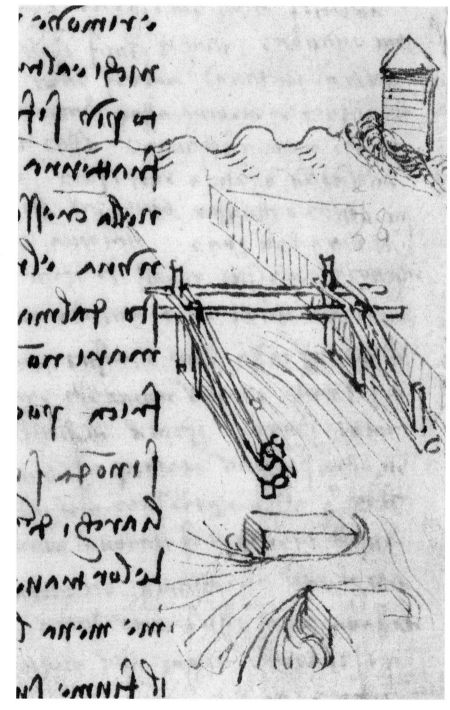

Sheet discussing water currents, from the Codex Leicester

Here Leonardo continues his interest in controlling the flow of rivers, and he gives indications here that his observations involve more than just watching a river from a boat. In one passage he proposes an accurate method of gauging the speed of a current. In his time there was no concept of a second hand or a stopwatch. To measure a short-term event, such as the passage of an object bobbing in a swift current, one normally counted by the beats of one's own pulse. Leonardo, an accomplished musician, decided that the beat of musical measure would be more regular and defines it as 1,080 units per hour. With his usual resourcefulness, Leonardo invents standard measures to quantify his studies of nature. He adds another dimension of scientific precision to his study of water when he includes controlled experiments, such as: *how a small weight close to the bottom of transparent water, suspended by a tread from a float, may explain the varieties of the motions below the surface of the water.* Leonardo recognizes not only the relationship between the surface of water and its bottom, but also the need to clearly understand the workings of the intervening column of fluid. This programme of study is one that any modern hydraulic engineer would recognize, as it involved the creation of glass-sided tanks that allowed him to observe and control as many conditions as possible. His last idea on this page addresses avoiding or reducing the effects of erosion: *When one wants to extinguish such power which causes the hollowing out of a riverbed, one ought to order a transverse current directed against such clashing of the waters, so as to hit them and set them apart, and to spread and weaken them.*

Detail showing water pressure measurement, from the Codex Leicester

Leonardo comes to terms with topics of physical geography, such as how viscosity affects wave action. He describes a number of practical applications of the theoretical study of water pressure. He also describes a number of practical applications of the theoretical study of water pressure, particularly as it is applied to swamp drainage. Here, as elsewhere, he lists a number of 'cases', in this instance, 18 to be examined in the future. Leonardo begins the page with directions on how to empty a swamp by means of 'siphonic action' and ends with a sketch describing the weight of water in a cylindrical container upon which he has marked off measurements similar to those on a modern measuring cup. His conception, however, is somewhat different from ours: he assumes that the water at the bottom of the container is 'heavier'. We would say it is under greater pressure from the column of water above it. Drafts of the passages included here appear in the *Codex Atlanticus*. The physical evidence indicates that Leonardo kept the information for that codex on loose sheets stacked one inside the other. The *Codex Leicester* probably originated the same way.

***Detail showing wave motion, from the* Codex Leicester**

Leonardo's studies of compound motion address the confluence of water meeting from different directions. Leonardo deals with water movement and also tries to calculate the accidental gravity of the earth. Most of this page, which at the top announces 15 cases to be considered in the future, deals with the movement of water. Leonardo's studies of compund motion here analyze the shapes and patterns that result from the confluence of water meeting from different directions. He considers factors of depth, percussion (impact), and velocity. Much of this material detailing examinations of eddies and whirlpools formed in water has been dealt with on other pages. Leonardo's illustrations here are some of the most beautiful of the codex. The vortices formed by the water, the curling wave action, the separation of currents caused by obstacles placed in the water's flow all exhibit a careful observation of nature. This page ends with a comparison of the movements that result when water percusses air and sand.

Detail showing the draining of a swamp, from the Codex Leicester

Here Leonardo discusses the sediment carried by rivers and where various kinds of this sediment are deposited. He also records ideas for draining swamps, a subject on which his expertise was frequently sought. The writing has the flavour of a technical manual for hydraulic engineers. It is a far cry from his philosophical musings or evocative poetic descriptions about the body of the earth found elsewhere in the codex. Leonardo rarely makes sketches within the text, preferring to illustrate his major points in the outer margin with substantiating explanations. This page, with its interspersed drawings directly referring to specific notes, is an exception. His margin here contains only one reference and illustration, on the method for draining a swamp. The presence of silt or other detritus radically affects the flow of water. Leonardo extrapolates, case by case: _How clear waters which enter into swamps cause their waters to lower that is, by removing soil from their bottom. How waters taken from swamps in order to dry them ought to be taken when the tide causes the sea level to drop. How narrow entrances and exits in great lakes cause the soil carried by turbid waters to be deposited in these lakes. How wide entrances and exits in lakes cause the soil to be removed, making such lakes deeper. How a turbid river which pours into a swamp fills up and dries this swamp._

***Detail showing converging water currents, from the
Codex Leicester***

These pages discuss the confluence of currents. This catalogue of 26
cases deals with hydrodynamics and the meeting of two or more
currents. One of the most interesting pages, it demonstrates how
Leonardo's aesthetic and scientific interests are integral to each other.
Obstacles are not placed in currents simply to create beautiful
stationary patterns. Leonardo observes these effects to find ways to
keep river currents from eroding the banks they percuss. This page
includes a comparative discussion of the formation of clouds from
water vapour. Leonardo's surprisingly modern concern with friction
(*confregazione*) shows his sensitivity to the physics as well as the
geometry of water flow.

Chapter Ten
Amboise
1516–19

OPPOSITE

Portrait of François I on horseback (c.1540)

Uffizi, Florence

Courtly portrait by an unknown artist of François I, Leonardo's last and perhaps most generous patron. Such was French fascination with the Italian Renaissance that Leonardo was more a kind of treasured token than an employee.

When King Louis XII of France died in January 1515 he was succeeded by François I, who belonged to another line of the House of Valois and, as heir presumptive, had married Louis's daughter. He was 20 years old, a dashing young giant of a man who relished the role of Renaissance prince and cultivated the image of a medieval chivalric hero.

François lost no time in renewing Louis's claim to Milan, formed an alliance with Venice and by July, in his golden armour, he had led his army across the Alps via an unexpected route made known to the French by that veteran warrior Trivulzio. They took a papal force by surprise, whereupon the rest of Massimiliano Sforza's forces retreated to Milan. The bulk of them were Swiss mercenaries, and François adopted the usual means of neutralizing mercenaries by offering a large bribe; but on this occasion the arrival of another force from the cantons, anticipating loot and hostile to French control of the passes, spoiled his scheme.

In the ensuing battle of Marignano (French Marignan) in September, the French had a huge advantage in artillery – allegedly 72 guns to ten – which, together with the timely advent of the Venetians and Trivulzio's local knowledge (he showed them how to flood the fields), proved decisive. After a long and bloody battle, called off at midnight (the moon was bright) and resumed at dawn, the Swiss were all but annihilated. Massimiliano retreated to the Castello, where he might have held out for months, but François offered him good terms, including a generous pension, and he agreed, with some relief, to leave Italy. Forsaking his glittering armour for a suit of blue velvet embroidered with gold lilies, François entered Milan.

Pope Leo X was in a state of some embarrassment, since his troops had fought on the side of the Sforza, but peace talks were successfully concluded at Bologna the following month. We know little about Leonardo's movements at this time, but somewhere he must have met the young French king, either at Bologna or when Leonardo paid a visit to Milan, though there is no firm evidence of either. The famous mechanical lion, which walked a few paces then opened its chest to reveal the fleur-

de-lys, may have made its appearance at Bologna although, unless there were two or more of these creatures, it is also said to have featured on both earlier and later occasions.

In any case, François is sure to have known of Leonardo and as he, like other monarchs, was on the lookout for Italian artists and experts, and the supply of first-rate artists was not endless, he probably repeated to Leonardo the invitation of his predecessor. For the time being Leonardo remained loyal to Giuliano de' Medici, who in spite of having recently taken a wife (a purely political match, however), was in poor health. He died in March 1516, leaving Leonardo again without an obvious patron – other than King François.

Leonardo was still in Rome in August, but he must have left before the winter, having decided to take up the invitation to settle in France. He was now indubitably an old man. He had never before been out of Italy, although he had never been exclusively identified with a single state, and it must have been plain that if he went to live in the Loire valley he was unlikely to see Italy again. If that

thought occurred to him, it probably did not trouble him much.

It proved a sensible decision. He was again among admirers, and again without rivals. Yet there was no pressure on him to produce new work. François seems to have wanted nothing from him but his company and conversation. There is no question that this gilded young monarch admired the old Italian guru enormously, and grew fond of him too. In spite of the giant gap between a king and a commoner, their relationship was more than that of patron and client. It might be compared with the relationship between François's great future enemy, the Emperor Charles V, and Titian. According to Benvenuto Cellini, the French king (then still in his early 20s) was 'enamoured to an extraordinary degree of Leonardo's marvellous talents [and] took such pleasure in hearing him talk that he would only very occasionally deny himself the pleasure of listening to him… I must repeat the words the King used to me in the presence of the Cardinal of Ferrara, the Cardinal of Lorraine, and the King of Navarre. He said that he did not believe that a man

Leonardo da Vinci

had ever been born who knew as much as Leonardo, not only in the spheres of painting, sculpture and architecture, but also in that of philosophy.' It would be interesting to know what language they talked in. The king probably knew at least some Italian and Leonardo some French, but one of them must have been fluent in both.

Leonardo was provided with the little château of Cloux, a house near Amboise. A large room on the ground floor provided a suitable studio. The building was connected to the royal palace by a tunnel and looked out on pasture, gardens with a dovecote, a vineyard and a small stream. To judge from Melzi's drawing from a bedroom window, the surroundings are much the same today. Leonardo's household, excluding what French staff were provided, numbered only three: Melzi, Salai and a servant called Battista de' Villanis. He was awarded a pension, which was considerably more generous than that he had received from Giuliano de' Medici, with a small salary for 'the Italian gentleman' (Melzi) and a one-off payment for Salai. Leonardo's last three years were comfortable and secure.

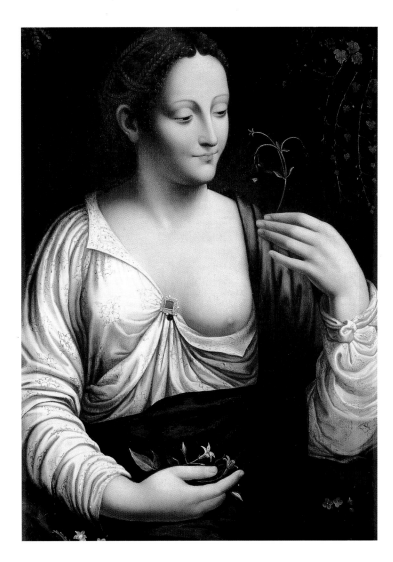

OPPOSITE
Bacchus *(c.1695)*
(from the studio of Leonardo da Vinci)
Oil on canvas

This was once attributed to Leonardo and probably started life as a St. John. It was converted to the pagan god of wine perhaps because, as an Italian who saw it at Fontainebleau in 1625 remarked, it entirely lacks the spirit of devotion. It is generally regarded as a studio work, possibly by Cesare de Sesto, although Kenneth Clark thought it probably a copy.

LEFT
Columbine
Oil on canvas
Musée des Beaux-Arts, Blois

This painting, ascribed to the 'school of Leonardo', is possibly by Francesco de Melzi.

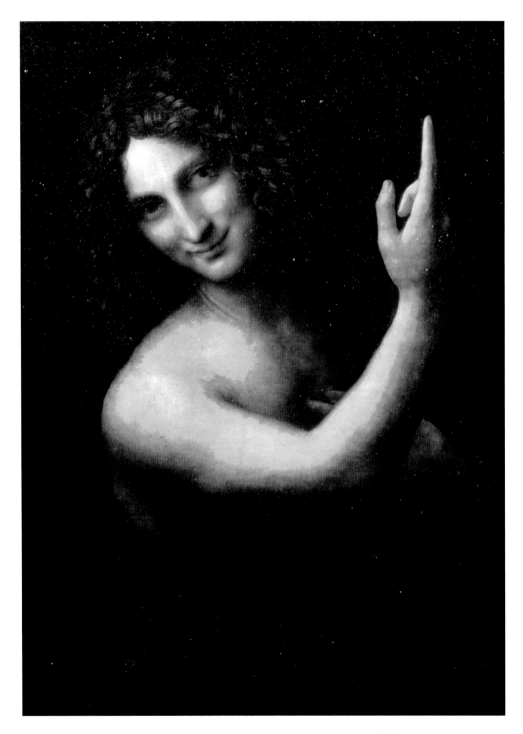

ST. JOHN THE BAPTIST

Leonardo brought his possessions with him, as well as paintings that included the *Mona Lisa*, the *Virgin and Child with St. Anne*, and what is generally regarded as his last painting, *St. John the Baptist* (now in the Louvre). Although this painting was perhaps completed in France, it must have been done to a fairly advanced stage in Rome and, since there are so many contemporary Italian copies, was probably started during his second period in Milan.

In recent times, Leonardo's extraordinary picture of the Baptist has been the least popular of all his paintings. At one time many writers doubted it was his work, and there may have been some repainting, for instance of the raised hand, that spoils Leonardo's *sfumato* effects. An additional problem is that the painting, a dramatic exercise in *chiaroscuro* and rather dark except for the flesh tones, has by now become downright murky. But Leonardo's image of the saint has provoked harsh comments from even his most learned admirers: 'baffling ... almost blasphemous ...', an 'effete, almost obscene ephebe', 'the effusion of an ageing

Leonardo da Vinci

homosexual', and others. Far-fetched theories have been advanced: that Leonardo was working off a deep-seated antagonism to homosexuality, or that he was deliberately mocking Christianity. Leonardo was not a very religious man, but he was not antagonistic to religion or even to the Church (he did not share Michelangelo's passionate desire for ecclesiastical reform). And he was certainly no atheist. Like some scientists today, he felt that the very complexity and efficiency of nature argued some supreme creative agency beyond it.

The trouble is that Leonardo's *St. John the Baptist* is almost the total opposite of the image of him presented by the Gospels (or for that matter by Donatello, among others). The fierce, tough, desert-dwelling ascetic is here transformed into a plump and strangely grinning androgyne. It is not an attractive figure, even to non-Christians. But it is Leonardo's image and, like all his pictures, the subject and the design evolved over a very long period. There is no reason to think that Leonardo's attention was less intense, careful and devoted in this than in any other work, which is confirmed by close analysis of the painting.

The genesis of the work can be traced back to a painting of an angel described by Vasari, in whose time it was owned by Cosimo de' Medici, first duke of Florence (from 1537) and later grand duke of Tuscany. It probably dated from Leonardo's last residence in Florence and showed the angel raising his arm in the air, so that the upper arm was foreshortened, with the other hand resting on his chest. Vasari refers to it as 'a head' but it is clear that it was a half-figure. Although the original painting is lost, several copies exist, including what looks like a workshop copy in Basel. (There is also a drawing at Windsor, apparently by one of Leonardo's pupils and corrected by the master, on a sheet that also contains little half-done sketches, high-class doodles really, relating to the *Battle of Anghiari*, an indication of the date.) These exactly follow Vasari's description of the design, which differs significantly from the later St. John the Baptist in one respect only (disregarding the fact that the left hand now holds the reed cross identifying the Baptist). The right arm which, in the

OPPOSITE and OVERLEAF *details*
St. John the Baptist *(c.1513–16)*
*Oil on panel, 27$\frac{1}{8}$ x 22$\frac{3}{8}$in
(69 x 57cm)
Louvre, Paris*

Leonardo's last painting and possibly the most controversial. It has been suggested that some of its unpopularity is due to the large number of surviving copies by various run-of-the-mill artists obsessed with the smile, which in their work becomes a gross and alarming leer. Moreover, the gesture of the pointing finger, dear to Leonardo, was employed to ridiculous excess by his followers.

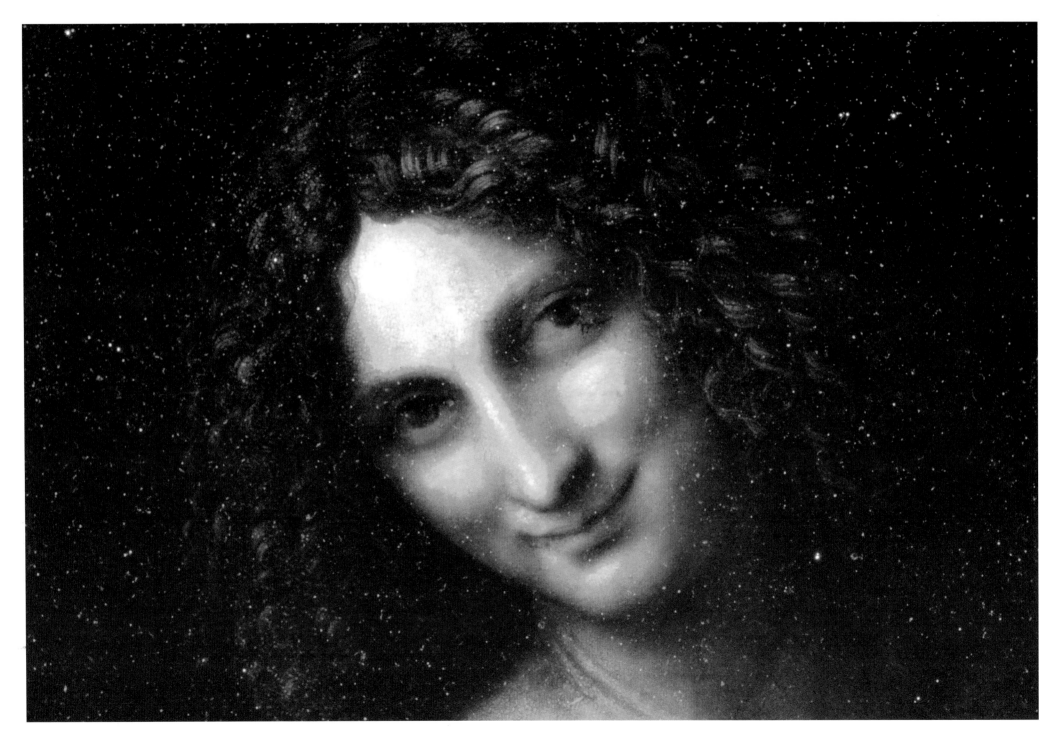

Leonardo da Vinci

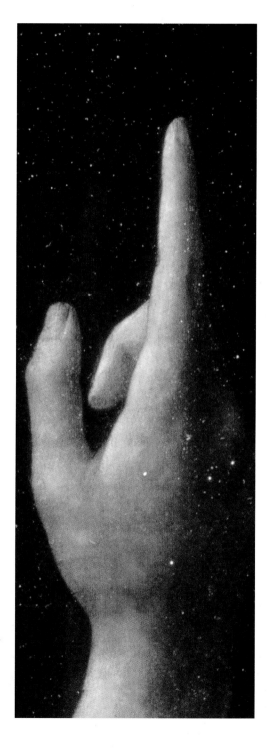

angel, points straight up (with the hand appearing to the left of the head), in the *St. John* is brought across the body so that the hand appears to the right of the head. Structural reasons might be advanced to explain the change, but obviously there is more to it than that. The angel was clearly an Angel of the Annunciation (Gabriel). It was not uncommon for the two figures, the Angel and the Virgin Mary, to appear on different panels. This is incidentally a very bold, almost a revolutionary design, since the Angel looks straight out of the painting and thus puts the spectator in the position of the Virgin Mary. He points heavenwards to indicate the divine origin of the Child that Mary will bear. The gesture of St. John the Baptist also advises the coming of Christ: 'he that cometh after me [who] is mightier than I…'. The hand points up, indicating divine origin, and also back ('he that cometh after').

Whether the Angel's supposedly reassuring smile is equally appropriately transferred to this second prophet of the coming of the Messiah is another matter. There was a recent fashion for figures of the Baptist as a youth, in fact Leonardo had contributed to it with a drawing of a nude Baptist about 1481, but the Louvre *St. John* is not quite a youth. The smile, even if not quite the 'grotesque leer' that some have called it, seems to us rather smug, but this expression, like the gesture of the pointing finger, had some deep significance for Leonardo that we cannot fully comprehend. As we have seen, this gesture was not invented by Leonardo, but he made it his own, and its familiarity through the work of his countless copiers, provokes an unsympathetic reaction; far from conveying a sense of divine mystery, it seems too obvious. It would be wrong to think that this was the reaction of Leonardo's contemporaries.

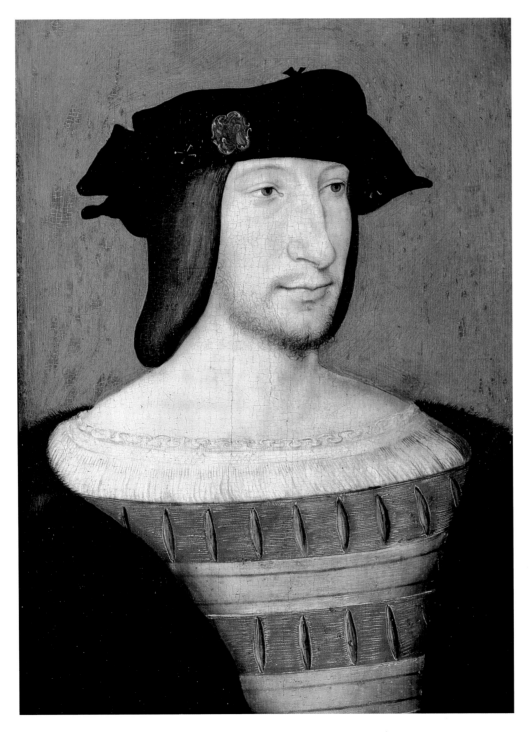

THE LAST YEARS

We can be sure that Leonardo had many visitors at Cloux, but only one has left any record of him in his last years in France, Antonio de' Beatis, secretary to Cardinal Louis of Aragon, who came in October 1517. We have already encountered De' Beatis reporting that Leonardo showed the cardinal a picture that was surely the *Mona Lisa*, along with two others, the *St. John the Baptist* and the *Virgin and Child with St. Anne*. The secretary also wrote enthusiastically of Leonardo's studies of water, and of 'divers machines, and other things', but especially his work in anatomy, 'in a way that has never yet been done by any other person'. Leonardo had written extensive works on all these subjects, which were being prepared for publication, he said, and would be immensely useful, as they were 'all in the vulgar tongue'. Castles in Spain, alas.

His report on Leonardo's health was less hopeful. In the first place he took him to be 'over 70 years old', when he was only 65. He warned that no more great works could be expected of him

Leonardo da Vinci

because of 'a certain paralysis that has affected his right hand'. He was not able to work with colour in his customary delicate manner, the cardinal's secretary recorded, but could still produce designs and had a well-trained Milanese pupil [i.e. Melzi] who worked very well under his instruction.

This is a little odd. Leonardo, of course, was left-handed, so failure of his right hand would not have prevented him painting. Perhaps this was just a slip, and De' Beatis meant his working hand, which in most people is the right. Or perhaps he had recently suffered a slight stroke or something similar from which he recovered. For Leonardo could certainly still write, and as evenly as ever. He could still presumably draw, as it is said that he could make designs, and some of the late drawings, although they cannot be dated exactly, are likely to be later than October 1517, most notably a full-length figure of a woman, hair blown by a breeze and pointing at something out of the picture, which is thought to have been an illustration to Dante.

His chief task as painter, engineer and architect for François I was the design for a royal palace at

Romorantin and what amounted to a new town to service it. He visited the place soon after his arrival at Cloux together with the king, one of whose reasons for selecting Romorantin was that it lay at the exact centre of France. This was another vast hydroengineering project, which included the draining of marshes, the diversion of the river Sauldre and the creation of a complex of waterways providing links to both the English Channel and the Mediterranean, as well as fountains and a lake-cum-reservoir. For all this Leonardo was able to make use of his earlier hydroengineering projects in Lombardy and Tuscany and his earlier plans for a new town. The royal château at Romorantin would have been enormous, though we do not know what it would have looked like, and he also designed pavilions, gardens and stables. Some building actually took place, and the walls are said to have reached a height of nearly 10ft (3m) before the plans were abandoned, after Leonardo's death, when François diverted his ambitions to Chambord.

Leonardo was also no doubt called upon to contribute to court festivities of the kind he had

OPPOSITE

The Ermine as a Symbol of Purity (c.1494)

Pen and ink on paper

Fitzwilliam Museum, Cambridge

designed for Lodovico Sforza, though probably not as chief impresario. He must have been involved in the two weeks of festivities at Amboise in April 1518 that marked the baptism of the dauphin as well as the marriage of Lorenzo di Piero de' Medici, nephew of Leonardo's dead patron Giuliano, to a French princess. A few weeks later he must have presided over a production of the *Masque of the Planets*, which he had produced in Milan 28 years before in honour of Lodovico's duchess, Beatrice.

On 23 April 1519 Leonardo, who had been ill and apparently bedridden for some time, made his will. He asked to be buried in the church at Amboise, made arrangements for his funeral and provided for masses to be said for him, but gave no instructions for his actual burial nor what should be written on his tomb. What this means in terms of Leonardo's religious beliefs is open to question. According to Vasari, at the end of his life he asked for religious counsel and repented and confessed, which may well be true, though we should allow for some wishful thinking by Vasari's informants.

He died a little over a week later, on 2 May.

Vasari says that François I visited him often. On the final occasion he arrived after Leonardo had received the last rites, when the dying man, characteristically, endeavoured to explain his symptoms and their significance. He also uttered his regret that he had 'not worked on his art' as much as he should have. If that meant painting, it sounds improbable, but perhaps the words should be linked with one or two remarks in the notebooks which, as we have seen, offer some support for the idea that towards the end of his life Leonardo worried about not having fulfilled his potential. We know that he made some effort towards assembling his notes for the various treatises he had meant to write, but for such a task he was not well fitted, old or young.

Vasari adds that Leonardo died in the arms of the French king, a nice story that was apparently exploded in 1850 by the discovery of a royal act signed at Saint-Germain-en-Laye, at least two days' journey from Amboise, on the day after Leonardo's death. However, it is not certain that François signed the act in person, so that Vasari's

story, however unlikely, is not impossible.

Leonardo's tomb has never been located and the church was largely demolished in the post-revolutionary era. In 1863 some bones were discovered that were said to be his, an ascription that depended on hope rather than evidence.

His will, of which only a copy survives, divided the Milanese vineyard between the servant Battista de Villanis and his old retainer, Salai. In fact the latter was already living there, in a house he had built, no doubt with Leonardo's money, on the land. Nothing more is heard of Salai for certain, but he is said to have been shot and killed about five years later. Leonardo's money and property (the legacy of his uncle Francesco) in Florence went to his half-brothers. Everything else, including his books and writings, went to his executor, Francesco Melzi.

LEONARDO'S NOTEBOOKS

We have more of Leonardo's writings, drawings and working notebooks than we have for any comparable artist, but they represent only a comparatively small proportion of what once existed. Some of his manuscripts probably disappeared in his own lifetime, lost or given away. Subsequently they passed through a variety of hands, some careless, some clumsy and some criminal. The first serious collector, Pompeo Leoni, who was sculptor to the king of Naples, numbered the manuscripts he possessed from one to 46, but only 19 can be traced now. The *Codex Trivulzianus*, in Milan, originally contained 92 folios. When Leoni acquired it, it had only 55; today it has 51.

In some ways, the Leonardo writings are disappointing. Typically, the material is arbitrary and repetitive, with quite disparate subjects mixed up together and mingled with unacknowledged quotations. Some are addressed to a reader, some are merely memos to himself. They occur in large bound manuscripts in many folios and on odd

scraps of paper: Leonardo made notes on whatever was to hand. For all his good intentions, hardly a coherent chapter, let alone a book, can be found in Leonardo's entire surviving production.

Melzi did not leave Amboise until at least a year after Leonardo's death. The paintings remained in France, but he took to the Melzi villa at Vaprio all Leonardo's manuscripts – thousands of pages of writings and drawings. Several people (including Vasari) saw them in the 1520s. Melzi made an attempt to catalogue them, and selected the passages that made up the original *Treatise on Painting*, though it was still unfinished when it left his possession. Eventually a reliable copy was to pass, as we have seen, via the dukes of Urbino to the Vatican.

Melzi outlived his master by over 50 years, dying in 1570. His son and heir, Orazio, who had no interest in the manuscripts and did not think they were valuable, seems to have distributed them freely more or less to anyone who asked. A substantial number passed, via the Medici grand dukes of Tuscany, into the possession of Giovanni

Leonardo da Vinci

Ambrogio Mazenta, an honest man (later a monk), who tried to return them to Orazio Melzi, only to be told they were not wanted. It was Mazenta's extensive collection, or rather a substantial part of it, that was acquired by Pompeo Leoni, who also got hold of various assorted papers from elsewhere.

Like others before him, Leoni tried to put the material into some kind of order. He sorted them into two groups. One group, 'Designs of Leonardo...' now forms the English royal collection at Windsor. The other, 'Designs of Machines and Secret Arts and other Things by Leonardo...', became the *Codex Atlanticus* (named after the large-sized paper, atlantica) in the Biblioteca Ambrosiana in Milan, the main repository of Leonardo manuscripts in the 18th century. Unfortunately, the Ambrosiana was not thoroughly secure. A good deal of material disappeared in the course of time, and what remained was carried off to Paris by Napoleon, although the Codex Atlanticus was returned after his defeat. Leoni had claimed to be buying the Leonardo manuscripts for the king of Spain, and part of his collection, the largest since Melzi, did find its way to Madrid. In 1866, this material (*Madrid Codex I* and *II*) went missing, but turned up almost exactly 100 years later on the shelves of the National Library.

Today, most of Leonardo's manuscripts are to be found in libraries and museums in Italy, England, France and Spain. Only one, the Codex Leicester, named for a former owner, is still privately owned.

Giorgio Vasari:
The Life of Leonardo da Vinci

OPPOSITE

Leonardo da Vinci

Giorgio Vasari (1511–74) wrote about hundreds of artists in his *Lives of the Most Eminent Italian Architects, Painters, and Sculptors*, which he published first in 1550, and later revised in 1568.

LIFE OF LEONARDO DA VINCI: Painter and Sculptor of Florence.

The greatest gifts are often seen, in the course of nature, rained by celestial influences on human creatures; and sometimes, in supernatural fashion, beauty, grace, and talent are united beyond measure in one single person, in a manner that to whatever such an one turns his attention, his every action is so divine, that, surpassing all other men, it makes itself clearly known as a thing bestowed by God (as it is), and not acquired by human art. This was seen by all mankind in Leonardo da Vinci, in whom, besides a beauty of body never sufficiently extolled, there was an infinite grace in all his actions; and so great was his genius, and such its growth, that to whatever difficulties he turned his mind, he solved them with ease. In him was great bodily strength, joined to dexterity, with a spirit and courage ever royal and magnanimous; and the fame of his name so increased, that not only in his lifetime was he held in esteem, but his reputation became even greater among posterity after his death.

Truly marvellous and celestial was Leonardo, the son of Ser Piero da Vinci; and in learning and in the rudiments of letters he would have made great proficience, if he had not been so variable and unstable, for he set himself to learn many things, and then, after having begun them, abandoned them. Thus, in arithmetic, during the few months that he studied it, he made so much progress, that, by continually suggesting doubts and difficulties to the master who was teaching him, he would very often bewilder him.

He gave some little attention to music, and quickly resolved to learn to play the lyre, as one who had by nature a spirit most lofty and full of refinement: wherefore he sang divinely to that instrument, improvising upon it. Nevertheless, although he occupied himself with such a variety of things, he never ceased drawing and working in relief, pursuits which suited his fancy more than any other.

Ser Piero, having observed this, and having

Leonardo da Vinci

considered the loftiness of his intellect, one day took some of his drawings and carried them to Andrea del Verrocchio, who was much his friend, and besought him straitly [sic] to tell him whether Leonardo, by devoting himself to drawing, would make any proficience. Andrea was astonished to see the extraordinary beginnings of Leonardo, and urged Ser Piero that he should make him study it; wherefore he arranged with Leonardo that he should enter the workshop of Andrea, which Leonardo did with the greatest willingness in the world.

And he practised not one branch of art only, but all those in which drawing played a part; and having an intellect so divine and marvellous that he was also an excellent geometrician, he not only worked in sculpture, making in his youth, in clay, some heads of women that are smiling, of which plaster casts are still taken, and likewise some heads of boys which appeared to have issued from the hand of a master; but in architecture, also, he made many drawings both of ground-plans and of other designs of buildings; and he was the first, although but a youth, who suggested the plan of reducing the river Arno to a navigable canal from Pisa to Florence. He made designs of flour-mills, fullingmills,

and engines, which might be driven by the force of water; and since he wished that his profession should be painting, he studied much in drawing after nature, and sometimes in making models of figures in clay, over which he would lay soft pieces of cloth dipped in clay, and then set himself patiently to draw them on a certain kind of very fine Rheims cloth, or prepared linen; and he executed them in black and white with the point of his brush, so that it was a marvel, as some of them by his hand, which I have in our book of drawings, still bear witness; besides which, he drew on paper with such diligence and so well, that there is no one who has ever equalled him in perfection of finish; and I have one, a head drawn with the style in chiaroscuro, which is divine.

And there was infused in that brain such grace from God, and a power of expression in such sublime accord with the intellect and memory that served it, and he knew so well how to express his conceptions by draughtmanship, that he vanquished with his discourse, and confuted with his reasoning, every valiant wit. And he was continually making models and designs to show men how to remove mountains with ease, and how to bore them in order to pass from one level to another; and by means of levers, windlasses, and screws, he showed the way to raise and draw great weights, together with methods for emptying harbours, and pumps for removing water from low places, things which his brain never ceased from devising.

It is clear that Leonardo, through his comprehension of art, began many things and never finished one of them, since it seemed to him that the hand was not able to attain to the perfection of art in carrying out the things which he imagined; for the reason that he conceived in idea difficulties so subtle and so marvellous, that they could never be expressed by the hands, be they ever so excellent. And so many were his caprices, that, philosophizing of natural things, he set himself to seek out the properties of herbs, going on even to observe the motions of the heavens, the path of the moon, and the courses of the sun.

He also painted in Milan, for the Friars of S. Dominic, at S. Maria delle Grazie, a Last Supper, a most beautiful and marvellous thing; and to the heads of the Apostles he gave such majesty and beauty, that he left the head of Christ unfinished, not believing that he was able

to give it that divine air which is essential to the image of Christ. This work, remaining thus all but finished, has ever been held by the Milanese in the greatest veneration, and also by strangers as well; for Leonardo imagined and succeeded in expressing that anxiety which had seized the Apostles in wishing to know who should betray their Master. For which reason in all their faces are seen love, fear, and wrath, or rather, sorrow, at not being able to understand the meaning of Christ; which thing excites no less marvel than the sight, in contrast to it, of obstinacy, hatred, and treachery in Judas; not to mention that every least part of the work displays an incredible diligence, seeing that even in the tablecloth the texture of the stuff is counterfeited in such a manner that linen itself could not seem more real.

It is said that the Prior of that place kept pressing Leonardo, in a most importunate manner, to finish the work; for it seemed strange to him to see Leonardo sometimes stand half a day at a time, lost in contemplation, and he would have liked him to go on like the labourers hoeing in his garden, without ever stopping his brush. And not content with this, he complained of it to the Duke, and that so warmly, that

he was constrained to send for Leonardo and delicately urged him to work, contriving nevertheless to show him that he was doing all this because of the importunity of the Prior. Leonardo, knowing that the intellect of that Prince was acute and discerning, was pleased to discourse at large with the Duke on the subject, a thing which he had never done with the Prior, and he reasoned much with him about art, and made him understand that men of lofty genius sometimes accomplish the most wh en they work the least, seeking out inventions with the mind, and forming those perfect ideas which the hands afterwards express and reproduce from the images already conceived in the brain. And he added that two heads were still wanting for him to paint; that of Christ, which he did not wish to seek on earth; and he could not think that it was possible to conceive in the imagination that beauty and heavenly grace which should be the mark of God incarnate.

Next, there was wanting that of Judas, which was also troubling him, not thinking himself capable of imagining features that should represent the countenance of him who, after so many benefits received, had a mind so cruel as to resolve to betray his

RIGHT

Head of a man

Chalk on paper

Galleria dell' Accademia, Venice

OPPOSITE

Study of flowers

Pencil on paper

Galleria dell' Accademia, Venice

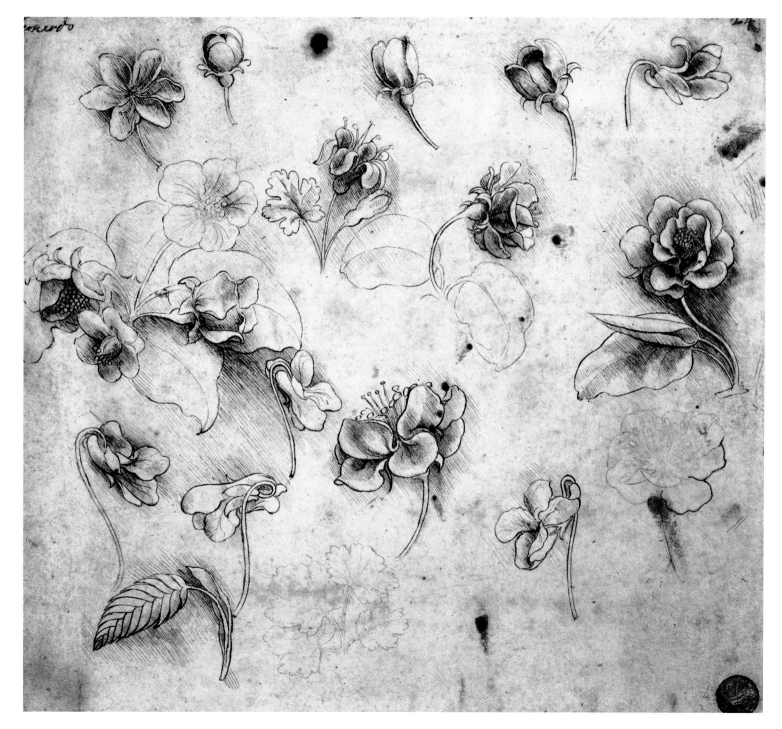

Lord, the Creator of the world. However, he would seek out a model for the latter; but if in the end he could not find a better, he should not want that of the importunate and tactless Prior. This thing moved the Duke wondrously to laughter, and he said that Leonardo had a thousand reasons on his side. And so the poor Prior, in confusion, confined himself to urging on the work in the garden, and left Leonardo in peace, who finished only the head of Judas, which seems the very embodiment of treachery and inhumanity; but that of Christ, as has been said, remained unfinished.

Leonardo undertook to execute, for Francesco del Giocondo, the portrait of Mona Lisa, his wife; and after toiling over it for four years, he left it unfinished; and the work is now in the collection of King Frances of France, at Fontainebleau. In this head, whoever wished to see how closely art could imitate nature, was able to comprehend it with ease; for in it were counterfeited all the minutenesses that with subtlety are able to be painted, seeing that the eyes had that lustre and watery sheen which are always seen in life, and around them were all those rosy and pearly tints, as well as the lashes, which cannot be represented without the greatest

subtlety. The eyebrows, through his having shown the manner in which the hairs spring from the flesh, here more close and here more scanty, and curve according to the pores of the skin, could not be more natural. The nose, with its beautiful nostrils, rosy and tender, appeared to be alive. The mouth, with its opening, and with its ends united by the red of the lips to the flesh-tints of the face, seemed, in truth, to be not colours but flesh. In the pit of the throat, if one gazed upon it intently, could be seen the beating of the pulse. And, indeed, it may be said that it was painted in such a manner as to make every valiant craftsman, be he who he may, tremble and lose heart.

He made use, also, of this device: Mona Lisa being very beautiful, he always employed, while he was painting her portrait, persons to play or sing, and jesters, who might make her remain merry, in order to take away that melancholy which painters are often wont to give to the portraits that they paint. And in this work of Leonardo's there was a smile so pleasing, that it was a thing more divine than human to behold; and it was held to be something marvellous, since the reality was not more alive.

Leonardo da Vinci

There was very great disdain between Michelangelo Buonarroti and him, on account of which Michelangelo departed from Florence, with the excuse of Duke Giuliano, having been summoned by the Pope to the competition for the façade of S. Lorenzo. Leonardo, understanding this, departed and went into France, where the King, having had works by his hand, bore him great affection; and he desired that he should colour the cartoon of S. Anne, but Leonardo, according to his custom, put him off for a long time with words.

Finally, having grown old, he remained ill many months, and, feeling himself near to death, asked to have himself diligently informed of the teaching of the Catholic faith, and of the good way and holy Christian religion; and then, with many moans, he confessed and was penitent; and although he could not raise himself well on his feet, supporting himself on the arms of his friends and servants, he was pleased to take devoutly the most holy Sacrament, out of his bed.

The King, who was wont often and lovingly to visit him, then came into the room; wherefore he, out of reverence, having raised himself to sit upon the bed, giving him an account of his sickness and the circumstances of it, showed withal how much he had offended God and mankind in not having worked at his art as he should have done. Thereupon he was seized by a paroxysm, the messenger of death; for which reason the King having risen and having taken his head, in order to assist him and show him favour, to then end that he might alleviate his pain, his spirit, which was divine, knowing that it could not have any greater honour, expired in the arms of the King, in the seventy figth year of his age.

From Giorgio Vasari's 'Life of Leonardo da Vinci', in *Lives of the Most Eminent Painters, Sculptors, and Architects*, translated by Gaston DeC. De Vere (London: Philip Lee Warner, 1912–14).

Enduring Icons

RIGHT
The Mona Lisa by Dennis Wiemar

Weimer, of Ladysmith, Wisconsin, painted his version of the Mona Lisa on a barn after the University of Wisconsin won the Rose Bowl in 1994.

OPPOSITE
A pastel-toned copy of Leonardo's painting of the Mona Lisa.

RIGHT and OPPOSITE
*Advertising images stolen from
Leonardo, in this case his drawing
of* Vitruvian Man.

Index

Index

Index

Index

Index

Index

Index

Acknowledgements

The Publishers wish to thank the following for providing photographs, and for permission to reproduce copyright material. While every effort has been made to trace and acknowledge copyright-holders, we wish to apologise would any omissions have been made.

AA Photo Library: Pages 166, 271,

AF Kersting: Pages 30, 31, 41, 52, 116, 165, 279, 307, 308, 377, 381

Alte Pinakothek, Munich, Germany: Pages 90 both, 91 left

©Arte & Immagini srl/CORBIS: Page 168

Ashmolean Museum, Oxford/The Bridgeman Art Library London: Pages 244, 269, 313, 374

Bernard Cox/The Bridgeman Art Library, London: Page 192

©Bettmann/CORBIS: Pages 14, 15, 258, 260, 261, 304, 425, 433 both

Biblioteca Ambrosiana, Milan, Italy: 303

Biblioteca Ambrosiana, Milan, Italy/The Bridgeman Art Library, London: Pages 300, 302, 360

Biblioteca Nacional, Madrid, Spain/The Bridgeman Art Library, London: Pages 191, 198

Biblioteca Reale, Turin, Italy: Page 385

Bibliothèque de l'Institut de France, Paris: Pages 253, 254, 255 left, 363, 364, 365, 366

Bibliothèque de l'Institut de France, Paris/The Bridgeman Art Library, London: Pages 170-171, 186, 255 right, 383

Bibliothètheque des Arts Décoratifs, Paris, France: Pages 338, 339

Bibliothètheque Mazarine: Page 251

Brancacci Chapel Santa del Carmine, Florence, Italy/The Bridgeman Art Library, London: Page 25

Brera Gallery, Milan, Italy/The Bridgeman Art Library, London: Page 231

The Bridgeman Art Library, London: Page 117, 193

The British Library, London/The Bridgeman Art Library, London: Page 382

The British Museum, London: Pages 247, 259

The British Museum, London/The Bridgeman Art Library, London: Pages 49, 162 right, 296

©Burtein Collection/CORBIS: Page 434

Christie's Images, London/The Bridgeman Art Library, London: Page 393

Copplestone, Trewin: Page 40

Courtauld Gallery, London/The Bridgeman Art Library, London: Page 195

Czartoryski Museum, Krakow, Poland/The Bridgeman Art Library, London: Pages 3, 134, 135, 137

©David Lees/CORBIS: Pages 252, 256, 257

École Nationale Supérieure des Beaux-Arts, Paris, France/The Bridgeman Art Library, London: Page 248

Edifice © Gillian Darley: Page 16

Edifice © Kim Sayer: Pages 29, 32

Edifice © Phillipa Lewis: Page 60-61

Fitzwilliam Museum, University of Cambridge/The Bridgeman Art Library, London: Page 19, 421

Fratelli Fabbri, Milan, Italy/The Bridgeman Art Library, London: Page 37

Gabinetto dei e Stampe, Uffizi, Florence, Italy/The Bridgeman Art Library, London: Pages 79, 87, 311, 329 left

Galleria degli Uffizi, Florence, Italy: Pages 65, 110-111, 112, 246, 323

Galleria degli Uffizi, Florence, Italy/The Bridgeman Art Library, London: Pages 5, 45, 47, 70, 71, 72, 74-75, 76, 77, 78, 104, 105, 106, 107,

Acknowledgements

108, 109, 147, 197, 233, 241, 325, 356 both, 384, 389, 411

Galleria dell' Accademia, Carrara, Bergamo, Italy/The Bridgeman Art Library, London: Page 291

Galleria dell' Accademia, Florence, Italy/The Bridgeman Art Library, London: Pages 314, 315

Galleria dell' Accademia, Venice, Italy: Pages 336 both

Galleria dell' Accademia, Venice, Italy/The Bridgeman Art Library, London: Pages 162 left, 228, 234, 235, 240, 285, 289, 305, 312, 355, 428, 429

Galleria Nazionale delle Marche, Urbino/The Bridgeman Art Library, London: Page 85

Galleria Nazionale, Parma, Italy/The Bridgman Art Library, London: Page 122

Hermitage, St. Petersburg, Russia: Pages 88 both, 89 both

Hermitage, St. Petersburg, Russia/The Bridgeman Art Library, London: Pages 130, 131 both, 273

©James L. Amos/CORBIS: Pages 12, 13

©Layne Kennedy/CORBIS: Page 432

Leonardo Museum, Vinci, Italy/The Bridgeman Art Library, London: Pages 10, 18, 22, 23, 187, 277

The Louvre, Paris, France: Pages 188 both, 189 both, 237 right, 243, 245, 245, 359

The Louvre, Paris, France/The Bridgeman Art Library, London: Pages 38, 46, 115, 139, 142, 143, 148 left, 150, 151, 152, 160, 161, 238, 249, 264, 286, 319, 329 right, 330, 340 both, 342, 344, 345, 346, 347, 348, 349, 350, 412, 414, 416, 417

©Michael S. Yamashita/CORBIS: Page 435

Musée Angers, France/The Bridgeman Art Library, London: Page 326

Musée Bonnant, Bayonne, France: Page 91 right, 100, 236

Musée Bonnant, Bayonne, France/The Bridgeman Art Library, London: Pages 56, 80, 97, 114

Musée Condé, Chantilly, France/The Bridgeman Art Library, London: Pages 354 both, 355, 418

Musée des Beaux-Arts, Blois, France/The Bridgeman Art Library, London: Page 413

Musée des Beaux-Arts, Caen, France/The Bridgeman Art Library London: Pages 6, 124-125

Musée des Beaux-Arts, Dijon, France/The Bridgeman Art Library, London: Page 281

Museo di San Marco dell' Angelico, Florence, Italy/The Bridgeman Art Library, London: Page 280

Museo e Gallerie Nazionali di Capodimonte, Naples, Italy/The Bridgeman Art Library, London: Page 272

Museo Nazionale del Bargello/The Bridgeman Art Library, London: Pages 50, 51, 62, 66 both

The National Gallery, London: Page 69

The National Gallery, London/The Bridgeman Art Library, London: Pages 82-83, 84, 148 right, 154, 155, 156, 159, 282, 283, 284 both

The National Gallery of Art, Washington D.C. USA: Pages 58, 59 both, 94, 95

©Neil Kirk/CORBIS OUTLINE: Page 218

New Sacristy, San Lorenzo, Italy/The Bridgeman Art Library, London: Page 378

©Owen Franken/CORBIS: Page 11

Palazzo Medici-Riccardi, Florence, Italy/The Bridgeman Art Library, London: Pages 98, 203

Palazzo Reale, Turin, Italy/The Bridgeman Art, Library, London: Page 295

Piazza Santissima Annunziata, Florence,

Acknowledgements

Italy/The Bridgeman Art Library, London: Page 44

Pinoteca Ambrosiana, Milan: Page 172

Pinoteca Ambrosiana, Milan/The Bridgeman Art Library: Pages 144, 145, 163, 239, 242, 244

Pitti Palace, Florence, Italy/The Bridgeman Art Library, London: Page 353

Prato Cathedral/The Bridgeman Art Library, London: Page 205

Private Collection/The Bridgeman Art Library: Pages 140, 175, 230, 274, 299, 309, 332, 391

The Royal Collection, Windsor Castle, England: Pages 81, 190, 237 left, 292, 331, 333, 337, 369, 370, 373, 375, 394, 395

Scrovegni (Arena) Chapel, Padua/The Bridgeman Art Library, London: Page 206

San Francesco Upper Church, Assisi, Italy/The Bridgeman Art Library, London: Pages 21, 39, 207

Santa Maria della Grazie, Milan, Italy/The Bridgeman Art Library, London: Pages 208, 210, 212, 213, 215, 216, 220, 222, 223, 224, 225, 226

Santa Maria Novella, Florence, Italy/The Bridgeman Art Library, London: Pages 42

©Seth Joel/CORBIS: Pages 176, 177, 178, 179, 180, 181, 182, 185, 380, 396, 397, 398, 399, 400, 402, 403, 405, 406, 407, 408, 409

TRIP/Eric Smith: Page 27

©Underwood & Underwood/CORBIS: 387

The Vatican, Rome, Italy: Pages 101, 102, 103, 204, 322